W9-DEE-235

3000 800056 33939
St. Louis Community College

Florissant Valley Library
St. Louis Community College
3400 Pershall Road
Ferguson, MO 63135-1499
314-595-4514

THE ARTS OF JAPAN

WITHDRAWN

THE ARTS OF JAPAN

Ancient and Medieval

Seiroku Noma

KODANSHA INTERNATIONAL
Tokyo · New York · London

Translated and adapted by John Rosenfield

Photographs by Bin Takahashi

Jacket illustrations: (FRONT) *Thunder God.* Painted, assembled woodblock. Detail. H. 105 cm. Thirteenth Century. Rengeō-in Sanjūsangen-dō, Kyoto. Photograph by Asukaen. (BACK) *Bronze mirror with a design of gods, humans, carts and horses.* Fourth to Fifth Centuries. From the Funayama tomb, Eta, Kikusui-machi, Tamana-gun, Kumamoto Prefecture. Tokyo National Museum.

Distributed in the United States by Kodansha America, Inc., 575 Lexington Avenue, New York, N.Y. 10022, and in the United Kingdom and continental Europe by Kodansha Europe Ltd., 95 Aldwych, London WC2B 4JF. Published by Kodansha International Ltd., 17–14, Otowa 1-chome, Bunkyo-ku, Tokyo 112–8652, and by Kodansha America, Inc.

Copyright © 1966 by Seiroku Noma.
English language copyright © 1966 by Kodansha International Ltd.
All rights reserved. Printed in Japan.

First deluxe edition, 1966
First standard edition, 1978
First paperback edition, 2003
ISBN 4–7700–2977–2
03 04 05 06 07 08 09 10 10 9 8 7 6 5 4 3 2 1

www.thejapanpage.com

CONTENTS

NOTE TO READERS

By noting the last syllable of the name of a particular Buddhist structure, an indication of the structure's general nature can be gained. Here are some of the most common name endings.

-ji, -tera, -dera: variant readings of the same Chinese character meaning "temple" (e.g., Tōdai-ji, Asuka-dera).

-in: often used to denote a subordinate part of a large temple (e.g., the *tō-in,* or "east precinct," of Hōryū-ji; or the Daisen-in, a small subtemple within the compound of Daitoku-ji, Kyoto).

-dō: a temple building with a specific function (e.g., *kōdō,* a "lecture hall" for the ceremonial reading of texts or sermons).

-den, -dono: alternate readings of the same character used as an especially honorific reference to either a religious or secular building (e.g., the Shishin-den of the Imperial Palace in Kyoto).

TRANSLATOR'S FOREWORD

This book by Noma Seiroku is one of the rare studies in the history of Oriental art which treat many forms of expression together in terms of the qualities which they have in common, the unifying spirit of the environment and time for which they were made. Most of the visual arts are discussed here—sculpture, painting, ceramics, costumes—yet the author has been highly selective, exploring just those works which seem to evoke the aesthetic, spiritual, and even social ideals of their original setting.

Mr. Noma's prose style is extremely attractive and conveys a great deal in poetic terms which cannot be rendered literally into English. My pleasant if challenging task has been to try to capture the flavor of his insights and preserve his gracious, nontechnical way of expression. This has been complicated by the fact that Mr. Noma has referred to historical or religious matters which are familiar to his original Japanese audience but not to foreigners—the Dōkyō affair, the Gempei war, the deity Fudō Myō-ō. Although frequently discussed with only a word or brief phrase, these are important to his historical concepts, and I have had to expand and clarify them while still trying to keep the technical detail to a minimum. Unavoidably, I have had to make many small alterations and insertions, but have done so with the sole intention of adapting the book for non-Japanese readers. I have attempted to amplify the author's ideas, not to censor or change them.

Another problem is the matter of Buddhist terminology. Some names are more familiar to the Western reader in their Indian form, others by their Japanese names. With this in mind, I have not tried for uniformity of usage, but rather to find a reasonable balance; however, an explanatory phrase is frequently added, or else the name in the alternate form is given in parentheses. These terms are also included in a general glossary which lists historical, religious, and technical words which may be unfamiliar to the Western reader.

The book is divided roughly as follows. The text in ten chapters outlines the unifying aesthetic, religious, and historical factors of a given epoch or region. The captions help define the aesthetic tone of the works illustrated and indicate major points of interest. The Notes at the rear fill out the explanations of religious iconography, factual history, or details of craftsmanship. Mr. Noma has dealt with topics about which Japanese

scholars occasionally disagree—the dating, for example, of two bronze statues at Hōryū-ji attributed to the sculptor Tori Busshi, or the degree of influence exerted on the arts of the eleventh century by the Buddhist notion of the End of the Law (the idea that mankind was entering into an era of weakened virtue). To preserve the flow of his narrative, Mr. Noma has presented his own views without introducing scholarly disputes of a highly technical nature. Unsolved problems lurk in every field of art history, and Japan is no exception. Mr. Noma's views differ occasionally from those of some of his colleagues, but other distinguished scholars share his opinions, which are the result of decades of thoughtful writing and research.

PREFACE

Japan was once joined to the mainland of Asia; numerous fossil remains bear testimony to this. Even after the separation, seeds of trees from as far away as the Indies would be washed ashore by the Black Current, take root, and flourish; migratory birds would fly in from the mainland. Japan has never existed completely apart from the continent, nor has her culture ever been totally isolated. Her ancient artifacts bear traces of influences from Greece, Iran, and India, and all parts of East Asia, as they were channeled through the Korean Peninsula and China. The Japanese, however, have never been content with merely copying—this is universally recognized today—but have made of these influences something new in keeping with their own needs and traditions. This is due, of course, to a strong national character, but what is called a national character is the product of a country's climate and soil and the traditions which are preserved there. With flowers, a seed might flourish in one plot of soil, but in another it would wither and die, and it is the same with the arts. The soil of Japan has been uniquely hospitable to artistic impulses.

Most studies of Japanese art today emphasize the evolution of style from period to period to the neglect of the environmental factors—the land, the people, and their changing ideals. To speak of the arts without considering these, as if artists worked in some ideal and disembodied realm, is to fail to grasp vital realities which have molded aesthetic forms. The arts of Japan flourished primarily in four major centers: first the Asuka district, then Nara, Kyoto, and, last of all, Tokyo. Why were these the centers of production? Why were the centers moved? How did the changes in locale affect the arts? How were styles transmitted from the major centers to smaller, provincial ones? These are problems which should be considered together with other aspects of the background—social, religious, and philosophical. This book is organized according to the chronological evolution of Japanese art, but as much as possible it attempts to analyze the local circumstances which fostered the various schools and styles. A flower placed in a vase has beauty, to be sure, but this is because we feel in it the living beauty of those blossoming in the fields. Ideally, a person should visit the monuments of Japan and explore them slowly and carefully. Not everyone can do this, obviously, and the author would be pleased if his book, through words and photographs, can recreate

something of the experience of actually searching out the arts of Japan in their own physical setting.

Who has not been struck by the fact that the world is becoming ever narrower and that a uniform culture has begun to spread everywhere, supplanting the distinctive traditions of districts and whole nations? Men have tired of its monotony, and warning voices have been raised against it. For, just as we expect a person to demonstrate his own individuality, so each region should be able to express its own distinctive character. The world will have regained its breadth when once again the flowers of each region bloom in a wild profusion of colors. Japan herself had developed a culture enriched with the special art forms of various localities, but these places are being overwhelmed by the culture patterns transplanted from the great commercial and industrial centers; they are losing the power to generate their own arts and crafts. When individuals can express themselves effectively through the arts, the creativity of the collective culture is strengthened. When rooted in the ability of the small regions to produce a living culture, the artistic life of the capital and the entire nation flourishes all the more.

In exploring such ideas, this study occasionally neglects objects which are typical of one or another chronological period in order to emphasize environmental factors. The environment—its economic, political, and spiritual aspects, the structure of patronage, the support, training, inspiration, use, criticism, and protection of the arts—must be firm and solid before the arts can flourish. A flower whose roots are shallow will not bloom for long. It is man himself who provides the bases of creativity; but there is a certain ineluctable force, like that of nature itself, which repeatedly thwarts his efforts. One of the basic processes of civilization is to oppose this baleful destiny, to marshal the forces of human ingenuity and ethnic character, and to construct from its foundations a society in which the arts will continue to nourish the human spirit.

FROM FOREST TO VILLAGE LIFE

HANDICRAFTS IN THE AGE OF HUNTING

In order to see the arts of Japan in proper perspective, we should trace them back as far as possible toward the time of their germination. The oldest distinctive body of material is the pottery called Jōmon ware, and some of the objects associated with it are said to be as much as nine thousand years old on the basis of the measurement of the radioactivity of carbon—the so-called carbon 14 tests. While the reliability of these estimates is open to question, it would still be safe to say that Jōmon ware was produced continuously for several thousand years until the beginning of the Christian era. It is. called Jōmon, or "rope-pattern," because at the time of its manufacture ropes were often pressed against the damp clay surface, leaving impressions of strands and knots. Objects bearing this simple, direct kind of decoration have been found in virtually all parts of Japan—from Hokkaidō in the north to Kyūshū in the south. That similar objects have been found neither in Korea nor elsewhere on the continent of Asia is a factor of marked significance.

The period of Japan's history in which this ware was used has been named the Jōmon period. For most of this time, agriculture was as yet unknown, and human livelihood was based primarily on the hunting of animals and the gathering of wild fruits and grains. During so long an era, it was natural that variations in the pottery forms would have developed, and on the basis of these, scholars have divided the Jōmon period into early, middle, late, and latest phases. The pottery of the early period has a slight amount of decoration, but on that of the middle period the ornament is free and bold—more extravagantly so than any other ware of the ancient world. The find spots of this particular type of Jōmon pottery are limited to the mountainous area of central Honshū—mainly Nagano and Yamanashi prefectures. It is surprising that such remarkable work was produced in an isolated region far from seacoasts and foreign contacts; but on further consideration, the mountainous interior was relatively free from the danger of attack and was blessed with free-flowing streams and abundant fish, game, and fruit. For most of the year it must have been a veritable garden, but the cold of the winter season is so severe that in ancient times mere survival must have demanded an indomitable spirit. Moreover, to relieve the monotony of life during the long winters, families

11

dwelling in their primitive houses must have felt the need of ornament on their everyday utensils. Struggling with an environment which was at times benevolent and at times cruel and severe, these people developed religious beliefs, however primitive, and they may well have imbued their pottery decor with animistic or magical significance.

From the beginning, Jōmon-style vessels were used for cooking, chiefly boiling; and in the early period, their bottoms were pointed so that a pot might be stood between rocks in the center of the hearth. In the middle period, the pots were used for food storage as well as cooking; their bottoms were flat and the vessels stood upright by themselves. On the pottery with a pointed end, the ornament was relatively flat and modest, whereas when vessels were made so that they would not rest on their sides, it became possible to carve extremely bold and deeply modeled decor. For containers used to hold especially valued foods, it was likely that they would be given more elaborate ornament, the motifs having animistic overtones which ensured that the contents would not spoil or that tomorrow's food would be equally abundant. For most of the Jōmon era, people did not form towns or even villages, but rather lived in small, isolated family units. The pottery must have been made not by specialists but by individuals who imparted great originality and variety to this ware and who seem to have taken great delight in the creative process itself, even as they remained in awe of the supernatural forces they invoked with their designs. These anonymous craftsmen did not strive for mechanical regularity in their vessels; they preferred asymmetric patterns with vortexlike, swirling qualities. For tens of centuries, this style continued unabated due perhaps to the sense of vitality, to the suggestions of growth and increase which its decorations conveyed. However, in the development of Jōmon ware from the late to the latest phases, the older tradition died out, and the clay surfaces became smooth and regular; only curvilinear patterns remained, but these became formalized and lost that sense of harmonious, organic relationship between surface ornament and the body of a vessel which had prevailed in the middle period. Meticulous craftsmanship replaced the bold, unrestrained manner, and thus the primeval spirit diminished as more stable village groups were formed and life took on a greater security.

Small, charming idols which are called *dogū* ("clay figures") were produced during the middle period, and they have much in common with the boldly ornamented pottery vessels. Resembling human beings and also squirrels, rabbits, and cats, they are radically deformed as a rule and must have been given symbolic significance; their exact purpose and use, however, is still unknown. It is sometimes assumed that they were used in very primitive religious rituals, perhaps to ensure fertility or to exorcise evil forces; and forms similar to the figurines occasionally appear on the handles and other parts of pottery vessels, suggesting that they added their significance to that of the rest of the decor. Like the pottery of the middle period, they are richly inventive in shape, but those of late and latest periods are more uniform, the most characteristic examples being female figures with wide shoulders, their legs spread apart—fertility fetishes, perhaps.

At the dawn of human civilization, Japan was far removed from cultural developments elsewhere in the world, and yet she produced in abundant quantity aesthetic objects of haunting, memorable beauty. Long before the influence of continental civilizations reached her, the visual arts had begun to play a meaningful role in the daily life of her people. If this was the dawn of Japanese art, it was certainly not graced with ease and tranquility, but rather was part of a stern confrontation with nature. Perhaps for this reason alone, the arts so engendered were hardy and enduring.

For thousands of years, the livelihood of the people of Japan was based on hunting and the gathering of fruits; the storage of food was their only means of fending off starvation. It was not until the second and third centuries B.C. that the Japanese came to know of agricultural life on a planned, systematic basis. Along with the techniques of casting bronze and iron, this new way of life was transmitted from the Asian continent, coming first to Kyūshū and then gradually spreading as far east as the Chūbu region; that is, Shizuoka, Aichi, Gifu, Nagano, Yamanashi, and Niigata. The development of agriculture brought profound changes to the nature of Japanese society. Stable supplies of food could be guaranteed; the titles to plots of land were fixed; villages were formed, and then larger political units were established. A new religion developed, centered on the rhythmic cycles of planting and harvesting, one in which ceremonials played an important role—in contrast to the more primitive beliefs of the age of hunting.

As though in reflection of these fundamental changes in society, an entirely new type of ceramic ware was developed, called Yayoi ware. The name could not be more appropriate, for, taken from that of the district near Tokyo where this pottery was first found, Yayoi is an ancient word for the third month of the year and has connotations of springtime and youth. This ware is functionally simple, refined in shape, orderly and regular—in contrast to the complex and exuberant Jōmon style. It was developed in Kyūshū, where influences from the mainland had so changed the local Jōmon style that an entirely new type of pottery was produced. Despite the foreign influences, however, shapes like this have not been found on the continent, and Yayoi ware demonstrates once again the strong individuality of Japanese taste.

Having received the techniques of metal craft as well, Japan entered the first stages of advanced civilization during the Yayoi period. In those parts of the world where metalworking was originally discovered, a lengthy bronze age was, as a rule, followed by an iron age; but in Japan, bronze and iron appeared at virtually the same time, and there are even indications that some iron implements were introduced earlier than bronze ones. The use of metal tools must have greatly stimulated other crafts, such as woodworking and gem making, but apart from the Yayoi vessels, the chief artistic remains of this period are its bronze weapons—swords and halberds—and bronze bell-shaped objects called *dōtaku*. The weapons are found most abundantly in northern Kyūshū. Their shapes are those of regular military weapons, but the objects themselves are so flat and thin that they must have been made for symbolic use rather than for actual combat. The *dōtaku* come chiefly from the plains around Osaka, Kyoto, and Nara (the Kinki district), and though these seem to have been made in emulation of musical bells of the continent, they too must have lost their utilitarian function. The fact that bronze implements with no practical use should have been distributed over so wide an area during this period may be explained, perhaps, by the idea that they were worshiped or treasured in their own right. Metal implements were extremely useful in everyday life, but those made of iron were subject to rust, and as a result few have been discovered intact. Beyond utility, however, the material was rare and must have been highly treasured—especially bronze. At the dawn of the metal age, people may have been satisfied simply to own metal implements as symbols of status rather than, in all cases, to use them. Families must have competed with each other in collecting them, but the degree to which any one given object was a symbol of power and wealth is not clear today. The swords and halberds were very skillfully cast and their shapes given refined subtleties of design. The same is true of the *dōtaku*, which have a great variety of

patterns on their surfaces—saw-tooth motifs, spirals, flowing-water shapes, and the like. Clarity and refinement of form replaced the contorted quality of Jōmon arts; and on a few rare *dōtaku,* scenes of daily life appear. These pictures are simple things, to be sure, but one can still feel the strong urge to escape from the ambiguities and emotionalism of the Jōmon period into a life of greater sophistication and refinement.

During this period, skillfully wrought jewels came into use as personal ornaments. The discovery in the earth of gem stones, such as hard jasper or agate, and working them into ornaments must have been a source of great satisfaction, for neither the gems nor the symbolic bronzes were directly essential to livelihood. Their production in great quantity shows that the standard of living in Japan had risen far above the level of mere subsistence.

THE PERIOD OF THE ANCIENT TOMBS

As agriculture advanced and villages became larger and more complex, local chieftains came into being, dominated by powerful, landholding families. Soon something like small, regional states developed, and the process continued until a national entity was established—that is, a concept of nationhood and of a supreme ruler, even though his authority was limited to the central and western part of Honshū and Kyūshū.

Chieftains and rulers in the late third century A.D. began to build large moundlike tombs which, because of their scale, demonstrated the authority and prestige which they had attained on earth. Now called *kofun* (or ancient tombs), these mounds at first were adaptations of natural formations of the ground; inside the burial chamber were placed swords, the ruler's state seal, objects used in the burial ceremony, and mirrors which served as magical protection. As the clans became more powerful, the tumuli became larger and larger, and by the fifth century, immense artificial burial mounds were constructed, often surrounded by water, like a moat. While serving as the last resting place of a mighty man, they became after his death an even more ostentatious display of his might and authority, and the most dramatic examples are the grave mounds near Osaka of two emperors under whose reign great steps were taken in the unification of the nation: Ōjin and his successor Nintoku. These two sites mark the climax of grave building, and thereafter the graves became smaller and less ambitious. The social order and the structure of political power had become more stabilized, the position of the emperor established, and it was no longer necessary to make such demonstrations of power. On the other hand, the number of objects buried with the dead continued to increase out of the belief, influenced perhaps by Chinese ideas, in a life of the spirit after death. With the introduction of Buddhism in the sixth century, however, the Indian custom of cremation was adopted, removing the need for an elaborate tomb to house the corpse. The Buddhists also believed in rituals and prayers which encouraged the rebirth of souls in Paradise, and for these reasons the old funeral practices rapidly waned. It is the attainment of Japanese culture just before the introduction of Buddhism that is so well represented by the *kofun,* by the grave implements, and by the striking clay figurines *(haniwa)* which were added to them.

Various theories have been offered concerning the origins of the *haniwa,* but the one most generally accepted is that they were made for the consolation of the dead. But no matter how serious their religious value may have been, the *haniwa* have an air of lightness and freedom about them, and the craftsmen who made them in such large numbers seem to have felt no inhibitions about introducing playful elements as they built up the

clay forms. The chief limitation which the potters did recognize was the necessity of making these large figures hollow so as not to crack when fired in the kiln. This did not diminish in any way, however, the archaic boldness and frankness of these pieces. Had they been made with greater detail, they might have told more about the manners and customs of the time; as it is, their vigorous simplicity has preserved strong emotional qualities, even if the emotion is sometimes nothing more than the sheer delight the potters took in the inventions of their craft.

The most elaborate development of the *haniwa* took place in the Kantō district, the great plain around Tokyo. This was far from the main centers of culture of the time, but the hardy and unsophisticated spirit of the people in that eastern region found a most congenial outlet in the *haniwa*. On the other hand, the figurines are rarely found in northern Kyūshū, but the same motifs appear in painted form on the walls of old tombs there. Ancient paintings are found only in this region, which is closest to the mainland, and they were probably inspired by Chinese and Korean grave customs.

One must not imagine that the utter simplicity of the *haniwa* or the wall paintings are characteristic of the entire culture and technology of the time. Highly developed casting techniques and designs can be seen on mirrors and military equipment recovered from the tombs. Moreover, while it must be true that metal objects coming from the continent were highly prized, implements made in Japan show a decided independence of form. A notable example is the type of design called *chokkomon* found on mirror backs, a sinuous pattern of arc and fret shapes devised apparently by craftsmen in the area around the modern Osaka, Kyoto, and Nara. Found also near Nara is a celebrated mirror with representations of four different building types, all indigenous in style. These demonstrate the manner by which the Japanese, not entirely satisfied with imported objects, produced their own innovations, an independence of spirit reflected also by the military expeditions that they launched onto the Korean Peninsula during this period. A warrior's helmet has been excavated having gilt copper bands on which charming representations of birds and animals are made with tiny, engraved circles; these have much the same boldness and spontaneity of form as the *haniwa*.

It is extraordinary that the shapes of houses would have been used to ornament a mirror, but two of these very building types are still to be seen in Shinto sanctuaries at Izumo and Ise, the most ancient and revered of the national shrines. At both places the archaic building types have been preserved on a giant scale and with clarity and orderliness which reveal a distinctly Japanese attitude toward ancient canons of beauty. Forms retained for fifteen hundred years have naturally been refined and simplified, but the results are still much in the spirit of the *chokkomon* designs. This ancient, national tradition has been neither destroyed nor greatly distorted, even in such times as the Nara period when Japan was overwhelmed by the culture of T'ang China. And at Ise today as in the past, a ceremony is performed each dawn and sunset, offering to the shrine deities a share of the bountiful foods of the sea and mountains—a ritual as archaic in spirit as the buildings around it. With enthusiasm Japan has welcomed and absorbed cultural elements from abroad, but she has also had the strong determination to guard her indigenous customs. These two traits have played a fundamental role in the evolution of her culture and arts.

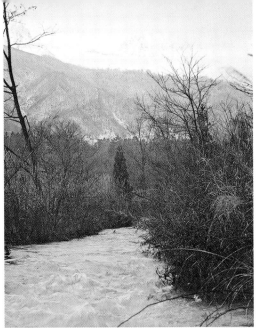

1. View of Shinano district.
High in the mountains of central Honshū, this is one of the districts where the craft of pottery in neolithic times flourished most strongly. It is a land of abundant food and refreshing beauty, protected by its mountains and watered by the highland streams. The winters at this altitude are severely cold, however, and in many parts the natural setting is as unspoiled today as it must have been in the remote past. (See color plate 1.)

2. Middle Jōmon ware. H. 36 cm. (14 in.).
This seems to have been made as a lamp, but its actual use is not clear. Its structure, drastically bold in concept, may have been suggested by the shapes of fire or of a whirlpool. This evocative object is part sculpture and part utensil; it is a token of man's fundamental urge to creativity even in his primeval stage of life. (See color plate 2.)

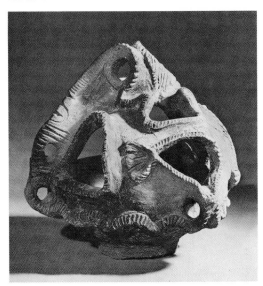

3. Middle Jōmon ware. H. 36 cm. (14.1 in.).
The surface of this storage jar is encrusted with strips of clay and incised lines in bold, arbitrary patterns not unlike those a child might make with crayons. Amid this exuberance, however, is a search for system and order that demonstrates the elemental aesthetic needs of man at the very beginning of his artistic traditions.

5. Clay figurine *(dogū)*. Jōmon period. H. 36.5 cm. (14.3 in.).

Whether this is a male or female is not clear, but the fierce, wrinkled face and long neck impart a sense of bizarre energy. The face is an applied disc shape with schematic incisions; the short arms appear unnatural. This small idol, amazingly subtle in form, is a work of compelling power.

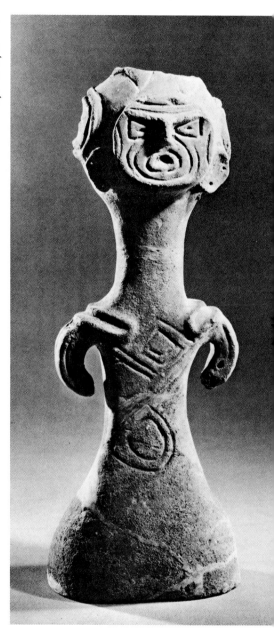

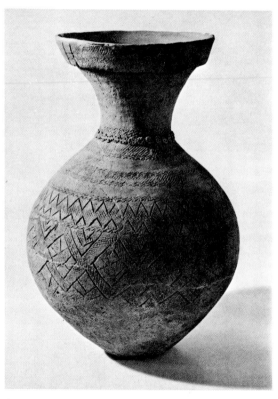

4. Earthenware. Late Yayoi period. H. 38 cm. (14.8 in.).

In the age of bronze and iron, Japanese pottery lost much of the exaggerated surface modeling of the Jōmon wares. Instead, the beauty of such wheel-made and symmetrical vessels lies in the refinement of shape and the sense of unity between the incised surface designs and the vessel itself. Only the small clay pellets around the neck and the impression of ropes in the decorative bands remain as relics of the techniques of the Jōmon tradition.

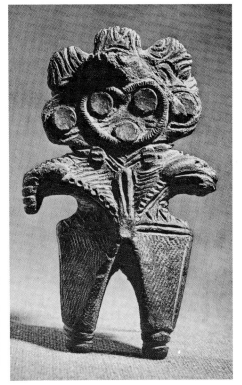

6. Pottery figurine *(dogū)*. Jōmon period. H. 20.2 cm. (7.9 in.).

Perhaps an amulet for securing easy childbirth, this strange figure combines a sense of fanciful mystery with that of doll-like charm. Deft incisions with a spatula depict the hair and clothing; ropes were impressed against the legs, and the surface was originally painted red. (See color plate 3.)

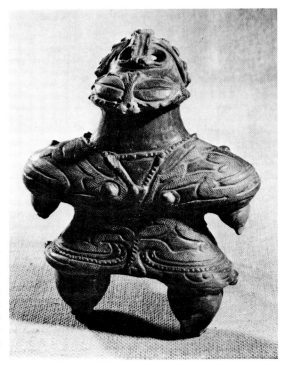

7. Clay figurine *(dogū)*. Jōmon period. H. 26.2 cm. (10.2 in.).

This figurine, finely wrought, is one of a large number of stereotyped female images which come from the northeast side of the main island of Honshū. They have very distinctive qualities, such as the rudimentary arms and legs, enlarged eyes which seem to be spectacles or goggles, and thick clothing which is decorated with recessed patterns of curved lines.

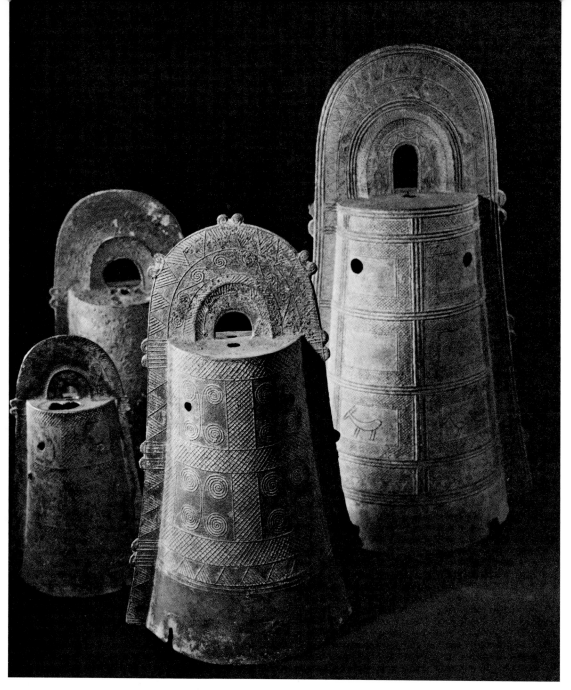

8. *Dōtaku.* Middle Yayoi period. Height of bell in center, 47.5 cm. (18.7 in.); right, 64 cm. (25.1 in.). When metal culture was transmitted from the continent, the Japanese must have treated bronze implements as precious treasure and used them in rituals. Bell-shaped objects of this type may even have served as emblems of power and wealth. The arrival of the new technology brought forth great changes in the artistic sensibilities of the Japanese.

9. Male and female *haniwa* figures. Sixth century. H. left figure, 57 cm. (22.4 in.); right figure, 64 cm. (25.1 in.).
Large, hollow clay figurines were placed around the grave mounds of persons of power and high status; even so, they possess a spirit of utmost simplicity and naive charm. In this pair of dancers, the noses are long wedge shapes; simple holes form the eyes and mouths; the heads and torsos are joined as a single cylindrical shape. For all their simplicity, however, human qualities are expressed with great boldness and sophistication.

10 (overleaf). The tomb of the Emperor Nintoku. Fifth century. Main axis of tomb, front to back, 480 m. (1,574 ft.); diameter of rounded part, 245 m. (803 ft.); h. 35 m. (114 ft.).
Amid the rice fields on the fertile plain east of Osaka are a number of elaborate tombs, of which this is the largest. From the air, its keyhole shape encircled by three moats is quite clear; from the ground, however, it appears to be a large hillock. Emblems of worldly power, these tumuli are symptomatic of a deep desire in ancient man to build something which was overwhelmingly grand and everlasting.

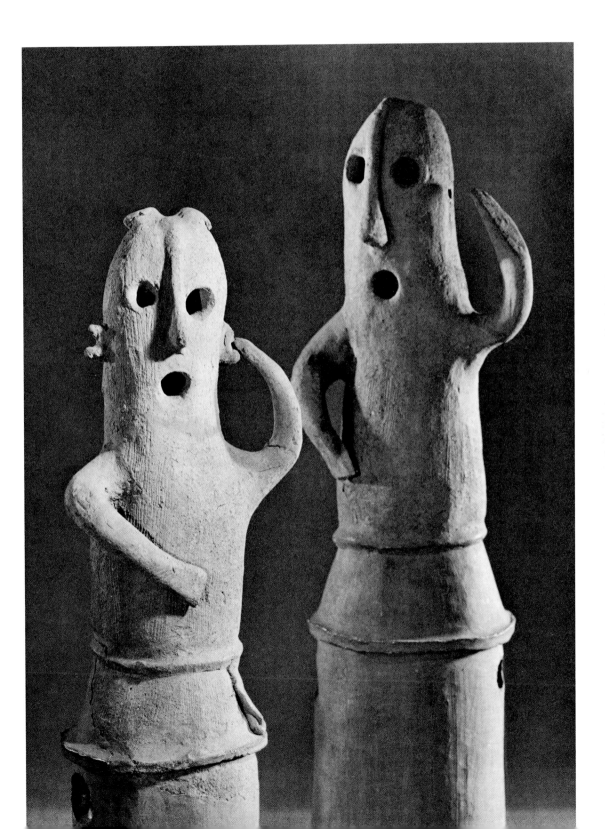

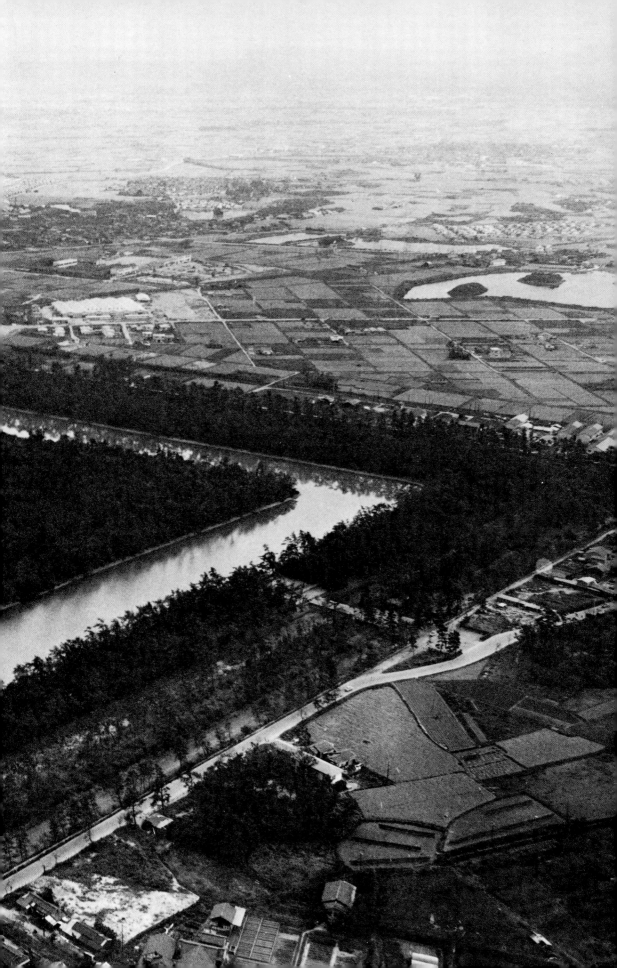

12. Head of girl, *haniwa*. Fifth century. H. 20 cm. (7.8 in.).

This head, said to have come from the vicinity of the tomb of the Emperor Nintoku, has the greater subtlety and refinement of form found in the *haniwa* of this region. Depicted with the utmost economy of means, the pensive expression of the face and the darkened slits of eyes and mouth make one forget that this is an object made of the simplest, roughened clay. (See color plate 4.)

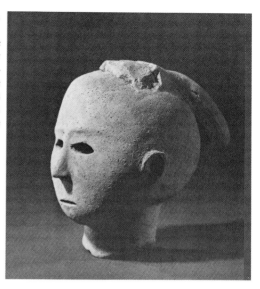

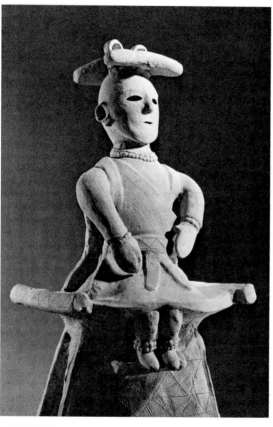

11. Seated female figure, *haniwa*. Sixth century. H. 68.5 cm. (26.9 in.).

This may be a representation of a type of woman thought to have had a role in funeral ceremonies, serving as a spirit medium between the realm of man and that of the spirits. She is shown with true aristocratic hauteur, her robe and hat and jewelry depicted with great care.

13. Wall painting in the Takehara tomb. Sixth century. L. 111 cm. (43.2 in.), h. 133 cm. (52.2 in.).

This is one of many tombs in Kyūshū in which colored wall paintings have been preserved. Between two upright standards are an armored warrior, horses, a ship, and waves—a depiction perhaps of the military or hunting exploits of the deceased done in a highly abstract manner. (See color plate 5.)

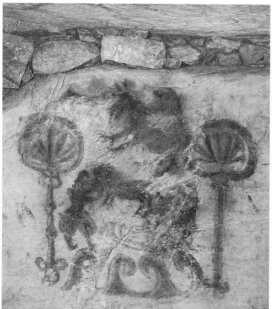

14. Bronze mirror ornamented with a design of four houses. Fourth century. D. 23 cm. (9 in.).
The Japanese delighted in the exotic ornament of mirrors from China and treated them as objects of great value. However, with characteristic independence of spirit, they began to make mirrors with their own motifs, such as this one which depicts four native-style buildings. The two types which are shown standing on high foundations have been preserved to this day in traditional Shinto architecture.

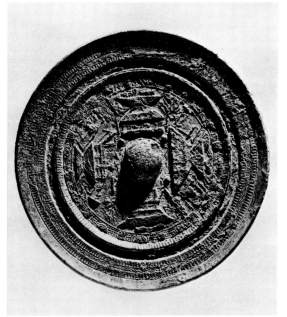

15. Bronze mirror with *chokkomon* design. Fourth century. D. 28 cm. (11 in.).
This design of straight and bow-shaped lines is uniquely Japanese and one which apparently had a magic or sacred significance. The pattern, although distinct and lucid in form, has overtones of mystery, for it is slightly baffling in its complexity—a highly sophisticated concept which clearly marks the passing of the primitive directness of the most ancient designs.

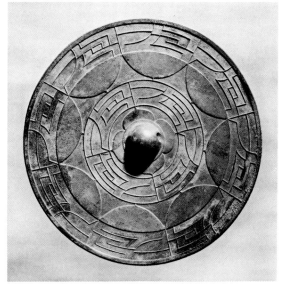

16. Gilded bronze helmet. Fifth century. H. 21 cm. (8.2 in.).
The aristocratic warriors of the ancient period entered battle in gilded armor, perhaps inspired by a vision of the glory attained by a man on the battlefield. This finely wrought bronze helmet is made of many small plates riveted together and held by gilded bands. On the bands are motifs drawn with stippled dots—cows, birds, fish, and the like.

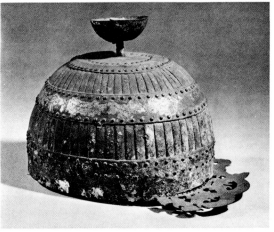

17. The main hall of the Izumo Shrine.
The region was, in antiquity, the seat of the powerful Izumo clan, and it is said that this "main hall" *(honden)* was patterned after the dwelling of the clan chief. Even today, it vaunts its assertive air in the upward thrust of the great roof of cypress bark and its fittings. The hall was said originally to be at least twice the height it is now, for the Japanese people, as they began to consolidate their strength, exulted in the challenge of vast building projects.

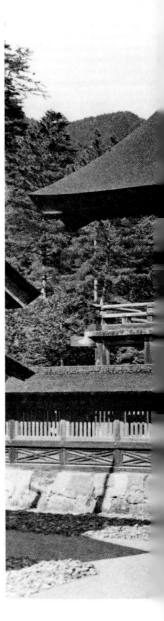

18. The inner shrine at Ise.
Dedicated to the divine ancestress of the imperial family, the inner shrine has been rebuilt at least sixty times in its history and yet has preserved its ancient form. Set within a forest of giant old cedars, these buildings are imbued with the simplicity and quiet restraint of the native tradition. The roof is of heavy thatch; the roof members are symbolic adaptations of functional forms still occasionally used in farm buildings to give structural stability. Unpainted and barely ornamented, the building retains that strong sense of physical purity and sympathy with natural materials which is so essential to Shinto ritual and arts.

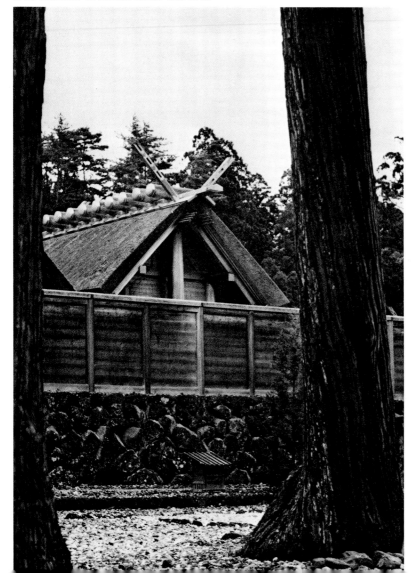

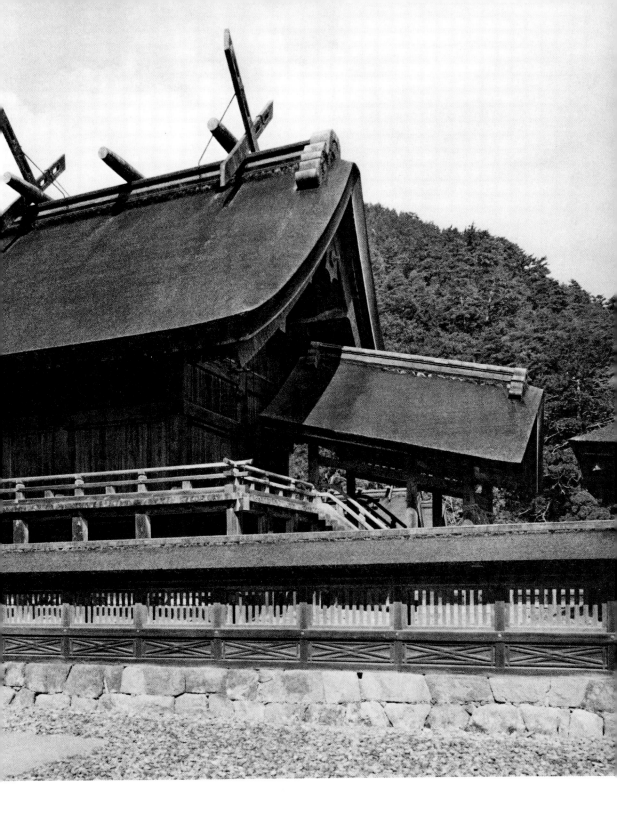

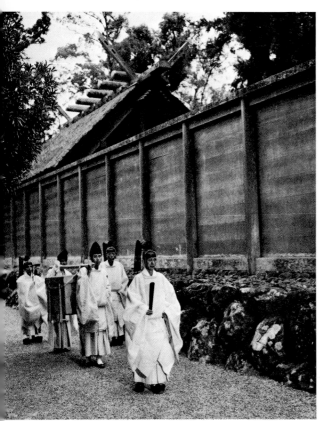

19. Bearers of food offerings, Ise.
Twice a day, at dawn and sunset and regardless of the weather, a silent procession of priests in white robes moves along the gravel paths bearing offerings of food to the deities. From the remote past to the present there has been the unflagging conviction that the gods live and must be served.

20. Food offerings.
The food offerings are cooked by special attendants over purified fires in accordance with ancient customs and consist of sea foods and vegetables or fruit—the bounty of ocean and mountain. In their spartan simplicity these dishes are imbued with the spirit of a way of life deeply aware of the most elemental forces of nature, of life and prosperity, of hardship and death.

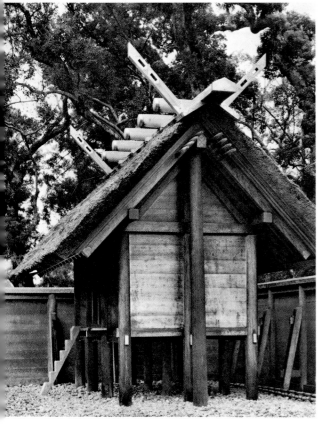

21. Outer hall of worship, Ise outer shrine.
It is very difficult to enter the rough enclosures which surround the main hall of the inner shrine, but there are other buildings in the area which are also built in the antique manner. Standing on great pillars which rise directly from the earth, this votive hall has a roof of reed thatch and bears a heavy ridgepole, ornamental crossed rafters, and horizontal billets. The stairway is carved from a single log of squared wood, and within its striking simplicity is preserved a sense of strength and decisiveness.

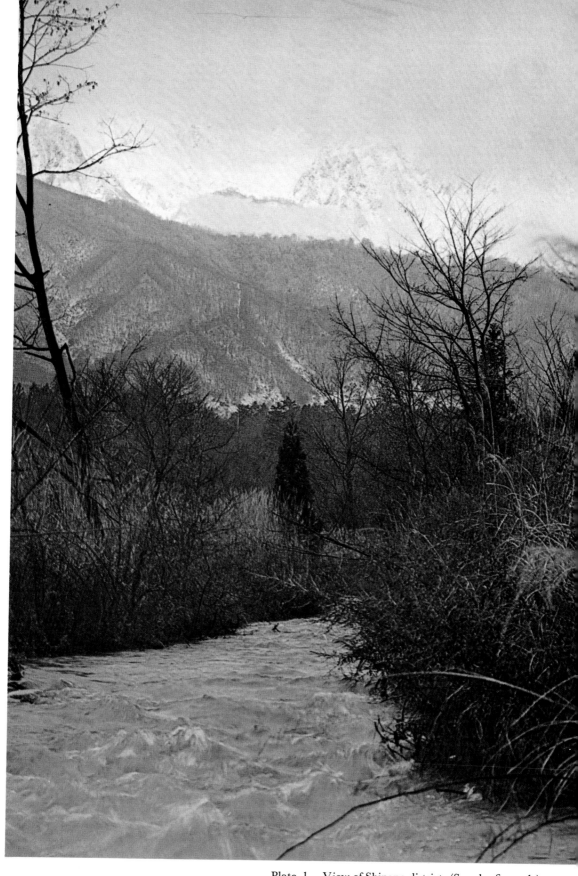

Plate 1. View of Shinano district. (See also figure 1.)

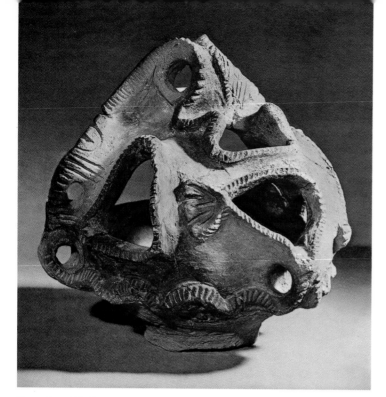

Plate 2. Middle Jōmon ware. (See also figure 2.)

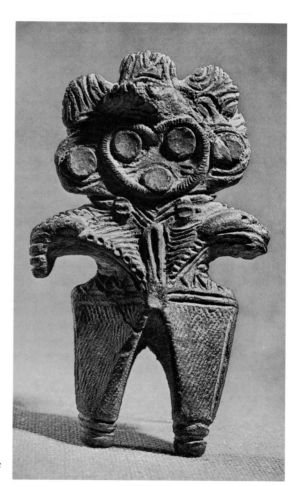

Plate 3. Pottery figurine *(dogū)*. Jōmon period. (See also figure 6.)

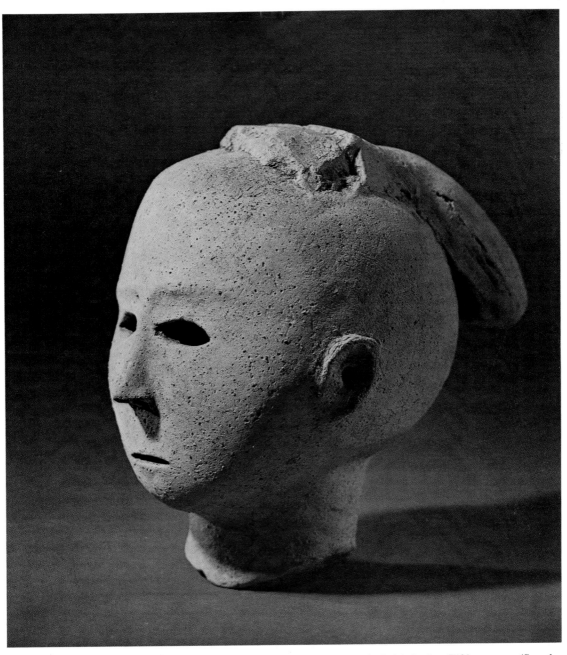

Plate 4. Head of girl, *haniwa*. Fifth century. (See also figure 12.)

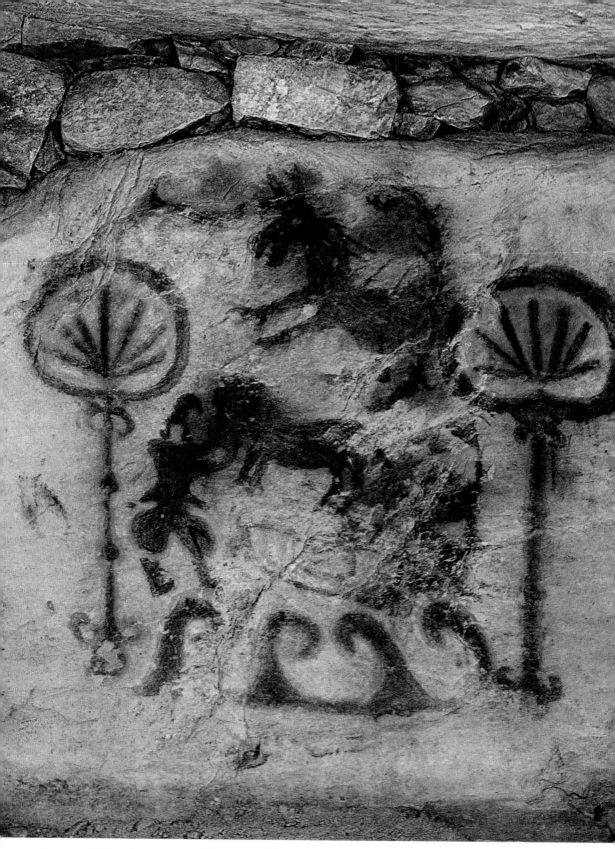

Plate 5. Wall painting in the Takehara tomb. Sixth century. (See also figure 13.)

FROM FOREST TO VILLAGE LIFE

~ 2 ~

THE YAMATO REGION: FROM ASUKA TO IKARUGA

THE ADVENT OF BUDDHISM

As the locale of Japan's most ancient capital and the cradle of Buddhism in the land, the Yamato district evokes great sentiment among the Japanese people. Bounded by a mountain rampart, the region lies at the southeast end of the vast alluvial Kinki plains; through it flow the gentle Asuka and Tomio rivers. Today this is a quiet country district of rice fields, orchards, and wood lots on the hillsides; its charm is enhanced by vegetable gardens in the springtime and by vivid red persimmons in the autumn. All that remains of historic importance in the area are a number of imperial tombs and the scanty vestiges of ancient temple compounds and palaces. These nonetheless invite the stroller and stimulate his vision of history.

This district was selected as the site of the capital because the encircling mountains made it easy to defend. Its remarkable fertility and beauty must also have been a factor; and the intense feeling of the Japanese for the Yamato region is conveyed by terms used in ancient texts to characterize it as the most excellent of places, the central core and heart of the nation—"Oh, what a beautiful country we have become possessed of!" Despite this, it had not been the custom in Japan to build a permanent, impressive seat of government. This was due to the animistic concept of the impurity of death; a palace was thought to be contaminated when the emperor died there. For each new sovereign, a new palace was built; and generation by generation, the seat of government moved through the plain, with modest buildings to house the relatively simple business of the state. However, the Buddhist temples erected in the late sixth century were free of this notion; having the air of permanency, they allowed the processes of building and ornamentation to become more stabilized. The culture of the imperial court in the Yamato country became increasingly centered on the rituals and imagery of the great monasteries, and entered into an era of artistic brilliance.

The Buddhist faith, which was flourishing in China and Korea, may have been first brought from the mainland to Japan by exiles. In the beginning, it must have been little more than a secret creed, with no energetic effort to spread it further. However, in A.D. 552 (or 538 by another account), King Syöng Myöng of the Korean state of

33

Paekche (Kudara) presented Buddhist images and texts to the Japanese court and urged the adoption of this faith of Indian origin. At the time, the Buddhists of East Asia stressed the notion that the well-being of a kingdom could be promoted by supporting the Church—the ethical and spiritual level of the people could be raised, ceremonies could be performed to bring a nation under the protection of the huge and powerful Buddhist pantheon, the fertility of crops and the prosperity of the people assured.

Japan, however, had its own native religious system and did not respond easily to this recommendation. Moreover, a violent struggle for power was taking place among the powerful clans which surrounded the imperial throne, and the question of Buddhist worship became entangled in a purely political contest. After a prolonged dispute, the anti-Buddhist faction led by the Mononobe family was overthrown in battle. Triumphant was the Soga family, which had supported the faith; and Buddhism, freed of the danger of persecution, was given government support. Elated by their success, the Soga family built the splendid Hokkō-ji monastery near the Asuka River as a memorial to their victory. Today, still standing on the site is a small temple called the Asuka-dera, which contains a large cast-bronze image of Śākyamuni. The fate of this statue, however, has been almost as forlorn as that which pursued the Soga family, for it has been damaged by fire and clumsily restored, just as the Sogas were overthrown and their power broken. Apart from the statue, though, there is little to remind one of the ancient prestige of the family and their patronage of the first full-fledged temple in the land.

The Patronage of Shōtoku Taishi

It has never been forgotten that Shōtoku Taishi was probably the single person most responsible for the flowering of Buddhism in Japan. A prince of imperial blood, he was given the general control of the government during the latter part of the sixth century and the first quarter of the seventh, ruling as regent for his aunt the Empress Suiko. His true character and role in history have been obscured by the legends which sprang up soon after his death, many of them marked with supernatural events. He even came to be considered a manifestation on earth of the Buddhist deity Kannon (Avalokiteś-vara), the embodiment of divine compassion—a reflection of his gentleness and wisdom. The prince had been a member of the victorious Soga party, but was disturbed by its despotism, its vindictive spirit, and by the aggressiveness of other powerful clans which interfered with the administration of the state. As a fervent Buddhist, Prince Shōtoku conceived of an ideal government conducted according to the spirit of the faith; as a progressive figure, he thought also of importing the highly developed culture of mainland China and Korea—especially the more sophisticated modes of government—using the paths of communication and the high level of learning offered by the Church. In A.D. 594, he assisted the empress in issuing an edict promoting the prosperity of the faith; in A.D. 604, the "Constitution in Seventeen Clauses" was drawn up in which Chinese and Confucian concepts of central authority and respect to the throne were interwoven with Buddhist ideals.

The Soga family comes to mind as one walks in the quiet atmosphere of the Asuka River, whereas the memory of Prince Shōtoku permeates the great temple compound of Hōryū-ji, still standing at the village of Ikaruga. Sometimes called the Ikaruga-dera, the temple's traditional histories state that it was founded by the prince near his own villa for the sake of the soul of his father, the emperor Yōmei. Over the centuries, buildings have been added in honor of the prince himself. The "east precinct" *(tō-in)*

of the temple is said to have been built on the very site where his villa stood, and remnants of dwellings of that period have been found beneath its halls.

What did the complex and demanding doctrines of Buddhism mean to the Japanese of this era? A learned man such as Shōtoku Taishi must have understood them deeply. He studied with Korean monks and is said to have been the author of commentaries on three texts (sutras) of Indian origin. But during a period when even the sutras themselves were scarce in Japan, one can imagine the limited level of understanding of the people in general. What often captured their hearts and attracted new converts was the sheer splendor of the temple buildings and images. It is true that the temples were intended primarily as dwellings for monks, who were housed in plain dormitories, austere in form; but in the center of most compounds were a pagoda, which enshrined relics of the Buddha Śākyamuni, and a *kondō* or "golden hall," in which statues and paintings of the main objects of worship were installed. Another standard building was the *kōdō* or "lecture hall," where monks and laymen would gather for the reading of religious texts before appropriate statues—these were the elements of importance to the laity. For their day, the buildings were vast in scale; each stood upon a substantial stone plinth and was capped by a large roof of gray tile, its woodwork painted cinnabar red. Rising above the heavy roof of the pagodas were masts with nine bronze rings, their gilded surfaces glittering against the sky; wind bells hanging from the eaves added a melodious sound as they swung in the breeze. Even today the visitor is captivated by the ensemble of forms in the "west precinct" *(sai-in)* of Hōryū-ji; in ancient times the impression must have been even more profound. Absent then were the private dwellings and the pine groves that now enclose the site, and the buildings must have seemed to float against the verdant green of the hillside. Monasteries such as Hōryū-ji were a refuge from the commerce and excited passion of the everyday world; being confronted by its unprecedented beauty, a devotee would have conceived more clearly the Buddhist ideal of the purity of the human spirit unstained by anger or egoism or lust, an ideal which governs both the concept of Buddhist Paradises in heaven and the symmetry and splendor of the temple on earth. The visitor who peered into the gloomy darkness of the *kondō* would have dimly perceived the golden images seated in stately splendor upon their pedestals high on the altar platform, their faces bearing a mysterious, unaccountable smile. Gazing up into the ceiling, he would have seen the intricate, multicolored canopies suspended overhead. Prayers chanted in a solemn monotone and the pungent odor of foreign incense assaulted his senses and drew him deeper into a world totally removed from that of his daily life. The buildings now standing in the west precinct of Hōryū-ji are reconstructions—mostly of a slightly later date—of those of the seventh century which were destroyed by lightning and fire. The visitor of today, with patience and imagination, can recreate the emotional aura which this temple had at the time of the first great expression of Buddhist devotion and art in Japan.

The plastic arts played a fundamental role in the spread of Buddhism throughout East Asia. Indeed, the very fact that the Church possessed a rich tradition of building and image making is a major reason for its success. The fact that King Syŏng Myŏng of Paekche, who had previously given Buddhist statues to the Japanese, continued to send temple craftsmen and artists shows his own estimate of their importance. And the fact that the representative sculptor of the period, Tori of the Kuratsukuri clan, was given the rather exalted title of *busshi* ("Master Craftsman of Buddhist Images") indicates the high esteem he enjoyed.

Hōryū-ji has preserved a number of statues from the workshop of Tori Busshi, and the two housed in the *kondō* are among the key monuments in the entire history of Buddhist art. One of these, as stated by the inscription on its halo, was made in A.D. 607 at the request of Shōtoku Taishi and the Empress Suiko. Representing the Buddha of Healing, Yakushi Nyorai, it was made in compliance with the wishes of the Emperor Yōmei, who had pledged both the statue and the temple itself at the time of his final illness twenty years before. The sculptor's name is not given, but of this period, Tori is the only known figure who could have made such a work. The other example in the *kondō* does bear his name, the seated Buddha Śākyamuni and two standing attendants, which is dated fifteen years later, in A.D. 623. The inscription on the halo records that it was made by Tori Busshi for the benefit of the soul of the deceased Shōtoku Taishi in the next world. There are scholars who hold doubts concerning both these inscriptions, but rather than wasting time prying into this possibility, one should use the inscriptions and statues to form a concept of the Asuka style. These images are at once affirmative and gentle in spirit. Each of the Buddhas sits erect, and his robe hangs down in front of the seat as a broad, emphatic planar surface. The silhouette of the figure makes a triangular shape whose formal quality is that of composure and stability. The undulations of the folds of the robe—not quite symmetrical in pattern—have a rhythmic solemnity about them. The enlarged hands and face convey a sense of composure and reliability. These are only part of the distinctive traits of this style, but even so they reveal much concerning the broader basis of the culture of the time. Japanese Buddhist art was then still in an early stage of development; a variety of continental traditions were being imitated, and yet these works of Tori have a decided maturity and coherence of spirit. It is always difficult to account for a thing as subtle as the artistic style of a remote age, yet one fact seems clear: Tori Busshi received the patronage of Shōtoku Taishi and was assigned to projects in the most important temples of the realm. An honored specialist and not merely an anonymous craftsman, he must have shared in large measure the advanced ideals held by the prince.

The style of Tori Busshi was influenced by that of China in the Northern Wei period—certainly there are similarities in the stone carvings of the great cave temples at Lung-men—but the true value of these images cannot be grasped merely by tracing the resemblances. The energetic vigor and precise formal organization of the Asuka statues are not to be found in those of the Northern Wei, for the spiritual atmosphere of northern China and that of the Japanese capital were naturally greatly different. There are strong analogies, however, between what is called here the Asuka spirit in sculpture and the deeds of Shōtoku Taishi. The sense of resolute energy in the statues of Tori is not out of keeping with Prince Shōtoku's determination, despite the resistance of the powerful clans, to enforce the reform policies intended to diminish their power. The instinct for regularity in the art of Tori may be likened to the prince's enforcement of discipline among the courtiers by establishing a system of twelve ranks. It is possible that in matters of government and in images of the Buddha, Shōtoku Taishi and Tori Busshi were expressing common ideals—each in his own medium. Certainly, the feeling of tenderness amid great dignity in the statues by Tori is in complete harmony with our historical image of the noble prince.

For a while after his death, however, those who upheld the prince's ideals were forced along a thorny path. The Soga family once again rose in tyranny and attacked the sons of Shōtoku, finally forcing them and their families to commit suicide. The village of

Ikaruga, where the prince had lit the Lamp of the Law, became the scene of the miserable last moments of his descendants. The spilling of their blood, however, was not entirely in vain. The ideals of Shōtoku Taishi were gradually realized, and Japan was transformed from an uneasy confederation of tribes and clans into a stable, well-ordered nation.

At the center of the east precinct of Hōryū-ji is the exquisite Yumedono ("Hall of Visions"). This was built in the eighth century for the sake of Shōtoku's soul by the monk Gyōshin Sōzu, who lamented the fact that the palace where the Prince once dwelled had fallen into ruin. Behind the Yumedono is the Chūgū-ji nunnery, which contains fragments of an embroidered cloth hanging that also has a connection with the prince. Called the Tenjukoku Mandala, it was woven after the death of the prince by his consort, the Lady Tachibana-no-Ōiratsume, and other women of his household. Grieving over his passing, they embroidered a scene of the Paradise of the dead as a constant reminder of him. The remaining fragments are a precious relic of both the pictorial arts of the time and the craft of weaving and dyeing.

THE FADING OF THE ASUKA STYLE

Typified by the discipline of Prince Shōtoku, the austere spirit of the Asuka period gradually slackened off after his death, and the succeeding age sought new ideals. This becomes apparent in the lighter, more buoyant atmosphere of Buddhist imagery.

The tall statue at Hōryū-ji called the Kudara Kannon shows this tendency at an early stage. Absent in it is the highly organized, layered type of composition of the Tori style with its resultant gravity and seriousness. Instead, the elongated proportions produce a feeling of soaring exaltation not unlike that of certain Gothic images in the West. The art of Tori possesses a stability rooted in an awareness of the present world; the spirit of the Kudara Kannon aspires to escape from that reality. If the former shows a will to mold this world according to Buddhist ideals, the other reveals a deep yearning to leave the world, to escape to an unblemished realm beyond. It is true that the last half of the seventh century saw the increasing acceptance of the Buddhist faith and the building and ornamentation of temples, but it also saw a continuation of the savage struggles of the powerful clans, who resisted the strengthening of the central government and created a maelstrom of intrigue around the imperial court. The tragic fate of the family of Shōtoku Taishi was not the only result of this. Such wanton butchery and anguish may well have prompted men to yearn all the more for the benevolent grace of the Buddhist ideal. The statue of the meditating Bodhisattva of the Chūgū-ji is suffused with a sense of almost maternal tenderness, and actually it symbolizes the first stage in the career of the saviour Bodhisattvas, the vow of compassion to aid those who are lost and in distress. Because the age sought to imbue Buddhist imagery with the spirit of compassion, one can assume that this was essential to its spiritual needs. Hōryū-ji has been a religious center for more than a millennium; its buildings and cult images, in the subtle nuances of form, reflect such changes of spiritual aspiration.

A youthful, boyish quality in face and body, for example, can be seen in six statues of Kannon (Avalokiteśvara) at Hōryū-ji, dating from the latter half of the seventh century. These are typical of a large number of small, gilt bronze statues of the period which were intended probably as household icons and later given to various temples. The unusual, boyish quality here contrasts with the attempts in the past to imbue Buddhist images with a sense of supernatural power or else one of exquisite grace. These statues

were objects of worship, but they possess such charming directness that the devotee, rather than feeling a barrier of hieratic sanctity in the object, might almost wish to pick it up and caress it. The sculptors seemed to suggest that salvation would come more through the very act of worship than through the power of an almighty deity—as though childlike innocence and purity were the essential qualities of the faith.

The age in which this spirit arose—the latter half of the seventh century—is now called the Hakuhō period, taken from the name given to the years A.D. 673–85 in keeping with the Chinese custom of assigning auspicious names to regnal periods. During this time the study and assimilation of continental Chinese civilization continued as energetically as before; yet the ingenuous spirit of innocence of the Hakuhō statues is not to be found among the vast number of Buddhist images in China; it can be seen in only a few Korean ones. Also, it is strange that an attitude which seems to disdain the human intellect should appear in Buddhist art at this time, but one ancient trend in Buddhist thought has stressed intuitive, heartfelt communion with the divine. Its philosophy negated the intellect by describing the highest sacred value as an unknowable essence—the ultimate void, felt only through intuition. In the Zen sect, this tendency grew in later centuries to be a prominent factor in Buddhist art; here it was manifested as gentle beauty in an uncomplicated, almost artless guise. Such a spirit must have had a strong appeal in an age of political tension and disorder, just as imperial edicts inspired (perhaps naively) by the ideals of Buddhist compassion were issued throughout the latter part of the century, forbidding the use of cruel traps by hunters or eating the flesh of animals, ordering the installation of household shrines and the freeing of slaves. The quality of youthful innocence in the arts, however, may also have been a reflection of the lyricism and economy of expression which have been ever present in native Japanese thought, apparent in the *haniwa* figures as well as in the *Man'yō-shū*, a collection of ancient poems rich in examples from the Hakuhō era. In sculpture, this attitude was conveyed by the slenderness of arms and torso, in the frank, open expression of the face; it resisted any suggestion of aggressiveness and physical power. The human figures in the paintings of the Tamamushi-no-Zushi (the "Beetle Shrine" of Hōryū-ji) also show this clearly. Not only does the youthful Brahman have a slender neck, so also do the guardian devas painted on the upper doors, who by long tradition should have been bulky and vigorous. But rather than calling this a predilection for youthful forms alone, it should also be seen as a growing affinity for finesse and delicacy, one which led sculptors to delight in decorative effects in shallow relief. A taste for delicacy was yet another extension of the expressive range of Japanese art; the Hakuhō period thus saw the growth of artistic sophistication but also the restoration of that touch of simplicity which lies close to the heart of the native tradition.

Only a half mile north of Hōryū-ji are a pair of temples in which a few survivals from the Asuka period can be seen—Hōrin-ji and Hokki-ji. There are various explanations of their origins, but in their small and intimate scale they seem to reflect the patronage of individual families rather than that of the imperial household itself. It was a great loss when the three-story pagoda at Hōrin-ji, built in the Asuka style, was destroyed by lightning in 1944; however, a striking wooden Bodhisattva image has been preserved there. In its canon of proportions—short torso, enlarged hands and head—it is diametrically the opposite of the tall and slender Kudara Kannon. It is considerably more archaic in spirit, even though of a slightly later date—an atypical but appealing work among the Buddhist images of the period.

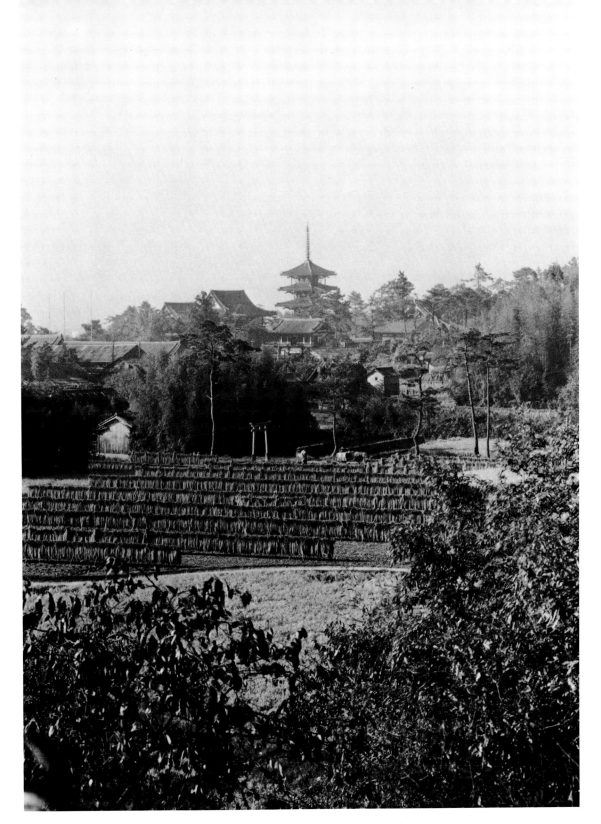

22. Distant view of Hōryū-ji.

The roofs of the ancient temple compound rise above the quiet fields of the Yamato country. When first seen by men of the seventh century, these buildings must have evoked a sense of wonder and awe—the nine golden rings atop the towering pagoda, the woodwork painted bright cinnabar red, the roof tiles flashing in the sunlight—architectural forms born on the mainland of Asia and suffused with the spiritual ideals of Buddhist India.

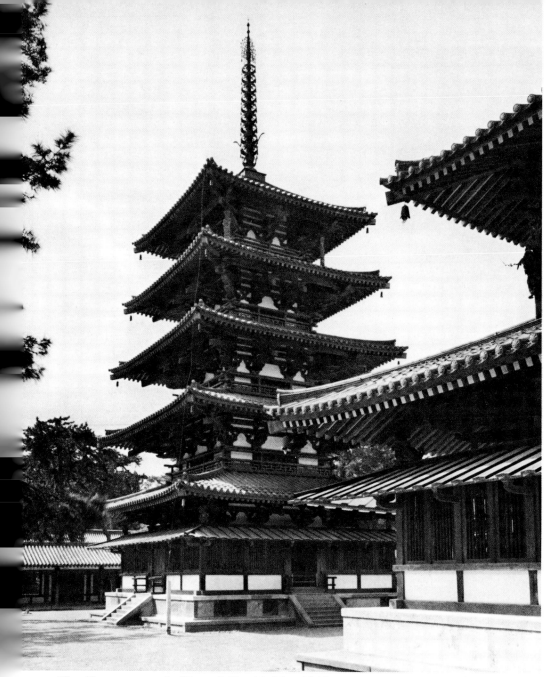

23. Five-story pagoda, Hōryū-ji. Total height, 32.45 m. (122 ft.).

The pagoda of Hōryū-ji contains a relic box in the foundation stone beneath its central pillar, for the pagoda form originated in India as a memorial to enshrine relics of the Buddha—his begging bowl, his bones, or the like. The building is not functional in the usual sense. As a rule, the visitor does not enter it, nor can he climb in the interior. Instead, its lofty height and multiple roofs are a concrete expression of the soaring spiritual aspirations of the faith.

24. Bronze statue of Yakushi Nyorai. Hōryū-ji *kondō*. Seventh century. Height of figure, 63 cm. (24.8 in.).

Early Japanese Buddhists frequently turned to Yakushi, Lord of Healing, at times of illness and distress. The inscription on the back of this statue's halo, for example, states that the Emperor Yōmei, desperately ill, asked his sister (later the Empress Suiko) and his son Prince Shōtoku to dedicate a temple and image to Yakushi to aid in his recovery. His death postponed the work, but in 607 his wishes were finally carried out. Once covered with bright gilding which is largely worn away, this monumental bronze figure is installed on the dais of the *kondō* to the east of the Shaka Trinity (figure 25), which was most likely a product of the same workshop.

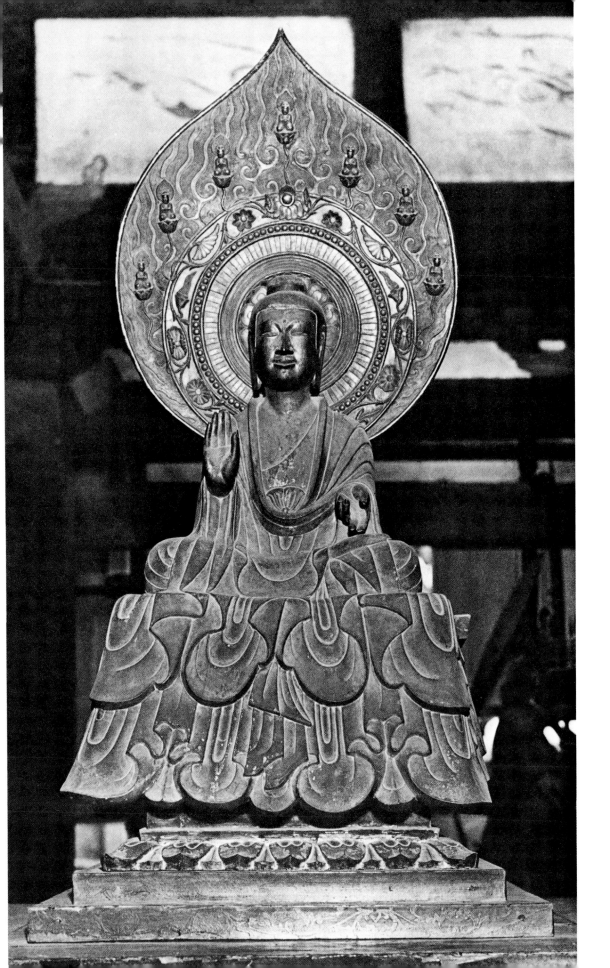

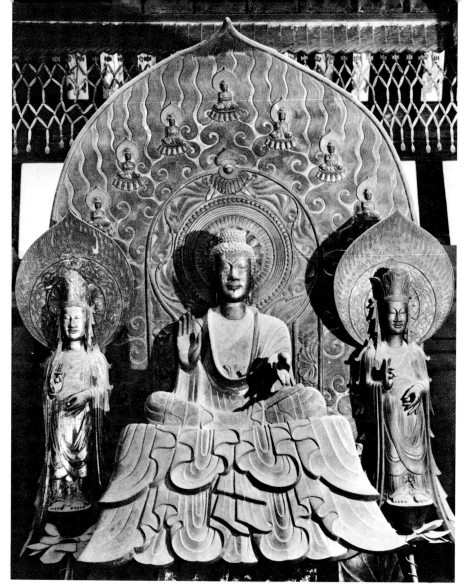

25. Shaka Trinity (Śākyamuni and two attendant
Bodhisattvas). Hōryū-ji *kondō*. Seventh century.
Height of central figure, 86.4 cm. (34 in.).
Seated erect before the splendid halo, the Buddha holds
his right hand in the gesture of consolation—a symbol
of the faith as a trustworthy haven, a refuge from spiri-
tual torment. The flickering fire patterns of the halos
and the unworldly sheen of the gilded surface combine
to suggest a crucible smoldering within, in contrast
to the serenity of the figures themselves.

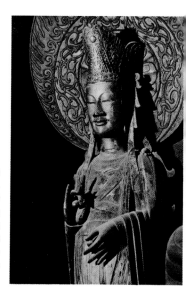

26. Attendant Bodhisattva from the Shaka Trinity.
H. 93.9 cm. (36.9 in.).
Standing beside the solemn Śākyamuni, this figure is
filled with gentleness and a sense of reserve and modesty.
It is stocky in proportion, frontal and static, yet the
sweep of its garment folds and scarves enhances its
quality of exquisite grace. At a time when monasticism
was still its main tradition, the Buddhist faith was
austere and demanding; yet in beauty like this, a lay-
man could experience something akin to religious ex-
altation. (See color plate 6.)

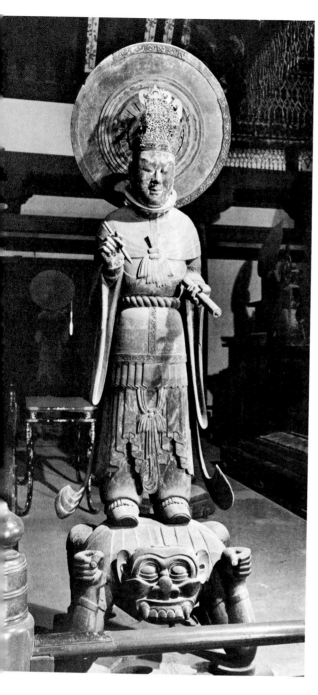

27. Kōmoku-ten. Hōryū-ji *kondō*. Seventh century. H. 133.3 cm. (52.3 in.).
This is one of the Four Guardian Kings who guard the altar dias. Columnlike in its torso, the figure conveys a sense of power and authority without the excited motion usually found in such militant figures. Its mood is reliable and stable, and the fanciful demon beneath his feet brings a humorous note to the darkened hall.

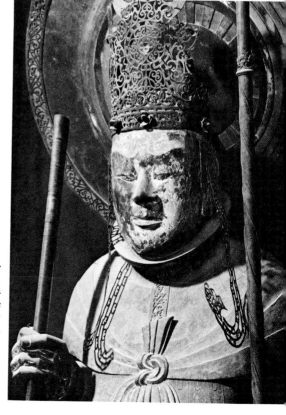

28. Zōchō-ten. Hōryū-ji *kondō*. Seventh century. H. 134.8 cm. (52.9 in.).
The garment folds, carved in delicate relief, set up a melodious rhythm over the surface and enhance the sense of solidity and volume. Rather than scrupulously realistic, many of the details are handsome formalizations of natural shapes—the knot of cloth at the chest, the symmetry of the folds, the eyes, eyebrows, and lips. The crown, made of openwork bronze that was originally gilded, harmonizes with the open countenance of the face.

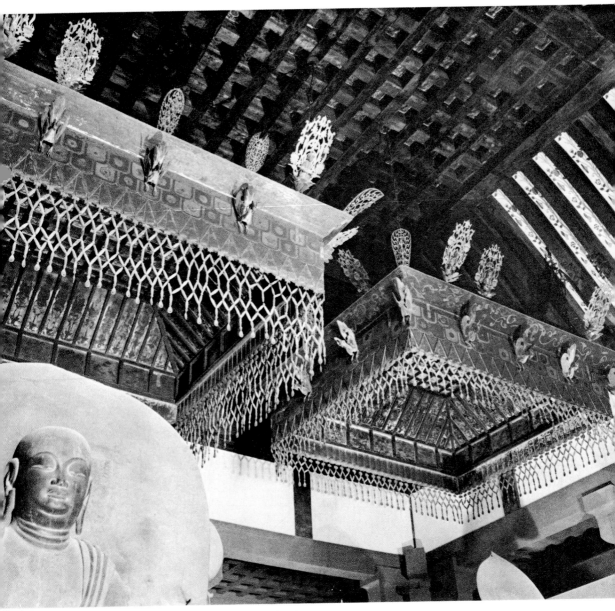

29. Canopies, over the main altar of the *kondō*, Hōryū-ji. Late seventh century.

Suspended above the three main Buddhist images are these brightly colored canopies. Lotuses and imaginary heavenly flowers *(hōsōge)* ornament the inner panels, together with patterns of green mountains. Pendants of glass are suspended from the netlike cords. Incorporating designs from China, India, and Iran, these canopies enhance the sense of divine glory which sets the main cult images even further apart from the atmosphere of the everyday world.

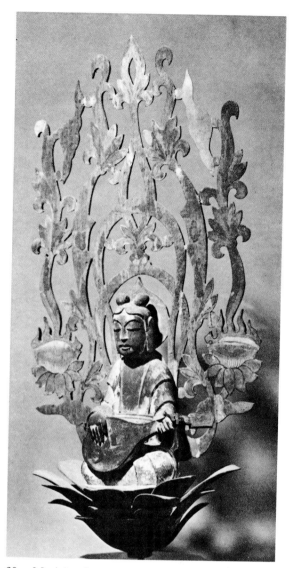

30. Musician from a canopy. Late seventh century. H. 26.4 cm. (10.3 in.).

This figure plays upon its lute with innocence and charm befitting the realms of heaven. Scarves rise upward in a flowing rhythmic pattern; they end in blossoming flowers which, in both concept and appearance, are utterly visionary.

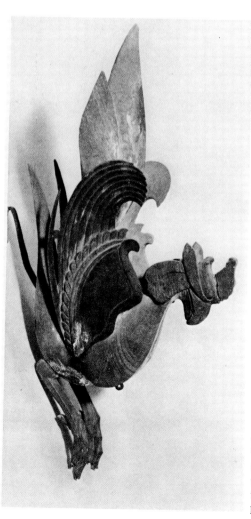

31. Phoenix bird from a canopy. Late seventh century.

This fabulous bird descends from Paradise, celebrating the appearance on earth of the Buddha. Carved in wood, its highly schematized shape is far removed from that of a real creature, yet the vitality of a bird is expressed with extraordinary skill.

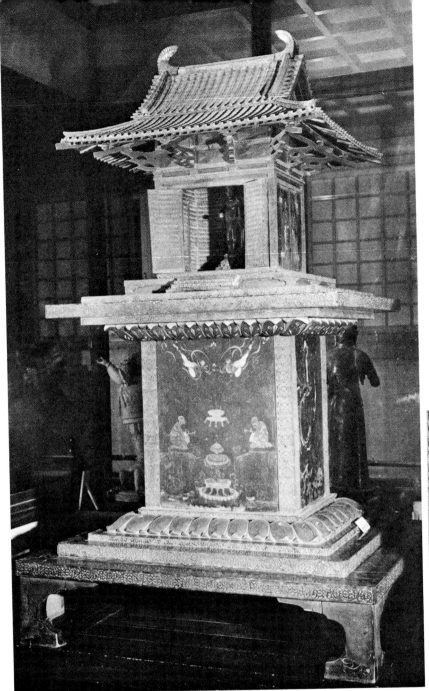

32. The Tamamushi Shrine. Hōryū-ji. Seventh century. H. 233.3 cm. (91.6 in.).

A tabernacle for a Buddhist statue, this shrine is celebrated for the fact that thousands of iridescent wings of the Tamamushi beetle were laid beneath the decorative bands of openwork bronze, originally gilded. The upper portion, built in the shape of a palace hall, resembles in some respects the *kondō* of Hōryū-ji.

33. The Bodhisattva's self-sacrifice. Tamamushi Shrine. H. 65 cm. (25.5 in.).

On both sides of the pedestal of the shrine are scenes of self-sacrifice by which Śākyamuni, in previous incarnations, demonstrated his devotion to truth and compassion for all beings. Shown here is the legend in which he had been born as a Brahman who offered his life to a demon in order to hear the last part of a poem of great insight. The Brahman is shown at the bottom interviewing the demon; in the left center, he engraves in stone the sermon he has heard; in the right center, he is being caught in midair by the god Indra, who had earlier disguised himself as the demon in order to test the Brahman's resolve. (See color plate 7.)

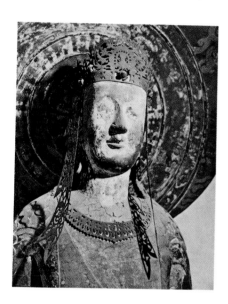

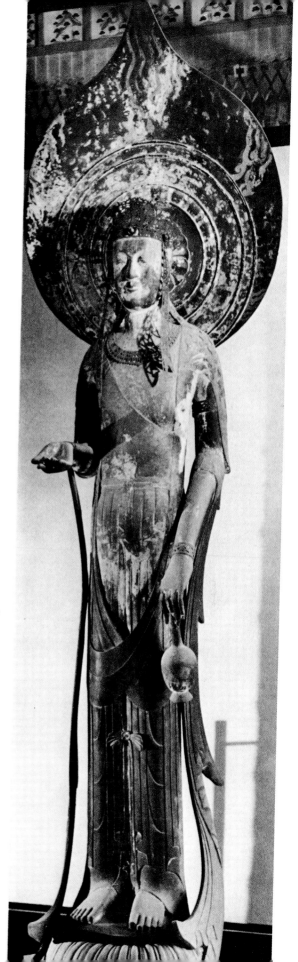

34. Head of the Kudara Kannon. Hōryū-ji. Seventh century.

The elongation of the face reflects the proportions of this uniquely tall statue, and the expression is gentle, almost maternal in spirit. The sinuous tresses of hair falling onto the shoulder strengthen this effect, and yet they, like the eyes or lips, are quite schematic and abstract in form. The flaking paint surface and cracks in the lacquer have not been repaired, for the patina of age is esteemed by those who respect the integrity of an object and the ways in which time transfigures it. The crown of openwork bronze was originally gilded, and it bears a small engraved image of the Buddha Amitābha above the central jewel. (See color plate 8.)

35. Kudara Kannon. Hōryū-ji. Seventh century. H. 209.4 cm. (82.3 in.).

Even with the gentleness of the face, a sense of sublimity is evoked by the extraordinary length of the figure and the forthright emphasis on lofty height. The crystallization of an ardent longing for spiritual grace, this religious icon possesses the beauty which, while born of faith, gives rise to faith as well.

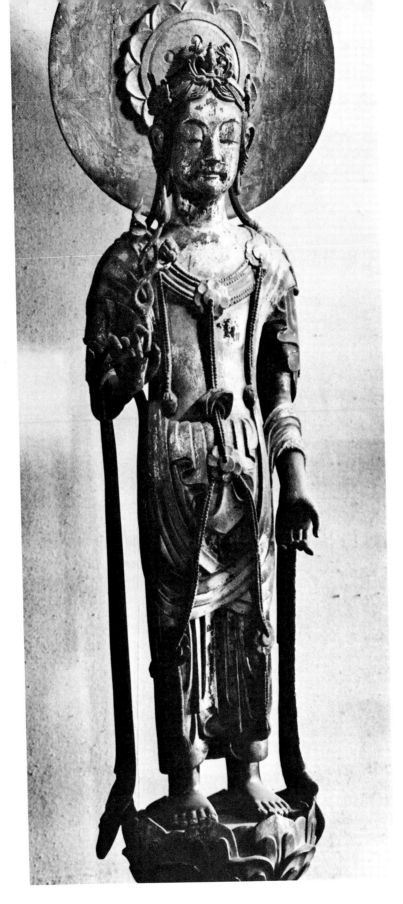

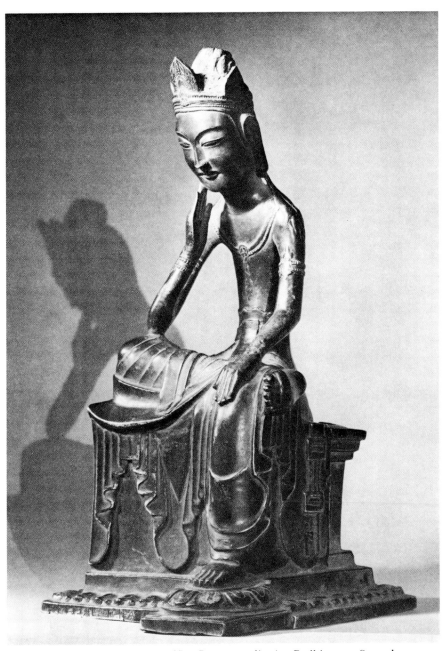

37. Bronze meditating Bodhisattva. Seventh century. H. 41.5 cm. (16.3 in.).

This figure is seated in the position called "half cross-legged in meditation" which was often depicted in the sculpture of China, Korea, and Japan in the fifth, sixth, and seventh centuries. One of its most moving and developed expressions, perhaps, is the wooden statue in the Chūgū-ji (figure 45). The bronze image, small enough to have served as a household icon, is impressively reserved and grave; the slightly clumsy narrowing of the torso and the concomitant enlarging of the head result in a thoughtful presence whose face conveys aesthetically the sense of divine compassion which is the symbolic significance of the pose itself.

36. Bodhisattva in wood. Hōryū-ji. Late seventh century. H. 106 cm. (41.8 in.).

One of a set of wooden figures known as the Six Kannon, it is imbued with a youthful spirit which pervades many of the smaller cult images of the latter part of the seventh century. The surface was lacquered, gilded, and given an almost metallic finish, and strings of jewels were depicted over the body for the sake of elegance; yet the columnar simplicity of the torso and the open countenance of the face preserve an ingratiating charm.

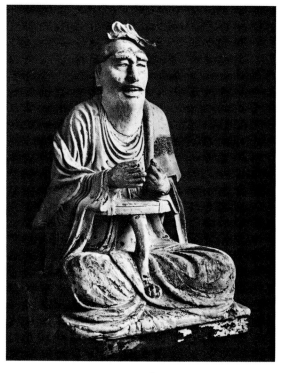

38. Dry clay statue of Vimalakīrti from the five-story pagoda, Hōryū-ji. Eighth century. H. 51.5 cm (20.3 in.).

Four groups of small, unbaked clay statues are arranged in grottolike settings on the gound floor of the Hōryū-pagoda. Vimalakīrti is the leading figure from the group on the east, in which he is depicted as an ill and aged man to whom the Bodhisattva Mañjuśrī comes in a visit of condolence. Vimalakīrti takes this opportunity to deliver (as depicted here) a sermon which includes remarks on the frailty of the human body and the way in which a layman in ordinary secular life can experience sanctity. The sculptor, working in a realistic idiom, attempted to imbue the figure with the ravages of illness and age and yet give him dignity and intensity of expression befitting the fact that Vimalakīrti is in the act of pronouncing some of the most profound of all Mahāyāna doctrines.

39. Dry clay statues in the five-story pagoda, Hōryū-ji. Eighth century. Height of individual figures approx. 46 cm. (18.1 in.).

This is a detail of one of the groups of dry clay figures on the ground floor of the five-story pagoda. It shows some of the disciples of Śākyamuni gathered in mourning at his death. A chorus of lament depicted in a realistic manner, their bodies tremble in the contortions of grief.

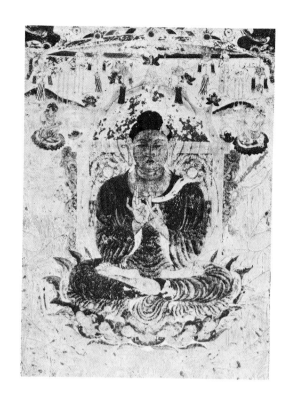

40. Wall painting, Hōryū-ji *kondō*. Late seventh century. Size of total scene, 313 × 260 cm. (123 × 102 in.).

This is a detail of the Buddha Amida (Amitābha) revealing the Law in the Western Paradise. On either side of his throne, bent in gestures of supplication, are the small souls reborn there to receive his instruction. Stylistically, a strong Indian flavor permeates this scene, as in the ''lines of iron wire'' used to establish the contours, and in the facial features and strict symmetry of the Buddha. The prominence of paradise motifs in the wall paintings of the *kondō* reflects the growing tendency for men to seek salvation in the grace and compassion of the great deities of the Buddhist pantheon. (See color plate 9.)

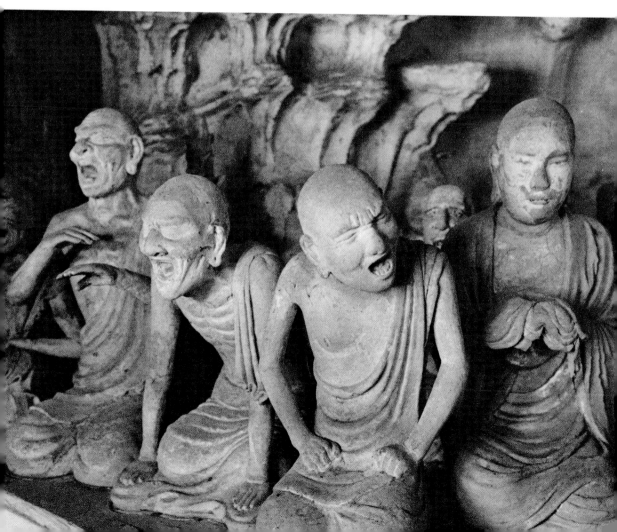

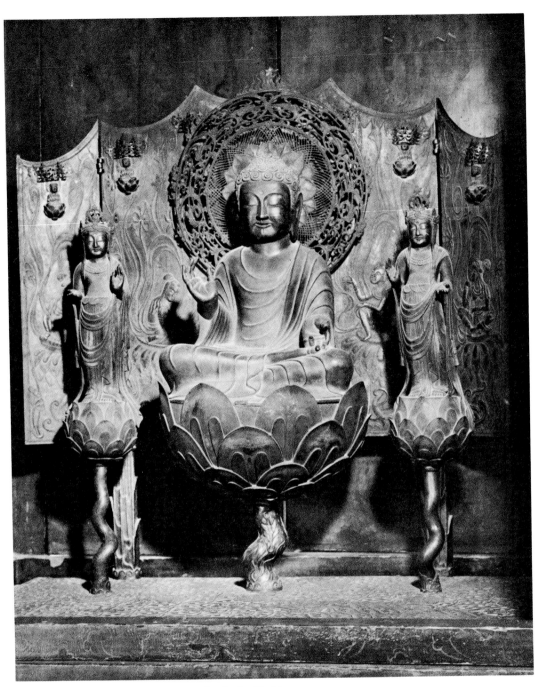

41. Amida trinity. The Shrine of the Lady Tachi-
bana, Hōryū-ji. Late seventh century. Height of cen-
tral figure, 33.3 cm. (13 in.); attendants, 26.9 cm.
(10.5 in.).
Amitābha and his two Bodhisattvas are each placed on
a lotus flower rising from a pond—symbolic of the
spotless purity of their nature. Exquisite craftsmanship
is shown in the openwork halo and the flowing rhythm
of the low relief on the rear wall. Befitting its original
role as a personal, household image, the intimacy of
this miniature group reflects affection for the deities
as well as respect and awe.

42. Yumedono. Hōryū-ji. Eighth century.
Built at the site where Shōtoku Taishi once lived, this
serenely proportioned octagonal-shaped hall presents
a variety of visual effects as one walks around it. The
roof ornament in gilded bronze is a complex combina-
tion of lotus flowers, a vase, canopy, ball-shaped jewel,
and beams of light projecting in all directions. The
notion of a divine force radiating from a central nucleus
is carried out in both the building and its roof orna-
ment, as though the Buddhist Law itself were being
generated from this sanctified spot.

43. The Guze Kannon. Yumedono. Seventh century.
H. 197 cm. (77.5 in.).

According to pious tradition, this image was modeled
after Shōtoku Taishi and given the same bodily length.
In its hands rests the flaming gem, emblem of the Bod-
hisattva's power of salvation. The hair locks falling over
the shoulders are strangely abstract in form, enhancing
the frontality and archaic appeal of the statue. (See
color plate 10.)

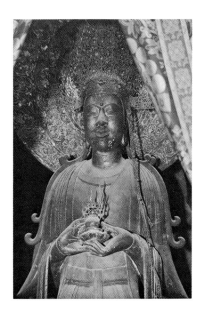

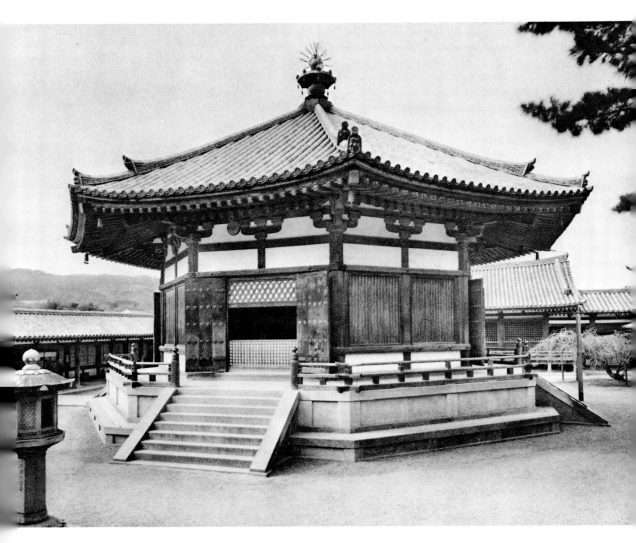

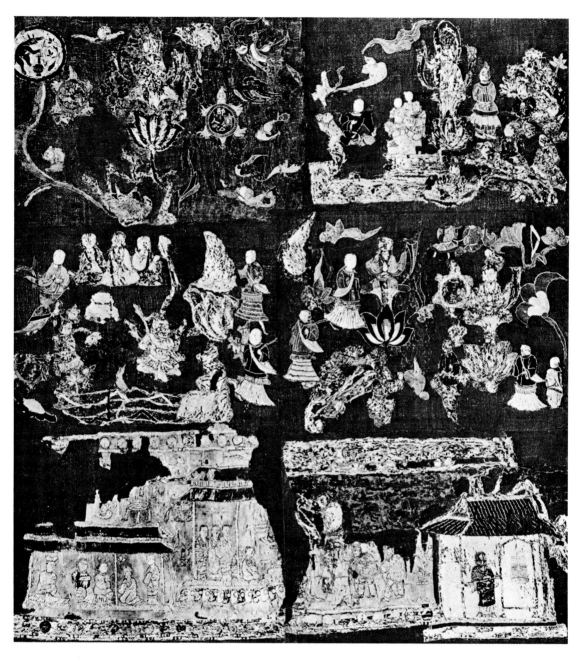

44. Tenjukoku Mandala. Chūgū-ji. Seventh century. Following the death of Shōtoku Taishi, his consort and attendants made two embroidered hangings to illustrate the Paradise where the soul of the prince was thought to dwell. From the few remaining fragments, it is difficult to conceive of the original compositions; but the individual figures have an innocent, personal charm at a time when the arts were becoming increasingly hieratic.

45. The Bodhisattva in contemplation. Chūgū-ji. Seventh century. Height from topknot to seat of figure, 87 cm. (34.2 in.).

Housed in the nunnery attached to Hōryū-ji is this remarkable statue, patterned after images of the First Meditation of Śākyamuni, when, as a prince, he first encountered the hardships and brutality of life and resolved to untangle the dilemma of human suffering. In this work is a distinct sense of gentleness which comes close to that of maternal tenderness—almost the archetypal expression of divine compassion. An aura of warmth and profundity is added by the wooden surface, once gilded, but now darkened by the passing of the centuries.

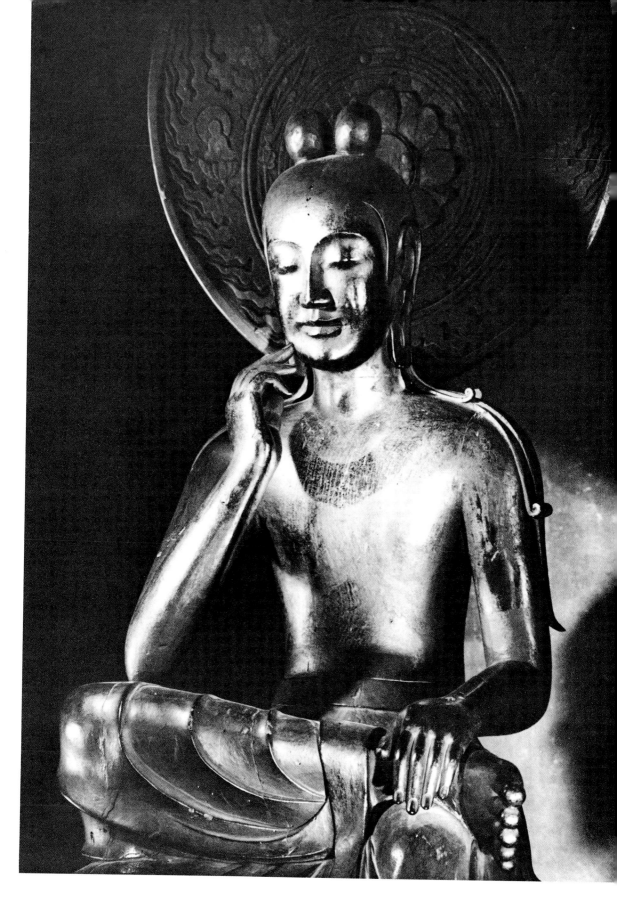

Plate 6. Attendant Bodhisattva from the Shaka Trinity. Hōryū-ji *kondō*. Seventh century. (See also figure 26.)

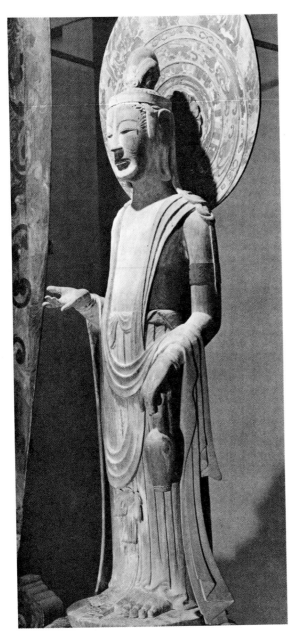

46. Kokūzō Bodhisattva. Hōrin-ji. Seventh century. H. 175.5 cm. (68.9 in.).
The surface of the image betrays the effects of long weathering and abrasion, but in the process it has taken on a kind of austere purity. Indestructible was the clarity of its style, which imbues the figure with stability and assurance.

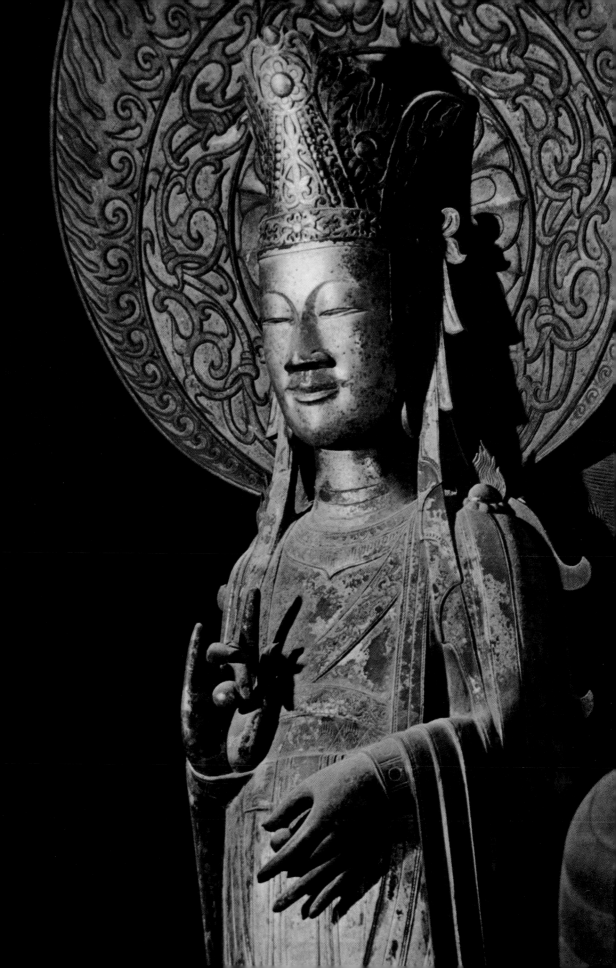

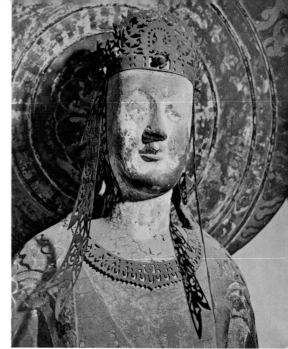

Plate 7. The Bodhisattva's self-sacrifice. Tamamushi
Shrine, Hōryū-ji. Seventh century. (See also figure 33.)

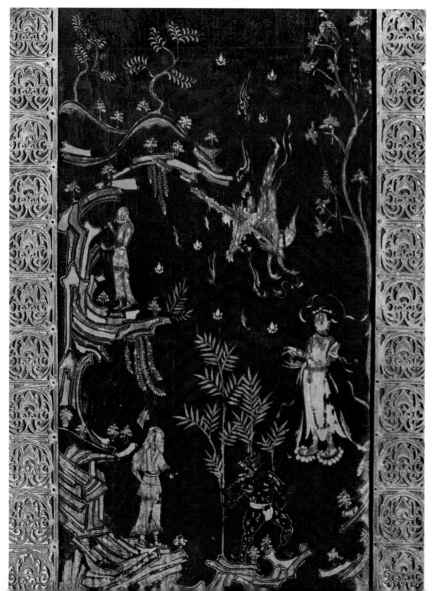

Plate 8. Head of the Kudara Kannon. Hōryū-ji. Seventh century. (See also figure 34.)

Plate 9. Wall painting, Hōryū-ji *kondō*. Late seventh century. (See also figure 40.)

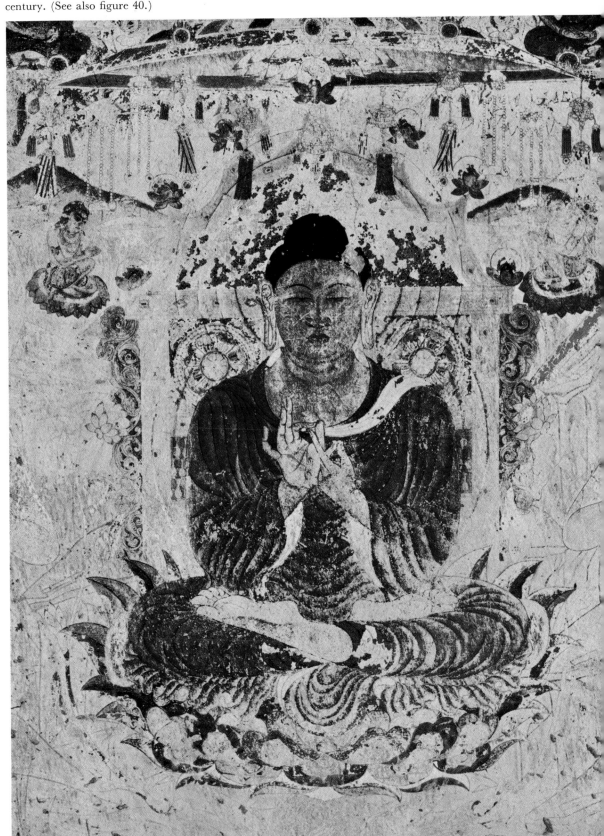

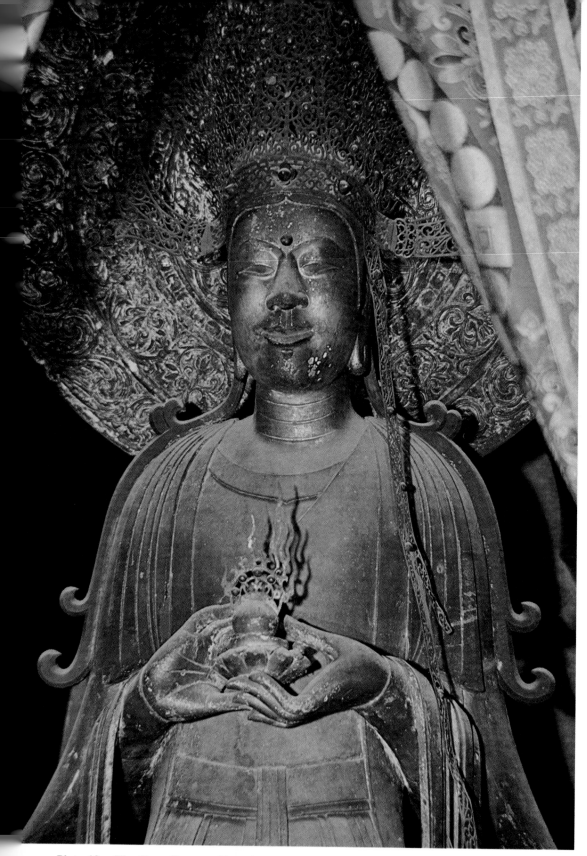

Plate 10. The Guze Kannon. Yumedono, Hōryū-ji.
Seventh century. (See also figure 43.)

~⊚ 3 ⊚~

ALONG THE WESTERN SIDE OF NARA

A broad expanse of rice fields separates the modern city of Nara from the district called the Nishi-no-kyō ("Western Capital"). In ancient times, this was the sector west of Suzaku Ōji, the broad north-south avenue which divided the town into two parts. The area was built up with urban structures of which only two great temples remain today, Yakushi-ji and Tōshōdai-ji.

Construction of the Nara capital was begun in A.D. 708, but the planning and actual building of a permanent seat of government had started twenty years earlier in the Asuka district, only fifteen miles to the southeast. The site was that of the Fujiwara palace, but the flat plain there, broken up by hillocks and ravines, proved to be too constricted for a great capital city laid out according to the principles of Chinese city planning. An urgent need was felt for a proper capital in order to maintain national prestige at a time of active international contacts and to provide a center for increased administrative and religious activity. In view of the fact that only a half century earlier the government had moved upon the death of each emperor, the need was in itself proof of the rapid development of the internal organization and strength of the state.

The foundation of this growing cohesiveness was the coup d'etat of A.D. 645, which is given the name of the Taika Reformation. Its leaders were a prince of imperial blood, Naka-no-Ōe, and the courtier Nakatomi-no-Kamatari. The latter was a thoughtful student of Chinese governmental theory and, upon his rise in influence, founder of the fortunes of the Fujiwara family. The prime goal of the Reformation was one which Shō-toku Taishi himself had worked to achieve, the establishment of the emperor rather than the clans as the prime source of political authority throughout the land. To bring this about, the despotic Soga family was finally overthrown; an imperial edict was promulgated declaring that ownership of great tracts of land and their attached serfs was to be transferred from the clans to the national government; a census and land survey was to be drawn up; administration of the remote provinces was to be brought under the direct control of the capital. This attack on the economic and military basis of the power of the clans stirred up fierce resistance; but Naka-no-Ōe succeeded to the throne under the name of Emperor Tenchi and issued the so-called Ōmi Edict, which further strengthened the reform movement. Thus, by the end of the seventh century,

the effects of centralization had become increasingly apparent, for the wealth and strength of the throne (and those surrounding it) had increased immensely.

While the Taika Reformation was prompted by internal problems, the Japanese were undoubtedly stimulated by the fact that China, under the early T'ang emperors, was at the height of its formidable power and boasted of a strong, centralized administration whose influence was felt in all aspects of national life. At the same time, the Chinese Buddhist Church was also flourishing, for, having continued to stress the doctrine that the faith would promote the prosperity and happiness of the nation, it received lavish support from the government. Following this pattern, the Japanese court also offered protection to the Church, and several emperors founded monasteries designated as special, state-supported temples *(kan-ji)*.

The new seat of government in the Nara area was but one of the fruits of this firm persistent policy of centralizing power. Large temples from other parts of the country were reestablished in the capital, adding their architectural splendors to those of the imperial residence, the Heijō-kyū ("Palace of the Fortress of Peace"). The great monastery of Yakushi-ji was one of the first of these, and was relocated in the western side of the city.

The District around Yakushi-ji

Yakushi-ji was originally built with imperial patronage in the Asuka district, at Unebi Kidono. Consecrated to the worship of Yakushi, the Buddha of Healing, it had been pledged by the Emperor Temmu in A.D. 680 in order to cure his empress's illness; but more than twenty years passed before it was finished. Together with other temples in the Asuka district which served the court, it was transferred when the capital moved to Nara; the old buildings, however, were not dismantled but apparently reproduced on a larger scale at the new site, probably during the 720's. The old monastery at Kidono remained standing until the middle of the Heian period, bearing the name of Moto ("the former")-Yakushi-ji. The Yakushi-ji at Nara also suffered greatly from earthquakes and fires, and of its original buildings only one pagoda remains today. In its prime, however, it possessed two pagodas, a large *kōdō,* and a splendid *kondō* crowned with a two-level roof; the entire compound covered about twelve blocks.

Innovations may be seen in the layout of the halls at Yakushi-ji, and their design was experimental as well. Prior to this time, Japanese temples had only a single pagoda; in the oldest examples, such as the Shitennō-ji or Tachibana-dera, this was in the center of the compound sharing the main north-south axis with the *kondō* and *kōdō*—a simple arrangement reflecting the central theological role of Śākyamuni, the historic founder of the faith. At Hōryū-ji, the pagoda and *kondō* were erected side by side, as though their sacral value were equal. At Yakushi-ji, however, the dominant position was given over to the *kondō* while the two pagodas were placed in a marginal, subordinate role—their duplication probably for aesthetic reasons, for the needs of symmetry and visual balance. Of these two pagodas, it is the eastern one which has remained standing; the position of the other is marked by its basement platform and foundation stone in which the temple's sacred relics had been deposited. This change in architectural emphasis was probably a response to the change in devotions in which the many deities of developed Mahāyāna Buddhism began to replace Śākyamuni as the center of popular worship. The age was one of innovation in statecraft; coincidental with it were religious developments which, in turn, produced these new forms of temple building and decor.

The Yakushi-ji pagoda appears to have six stories whereas, in fact, it has three, but each floor is equipped with a protective outer corridor with its own roof, making a total of six tile roofs. In the past, most pagodas had five stories; that those at Yakushi-ji, a rich and important temple, had only three must again indicate the ebbing of the symbolic and sacral importance of the old-fashioned, tower-type pagoda. Builders are never satisfied, however, and perhaps at Yakushi-ji they devised this six-roof scheme to give the pagodas the illusion of a more dignified form, even though it meant placing the outer corridors on two upper floors where they had no real function. Perhaps this was a product of the boldness and enterprise of the Hakuhō period, for the pagoda has another trait typical of the arts of the age, a strong rhythmical quality. The roofs, for example, diminish in size as they rise from bottom to top, but the eaves of each main story project farther out than those of the outer corridor. The result is a contrapuntal, almost musical relationship among the projecting forms. In contrast is the simple taper-ing outline of the roofs on the Hōryū-ji pagoda, which results, however, in a more monumental effect. The mast of the Yakushi-ji pagoda is as inventive as the rest of it; above the nine-ringed spire is a flame-shaped ornament of openwork bronze, in which angels are shown descending from Paradise, playing flutes and harps and gesturing as though in a dance. Musical elements have a distinctive role, both symbolic and aesthetic, throughout this towering monument and are quite similar to those present in the angels in the canopies of the *kondō* at Hōryū-ji, which date from about the same time. The appearance of these elements in the visual arts marks the transition from an age which had admired willpower and discipline to one which sought sentiment and charm.

In fact, during the Hakuhō period, many forms of music were brought from the Asian mainland. Until then, the chief form of ritual dance and music had been the *gigaku*, said to have been imported first by the naturalized Korean Mimashi. It was performed in Buddhist temples as part of the services and also in the palace, at banquets and receptions for foreign guests; it was prized as the only example of foreign music in Japan. *Gigaku* was, however, a very simple art form; for the most part the actors wore wooden masks, and their gestures were often humorous or grotesque; accompaniment was provided by nothing more than cymbals, small drums, and flutes. By the advent of the Hakuhō period, however, the continuous traffic between Japan and the continent had resulted in new varieties of music entering the country from Korea and T'ang China, the latter having fancied the music of India, Central Asia, and even the Indies. *Gagaku*, the stately court music which has flourished for centuries in Japan, seems to have started up here and on the continent at about this time. Novel musical instruments were im-ported, such as the *koto* (a long zither), the *biwa* (a lute), and the flutelike *shō*. In a sense, the musical perceptions of the Japanese, hitherto rather dormant, were jolted awake by this veritable flood of foreign influence, and it is by no means unreasonable to detect a musical element in the visual arts of the time.

Other aesthetic tendencies which developed toward the end of this fruitful era may be seen in Yakushi-ji's Buddhist images. Perhaps the most impressive of all these statues is the bronze Shō-Kannon, now enshrined in the Tōin-dō. If compared with the Kudara Kannon of Hōryū-ji, which was made at the most a half century earlier, the aesthetic impression is remarkably different, even though both depict essentially the same deity and have a similar sense of commanding, upright verticality. The later work is far more realistic in the modeling and structure of the body; but beyond this, where the Kudara Kannon has the quality of tenderness and almost maternal compassion, the far more

masculine figure in bronze is imbued with a sense of radiant, divine energy. The youthful reserve of many early Hakuhō figures is absent here, replaced by a greater maturity and solidity. The exact date of the Shō-Kannon is unknown; perhaps it was made around A.D. 700–710, about the time of the founding of Nara and the advent of the cultural epoch bearing the capital's name, one which began to think in terms of massive size and grandeur in the arts. Its form closely resembles some of the Bodhisattvas painted on the walls of the *kondō* at Hōryū-ji, also thought to have been done at this time. And while it is regrettable that the origins of such impressive works cannot be fixed more precisely, this very uncertainty gives some leeway to the imagination and sharpens one's perceptions of the pieces themselves.

Of the same period (or slightly later) are the giant, bronze statues of the main deity of the temple, Yakushi Nyorai, and his two attendant Bodhisattvas, housed in the *kondō*. Their bodies are imbued with an even greater sense of softness than that of the Shō-Kannon, almost to the point that the massive bronze surfaces seem pliable. In addition, the jewelry and clothing of the attendants were depicted with a lavish care that suggests a growing fascination with ornamental effects. Even the bronze pedestal of the central figure has intricate decorative designs which include the legendary Chinese animals of the four directions: the dragon, tiger, phoenix, and the combined tortoise and serpent. Several groups of mysterious seminude men and women are shown half-hidden on the pedestal, a motif unique in Japanese Buddhist art. Perhaps their presence implied that the merciful compassion of the faith would reach out even to such barbarous, aboriginal folk as they. Today, the altar platform is of white marble, Chinese in origin, but according to old records it was originally covered with agate and lapis lazuli and measured over thirty feet long and nearly two feet high. The pedestals of the images were enclosed with a golden cord; exotic woods were used in the handrailing, while rose sandalwood was placed in the ceiling over the altar. Not only were canopies suspended overhead, but at their corners were precious gems in the shapes alternately of the sun and half-moon. Even if there were rhetorical flights of fancy in these descriptions, one can well imagine the splendor of the original two-story *kondō* when the giant statues still retained their coating of gold. Such sumptuousness and ornamentalism in art were a basic feature of the Nara period; they were fruits of the sheer wealth and power of the court, newly attained; they were also a reflection of the same taste in the urban civilization of T'ang China, just as the heavy roundness of the Yakushi figure reflected the canons of T'ang Buddhist images. While the aesthetic spirit of the Hakuhō age can be seen in the eastern pagoda, the Yakushi trinity expresses these new tendencies of the Nara period. Both were made at about the same time, however, which would seem to be a contradiction were it not for the fact that, even in times of great upheaval in artistic standards, the changes in traditional architecture have usually been less radical than those in sculpture and painting.

Yakushi-ji also possesses a painting of the Nara period which is worthy of note, a tiny image on fine hemp of the goddess Kichijō-ten (Śrī Lakshmī, goddess of learning) shown as an opulent court lady. According to Buddhist sutras popular in the day, the goddess would bestow good fortune on those who sincerely regretted their sins during a ritual of repentance. In an age so devoted to worldly power and luxury as the Nara period, Kichijō-ten was widely worshiped, and paintings or statues of her are to be found in many temples. The ritual at Yakushi-ji was first held in A.D. 772 and, with this painting as the *honzon* ("principal object of worship"), has continued to this day. Kichijō-ten is depicted here not as a heavenly figure but as an aristocratic lady very much of this

earth and possessed of a distinct sensual appeal. Clearly discernible here is the type of divine beauty seen in the Yakushi trinity—idealized form strongly tinged with the appearances of the visible world. This feeling for actuality and the love of splendor gave great force to the arts of the short-lived Nara period, but they were also its greatest liability.

THE VENERABLE PRECINCTS OF TŌSHŌDAI-JI

A few hundred yards north of Yakushi-ji is the monastery of Tōshōdai-ji. It was built only a half century later, but this half-century saw both the dawn of the arts of Nara and their twilight. The full noon, so to speak, is represented chiefly in the vast temple of Tōdai-ji, faintly visible among the buildings of the modern city to the east.

Tōshōdai-ji was built for the Chinese monk Chien-chen (or Ganjin in Japanese pronunciation), who had been invited in the mid-eighth century to come to Japan to correct the training and ordination procedures of the monks of Nara. The hardships of the journey and repeated shipwrecks cost Ganjin his eyesight; in fact, twelve years were spent between his first attempts and final arrival in Japan in A.D. 753, and the saga of his voyage is one of incredible heroism and forbearance. His coming had been eagerly awaited, for he was famed as a master of the Vinaya, the rules of Buddhist monastic life. At the time, monasticism was still the basic pursuit of the faith, and even though the Church in Japan was prosperous and influential as never before, the discipline of the monks was not properly enforced. Temples in the capital had been infected by the air of opulence and pleasure-seeking surrounding them, and it was hoped that Ganjin would be able to strengthen the training and self-control of the clergy. Upon his arrival, he began instructing not only the monastic brotherhood but also the Emperor Shōmu, the empress, the crown princess, and members of the court; soon he sought to have a seminary built in a secluded part of the capital where he could properly teach the Vinaya. With the patronage of the imperial household, the site of a mansion belonging to Prince Nitabe was taken over, and an audience hall from the palace was dismantled and rebuilt to serve as the lecture hall of the new temple, which came to be called Tōshōdai-ji ("T'ang Monastery"). This hall is still standing, together with the *kondō* and sutra storage, from the time of the temple's founding. The monks' dormitory was remodeled in the Kamakura period, and the front part converted into a "hall of relics," or *shariden*; the bell tower dates from this time as well. Each building thus has a slightly different aesthetic spirit, but their placement is the original one and they harmonize together so well that Tōshōdai-ji, together with Hōryū-ji, is one of the rare places where the aura of an ancient monastery remains more or less intact.

The first thing seen by the visitor entering the south gate is the severe, impressive *kondō*, but groves of pine trees standing within the precinct soften slightly the mood of monkish austerity. Nothing eccentric or discordant strikes the eye, nothing which speaks of the overweening ambitions of man; but in the interior of the *kondō* is an array of large statues which express the limitless power and grace of the Buddhist pantheon. A seated statue of Birushana (Vairocana) is placed in the center, emblem of the origin of all things in the cosmos, even all other deities. Although lacking personal or emotional qualities, Birushana was a deity to which the Nara court was devoted, as is shown by the gigantic bronze image of him completed in Tōdai-ji just before Ganjin's arrival in Japan. To the right is Yakushi Nyorai, and to the left is Kannon, here endowed with a thousand arms in literal evidence of the Bodhisattva's powers of salvation. The first two images are

made of hollow dry lacquer, a technique popular then in China, and some of the gilding still remains on their surfaces to glow in the darkened hall. Among them are placed wooden figures of Brahma, Indra, and the Four Guardian Kings, making an imposing phalanx of statues to which the devotee can come unusually close when he stands at the massive wooden doors of the portico.

The statues of Tōshōdai-ji, especially the wooden ones, are quite unique for their time, for they seem to have been among the first works in which the realism and ornamentalism of the Nara period were consciously rejected. In their day, they must have had a strong impact on those whose eyes had become attuned to the atmosphere of other Nara temples, for they sought a spiritual quality which lay beyond realism and physical grandeur. This sober style, together with the austerity of the buildings, is in full harmony with the original purpose of the temple as a seminary; it accords also with what is known of the personal character of Ganjin, who surely must have influenced Japanese craftsmen as well as the sculptors and architects who came with him from China. The ideals and memory of Ganjin pervade this temple as thoroughly as do those of Shōtoku Taishi at Hōryū-ji.

Until recently, a portrait statue of Ganjin was enshrined in a humble founder's hall atop a small hillock behind the former monks' dormitory. This statue, made about the time of his death in A.D. 763, is a careful record of his features, especially his blindness. Although Ganjin was deeply revered, the unknown sculptor made no attempt to flatter his appearances and avoided any suggestion of ostentation, thus capturing with sober realism the severity and calmness of the monk's character.

In these two temples on the west side of the ancient capital, one can clearly feel the spiritual forces which gave birth to the arts of Nara and then, at the end, corrected their extravagances.

47. Eastern pagoda, Yakushi-ji. Eighth century. H. 39.9 m. (130.8 ft.).
This is basically a three-story pagoda, but the roofs over the protective outer corridors give it the appearance of a six-story one. The building has an air of lightness and a strong rhythmic feeling which might be thought of as a translation into architectural form of the bold cadences of the poems of the *Man'yō-shū*. The spire of the pagoda is especially fine; angelic musicians in delicate openwork bronze appear above the nine rings, sweeping downward among flamelike patterns.

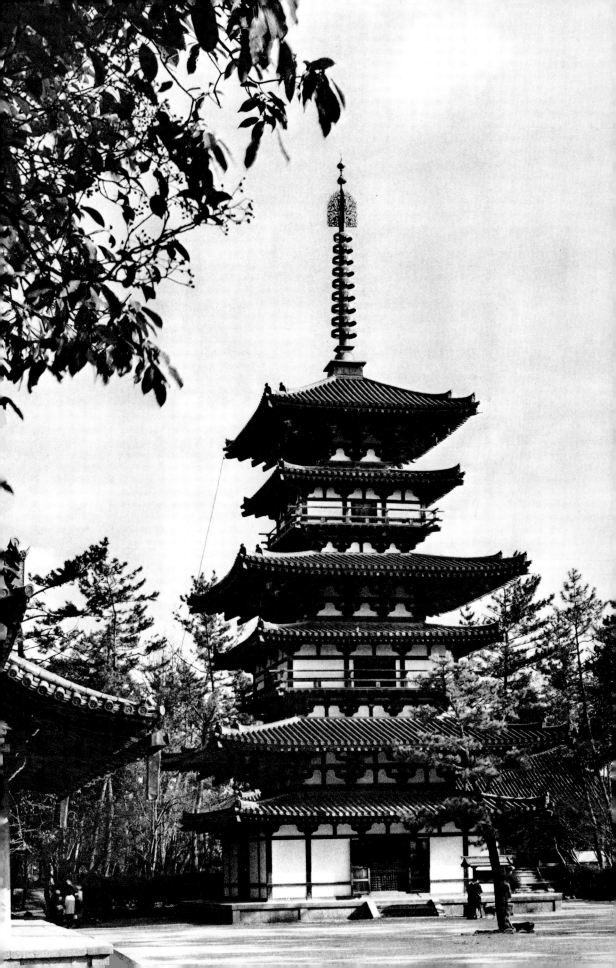

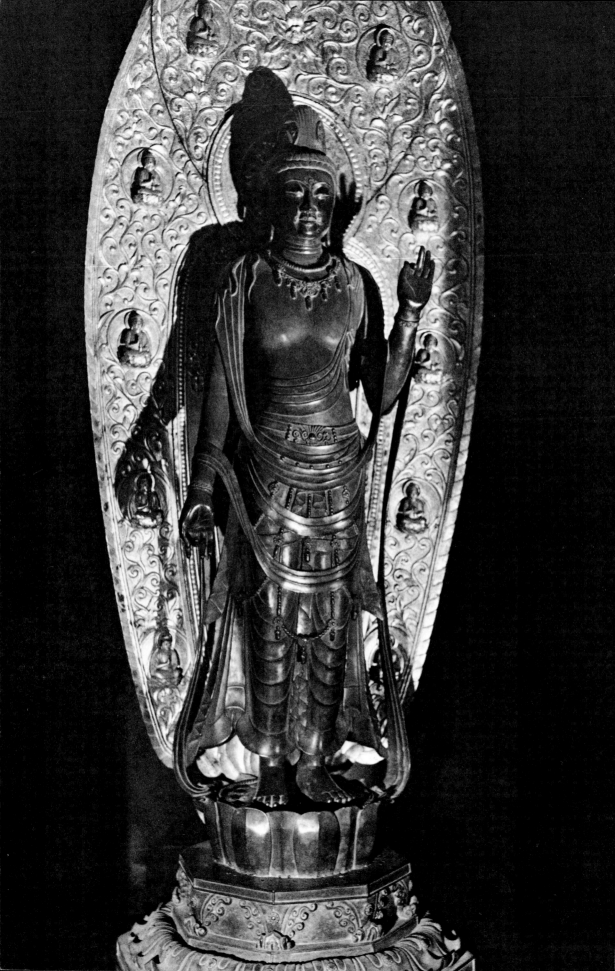

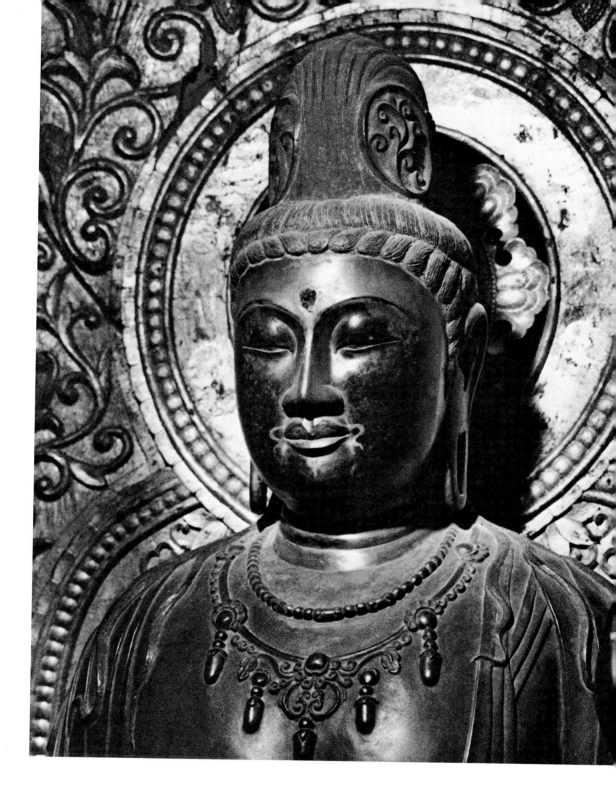

48–49. Shō-Kannon. Tōin-dō, Yakushi-ji. Eighth century. H. 188.5 cm. (74.1 in.).
Beneath the diaphanous garments can be seen the outlines of the sturdy, masculine body. No trace of sentimentality was allowed to intrude in this aloof figure, standing upright in solemn majesty. Necklaces and strings of jewels are depicted with loving care, giving evidence of the growing taste for rich decoration of the time. The ideals which engendered this figure must have fluctuated between those of physical beauty and those of the transcendental faith.

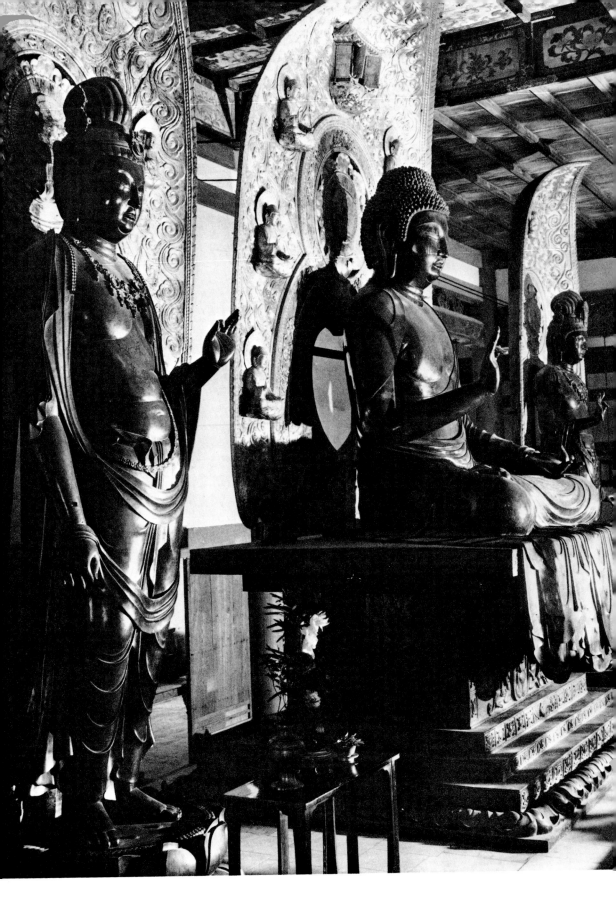

50. Yakushi trinity. Yakushi-ji. Eighth century. H. Yakushi, 254.8 cm. (100 in.); Gakkō (left), 309.4 cm. (121.6 in.); Nikkō (right), 311.8 cm. (122.5 in.). Originally gilded, the surfaces of the cast bronze have darkened over the centuries into a lustrous black. The bodies of the deities, far larger than life, are ponderous and heavy, and the two attendants are richly adorned with jewels, as though in affirmation of the fullness of the world. The Buddhist faith of this period had become closely linked with material as well as spiritual rewards.

51. Aboriginal figures on the pedestal of the Yakushi statue, Yakushi-ji. Eighth century. The lavish decoration of the pedestal of the Yakushi statue includes a number of seminude figures thought to represent barbarous aborigines. Their significance is uncertain, but they may well have symbolized the ideal that blessings of the faith reached even to persons of this sort—compassion for all beings in the universe.

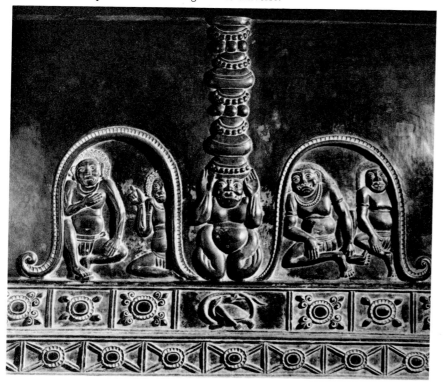

52. Grapevine pattern from the pedestal of the Yakushi statue, Yakushi-ji. Eighth century. The design in low relief which runs along the upper rim of the pedestal of the Yakushi statue is one of several exotic elements there, attesting to the cosmopolitan outlook which was gathering force both in China and Japan. In the minds of the Chinese, grapes had long been associated with western and central Asia, and the grapevine motif played a prominent role in the decoration of T'ang metalwork. When imported into Japan, it was still a fresh and meaningful design.

53. Kichijō-ten. Yakushi-ji. Eighth century. H. 53.3 cm. (20.9 in.), w. 32 cm. (12.5 in.).
The Goddess of Wealth and Beauty, Kichijō-ten, was frequently given the guise of a handsome court lady. This tiny work is a rare example of Nara period painting, but is considered typical for the extraordinary finesse of its craftsmanship. The unknown artist lavished great care in depicting the jewelry with gold leaf and showing the embroidery patterns, and he imparted a subtle, rhythmic undulation to the transparent veils. (See color plate 11.)

54. *Kondō*, Tōshōdai-ji. Eighth century. Dimensions of ground plan, 28 × 14.65 m. (99.8 × 46.5 ft.).
The eight massive columns of the portico lack that gentle swelling along the shaft, akin to the entasis of classical Greek columns, which appears at Hōryū-ji; but they do have a strong sense of structural stability. The open porch was a new development in its day, reducing the width of the interior and emphasizing the feeling of horizontality in the facade. The eaves, supported by a complex, three-stage bracketing system, are thrust out far from the walls, adding an element of decisive boldness.

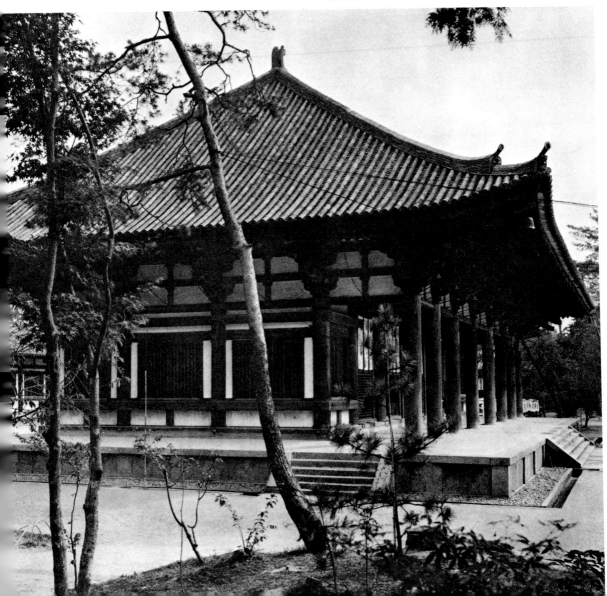

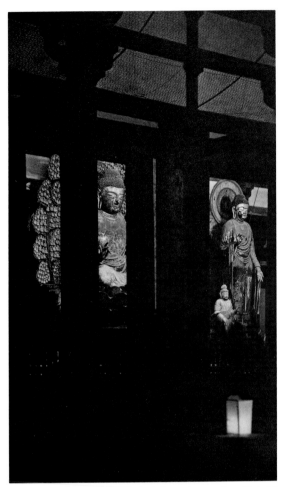

55. Interior of the *kondō* seen from the portico. Height of Birushana (left), 340 cm. (133.6 in.).

Made at the same time as the *kondō* itself, the imposing statues harmonize with it in scale and proportion and reflect the early stages in the transmission of the new religious system of Esoteric Buddhism, more complex and profound than the old. The central figure contains a thousand small Buddha images in his halo, for he is Birushana (Vairocana), personification of the essential, first principle of being, from which the entire cosmos and the rest of the vast Buddhist pantheon itself has emerged. (See color plate 12.)

56. Bodhisattva figure in wood. Tōshōdai-ji. Eighth century. H. 171.8 cm. (67.5 in.).

The combination of swelling volume with brooding, austere energy reflects new criteria of beauty in the arts which began to appear at the very end of the Nara period. The image was originally coated with thin plaster and painted, but the flaking away of the paint has revealed a beauty in the carving which surpasses that of color.

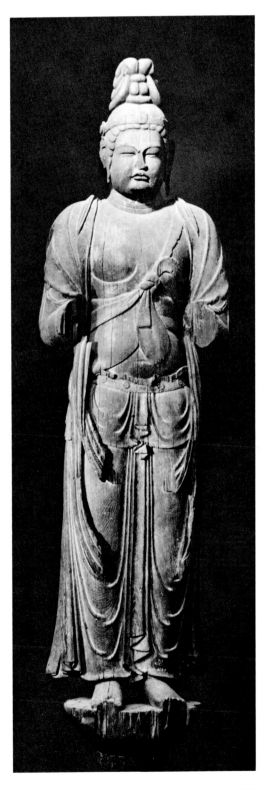

58. Portrait of the monk Ganjin (Chien-chen). Eighth century. H. 79.7 cm. (31.3 in.).
In his attempts to reach Japan, the Chinese monk Chien-chen endured hardships which cost his eyesight and brought him to the brink of death. The founder of Tōshōdai-ji, he was one of the most revered personalities in the history of Japanese Buddhism, and this portrait was probably made about the time of his death at the age of seventy-seven by an artist who must have known him well. Severely realistic in intention, the image nonetheless captures the intangible qualities of serenity and spiritual insight.

57. Lecture hall, Tōshōdai-ji. Eighth century. Dimensions of building plan, 33.8 × 13.52 m. (110.8 × 42.25 ft.).
Originally built as an assembly hall in the Imperial Palace compound in Nara, this building was moved to the temple and converted into the kōdō. Its air is one of extreme horizontality, in marked contrast to the tall, imposing kondō which stands before it. In the deep projection of its eaves and in the resolute manner with which it asserts its long and narrow proportions, one can savor the generous spirit of the Nara period.

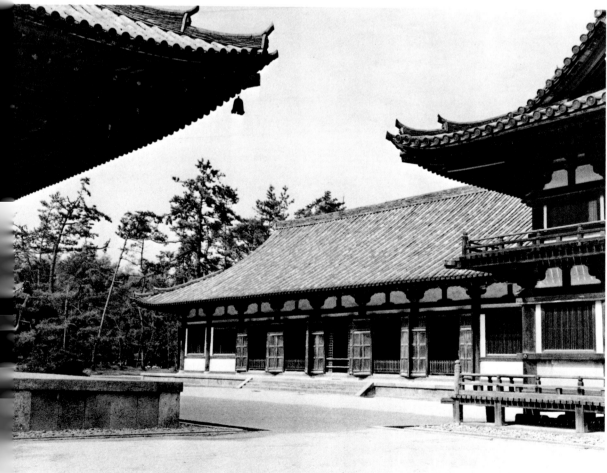

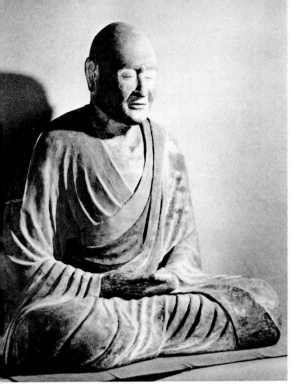

59. Founder's hall, Tōshōdai-ji.
Until recently, the portrait statue of Ganjin has been enshrined in the founder's hall situated on a small hillock behind the monks' dormitory. Extremely small and humble, the building served as an appropriate memorial to the saintly man who sought neither wealth nor honor. The image has now been transferred to a newly rebuilt hall, a hundred yards or so to the northeast.

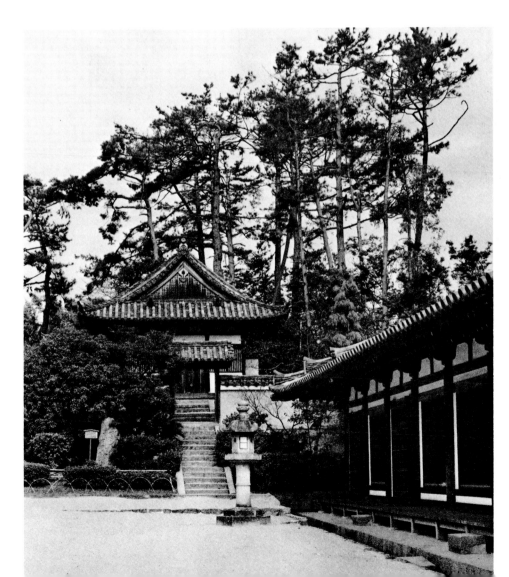

60. Overall view of Tōshōdai-ji.
In the middle of the upper left-hand section, partly
hidden by trees, is the pagoda of Yakushi-ji.

Plate 11. Kichijō-ten. Yakushi-ji. Eighth century.
(See also figure 53.)

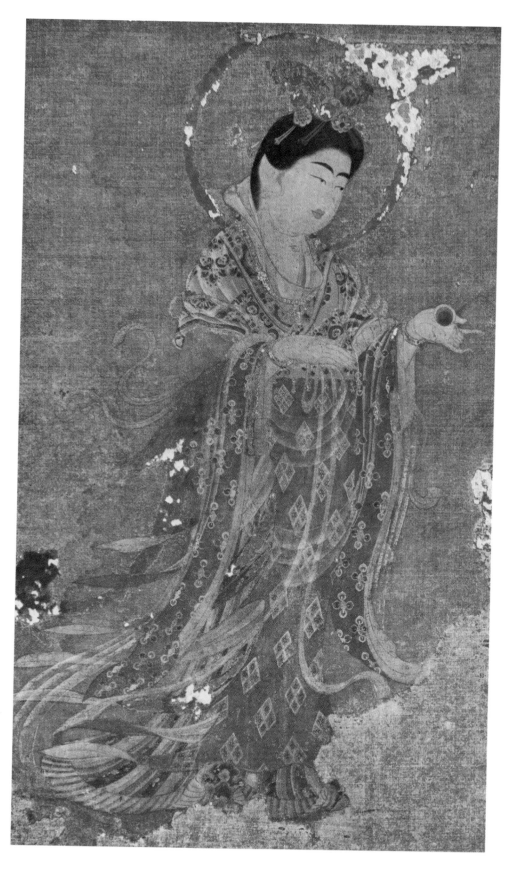

Plate 12. Interior of the Tōshōdai-ji *kondō* seen from
the portico. Eighth century. (See also figure 55.)

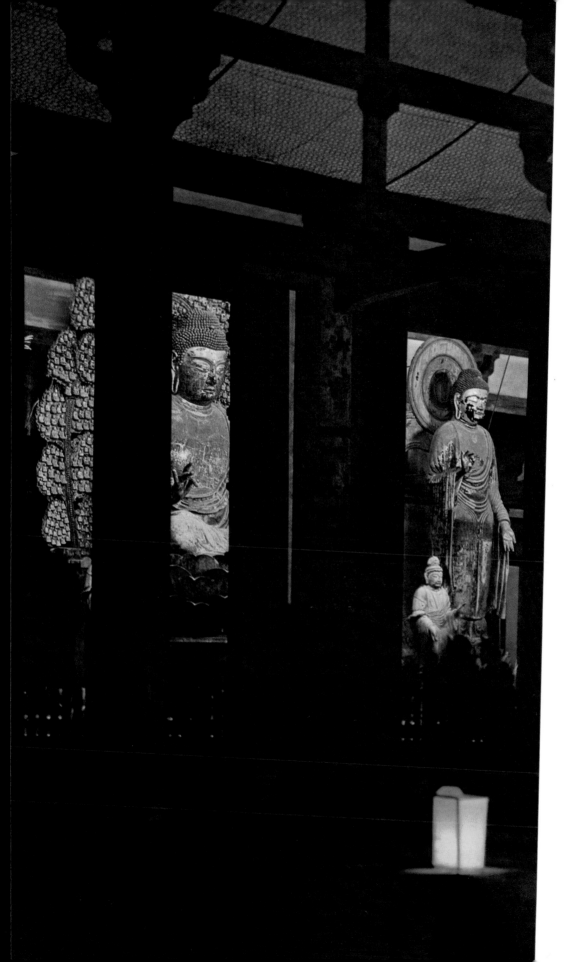

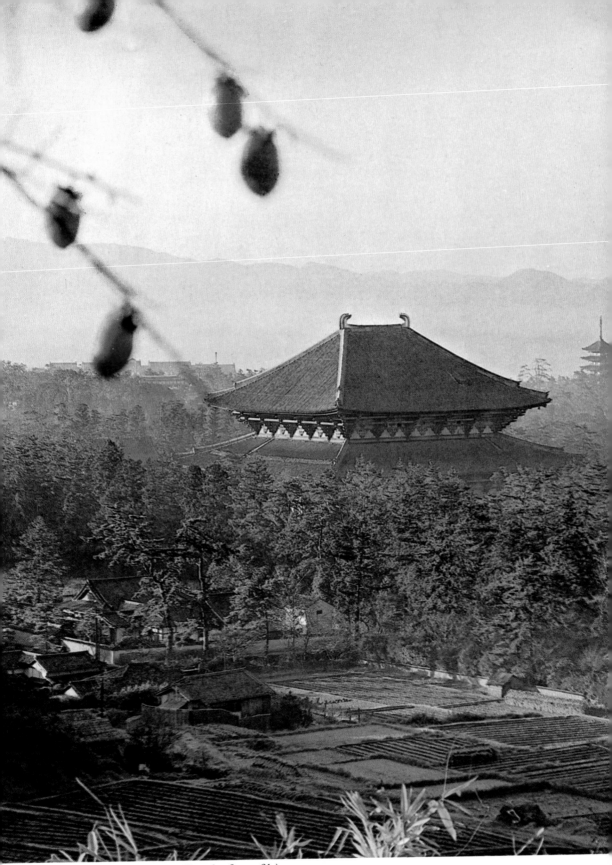

Plate 13. A view of Nara. (See also figure 61.)

4

THE CAPITAL CITY OF NARA

To Tōdai-ji

As one approaches Nara from afar, the great roof of the Daibutsu-den and its golden ridge ornament can be seen against the gentle slope of Mount Mikasa as though floating in a sea of verdant woods. To this day the Daibutsu-den, the main image hall of Tōdai-ji, remains the most fitting expression of the city and its history, for it was the monument which marked the achievement there of centralized governmental power in the eighth century.

The Emperor Shōmu had planned to base his rule on a union of both religious and political principles and, wherever there was a provincial government, to establish monasteries and nunneries as branches of Tōdai-ji. He vowed also to create as the main object of worship at Tōdai-ji a giant statue of Birushana (Vairocana) Buddha. In Buddhist theology, this deity was the source and origin of all things in the cosmos, even the other Buddhas and Bodhisattvas. As the central cult figure of the foremost official temple of the nation, this statue was the very nucleus of the emperor's project of centralizing both secular and religious power. The image rose to a height of over forty-eight feet; twelve years were spent in overcoming countless technical difficulties. The bronze casting had to be repeated eight times; the number of workers employed and the amount of material invested were immense. Without the ·strength of a centralized government, a project of this magnitude would have been quite impossible. Finally, on April 9, 752, a sumptuous ceremony of consecration was performed in the temple courtyard before the Daibutsu, a ceremony which also marked the completion of the centralization of state power, of which the giant statue was the most dramatic symbol. Standing to the right and left of the great bronze statue were two attendant Bodhisattvas made of dry lacquer, almost thirty-three feet high. In addition, at the four corners of the hall were placed dry clay statues of the Four Guardian (Deva) Kings, each nearly forty feet high. It required an additional thirty years to furnish the Daibutsu-den in full splendor and to complete the entire complex of attached buildings. In 1180, however, this was almost all destroyed by fire in the Gempei war which raged at the close of the Fujiwara period. Of the Daibutsu statue as it exists today, only parts of the lotus pedestal remain from the original, the upper sections having been reconstructed in 1691.

81

The hall itself was rebuilt about ten years later considerably smaller than before; even so it is still known as the largest wooden structure in the world.

Unchanged over the centuries, however, is the gilt bronze lantern in the center of the forecourt, its large size indeed appropriate to the scale of the Daibutsu-den. The octagonal light chamber is a splendid shape; its doors are ornamented with angelic musicians and lions in low relief; its roof is crowned with a sumptuous flaming jewel. The exquisite qualities of the lantern are characteristic of the art of the Nara period and reminiscent of the many lost splendors of the period at Tōdai-ji.

Just to the east of the Daibutsu-den is a hall which also preserves relics of the same period intact. Called the Hokke-dō or the Sangatsu-dō, both the building and its contents miraculously escaped destruction by fire. While it is not a large structure, its interior is crowded with statues representing primarily deities of Indian origin who serve as attendants and guardians in the Buddhist pantheon. The main cult image is of Fukūkensaku Kannon, over fourteen feet high. Arrayed with it are Bonten (Brahma), Taishaku-ten (Indra), the Four Guardian Kings (Shitennō), and the Two Guardian Kings (Ni-ō). All of these are made of dry lacquer; but, in addition, dry clay statues of four other deities were moved here from some other hall: Nikkō (Sūrya, the sun-god), Gakkō (Candra, the moon-god), Benzai-ten (Sarasvatī, the goddess of learning), and Kichijō-ten (Śrī Lakshmī, goddess of wealth and beauty). This concentration of large statues comprises an almost complete review of the expressive range of Nara period sculpture.

The largest of all, the six-armed statue of Kannon, is typical of the period, for it is masculine and sturdy and radiates in a serene way a sense of immense power. Moreover, it is embellished by an ornate necklace, halo, and canopy; its sparkling crown catches the eye even in the dim light of the darkened hall. The crown, two feet in diameter, is made of silver, ornamented with a filigree pattern of jeweled flowers, and hung with thousands of pearls, beads of quartz and agate, and other gems, showing to the full the degree to which sheer earthly wealth had entered the monasteries. In harmony with this, the other dry lacquer images project a sense of magnificence and power; in the dry clay figures, however, the sculptors seem to have searched for a deeper spiritual quality. Nikkō and Gakkō press their hands together in prayer; their faces impart an impression of piety. The spirit of this age sought above all sheer grandeur and magnificence, but it also strived to express the more modest spirit of devotion. At the rear door of the hall is a dry clay statue of Shūkongō-jin (Vajrapāni) enshrined as a secret image. A remarkable example of realism, it vividly expresses the wrath and anger of this militant deity. Because it has been kept carefully sealed, much of its original coloring has been preserved—an essential part of eighth-century sculpture.

Clay and dry lacquer statues such as these were commonly made in the Nara period. The techniques had been newly imported from T'ang China in the search for variety in artistic expression, and the prime reason for their popularity was the suitability of the soft materials to a realistic style. The artists of the Nara period, like those of T'ang China, tried to create lifelike qualities in terms of animation and vigor, sought to imbue Buddhist imagery with the appearances of ordinary mortals; they moved in the direction of realism in order to interpret religious experience in terms of the ordinary world.

In addition to the Shūkongō-jin, other outstanding examples of realism in the dry clay technique are the Four Guardian Kings, in the Kaidan-in, the hall for the ordination of monks at Tōdai-ji. Few people visit this hall, and the atmosphere of the ancient temple seems indeed to have survived along the quiet paths around it. The

Guardian Kings were probably brought from somewhere else; but unfortunately their original place of installation is unknown. Each of the four Kings was made life size, standing upon a small demon or evil spirit. Each figure was given its own distinctive pose, and especially noteworthy is the manner by which its energy was expressed. Violent action was avoided; rather the power was shown to be latent within a quiet pose. In striving for realism in order to communicate a feeling of vitality, the sculptors of the Nara period did not simply copy precisely the external appearances of an object. Instead, one feels that reality in itself has been created, so rich in aesthetic significance are statues like the Four Guardian Kings.

Before the destruction of so many Nara temples in the Gempei war, great numbers of realistic images must have been seen throughout the city. The works which survived, however, had a great effect upon the restoration work begun in the late twelfth and early thirteenth centuries, for the new carvings were done in a highly descriptive style which harmonized with that of the old. Revival of the taste for realism thus became one of the major characteristics of the sculpture of the later Kamakura period.

THE SHŌSŌ-IN TREASURE

An ancient warehouse called the Shōsō-in is located about 360 yards behind the Daibutsu-den of Tōdai-ji, and for this reason it escaped the fires which ravaged the temple. The repository contains primarily the rich personal effects of the Emperor Shōmu, founder of Tōdai-ji. His widow, the Empress Kōmyō, presented them to the Daibutsu for the sake of Shōmu's soul on June 21, 756, in a ceremony marking the forty-ninth day after his death. They have been kept under imperial seal and preserved intact to the present. Although possessions of the emperor comprise the bulk of the Treasure, it was further enriched by later donations; Tōdai-ji itself donated implements used in Buddhist rituals. The collection abounds thus in an extraordinary variety of things kept in safety for over twelve hundred years—writing materials, musical instruments, clothing and ornaments, weapons, Buddhist ceremonial implements, medicines, and written documents. From their perfect state of preservation, it is possible to see vividly the arts and crafts of the Nara period and also to understand something of the material content of contemporary Asian civilization.

Resting on forty pillars over eight feet tall, the storehouse was built high off the ground in order to keep out dampness. It was made chiefly in the so-called *azekura* system, in which the ends of the wedge-shape timbers cross each other and project outward at right angles. This gives such structural solidity that neither internal pillars nor walls were needed; the contents were well maintained by the way in which the logs would swell in humid weather—thus shutting out the moist air—and shrink in dry weather, allowing air to enter and ventilate the interior. The building is composed of what were originally two separate square log buildings which were joined together; thus the interior is partitioned off into three sections: the north, center, and south storerooms. Long and narrow and majestic in scale, Shōsō-in asserts an air of perfect composure.

The contents of the collection can be divided into two kinds of material: the prized personal belongings of the Emperor Shōmu, which were chiefly objects imported from the mainland, and the implements actually used in such Buddhist rituals as the consecration ceremony for the Daibutsu. The former were stored under imperial seal in the north and center storerooms, while the latter were placed in the south storeroom,

sealed off with rope tied by three officials of the temple. By now, however, the contents have become mixed together; consequently, for a number of objects it is difficult to determine whether they were made in Japan or imported from abroad. This is because the Nara period was a time of enthusiastic assimilation of continental culture, and the Japanese themselves had perfected continental designs and techniques. Until recently, pottery in the Shōsō-in bearing two- or three-color glazes had been thought to be of Chinese origin; but now, on the basis of certain details of technique, it is clear that they were made in Japan. In addition, there are many splendid brocades whose origins are difficult to distinguish, for Japanese crafts at that time had reached a high level.

When the Shōsō-in Treasure is seen as a whole, the aesthetic character of the crafts of East Asia in the eighth century is clearly apparent; for the taste of the court of T'ang China was the same as that of the court at Nara. As the T'ang empire greatly expanded, it assimilated the culture of the surrounding lands. Its crafts show this best of all, for they took in many exotic designs, materials, and techniques—softening and harmonizing them, creating an art of opulence with an appealing international flavor.

Strong influence was exerted by Iran and South Asia. From the former came the popular arabesquelike designs of grape vines, pearl borders, and winged horses, as well as the craft of marquetry (wood inlay). From South Asia came the use of ivory, tortoise shell, and mother-of-pearl in the thriving craft of shell inlay. Luxury goods and textiles have not been well preserved on the mainland, but because the Japanese of the time used them as a standard, the Shōsō-in Treasure is one of the main sources of information concerning the arts of the T'ang period. The craftsmen of Nara imported rare materials from abroad as best they could, but they were also obliged to work out substitute materials and techniques. There are examples in which artificial stones were used in the place of jewels, and colorful decoration was made of silver and gold leaf or made up of painted motifs. The crafts of the Nara period sought for brilliant color effects taken from exotic sources, but it must not be overlooked that a major characteristic was also the search for boldness and vitality. Within the decorative forms, one can feel a sense of power expanding from inside the structure; table legs show positive strength in the way they stand; in decorative patterns there is endless elasticity and fluidity of form. Just as the art of sculpture developed realistic techniques in its search for aesthetic vitality, so in the realm of the crafts, liveliness was a major goal. The Nara period was one which extolled the flood tide of expanding life, and the words of a poem well state the character of the period at the peak of its prosperity: "Like the fragrance of a blooming flower, the colorful capital of Nara reaches its prime."

KŌFUKU-JI

Even though it was a private temple, Kōfuku-ji ranked with the official state temple of Tōdai-ji as one of the main sanctuaries of the capital. It was supported by the wealthy Fujiwara clan, whose influence over the imperial court gave it immense power and prestige. Kōfuku-ji's founder was Nakatomi-no-Kamatari, the able statesman who led the family to political supremacy in the mid-seventh century, at the time of the Taika Reform; and the temple thereafter mirrored the rise and then the fall of the family's fortunes.

It was originally located at a Fujiwara residence at Yamashina, near Kyoto. Then it was moved close to the imperial palaces in the Asuka district, where it was called the

Umayazaka-dera. When the capital was transferred to Nara, Kōfuku-ji was moved again to its present site. In the Heian period, Tōdai-ji lost its protection as the official state temple, but Kōfuku-ji remained the family temple of the Fujiwaras, then at the height of their prosperity; on occasion the temple itself exerted direct influence on the throne. When the power of the Fujiwaras was finally broken, however, the temple suffered the ravages of frequent fires and most of its buildings were lost. The later restorations did not maintain the architectual grandeur of the temple; now all that remains are a few buildings of later periods, and the original splendor is lost beyond recall. The early Buddhist images are also few in number; works of later periods predominate, but among these, fortunately, are masterpieces of their day.

Kōfuku-ji employed many artisans on a hereditary basis, and its organized workshops served the entire capital. Receiving his training at Kōfuku-ji, for example, was the master sculptor Jōchō, the foremost Buddhist sculptor in Kyoto in the eleventh century. In the late twelfth and thirteenth, the masters who carried on the tradition of the atelier—Kōkei, Unkei, Kaikei, Tankei, and others—were active in the reconstruction not only of Kōfuku-ji but also of Tōdai-ji. It is true that the present appearance of the temple is not very striking; but its remaining statues bear eloquent proof of the fact that Kōfuku-ji, as both workshop and training center, left a mark of great distinction on the development of Buddhist art.

Representative works of the Nara period still remaining are the Hachi Bushū (eight demonic guardians of the faith) and six statues from a set of the Ten Great Disciples of the Buddha—all done in dry lacquer. It is thought that the Empress Kōmyō ordered them made in A.D. 745 for the sake of her mother, the Lady Tachibana, and that they were placed in the west kondō around the main cult image of Śākyamuni. Each is made of dry lacquer and is hollow in the middle. Each reveals the fresh, eager acceptance of realism, but in the flawless, youthful face of Ashura (Asura) there is a trace of the ancient idealistic tradition which extolled perfect beauty. A youthfulness resembling this can also be seen in the statue of Subodai (Subhūti) among the disciples. Within these two groups of statues there are many variations of pose and facial expression, for the sculptor took great pains to show differences of age, personality, or symbolic spirit.

From the time of the Kamakura-period restoration have been preserved a giant statue of the Fukūkensaku Kannon (Amoghapāśa) and portraits of the six patriarchs of the Hossō sect which were placed in a circle around it. These were made by Kōkei and his followers and installed in the south circular hall. In the north circular hall were statues of Miroku (Maitreya) Bodhisattva and two ancient Indian theologians Seshin (Vasubandhu) and Muchaku (Asanga), which were carved by Kōkei's son Unkei and his assistants. Unkei's style was characterized by imaginative realism, which is especially evident in the portraitlike features of the Indian sages. At Kōfuku-ji are many other works produced by the Unkei school which are widely admired for the variety and richness of realistic treatment. Paired together with a statue of the Bodhisattva Monju (Mañjuśrī) is that of the mythical Indian sage Yuima (Vimalakīrti), who was shown with meticulous regard for the effects of age and illness. The sculptor was Jōkei, who also made the two dynamic Guardian Kings (Ni-ō) in which he captured the tension of muscles and bones of men in violent movement. Jōkei's younger brother Kōben made statues of two demon lamp bearers, Tentōki and Ryūtōki, which are masterpieces of subtle humor. It should not be forgotten also that the master sculptor Kaikei, pupil of Kōkei and collaborator of Unkei, also worked in the Kōfuku-ji atelier. None of his

works remain in the temple, however, but are to be found in Tōdai-ji, where Kaikei had been a favorite artist of Chōgen Shōnin, the monk who supervised the reconstruction work at the temple.

As for the architecture of Kōfuku-ji, the oldest extant buildings are the north circular hall and the three-story pagoda, but these are little more than reminders that this compound once held more than a hundred temple halls and dwellings. However, even in the temple's rather forlorn state today, the south circular hall is counted as one of the thirty-three places in western Japan sacred to Kannon Bodhisattva. Supported by the faith of the common people, it attracts crowds of pilgrims even today.

THE KASUGA SHRINE

This shrine is dedicated to the protective deities of Kōfuku-ji, a group of militant Shinto gods whose cult had been transferred from eastern Japan. In this same way, the native war god Hachiman had been moved from the Tamukeyama Shrine in Kyūshū to Nara in order to serve as the tutelary deity of Tōdai-ji.

The integration of Shinto and Buddhist cults was not unusual in the Nara period. It promoted the rapid growth of the imported faith by bringing it under the spiritual protection of the indigenous gods of the land, and the fusion of creeds was mutually beneficial. The handsome style of architecture of the Kasuga Shrine was probably adapted from Nara period Buddhist buildings. Making skillful use of the slope at the foot of its mountain, the shrine is built in a colorful display of vermilion and green; indeed, it seems to reflect the Fujiwara family's fondness for audacity and boldness. Because the shrine received the support of this family for many generations, its impressive rituals preserve the flavor of aristocratic life at the imperial court. The performance of the *bugaku* dance has been handed down here in an unbroken tradition; and even today the elegant form of dance called the *yamato-mai* is offered in worship of the deities of the region. An ancient custom of donating votive lanterns prevailed originally among the Fujiwara clan; later it became a popular form of piety, and for this reason the shrine precincts and approach paths are crowded with thousands of lanterns in stone, metal, and wood.

61. A view of Nara.
Twelve hundred years ago, the new capital extended out into the distant fields. Throngs of monks, courtiers, warriors, and craftsmen gathered from all parts of the country and mingled in the thriving life of the capital. Today, only a few of the temple halls and pagodas remain, but here and there—in a corner of a temple compound or along the quiet back streets of town—the flavor of ancient days still lingers on. (See color plate 13.)

62. Bronze lantern before the Daibutsu-den of Tōdai-ji. Eighth century. H. 4.62 m. (15.33 ft.).
Those coming to pay homage to the Daibutsu must pass beneath the lantern standing in the center of the courtyard. Dedicated to the Daibutsu at the time of the statue's completion, it is one of the finest of all relics of the golden age of Nara.

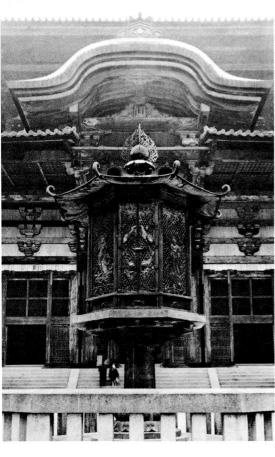

63. Bronze lantern, detail.

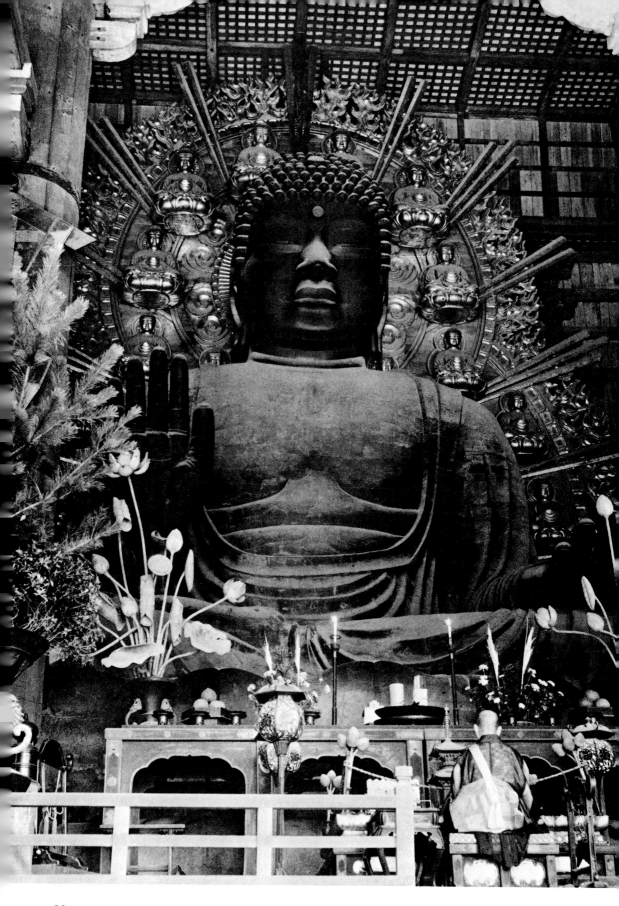

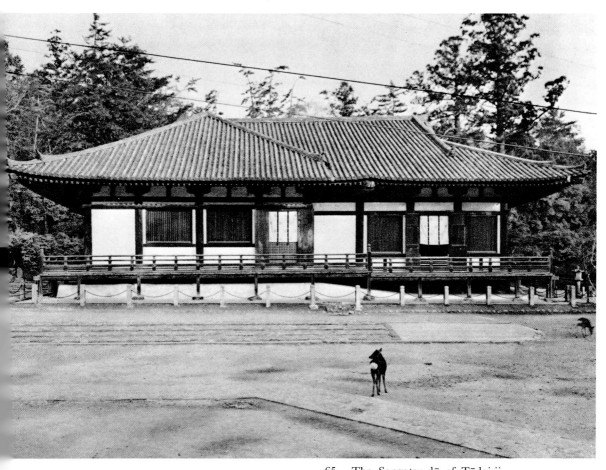

65. The Sangatsu-dō of Tōdai-ji.
While relatively small in scale, this building is an invaluable relic of early architectural forms, for it miraculously survived the fires which destroyed almost all of Tōdai-ji. It is best known for the statuary which fills the interior, but its exterior form, with simple and classic serenity, speaks eloquently of a great building tradition.

64. Interior of the Daibutsu-den, Tōdai-ji.
In its original splendor, the bronze Daibutsu was a symbol of the power of both the immense Buddhist pantheon and the well-governed empire of Japan. The ancient statue has been ruinously damaged, but even as it appears now in its restored form, one can imagine the sounds and colorful spectacle of the Buddhist services which unfolded before it.

THE CAPITAL CITY OF NARA 89

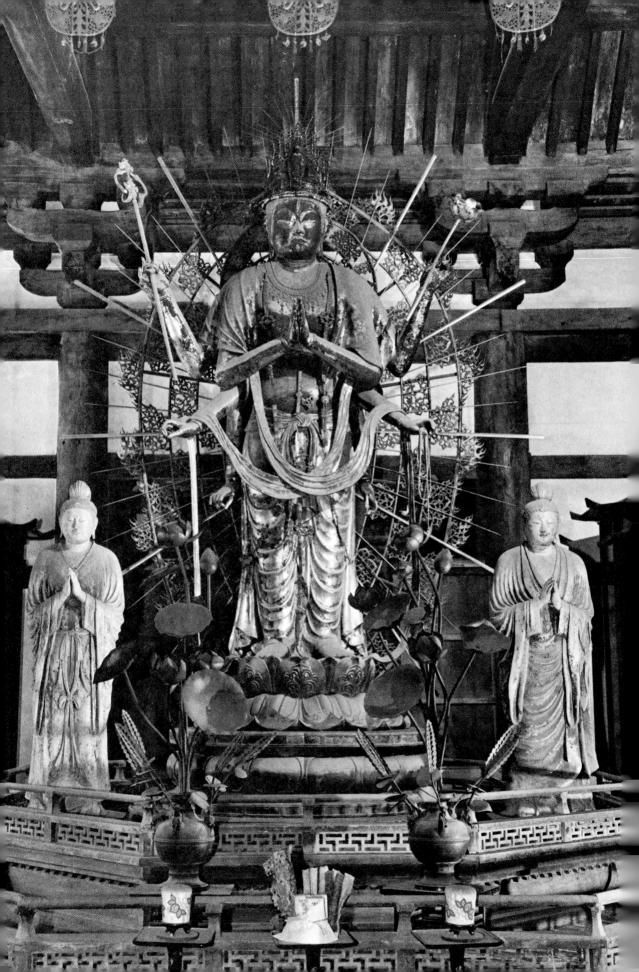

66. Interior of the Sangatsu-dō. Eighth century. Height of Kannon, 364 cm. (153 in.).
Upon entering the darkened hall, one is overwhelmed by more than ten large statues crowded together, in contrast to what one might imagine upon seeing the classically simple exterior. In the center stands the main object of devotion, the dry lacquer image of Fukūken-saku Kannon wearing a glittering crown. In attendance on either side are statues of Gakkō and Nikkō made of unbaked clay.

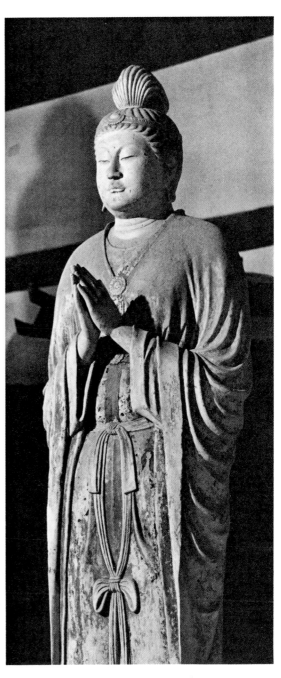

67. Shūkongō-jin. Sangatsu-dō. Eighth century. H. 173.9 cm. (68.3 in.).
Because it has been kept closed from view as a secret image, this dry clay statue retains much of its original brilliant color. It projects the warm vitality of the Nara period as it expresses the rage of the thunderbolt bearer, one of the many militant guardians of the Buddhist faith. (See color plate 14.)

68. Gakkō. Sangatsu-dō. Eighth century. H. 206.6 cm. (81.1 in.).
Its hands pressed together in prayer, this reverent form projects a mood of composure and dignity far removed from the distractions of the world. The flaking off of the color from the surface of the clay has given it a puri-fied quality, enhancing in this accidental way the sculptor's efforts to depict a spiritual state with a realistic style.

70. Kongō Rikishi. Sangatsu-dō. H. 331.8 cm. (130.7 in.).
With his body clad in leather armor, this figure does not have the bulging muscles of the usual, half-nude Rikishi statues. The hair bristling about his howling face shows the sculptor's skill in a rhythmical, modulated realism, illusionistic enough to suggest that the deity actually exists.

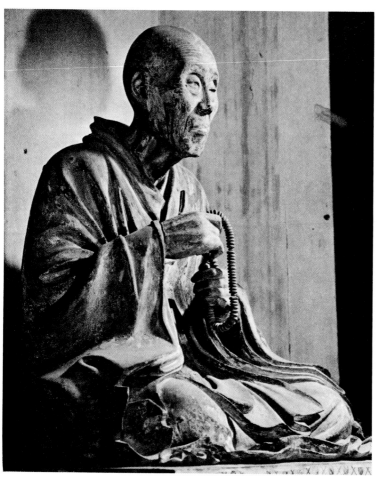

69. The monk Chōgen Shōnin. Tōdai-ji. Early thirteenth century. H. 82 cm. (32.3 in.).
The monk Chōgen devoted the last years of his life to soliciting funds and materials for the rebuilding of Tōdai-ji after it was burned in the Gempei war. This remarkable portrait, probably carved soon after his death at the age of eighty-six in 1206, depicts him with a type of mordant realism suitable to an aged monk who would have entertained no vain concern for his personal appearance. Realism in the Kamakura period was in many ways a revival of the realistic tendencies of the Nara period; but none of the works of the older era has quite the expressive power of this, whose sunken eye sockets, wizened neck and cheeks, and slumped posture make it one of the most notable essays of its kind in the entire history of art.

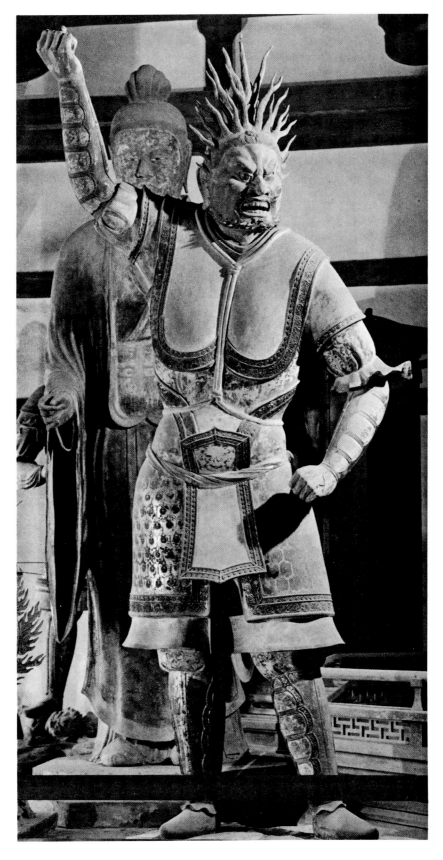

71. Jikoku-ten. Kaidan-in. Eighth century. H. 160.4 cm. (63.1 in.).
One of the dry clay statues of the Four Guardian Kings atop the ordination platform. Handled in a skillfully realistic manner, the figure has the frightful power which the deity should possess, but it is not shown in an obvious way. The taste of the artist, restrained and imaginative, must have produced this significant change in expression. (See color plate 15.)

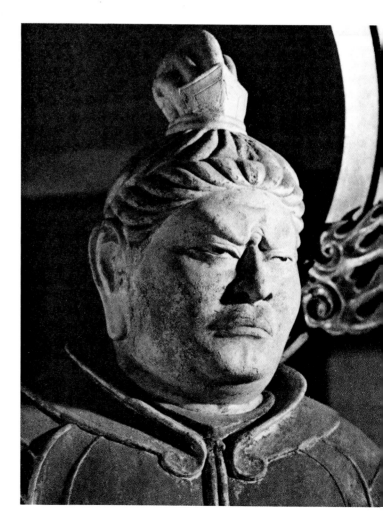

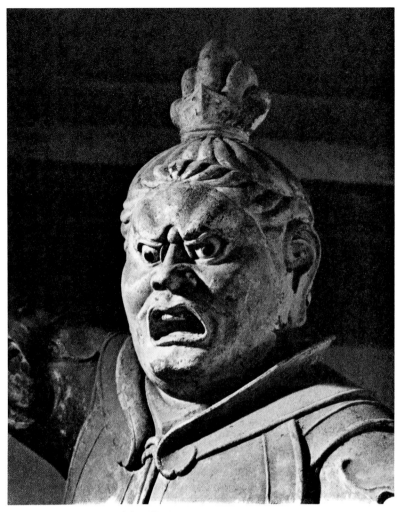

72. Zōchō-ten. Kaidan-in. Eighth century. H. 165.4 cm. (65 in.).
In each of the Four Guardian Kings, energy and anger are expressed by different body poses and facial features. With the eyes bulging and the mouth opened wide, this head can be said to express the active spirit of rage. The sparkle of the black obsidian inserted in the pupils of the eyes adds to the feeling of realism and vitality.

73. Kōmoku-ten. Kaidan-in. Eighth century. H. 162.7 cm. (63.9 in.).
With his brows knitted, eyes narrowed, and mouth closed, this image seems to be watching a distant enemy. Restrained in facial expression and bodily gesture, it suggests the amassing of energy and the fearfulness of its release. Its power is in a potential state, and the realism is understated.

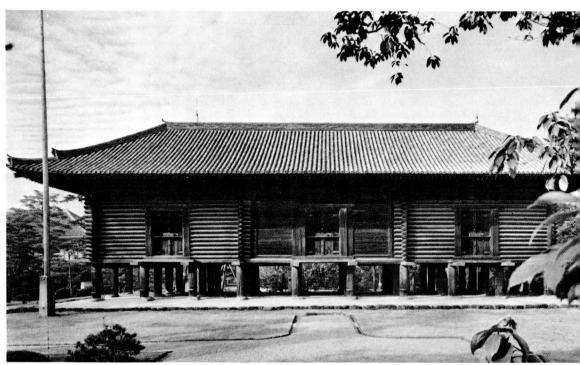

74. Shōsō-in. Eighth century. Facade, 33.22 m. (109 ft.); side, 9.45 m. (31 ft.); height of ridgepole, 13.94 m. (45.7 ft.).
This ancient warehouse is a treasury of precious objects which were offered to Tōdai-ji during the eighth century in honor of the Daibutsu. Constructed of giant timbers, it is divided into three large storerooms which, miraculously, have preserved their fragile contents intact for over twelve hundred years.

75. Shōsō-in. Detail of corner construction.
A highly functional form of construction called *azekura* was used in Japan for building warehouses. Thick, wedge-shaped logs were linked horizontally and layed one atop the other above the elevated floor, the structure thus having great strength and needing no internal walls. The powerful masculinity of these giant timbers of the Shōsō-in shares in the assertive spirit which permeated so much of the art of the Nara period.

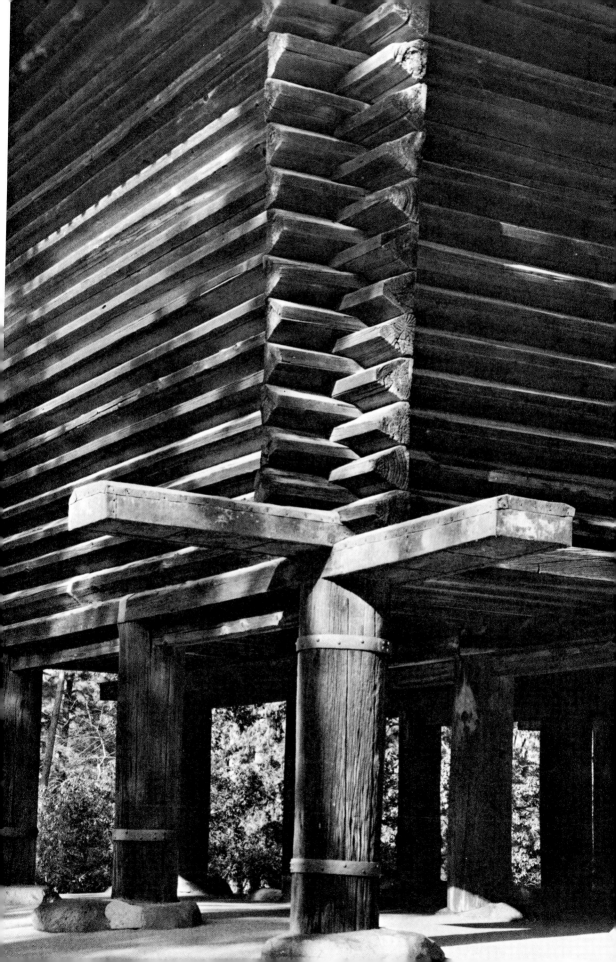

76. Five-string *biwa*. Shōsō-in. Eighth century. Overall length, 106.5 cm. (41.8 in.).
This exquisitely proportioned musical instrument is thought to have been brought from T'ang China. Inlaid like a mosaic with mother-of-pearl, tortoise shell, and amber, its flawless craftsmanship is worthy of an instrument used in the Imperial Palace. Perfectly preserved, this lute is a precious relic of the taste of the T'ang and Nara courts. (See color plate 16.)

77. *Genkan*. Shōsō-in. Eighth century. Overall length, 100.7 cm. (39.5 in.).
On the underside of the body are two charming parakeets holding strings of pearls in their beaks and seeming to revolve in a circular path. Inlaid into rose sandalwood, the iridescent mother-of-pearl was cut into different shapes and its surface delicately engraved; color was applied beneath the amber in order to enhance its translucence. The darkest areas in the flower and jewel patterns are inlaid tortoise shell.

78. Lacquered ewer. Shōsō-in. Eighth century. H. 41.3 cm. (16.2 in.).

Resembling at the top the head and neck of a bird, vessels in this shape were made in imitation of Iranian ware and greatly appealed to the love of the exotic among the T'ang Chinese. The decoration on the side is like that of a fine textile, with delicate cut gold- and silver-leaf inlaid into the ground of black lacquer, depicting flowers in bloom, rare birds, and running animals. Luxury objects in the Shōsō-in display the almost unbelievable standard of skill and sensitivity attained by the craftsmen of East Asia.

79. Mirror inlaid with mother-of-pearl and amber. Shōsō-in. Eighth century. D. 32.7 cm. (12.8 in.).

Mirrors in ancient China were considered as more than functional objects; they had overtones of magic and were ornamented with the greatest care and respect. In the T'ang period, new and different materials were used for their decoration, and this colorful object reflects the sheer ebullience and prosperity of the times.

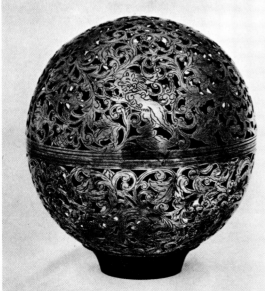

80. Silver incense burner. Shōsō-in. Eighth century. Diameter of the burner, 24.1 cm. (9.5 in.).

The court at Nara, assimilating Chinese culture with all its zeal, became literally intoxicated with expensive, exotic incense. Aromatic woods and many implements for burning them are found in the Shōsō-in Treasure. This globular censer of pierced silver, for example, was used to perfume clothing and has an elaborate safety mechanism inside to keep the fire-plate horizontal.

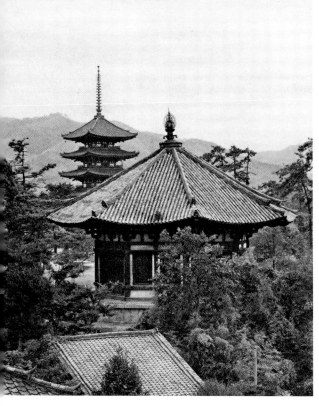

81. North Circular Hall (Hokuen-dō). Kōfuku-ji. Thirteenth century.

Builders of the Nara period took particular interest in the *endō* ("circular hall"), structures which were in fact octagonal-shaped and of great visual richness. The original Hokuen-dō at Kōfuku-ji was burned to the ground, but successive reconstructions were relatively faithful to the Nara tradition. The buildings of this temple, once among the richest and most elaborate in Japan, retain little of their former splendor, but something of the flavor of the ancient capital still lingers about this hall.

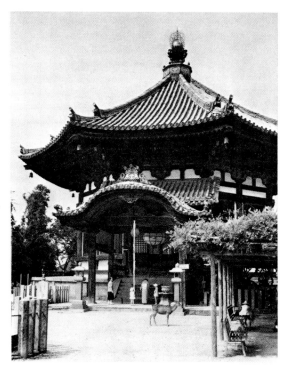

82. South Circular Hall (Nan'en-dō). Kōfuku-ji. Eighteenth century.

Dedicated to the Bodhisattva Kannon, the Nan'en-dō still has great popular religious appeal and is often crowded with devotees. Although built on ancient foundations, the building itself is of relatively recent vintage and is thus typical of Kōfuku-ji's current, rather forlorn condition. The canopy projecting from the front is an addition made to shelter large numbers of worshipers, reflecting thus the popularization in later centuries of a faith which was once aloof and remote from the masses.

83. Ashura. Kōfuku-ji. Eighth century. H. 153 cm. (60.1 in.).

Three faces and six arms show the supernatural power of this symbolic demon who has come under the authority of the Buddhist faith and serves as one of it guardians. The grotesqueness of its form does not seem unnatural, however, because it is counteracted by a spirit of humane realism present in the skillful use of the dry lacquer technique. One forgets that, iconographically, this is a wrathful and fierce deity, for its youthful faces and slender body have great personal charm.

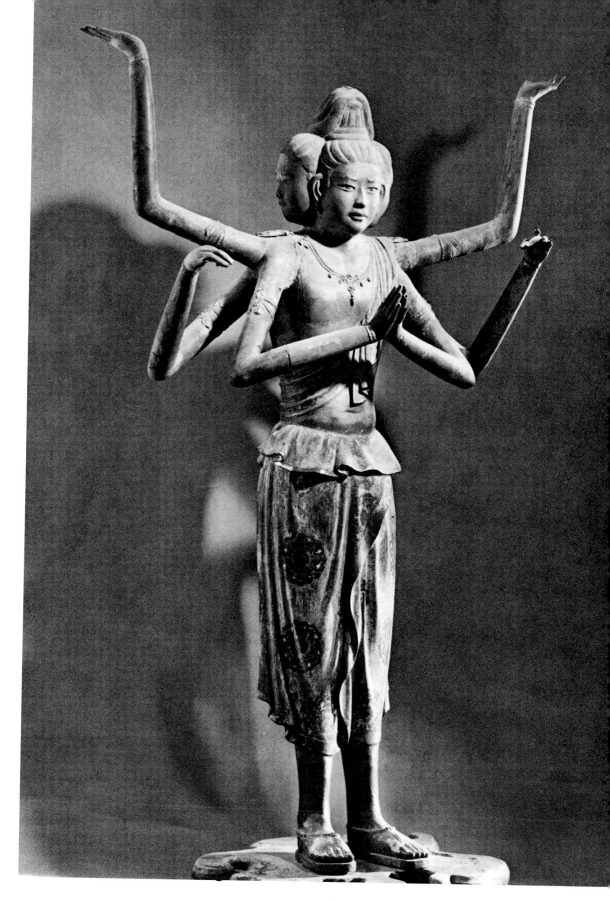

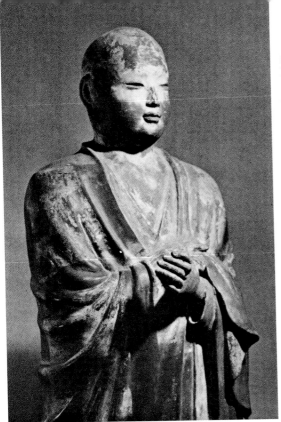

84. Subodai (Subhūti). Kōfuku-ji. Eighth century. H. 147 cm. (57.8 in.).
This statue is from a set of ten depicting the legendary disciples of the Buddha, and the expression of his face is almost that of childlike gentleness and ready wit. Modeled in dry lacquer, this and the remaining statues of the disciples at Kōfuku-ji are imbued with individual qualities of character and age, reflecting the great fascination which realism held for the artists of this century.

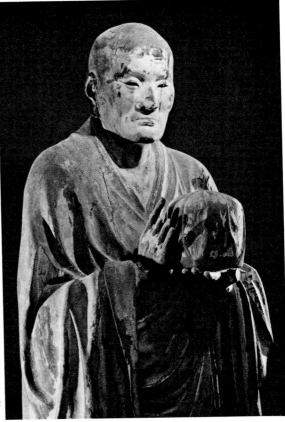

85. Imaginary portrait of Muchaku (Asanga). Kō-fuku-ji. Thirteenth century. Height of portrait, 193 cm. (75.9 in.).
When Kōfuku-ji was reconstructed following the burning and looting of the late twelfth century, the temple's workshops developed a new sculptural style which harmonized with the realism of the ancient statues still to be seen there and yet expressed the vitality of the new era. This portrait of the Indian theologian Asanga is far more monumental in scale and assertive in spirit than the statue of Subodai (Subhūti) above, nearly five hundred years older, but a spirit of descriptive realism nonetheless links them together.

86. Kongō Rikishi. Kōfuku-ji. Thirteenth century. H. 161.5 cm. (63.5 in.).

The realism and love of dynamic action in the arts of the Kamakura period are nowhere shown more clearly than in this one of a pair of wrath-filled guardians of a temple gateway. The half-nude body is an essay in the keenly observed effects of muscles stretched and twisted over the underlying skeletal structure, of the veins of the head and neck distended in anger, and of the torsions of a body animated by fierce energy.

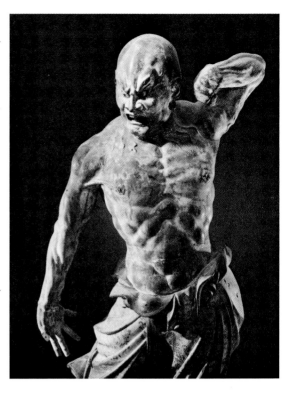

87. Imaginary portrait of Seshin (Vasubandhu). Kōfuku-ji. Thirteenth century. Height of portrait, 190 cm. (74.7 in.).

Made as a companion to the portrait of Asanga, there are marked differences in the bony structure of the heads, the facial features, hand gestures, and even the postures of the men—showing the acute powers of observation which underlay this style. The eyes, also, are inlaid with crystal, and the drapery hangs from the bodies with a sense of weight and gravity. The figures both have a bulk and massiveness which mold the air around them and enhance the feeling of a living presence.

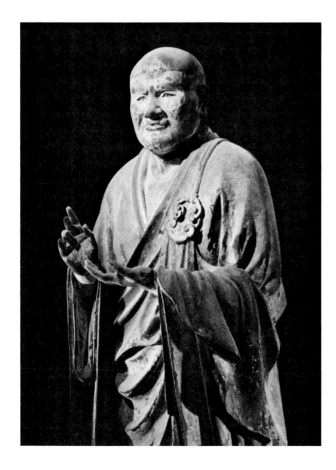

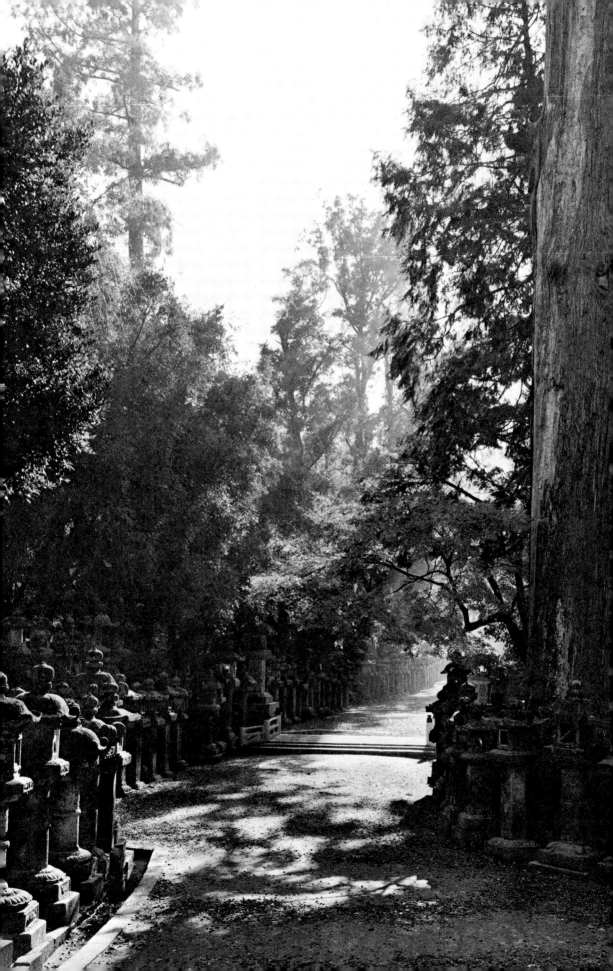

88. Approach path to the Kasuga Shrine.
Row upon row of stone lanterns crowd the sides of the
path as it winds through the forest which surrounds the
shrine. In ancient times, it was the custom to donate
metal lanterns to be suspended along the corridors of
the shrine itself, but with the passing of time, stone ones
have been erected along the pathways as well. Pious
donations by persons of all classes throughout the
land, they have been given in such quantities that they
take on the beauty of sculptural groups.

89. Sacred dance at the Kasuga Shrine.
The *yamato-mai* is an ancient folk dance believed to in-
voke the spirit of the land of the Yamato district. It is
performed here in the open air, in a courtyard of spot-
less white gravel, the bright cinnabar and green colors
of the shrine buildings serving as a background. Pre-
served by the shrine over the centuries, this austere,
solemn dance is neither a restoration from the past nor
a meaningless relic, but continues on as a quietly
modest, living thing. (See color plate 17.)

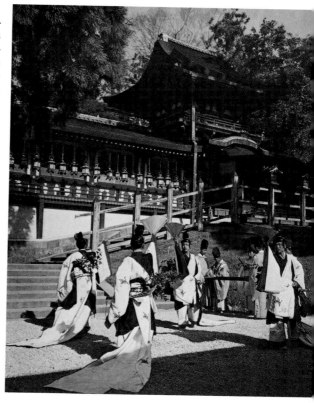

90. Basara, one of the Twelve Divine Generals of Shin-Yakushi-ji. Eighth century. H. 166.1 cm. (65.3 in.).

This face is one of the most expressive of the group. The cold clay has been brought to life and seems to pulsate with the hot blood of anger.

91. Main hall, Shin-Yakushi-ji. Eighth century.
Located on a quiet hillside overlooking the southeast side of town, this *hondō* has retained the classical simplicity of a building of the Nara period. In the low pitch of its roof and modest scale, it has a reticence and lucidity of form which are sometimes overlooked in our awareness of the sumptuousness and ornamentalism of the age.

92. Interior of Shin-Yakushi-ji.
The large wooden statue of Yakushi Nyorai is seated in the center of the circular dais which is made simply of earth. The Twelve Divine Generals who encircle and protect him were modeled of clay, unbaked. Imbued with the realism of the age, each figure has his own distinct pose and gesture.

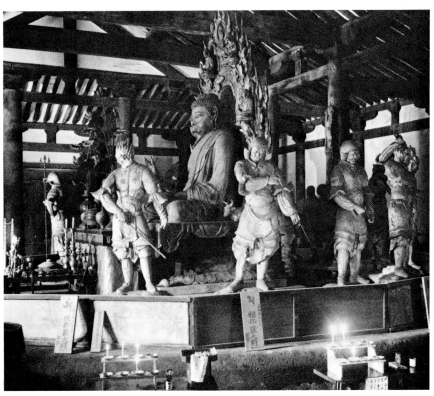

所以求出園林去耳
不樂在宮行夫婦禮
而自念言太子當是
王聞此語心生歡喜
樂欲輙出園林遊戲
住白王言在宮日久
欲出遊觀即遣伎女
流泉清涼太子忽便
歌詠園林華菓茂盛
介時太子聞諸伎女
男

93. Detail of court ladies in a garden from an illustrated sutra. Jōbon Rendai-ji, Kyoto. Eighth century. H. 26.4 cm. (10.3 in.), including text.

This detail is from a handscroll illustrating the biography of Śākyamuni, founder of the Buddhist faith; and even though the events take place in India, the court ladies and garden pavilion are purely Chinese in manner. The painting was done in Nara, but the style itself is very much that of the early T'ang period in China, the colors and composition having been simplified for the sake of the clarity of the subject matter. The legendary stories combined the qualities of a holy myth with those of a fairy tale and brought a human touch to the Buddhist creed, whose doctrines must have seemed strange and austere. Combining the illustrations with the text below, these works of early Japanese Buddhist art filled a most important role. (See color plate 18.)

Plate 14. Shūkongō-jin. Sangatsu-dō, Tōdai-ji. Eighth century. (See also figure 67.)

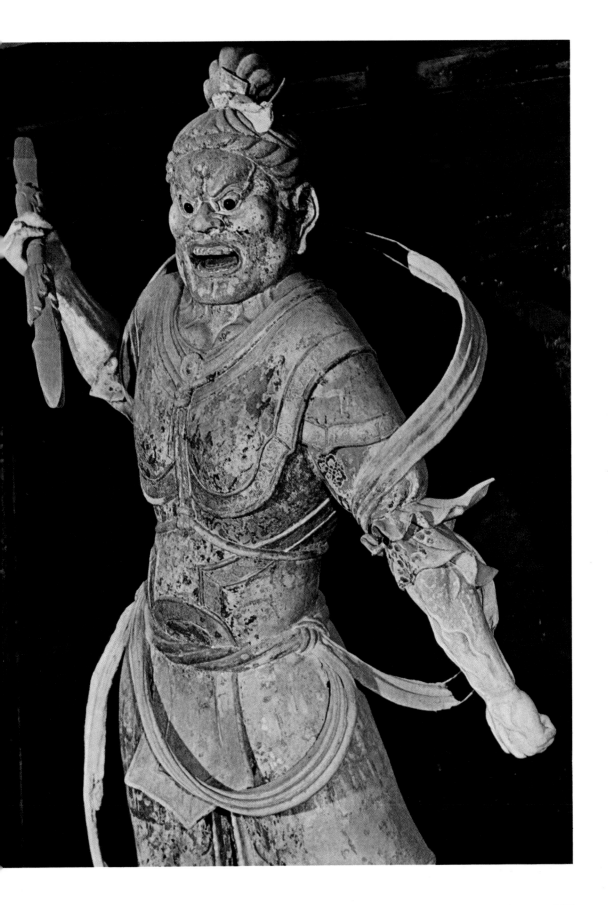

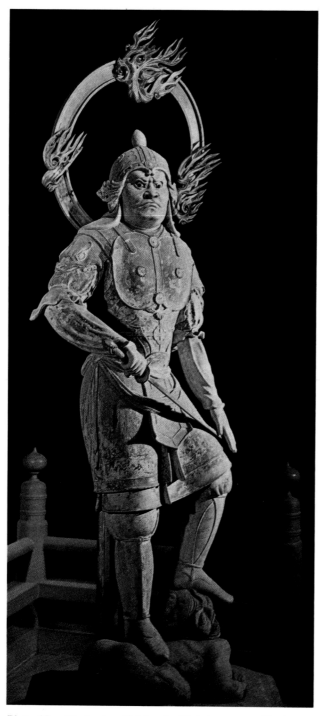

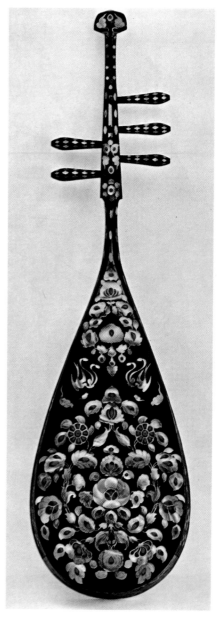

Plate 15. Jikoku-ten. Kaidan-in. Eighth century. (See also figure 71.)

Plate 16. Five-string *biwa*. Shōsō-in. Eighth century. (See also figure 76.)

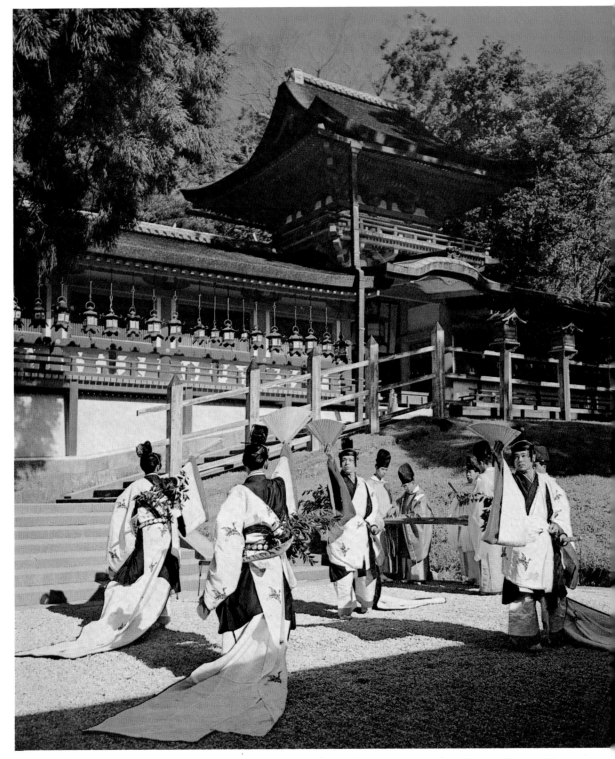

Plate 17. Sacred dance at the Kasuga Shrine. (See also figure 89.)

男

尒時太子聞諸伎女
歌詠園林華菓茂盛
流泉清涼太子忽便
欲出遊觀即遣伎女
往白王言在宮日久
樂欲輙出園林遊戲
王聞此語心生歡喜
而自念言太子當是
不樂在宮行夫婦礼
所以求出園林去耳

Plate 18. Detail of court ladies in a garden from an illustrated sutra. Jōbon Rendai-ji. Eighth century. (See also figure 93.)

5

THE SECLUDED MOUNTAIN TEMPLES

In the latter half of the eighth century, ominous shadows fell over the capital at Nara, then at the height of its brilliant Buddhist culture. The lavish support of the faith had promoted a certain arrogance in members of the clergy who attained great influence over the throne. The intrusion of Buddhist monks into the structure of national political power alarmed many courtiers and strengthened the desire to move the seat of government away from the Nara temples. In A.D. 794, the capital was relocated some twenty-five miles to the northwest in Kyoto, then called the Heian-kyō, but unlike the previous transfer of the government from the Asuka district, the great Buddhist temples did not accompany the court. New sanctuaries were founded in the Heian-kyō proper, but the monasteries which were to be most representative of the aesthetic and religious spirit of the new era were constructed high in the mountains, often in remote sites of great scenic grandeur.

A major cause of the corruption of Nara Buddhism was its pursuit of sheer physical splendor in such temples as Tōdai-ji and Kōfuku-ji. Theologically this was justified, but the dangers inherent in the situation were revealed by the relationship between the handsome and ambitious monk named Dōkyō and the Empress Shōtoku, daughter of Shōmu and Kōmyō, who rivaled her imperial parents in intense piety and gifts to the temples. Through years of court intrigue, she designated Dōkyō as a minister of the government and then as chancellor, giving him vast authority in secular matters. Finally she bestowed on him a title which had been reserved only for members of the imperial family, Hō-ō or "Ruler in the Law," and openly schemed to abdicate the throne in his favor. She was resisted in this by the courtier Wake-no-Kiyomaro, who was tortured for his rashness and would have paid with his life had he not been protected by the Fujiwaras. In the monasteries were monks who also opposed this corruption of the faith and who attempted to escape from the atmosphere of the capital by founding sanctuaries in the remote mountains. One of the earliest was the establishment of the family temple of Wake-no-Kiyomaro on Mount Takao west of Kyoto, where it was renamed Jingo-ji and destined to become one of the leading centers of theology and art of medieval Japan. The building of temples in the mountains was also prompted by another factor: the sudden rise of Esoteric Buddhism as the dominant creed of the new era.

113

Esoteric Buddhism, called Mikkyō in Japan, was part of a widespread religious movement which became very powerful in India in the sixth and seventh centuries A.D. and was brought by missionaries to China, where it quickly established itself. Called Tantrism in India, this movement actually embraced both the Buddhist and the Hindu creeds. It stressed the use of magical charms, incantations, ritual gestures, and special meditation in order to bring about states of religious exaltation. Buddhist Tantrism was considered an esoteric doctrine in the sense that its inner mysteries could be revealed only by a wise spiritual instructor to a small circle of initiates. This system organized the worship of a vast number of deities, some of them the traditional Bodhisattvas like Mañjuśrī or Avalokiteśvara who were symbols of spiritual powers—wisdom or compassion; others of them were newly devised to express the power or the mystery of the faith. This complex pantheon was conceived of as an emanation of the prime, creative principle of the universe, the Buddha Mahāvairocana; and a common feature of Tantric Buddhism came to be the mandala, a diagram in which the relationships between deities were outlined schematically, the center of the schema being reserved usually for the one of highest sacral value. In China the growth of Esoteric Buddhism was severely hampered by the anti-Buddhist persecutions of A.D. 845; in Japan its importation corresponded precisely with the need to reform the faith after the unhappy developments in Nara, and as a result its impact upon the spiritual atmosphere of Japan and her arts became extremely strong. Under the influence of Hinduism, Mikkyō images were often given an uncanny, wild aspect with multiple arms and heads and ferocious expressions. Such tendencies had already appeared at the end of the Nara period, as in the many-armed Fukūkensaku Kannon (Amoghapāśa) at the Sangatsu-dō of Tōdai-ji; but these were forerunners of what was to come and not yet part of the organized theological system.

The sudden rise of the system in Japan was in large measure due to the efforts of two gifted monks, Kūkai (later given the name of Kōbō Daishi) and Saichō (Dengyō Daishi), who had returned from prolonged study in T'ang China, deeply learned in Esoteric doctrines. Saichō opened a seminary for the training of monks atop Mount Hiei, rising some 2,600 feet above Kyoto; Kūkai established one in the fastnesses of Mount Kōya in a remote section of Kii province. Both men had sought natural settings with an atmosphere of grandeur and mystery removed from worldly distractions; but the Buddhism of the time still retained the coloration of a national creed essential for the well-being of the state, and it maintained its connections with both the imperial court and the aristocracy. The court hastened to support the new sects in order, perhaps, to have them oppose the old Buddhist institutions of Nara; and it might be said that the first steps in the degeneration of Esoteric Buddhism into a religion for the aristocracy took place during this early period.

The sudden rise of the Mikkyō sects in Japan produced great changes in the forms of traditional Buddhist art. For example, the strict symmetry in the layout of temple buildings was broken as the new monasteries were built in mountain settings in which there was little flat land. Also, the harmony of the buildings with giant trees surrounding them evoked a new sense of architectural beauty. Innovations appeared in the temple roofs, heretofore made of heavy, gray, rounded tiles in the Sino-Korean manner. In order to resist the extreme cold of the winters high in the mountains, roofs were made of cypress bark and shingles—a distinctly Japanese building technique paralleled by transformations taking place in the faith itself in Japan. Darkness and gloom prevailed within the ceremonial halls, a suitable atmosphere for mystic rites; moreover, the in-

teriors were divided into two sanctums, an outer one for laymen, and an inner reserved for officiating monks only. Certain images were locked away in darkened tabernacles, to be shown only on rare occasions. Mystery and austerity had replaced the buoyant, ornate atmosphere of the Nara period. But most noticeable of all were the ferocious, even horrendous deities who took their place beside the tranquil images done in the earlier tradition, deities such as the Five Myō-ō (Radiant Kings), manifestations of the wrath of Mahāvairocana against either spiritual or physical harm. Strongly influenced by Hindu Tantrism, they expressed an intense, if controlled, anger, and added a dimension of irresistible authority to the rituals which they guarded.

The great changes in subject matter which occurred in painting and sculpture naturally affected their aesthetic qualities as well. Realism was no longer important for the depiction of most supernatural beings, nor was sumptuous splendor appropriate for the incarnations of frightening mystic powers. The use of dry lacquer and unbaked clay in sculpture sharply declined, and wood, easily obtainable in the mountain forests, became the dominant medium. Huge, towering old trees evoke in the Japanese a sense of the sacred mystery of nature; and something of this essentially pagan spirit must have prompted the choice of massive blocks of wood for the sculpture of the time. The pictorial arts were subject to strict regulations in the iconography and coloring of the Mikkyō deities; free or willful expression by the painter was suppressed. Still preserved in the old Mikkyō temples are thousands of sketches and drawings by which the monk-artists perfected their mastery of these difficult regulations. The arts were not restricted by ceremonial limitations alone, for this was an age which reacted to the unbridled extravagance of the Daibutsu and other temple projects in Nara by building with relative economy. Both the new monasteries and their images were smaller in scale, with little of the colorful opulence which had prevailed up to then. Halls became simpler and more solemn, and a prominent place was given to the oddly shaped ritual implements used in the Esoteric system. A strong appeal was exerted by the blazing fires of the Goma ceremony—the ritual burning of faggots of wood inscribed with vows, the fire serving as a symbol of the wisdom which destroys obstacles to salvation. Tantric Buddhism in Japan was deeply colored with this kind of mysticism and sometimes lapsed into a religion of exorcism, abusing the purpose of its charms and magic, but a great many works of art remain from its early period that are filled with spiritual energy. It was, first of all, a time of reformation and renewal.

THE ROAD TO JINGO-JI

High on the flanks of Mount Takao to the north of Kyoto is the temple of Jingo-ji, originally built by Wake-no-Kiyomaro in a different locale where it was given the name Shingan-ji. Kiyomaro was one of the most loyal supporters of the imperial throne, and, taking advantage of the Dōkyō affair, had struck a crushing blow against the Nara Buddhists at the very depths of their corruption. In selecting a new site for the family temple far removed from human habitations, the sons of Wake were determined to break away from the secular atmosphere of the Nara temples. Here, the monk Saichō, just returned from T'ang China, performed in A.D. 805 the Esoteric ritual of baptism. In 810, Kūkai, also just come back from China, studied the "Sutra of the Benevolent Kings" (Ninnō-kyō). The rustic footpath leading to Jingo-ji, crossing the Kiyotaki River and winding up the steep slope, is in itself an important memorial, an appropriate starting point for an understanding of the new creed.

The main cult image of Jingo-ji is an imposing wooden statue of Yakushi Nyorai. It is not, strictly speaking, an Esoteric Buddhist icon, and it probably dates from the time of the original founding of the temple. Nonetheless, it was clearly an attempt to convey a sense of brooding spiritual awareness instead of external brilliance. After the temple had been made a center of the Shingon sect, however, a pagoda was built and equipped with statues of the Five Great Kokūzō Bodhisattvas, Esoteric symbols of the five species of wisdom which lead to enlightenment. While these images possess stateliness and gravity, they are also imbued with a certain femininity which projects a sensual appeal and a strange, unaccountable beauty. Despite the abstruse nature of the deities, the sculptors were striving not simply for the occult or weird; they tried to attain the mystery which resides in beauty itself. Although not a single one of Jingo-ji's ancient buildings remains standing today, its historical role is well represented by its sculpture and painting. The statues of Yakushi and the Five Great Kokūzō Bodhisattvas stylistically demonstrate the transition from the Nara to the early Heian periods; iconographically they reflect the replacement of the older schools of Buddhism by the Esoteric ones. A pair of beautiful mandalas, painted in gold and silver on purple silk, are also preserved here, relics of Jingo-ji's early history.

To Kōya-san

The monk Kūkai, while living on Mount Takao, received permission from the Emperor Saga to proceed into the heart of Kii province, where in A.D. 816, he opened the principal seminary of the Shingon sect atop Mount Kōya. Far removed from both the new and the old capitals, the site was three thousand feet above sea level and sequestered amid gorges and dense forests of overpowering grandeur. Only a man of iron determination would have chosen so challenging a spot for a sanctuary and place of meditation. Over the centuries, in times of prosperity, the site has presented a grand spectacle with its array of halls and pagodas, but it has also suffered from countless fires and from its entanglement with political factions. Buddhist statues of the early Heian period which had adorned the *kondō*, for example, were tragically lost in a fire in 1931; however, the Lamp of the Law continues to burn here, and many precious objects still speak of its history. Said to have been brought back from China by Kūkai are gilt bronze ritual implements and a famous sword, the Kurikararyō (emblem of the deity Fudō), which evoke the memory of ancient ritual incantations of the sect. Many celebrated paintings remain, above all the ferocious one of the so-called Red Fudō with a background of blazing fire.

An understanding of the complex and profound doctrines of Esoteric creed was beyond the capacity of the masses, but the common people could nonetheless feel its power of salvation simply by coming to this sacred spot deep in the mountains. Kōya serves even today as a great pilgrimage center, and road markers erected for the guidance of the pilgrims of the past still stand here and there along the winding mountain trails. Thousands of large gravestones stand on either side of the road leading to the *oku-no-in*, the "inner precinct" where Kūkai lies buried. They were erected by proud men of power and authority whose ashes were brought here in hopes of an auspicious rebirth. Even those who were fierce enemies when alive are buried near one another, as though in recognition of the evanescence of human affairs, the larger vision of a mystical faith having released them from the bondage of their hatreds.

KANSHIN-JI IN KAWACHI, OSAKA PREFECTURE

Kanshin-ji is another of the old mountain temples which were taken over by an Esoteric sect. Refurbished by Kūkai and his chief disciple, Jikkei (A.D. 785–847), it possesses a remarkable statue thought to date from their time, Nyoirin Kannon (Avalokiteśvara), holding the Wheel of the Law and the priceless Jewel of Enlightenment. Stylistically, this statue bears many points of resemblance to those of the Five Great Kokūzō Bodhisattvas at Jingo-ji, which must date from roughly the same period and must also have been carved according to directions bequeathed by Kūkai. Kanshin-ji has kept the statue as a secret image; its original coloring is preserved together with its strange aesthetic unity, the result of the reconciliation of seemingly contradictory elements. Six-armed, the deity is supernatural in aspect, yet its body has a fullness and ripeness which are feminine and immediate. It is permeated with a feeling of static melancholy, but is also highly complex; and the result is an indefinable sense of occult beauty. Depicting a mystic concept in human form, it harbors a conflict of flesh and spirit which enables man to sense the dimensions of the unknown.

MURŌ-JI

Most of the mountain temples of the Mikkyō sects have suffered so badly from fire and earthquake that their character has changed, but Murō-ji is rare in that its buildings remain intact, more or less as they were in antiquity. Like Jingo-ji, it was a temple of the late Nara period which was absorbed by the Shingon sect. To this spot had come monks who were abandoning the urban Buddhism of Nara. Penetrating their way deep into these mountains, they sought to discipline themselves, to forego the comforts and distractions of the capital, and to obtain the full spiritual powers of the Law. According to one legend, Murō-ji was begun by the mysterious En-no-Gyōja, a wandering ascetic and miracle worker of the late seventh century; and it would have been entirely fitting to convert this temple into a Mikkyō sanctuary for the performance of occult rituals.

The road to Murō-ji, threading its way along a mountain stream, is an avenue of seclusion and quiet. At the entrance to this long ravine is a large image of Miroku (Maitreya) Buddha engraved on the face of the cliff. Dating from the Kamakura period, it is a rare example in Japan of the colossal rock-cut Buddhist statues which mark the spread of the religion from India through Central Asia and China and is reminiscent of the colossi of Bamiyan, Kizil, Yün-kang, and Lung-men. From early times, Murō-ji was a popular pilgrimage center, for it admitted women into its precincts. Because holy Kōya-san, faintly visible in the distance, sternly prohibited them from entering the mountains in the belief that they polluted its soil, Murō-ji came to be known as "the Kōya for women." Crossing the bridge over the Murō River and winding up the steep slopes of the mountain, one finds the temple halls irregularly arranged, each built to take advantage of a narrow stretch of level ground. Their scale is quite small and compact, different in spirit from most other temples; their shingle roofs slope in a gentle curve with a grace that is almost feminine.

The interior of the *kondō* also preserves the character of an ancient mountain temple of the Esoteric sect. Divided into an inner and outer sanctum, the inner portion is bathed in darkness as the sunlight is softened and filtered by the towering cryptomeria trees. Such seclusion and gloom can stimulate the fantasies of a faith of incantation and charms; but despite this atmosphere, there is not a single ferocious Tantric image, nor

is there an admixture into the sculptural style of the sensual beauty seen, for example, at Kanshin-ji. The main cult image of the *kondō* is that of Śākyamuni standing in the center; to the left are Yakushi and the Bodhisattva Jizō (Kshitigarbha); to the right are the Bodhisattvas Monju (Mañjuśrī) and the Eleven-headed Kannon, each backed by a beautifully painted halo. The sturdy, masculine spirit of the carvings is reminiscent of the wooden figures at Tōshōdai-ji, due perhaps to the fact that Murō-ji is near Nara, where, in the late eighth century, distinct Esoteric tendencies in sculpture began to appear. There is not the slightest concern for realism in these statues; instead, a distinct linear quality shows how the sculptors sought for the beauty of repeated rhythmical lines of the garment folds, carved in shallow relief. In the sharply ridged chisel marks, there is a freshness indicative of a new awakening in wood sculpture. These characteristics are shown clearly in the superlative seated Buddha image in the Miroku-dō (Maitreya Hall), imbued with the solemnity and gravity which can be achieved only in wood sculpture. As it entered into the mountains in search of a mystic atmosphere, Esoteric Buddhism discovered anew the expressive beauty of wood carving.

At the rear of the inner sanctum of the *kondō* is a wooden wall painted with a brightly colored composition called the Taishaku Mandala, a mandala of the Indian deity Indra in his role as lord of rainfall. This, together with the painted halos, is worthy of attention, for although it retains something of the pursuit of opulent splendor of Buddhist arts of the Nara period, the brightness of that period had already been replaced by a gloomier, more reserved atmosphere of Esoterism. But even after the Mikkyō sects had escaped into the mountain fastnesses, its arts retained traces of the styles of the past, and its seminaries remained in contact with the secular world.

THE TEMPLE OF ENRYAKU-JI ON HIEI-ZAN

The Tendai sect was part of the movement of Esoteric Buddhism in Japan, but it differed in some respects from the Shingon sect of Kūkai. The latter was of recent origin and strongly touched by fresh Indian influences; the Tendai sect was older and had been formed by Chinese monks in an effort to unify and harmonize a variety of Buddhist schools, including the Esoteric. Kōya-san was a great distance from the capital, whereas Enryaku-ji, the main Tendai sanctuary atop Mount Hiei, while still a mountain retreat, nonetheless looked down upon the Imperial Palace and the city of Kyoto spread at its feet. In another direction, it overlooked Lake Biwa and the city of Ōtsu. The activities and anxieties of the world below were rapidly transmitted to Mount Hiei; even monks engaged in austerities were unable to remain indifferent to them, and yet, theologically, one of the characteristics of the Tendai sect was an attitude of impartiality toward worldly struggles in order that it might serve and save mankind. In contrast to the single-minded concern of the Shingon sect, which saw itself as the beginning and end of Esoteric Buddhism, Tendai had a broader vision. A number of other schools branched off from it: the Pure Land sect, which stressed the doctrine of salvation in Paradise; the Zen sect, which emphasized the act of meditation; and the Nichiren sect. That the philosophy of the Tendai sect as established by Saichō was comprehensive enough to include these other viewpoints does not indicate that it was impure as an Esoteric school. Rather it shows the degree of enthusiasm with which Saichō himself marshaled the forces of latter-day theology against the older Buddhist views. In this respect, Enryaku-ji became a cradle of the newer forms of Buddhism in Japan; it was also a seedbed for

the growth of new forms of Buddhist arts and crafts. But there was something in the atmopshere of Hiei-zan which kindled the passions of youthful monks still attached to the world. Unable to remain aloof, they often became entangled in the violent political arguments of the city below. The temple warriors, impetuous and aggressive, were often an annoyance to the secular authorities, and invited that ultimate, tragic denouement of 1571, when Oda Nobunaga burned all the temple buildings on the mountain and caused the mass slaughter of almost three thousand persons. As a result, few buildings or works of art remain to testify to the temple's past; but just as the spirit of the Tendai sect was given a new life in other sects, so works of art made for use here have been discovered elsewhere. The most celebrated example is the giant painting of the "Descent of Amida and His Heavenly Host" now displayed on Kōya-san but originally kept at Enryaku-ji.

The Komponchū-dō atop Mount Hiei is the main hall of Enryaku-ji. It was rebuilt following a fire of 1642, but the old building system was closely preserved. This impressive structure, a skillful Japanese adaptation of Chinese building forms, has a corridor which encloses the forecourt and resembles in this way the layout of the Shishin-den of the Kyoto Imperial Palace. This resemblance may have been intentional, for Saichō, a strong patriot, had originally conceived of the temple as a center for the protection of the empire—both spiritually and physically. The great mountain mass of Hiei-zan itself was thought to shield the capital from the malevolent forces which, in the Chinese cosmological scheme, flow from the northeast. There are many other temple halls strung out along the ridges of the mountain, but the ethos of the ancient days of prosperity is largely gone. A metal sutra box plated in gold and silver was found near the ruins of an old hall in the north precinct, and its very exquisiteness sharpens our awareness of how much has been lost. It had been intentionally buried containing scrolls of the *Lotus Sutra* which had been copied by the Lady Jōtōmon-in, consort of the Emperor Ichijō. The aristocracy of Kyoto were greatly devoted to Enryaku-ji and injected a rather humane quality into the austere and esoteric mood of the Tendai creed there.

94. The path to Jingo-ji.
Jingo-ji stands on the slopes of Mount Takao, a few miles northwest of Kyoto in a mountain district celebrated for its brilliant foliage in the autumn. This footpath crosses the mountain torrent in a narrow ravine and then winds up the steep slope to the temple. The path is actually older than the streets of Kyoto, for it was opened by monks in search of a secluded place for meditation even before the founding of the capital.

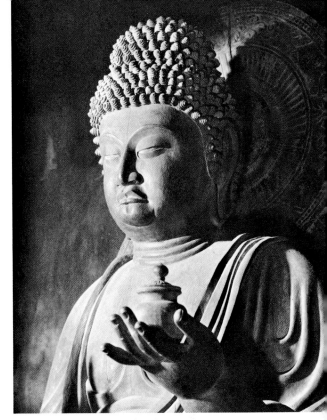

96. Yakushi Nyorai, detail.
This powerful head has a strong sense of tension, as though the volume were expanding from an internal pressure. The sculptor seems purposely to have avoided superficial grace and illusionism in his attempt to achieve a more resolute, determined feeling of spiritual power. Dating from the time when a mood of reform was gathering within the imperial court and the Buddhist faith itself, its austerity is symptomatic of the drastic changes in Japanese cultural life that resulted in the moving of the capital and the rise of the Esoteric sects.

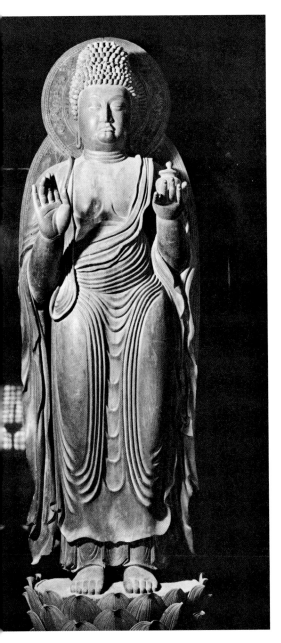

95. Yakushi Nyorai. Jingo-ji. Late eighth century. H. 169.7 cm. (66.7 in.).
This solemn figure combines a sense of spiritual energy with a ponderous physical presence. The folds of the robe around the waist and between the hips have a rhythmic, abstract beauty far removed from realistic description. Carved from a single block of cypress, it was left unpainted except for slight coloring in the eyes and lips. In the design of the drapery and in its powerful plasticity, it was influenced by Indian Buddhist sculpture whose style was transmitted (with appropriate changes) through T'ang China.

97. Renge Kokūzō Bodhisattva. Jingo-ji. Mid-ninth century.
The head is a taut, compressed form whose face harbors a sense of profound concentration. The half-closed eyes, narrow and elongated, are highly abstract shapes which respond to the geometric curves of the brows and the pursed lips. While this figure lacks multiple arms or heads as attributes of its divinity, it surpasses the beauty of ordinary mortals and embodies an awareness of the realms of mystery unique to Esoteric Buddhism. (See color plate 19.)

98. The Five Great Kokūzō Bodhisattvas. Jingo-ji. Mid-ninth century. H. 96.4 cm. (37.9 in.).
Closely resembling each other, differing only in body color and symbolic implements, the five Bodhisattvas are arrayed in mute silence, linked in mutual rapport. The expression of deep composure and the sense of volume of the opulent bodies is so convincing that we are less aware of the technique of the gifted sculptors than of the convincing presence of these embodiments of divine wisdom.

99. Kōya-san.
According to legend, this domain deep in the moun-
tains was discovered by Kōbō Daishi (Kūkai) with the
aid of an old hunter. With the same indomitable spirit
by which he mastered the complex mysteries of the
Esoteric creed, Kūkai erected this sanctuary in a pri-
meval forest. Dozens of subtemples and smaller com-
pounds are set in the thick woods; and even though
fires have destroyed many of the old buildings, Kōya-
san still remains a great bastion of the Buddhist faith.

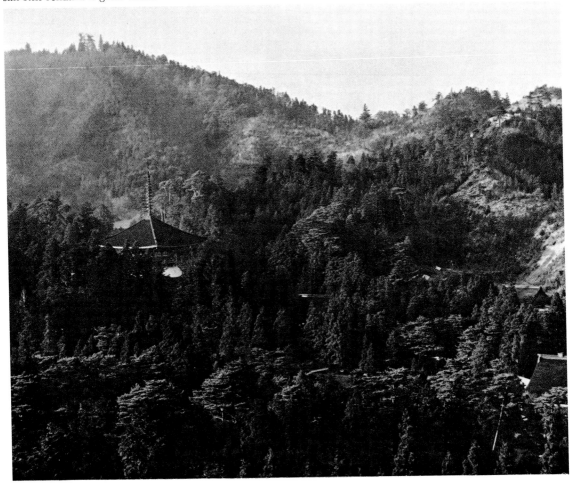

100. Ritual implements of Esoteric Buddhism.
Five-prong vajra bell, 23.5 cm. (9.2 in.); single-prong
vajra, 25 cm. (9.8 in.); three-prong vajra, 24 cm. (9.4
in.); five-prong vajra, 23 cm. (9.05 in.).
Patterned after ancient Indian weapons, ritual imple-
ments of this kind are a unique feature of Esoteric
Buddhism. They are used in the ceremonial exorcism
of evil, both physical and spiritual, and their varied
shapes are permeated with elaborate symbolic over-
tones. These particular objects, preserved at Kōya-
san, are said to have been brought back from T'ang
China by Kūkai.

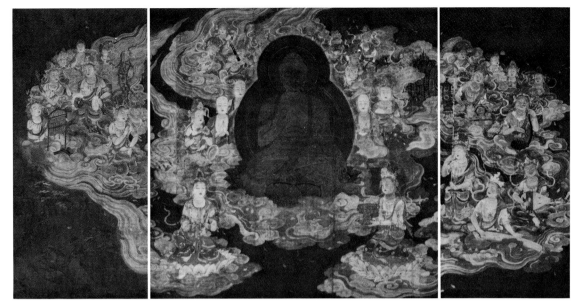

101. "Descent of Amida and His Heavenly Host." Reihō-kan, Kōya-san. Late eleventh or early twelfth century. Center, 210.8 × 210.6 cm. (82.2 × 82.1 in.); right, 211.2 × 106 cm. (82.3 × 41.3 in.); left, 210.8 × 105.7 cm. (82.2 × 41.2 in.).

This great triptych, nearly fourteen feet in width, is a most monumental expression of the belief that Amida (Amitābha) will approach the earth to receive the spirit of one who has died with the Buddha's name on his lips. The composition is dominated in the center by the figure of Amida, depicted with gold paint and *kirikane*; before him kneel his attendant Bodhisattvas, Kannon and Seishi, the former holding a lotus pedestal upon which to receive the spirit to be reborn in Paradise. Like the Raigō scenes of the Phoenix Hall in Uji (figure 139), which are somewhat older, this work is at once faithful to the ancient tradition of hieratic Buddhist art but also an expression of new developments in Japanese aesthetic taste. The composition is symmetrical; the faces and bodies are idealized, and yet the symmetry is by no means perfect. Inventiveness is shown in the placement of the figures, both laterally and in depth; the trailing edges of the clouds impart a sense of sinuous movement; and the color scheme, keyed to the iridescent pinks of the flesh tones and accented by patches of strong color and *kirikane*, imbues this vast theophany with a dreamlike aura which was so much a part of the religious atmosphere of the day. (See color plate 20.)

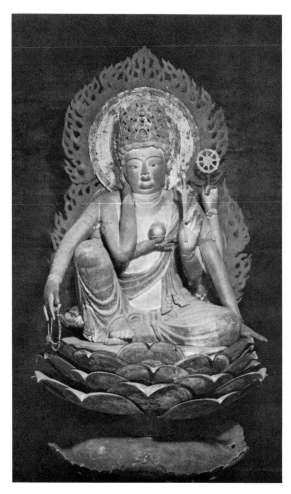

102. Nyoirin Kannon. Kanshin-ji. Ninth century. H. 108.8 cm. (42.8 in.).
For centuries this has been kept as a secret image; it is rarely shown even today. Hence its color is well preserved, especially over the torso where the pink is almost iridescent, like mother-of-pearl. Despite the supernatural aspect of its six arms, it has a certain voluptuous, feminine charm; however, the withdrawn expression of the face—the eyes half-closed in inner concentration—reinforces the static dignity and solemnity of this Esoteric Buddhist icon. (See color plate 21.)

103. The rock-cut Buddha image at Ōno. Thirteenth century.
Unlike Kōya-san, which forbade the presence of women, the smaller sanctuary at Murō-ji welcomed them and became, in its own right, a popular pilgrimage center. This large image of Maitreya Buddha, nearly forty-six feet high, was engraved on the face of the cliff overlooking the mountain stream and road which lead to the temple a mile or so away. Unlike the sculpturesque, rock-cut Buddhas of India and China, this is done in a delicate line engraving—actually the transference of a pictorial concept onto stone.

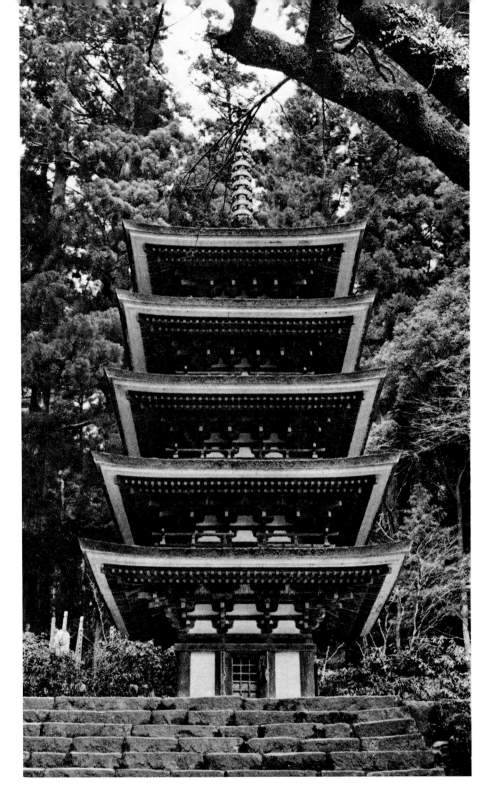

104. Five-story pagoda. Murō-ji. Late eighth or early
ninth century. Total height, 16.2 m. (53.2 ft.); square,
2.48 m. (8.1 ft.).
Utilizing the few small areas of flat land on the steep
hillside, the buildings of Murō-ji are modest in scale.
This pagoda is virtually a model in its diminutive size,
having a delicacy which is enhanced all the more by the
mighty cryptomeria cedars which enclose it.

105. Seated Buddha. Murō-ji. Ninth century. H. 105.7 cm. (41.5 in.).

Marks of the sculptor's chisel are clearly visible over the surface of this powerful figure. Strokes which are alternately narrow and wide overlap each other and add their rhythms to the larger patterns of the garment folds which give so strong a sense of movement to the whole—movements, however, which occasionally eddy into the small vortex shapes of the hem. The plaster hair-curls and surface paint have long since flaked away, leaving this statue in its quintessential state as one of the noblest, most distinctively Japanese of all Buddha images.

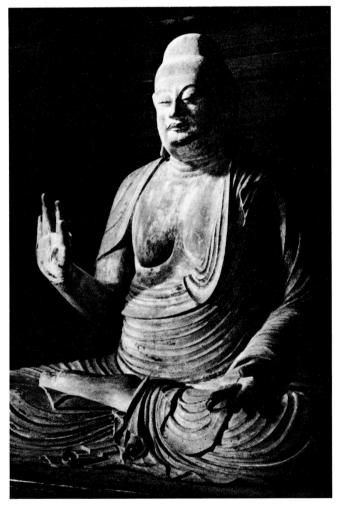

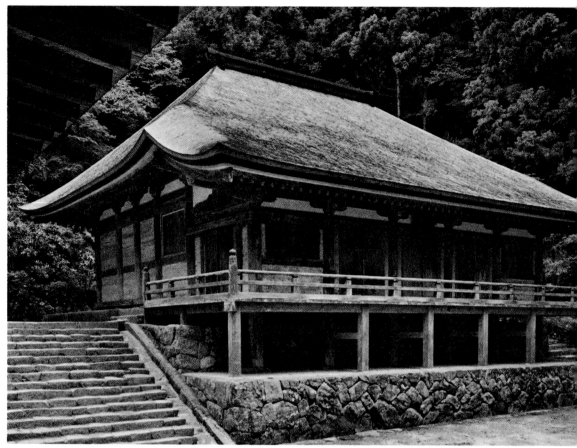

106. *Kondō*, Murō-ji. Ninth century. Width of facade
and side, 9.1 m. (29.8 ft.) each.

The care with which the narrow site has been utilized
is shown by the way the building projects forward on
its stiltlike foundations. A sense of unity between the
structure and the natural beauty of its site is shown in
the use of stone in the retaining walls and stairs, the
softness of the cedar-shingle roof, and in the faded paint
of the wooden boards and pillars.

107. Inner sanctum of the *kondō*, Murō-ji. Height of Śākyamuni Buddha, 238 cm. (93.5 in.).
Within the narrow confines of the inner sanctum stands a forest of large, solemn statues of the ninth century. Before them are the small, flamboyant statues of the Twelve Divine Generals dating from the Kamakura period. The wooden back wall is painted with a mandala of the god Indra in his role as lord of rainfall. The coloring of this and the flat wooden halos is reserved and austere.

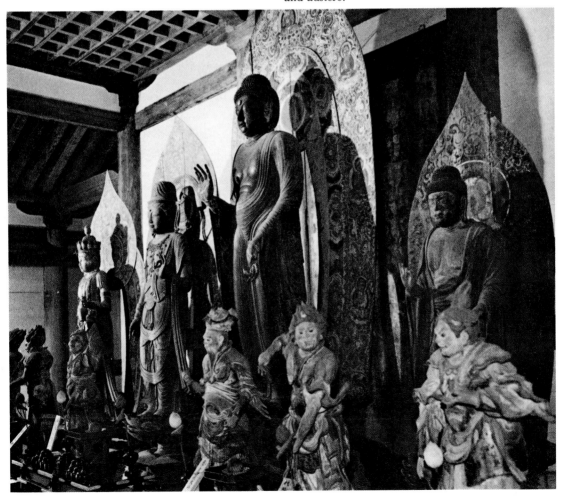

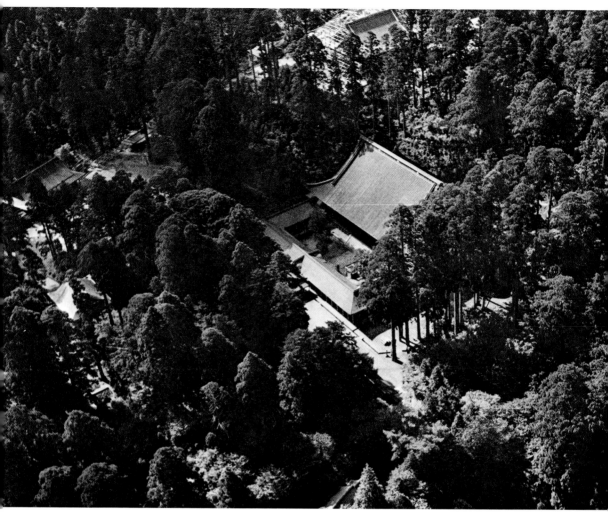

108. The Komponchū-dō of Enryaku-ji.
Enryaku-ji was founded by Saichō as a center for the
training of monks in the Tendai creed and for the per-
formance of rituals to protect the nation and its
sovereign. For this reason, perhaps, this main ceremo-
nial hall with its enclosed forecourt resembles the
layout of the audience hall of the Imperial Palace, the
Shishin-den (see figure 115). The Komponchū-dō is
sheltered in a wooded ravine below the summit of
Mount Hiei, which offers a breathtaking panorama of
the city of Kyoto and the great Kinki Plain.

109. A sutra box in gilt bronze. Eleventh century.
L. 27.1 cm. (10.6 in.); w. 12.1 cm. (4.7 in.); h. 8.3 cm.
(3.2 in.).
This box was found in a protective bronze outer case
on Mount Hiei, where it had been intentionally buried
in order to transmit the *Lotus Sutra* to future generations.
Its decor of delicately engraved floral arabesques is
enhanced by the patterns of gold inlaid on silver. In the
central cartouche is inscribed the name of the sutra.
The rounded edges of the lid counteract any feeling of
harshness from the metal itself and enhance the sense
of aristocratic gentleness and grace.

Plate 19. Renge Kokūzō Bodhisattva. Jingo-ji. Mid-
ninth century. (See also figure 97.)

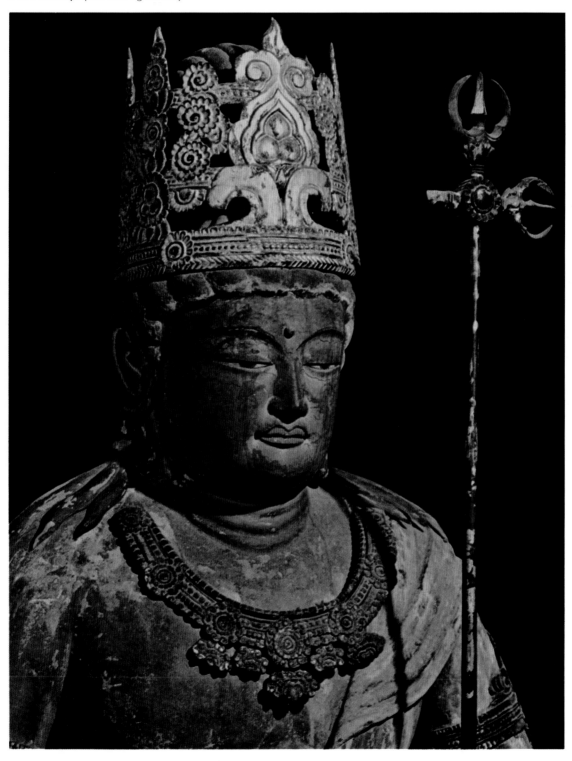

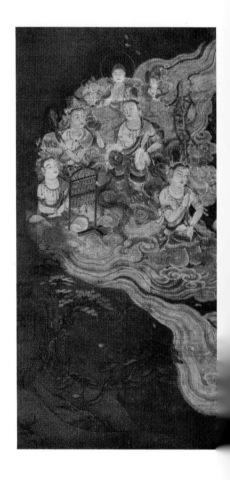

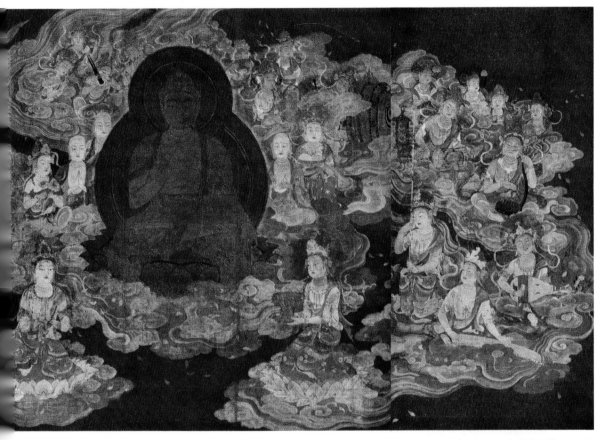

Plate 20. "Descent of Amida and His Heavenly Host." Kōya-san. Late eleventh or early twelfth century. (See also figure 101.)

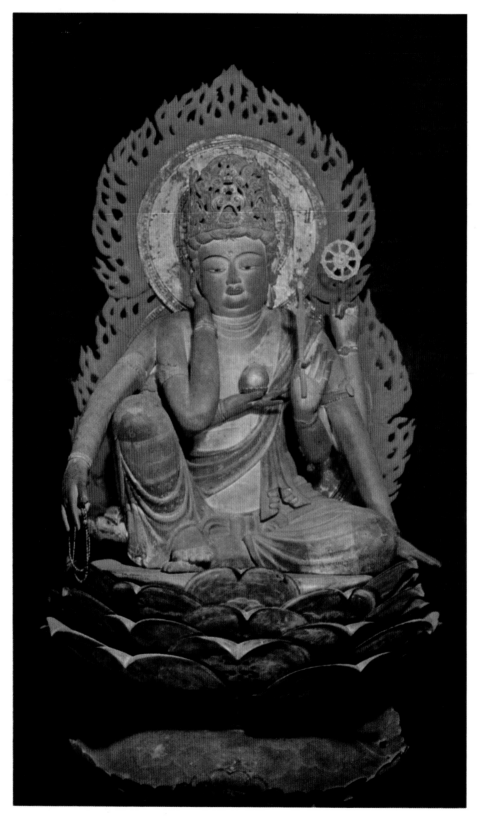

Plate 21. Nyoirin Kannon. Kanshin-ji. Ninth century. (See also figure 102.)

~6~

IN AND AROUND THE HEIAN CAPITAL

In A.D. 784, the court was moved from Nara to Nagaoka in the province of Yamashiro only a few miles southwest of modern Kyoto. But for reasons not entirely clear, the building of the new capital did not progress smoothly, and in 793 it was moved again, this time to the site of Kyoto itself, which was given the name of Heian-kyō ("Capital of Peace and Tranquility"). The seat of government had been in Nara for only seventy years, and it was most unlikely that the new one would remain in Kyoto for over a thousand. It remained, however, not because the city was easily defended or the affairs of its people were always tranquil, but because a culture distinctively Japanese in spirit began to develop there, spontaneously and easily. Let us trace the outlines of this culture as it flourished in and around the sprawling new city.

Tōji

A large monastery, popularly called Tōji ("East Temple"), was built at the time of the founding of Heian-kyō. It was one of the two official temples located just inside the Rashō-mon, the great south entry gate to the city, and on either side of the north-south avenue which bisected the town. Tōji's importance was reflected in its formal name, the Kyōōgokoku-ji ("Temple of the Protection of the Land through the Noble Law"); in A.D. 823 it was entrusted to Kūkai, who made it one of the basic seminaries of the Shingon sect. Kūkai had already founded the secluded monastery atop Kōya-san, but he retained not only this one foothold in the new capital; he was also given control of several of the temples of Nara. This was due both to the genius of the man, for Kūkai was one of the most gifted figures in all Buddhist history, and also to the appeal of Esoteric Buddhism, newly introduced, which offered control over supernatural forces, profound and mysterious. At Tōji, the most impressive relic remaining today is the lecture hall, whose long image platform is furnished with twenty-one statues arranged according to the schematic layout of a mandala. These served as cult objects of an elaborate ceremony performed often during the second quarter of the ninth century which promoted the well-being and safety of the nation. In the group of five wrath-filled deities stationed in the western sector of the platform, some of the special aesthetic

137

innovations of Esoteric Buddhism can be seen most clearly. Up to this time, the arts of the Mikkyō sects had imparted a sense of mystery stemming from an unseen world, but these wrathful figures project such ferocious energy that the spectator is repelled from any thought of questioning or challenging the realm which they guard.

The Esoteric schools discovered that conversions among the masses were more easily made through displays of this sort, which brought a feeling of submission to irresistible power, than through theoretical argument and persuasion. From this time on, cult images of ferocious appearance were made in great quantities, and this popular aspect of Mikkyō, its latest and least demanding development, degenerated into little more than a religion of prayers and charms. Moreover, a contradictory situation in the realm of the arts was soon encountered, for without a realistic style it is difficult to create a convincing impression of frightening powers. The arts of Mikkyō, however, had already discarded illusionism of the sort seen in the Nara and T'ang periods, and had begun to move in other directions. As a result, some of the later attempts to depict anger and wrath were unconvincing and even humorous in feeling. Fortunately, however, at the time the statues of the Tōji lecture hall were carved, the techniques of illusionism had not been totally lost; even the thin lacquer which was used to coat the wood was suitable to realistic modeling, and these statues may be taken as most expressive of the ferocious aspect of Esoteric Buddhism.

Images of Shinto Deities

A fusion of Buddhism and the native Shinto creed had been promoted throughout the eighth century. During the ninth, as artists of the Mikkyō temples were seeking to imbue their images with a sense of supernatural power, wooden statues of the native gods having their own distinct aura of mystery began to be made. Examples of these are preserved in Yakushi-ji in Nara and in Tōji, and some of the most splendid early figures are in the Matsuo Shrine in Kyoto. These were probably made by the same craftsmen who carved Buddhist statues, which is to say that, at the time, temples and shrines were closely linked; both Tōji and Yakushi-ji, for example, had a shrine dedicated to Hachiman, the war-god, within their precincts. The Matsuo Shrine was closely connected with Kōryū-ji, an ancient temple not far away along the western outskirts of Kyoto, yet the sculptors took great pains to provide the Shinto figures with a feeling of authority quite different from that of the Buddhist images. First of all, the gods were dressed in Japanese-style garments, and not the slightest touch of the eccentric or grotesque was allowed. In trying to suggest their divinity, the sculptors sought for a dignity and solemnity in the native Japanese tradition, for throughout the Heian period in the capital city, the national spirit in the arts was being carefully cultivated. Another basic example is the Kyoto Imperial Palace.

The Kyoto Imperial Palace

The Heian capital was planned around a vast enclosed area called the Daidairi ("Great Inner Interior"), the ceremonial and administrative seat of government. The Imperial Palace as it stands today dates only from the Edo period, but it was built in emulation of the sector of the ancient Daidairi given over to the imperial residence, and was based on careful antiquarian research. Two of the other main sectors, however, were not reconstructed. One of these was the Chōdō-in, which housed the original Throne Hall

and the Departments of State. (This has been partially reproduced on a smaller scale in the modern Heian Shrine in Kyoto.) The other was the Buraku-in, used for banquets, Buddhist and Shinto ceremonials, and the like. The heart of the modern palace is the Shishin-den, which now serves as the Throne Hall, and the Seiryō-den, the emperor's residence chambers. A great number of other structures make up this compound, many of which are joined together by a complex system of corridors; but when the corridors were dismantled as a precaution against fire during the Second World War, the distinctive beauty of these buildings could be seen more clearly. The two main buildings today, as careful reproductions of the ancient residential quarters, are made of plain, unpainted wood and roofed with cypress bark shingles, whereas the original Chōdō-in and Buraku-in were built in the much more colorful Chinese style with tile roofs. The severely plain buildings nonetheless have an air of quiet dignity and solemnity fitting their role in state symbolism. Like the statues of the Shinto gods, they are imbued with the spartan simplicity and respect for natural materials which are so esteemed in traditional Japanese taste. This taste, however, became increasingly complex during the Heian period, as courtiers took up artistic and literary pursuits with great zeal. In particular, when the Chancellor Fujiwara-no-Michinaga was at the height of his influence in the second and third decades of the eleventh century, he brought a number of gifted women into the court, the foremost of whom was the Lady Murasaki Shikibu. Around such women, a distinct court culture rapidly grew up, of which narrative tales of amorous intrigue were a major form of expression, and the romantic novel the *Genji Monogatari* ("The Tale of Genji") was its greatest example. These stories were usually written in an exquisite hand in the native Japanese *kana* alphabet, using a minimum of Chinese characters. There also developed the custom of inserting illustrations alongside sections of the script, and in this way the special form of painting called *e-makimono* (illustrated handscroll) came into great popularity.

During the Nara period, Japanese painters had been under strong Chinese influence. Not only did the painters copy T'ang pictorial techniques, they depicted Chinese landscapes, history, and customs—which were welcome at this time when exotic things were so much in fashion. In the growth of national self-consciousness in the Heian period, however, the Chinese manner was no longer satisfactory, and a pictorial style better suited to Japanese customs and scenery was developed. Encouragement came from the traditions of a native style of court poetry called *waka,* as well as from the rise of the new romantic tales. The history of the *waka* goes far back in time; originally it was a very simple and bold form of expression in the manner of the poems of the *Man'yōshū*. During the Heian period, this idiom was greatly polished and refined, and its subjects used for illustrations on screens and sliding doors in the apartments of the well-born, who delighted in being immersed in a poetic atmosphere. Similarly, the narrative tales which so beguiled the courtiers were given many purely poetic, evocative passages which were only incidental to the unfolding of the main plot. The painted illustrations of the stories captured the spirit of these passages in the color schemes and in secondary details. Thus, the distinctly Japanese style of painting called *yamato-e* came into being, and the style which had prevailed until then was given the name of *kara-e* (Chinese painting). As the *yamato-e* developed, its emotional range became very wide, capable of moving from an atmosphere of quiet and strong sentiment to one of exceedingly dynamic, excited events. These long horizontal paintings, the *e-makimono*, are sometimes said to be peculiarly Japanese in form, but similar scrolls had been made by the Chinese as well. The local innovations appear in the manner by which the texts and paintings were

interrelated, with subtle hints in the text of themes to be elaborated in the illustrations, and vice versa. Gradually, the *yamato-e* style was able to express with delicate nuances emotions of love and loneliness and grief, or those of excited events—wars or rebellion.

THE DEVELOPMENT OF NARRATIVE SCROLL PAINTING

The life of the courtiers in the Heian-kyō, for all their opulence and power, was pervaded by an extraordinary mood of melancholy and pathos, a sense of the tragedy inherent in human fate, the evanescence of glory, and the fragility of beauty. This mood, given the name *aware* or *mono no aware,* was captured most eloquently by Lady Murasaki's classic novel, *The Tale of Genji,* and by the oldest known illustrated version of it, which dates from the early twelfth century. To depict the many episodes of the novel which take place indoors, the painters employed an artistic device of looking down into a chamber from a high vantage point, as though there were no roof or ceiling—a bold, exaggerated use of the Chinese perspective system. For emotional effect, they manipulated color harmonies in subtle ways, making unexpected combinations of soft, pastel tints in thick coats of pigment. The painters also were fascinated by the interplay of lines and compositional patterns which are so abstract and intricate that they are sometimes difficult to identify at first glance. The faces of people were drawn with little regard for individuality, using standardized hooked noses and a simple horizontal line for the eyes, thus freeing the spectator to imagine the emotional states of the subjects— one of the several ways by which the *yamato-e* dealt with the implications of literary themes.

In contrast to this, the scroll painting of the *Shigisan Engi* depicts the amazing tale of a virtuous monk named Myōren, who could invoke supernatural forces through the power of his faith. But rather than present the realm of divine mysteries, the artist showed in an amusing fashion the reactions of people to miraculous affairs and unfolded the plot in a leisurely, diverting way. Unlike the painters of the Genji scrolls, he depicted the exteriors of buildings and, for the most part, earthy peasants and commoners. In keeping with the rapid action in the story, his painting technique was lively and animated. He also included scenes of deftly colored trees and herds of wandering deer, a pastoral touch not essential to the story itself, but one which reveals much of the broad, poetic atmosphere of the Heian period. These scenes of rustic life and common people were filled with a droll, dynamic spirit often given the name *okashi;* this was in sharp contrast to the atmosphere of *aware* which grew up in the arts of the Heian court— introverted, static, and pensive.

A middle ground between these two points of view is occupied by the *Ban Dainagon Ekotoba,* a set of three scrolls which unfold a story of arson and intrigue in the burning of one of the gates of the Imperial Palace. The life of the aristocracy is recorded in interior scenes, whereas the common folk are shown openly and frankly in other sections; and there is a skillful combination of both static and dynamic compositions. The feelings of the spectator are drawn between moods of sorrow and humor—one group of people is shown rejoicing openly at the false accusation of the crime, but Ban Dainagon's family is shown in hopeless despair at the discovery of the evil deed and their own ruin. These scenes are composed with extraordinary skill; and their sensitive insight into human psychology is a priceless document of the emotions of the men of the Heian capital.

Illuminated Sutras and Anthologies of Poems

The courtiers of the eleventh and twelfth centuries were patrons and practitioners not merely of painting alone. They eagerly sought ornamented sutras and collections of poems written in the most refined styles of calligraphy. The copying of the *Lotus Sutra* (*Hokke-kyō*) became extremely popular, for it was believed that in this era of the decline of the Buddhist Law, salvation could be approached through the merits of simply copying this one text, which was thought to epitomize all the teachings of the Buddha, and depositing the copies for the sake of later generations. The religious merit of the deed was heightened by the sheer physical beauty of the scrolls, which became so ornate they were sometimes confused with secular poems. Religious conviction inspired these patrons, but so also did their addiction to ornate beauty. Among the most interesting examples of this are the copies of the *Lotus Sutra* donated to Shitennō-ji in Osaka. Portions of the sutra were written on paper used to cover fans and then bound into albums. These were illustrated with paintings or hand-tinted woodblock prints of scenes of daily life, and were donated by ladies of the court who had copied out text. The same temple also preserves the amulet covers which had hung from the necks of high-born ladies, each made of rich brocade and embellished with delicate fittings of gilded silver, further proof of the degree to which faith and beauty had mingled in daily life.

The Appeal of Lacquer Ware

The courtiers of the new capital also became inordinately fond of lacquer work. The craft of coating boxes, tables, or the like with colorful designs had been transmitted from the continent during the Nara period, when the usual method had been to inlay patterns of gold or silver leaf and mother-of-pearl onto a dark lacquer ground. Largely as a substitute for this, the technique called *maki-e* developed in the Heian period. Powdered gold, silver, or copper was applied in a number of ways to the lacquer ground, usually to form a stylized picture. A purely Japanese development, this rather florid use of precious metal and the softness of outline in the designs caught the fancy of the Heian aristocracy, who had almost all of their utensils of everyday living decorated in this expensive way; for not only did they seek beauty in their lives, they had the resources with which to obtain it. Typical of this taste is the small box illustrated in figure 124, made merely to keep small objects, such as cosmetics, but decorated with utmost refinement. The design motif is that of the wheels of bullock carts being set into a river to absorb moisture to prevent warping and cracking, a thing frequently seen along the streams of the capital. The appearance of so poetic and yet casual a theme is typical of the period and of the sentiments which pervade the native cultural tradition of the Japanese—lodged in the hearts not only of poets and painters, but of the people at large. Life in the city of Kyoto could be the unceasing discovery of such visual delight— in its rivers and canals, in the nearby mountains with their ravines and deep gorges, in the rice fields which begin at the city gates, in the teeming life of the markets and pleasure quarters. And for this, if for no other reason, the great city has survived when others have long ago faded away.

Charm, ironically combined with melancholy, colored the vision of men in the Heian capital, and with critical sharpness they could document the follies of human nature. This may be seen in a set of satirical scroll paintings preserved at Kōzan-ji, a temple once part of Jingo-ji in the mountains west of town. The temple tradition ascribed these

famous scrolls to Kakuyū (A.D. 1053–1140), a theologian of the Tendai sect who is known more popularly as Toba Sōjō. This attribution is not certain, for Kōzan-ji was an active center of Buddhist painting for a number of decades, and skilled monk-crafts-men gathered there in large numbers. Whoever he was, the artist worked rapidly with brush and ink in line alone and caught the characteristic gestures of animals and men with great skill. It is much more likely that he was a monk-painter than the usual pic-ture specialist of the city, for the content of the scrolls seems to have an added dimension of religious meaning, even though scholars are not able to agree entirely as to what it was. Most likely, the artist depicted contemporary social conditions in the guise of frolicking animals and human caricatures. Some portions of the scrolls show animals amusing themselves in games and holding mock religious services. Others show proud and haughty persons arguing, or common folk in crude and violent games. They were painted, most likely, when bitter disputes were breaking out in the city below, destined to rage throughout the last half of the twelfth century; the social and political order which had prevailed for four centuries, centered on the power of the Fujiwaras, cracked and then collapsed. The cultivated folk of the capital, who had been steeped in their moods of exquisite melancholy or boisterous humor, were soon to be consumed in wretchedness and grief.

Located in the foothills of the mountains which form the eastern boundary of Kyoto is Kiyomizu-dera. From its main hall *(honden)*, the entire city can be seen in one sweep-ing panorama. The viewing pavilion projects dramatically out from the hall over a cliff and deep ravine. The hall was reconstructed in the Edo period, but it is thought to have preserved the shape of the mansion given to the temple at the beginning of the Heian period by the victorious general Sakanoue-no-Tamuramaro, who led an expedi-tion to bring much of eastern Japan under the authority of the emperor. Buildings skillfully adapted in this way to a difficult site were a special feature of Heian period architecture, a result of influence from the monasteries set in rugged mountains and also of the desire of the aristocracy for picturesque hillside retreats. For over a thousand years, citizens of the city have climbed up to this historic temple, not only for their Buddhist devotions but also for moon viewing in autumn or for the blossoms in the springtime—a simple custom, performed often with a light heart by the high born and common folk alike, but behind it lies their profound identification with the changing moods of nature, with the faith, the city, and the nation. The longevity of the old capital and the character of its people are rooted in such things as this.

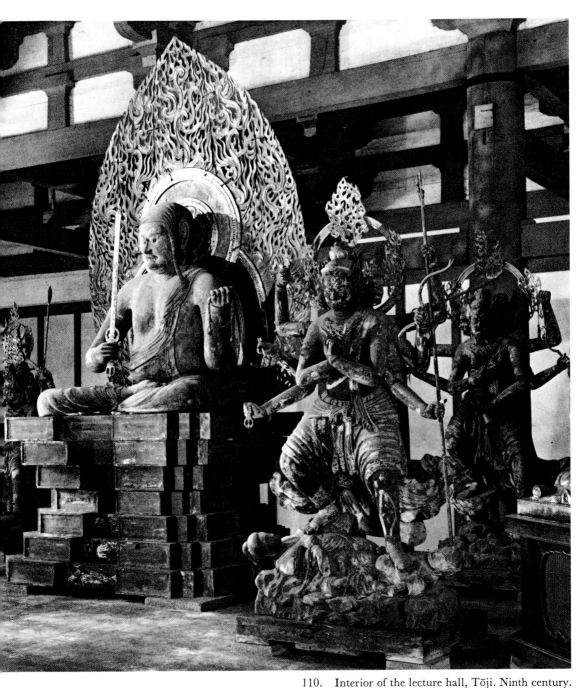

110. Interior of the lecture hall, Tōji. Ninth century. Height of Fudō Myō-ō, 173.2 cm. (68.1 in.).
The frightful energies of the Five Radiant Kings (Godai Myō-ō) symbolically enhance the effectiveness of the temple's rituals. They are stationed at the west end of the giant image platform, and in their center sits Fudō, "The Immovable One," steadfast in the face of passion and delusion. This group, together with the rest of the twenty-one images on the platform, offers an overwhelming experience of the emotional range of Esoteric Buddhist (Mikkyō) sculpture.

111. Mandala (detail of center section). Tōji. Late ninth or early tenth century. 183.6 × 163 cm. (71.6 × 63.6 in.).

In this detail of nine figures in the central portion of the Taizōkai mandala, the influence of Buddhist painting of India and Central Asia (as filtered through T'ang China) is still very much apparent. The high intensity of the color and the sense of radiant energy shown here carry into the rest of the composition, in which some 321 other figures are arranged with the same sense of geometric precision. This vast pantheon, as indeed all of creation, is considered an emanation of Vairocana, shown in the center with his jeweled ornaments and a halo whose undulating color pattern suggests an unearthly force. From Vairocana's circle radiate four lotus petals pointing in the cardinal directions, each enclosing a seated Buddha. Between them and set off by a three-pronged vajra are petals holding the four great Bodhisattvas, beginning with Fugen in the northeast, Monju in the southeast, Kannon, and then Miroku. (See color plate 22.)

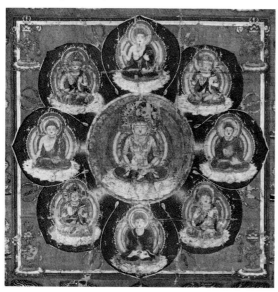

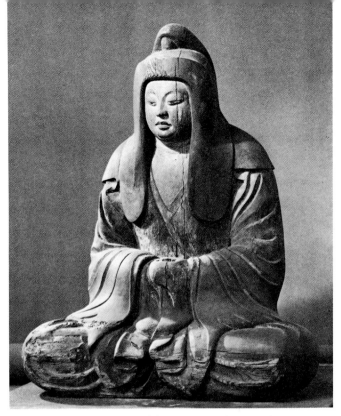

112. Shinto goddess. Matsuo Shrine, Kyoto. Ninth century. H. 86.9 cm. (33.8 in.).

Buddhist customs encouraged the Japanese to make icons of their native gods in much the same way that in India, centuries earlier, foreign images had stimulated the making of the first statues of the Buddha. But from the very beginning, the figures of Shinto gods revealed the growing self-consciousness of native traditions in the arts which came to maturity during the Heian period.

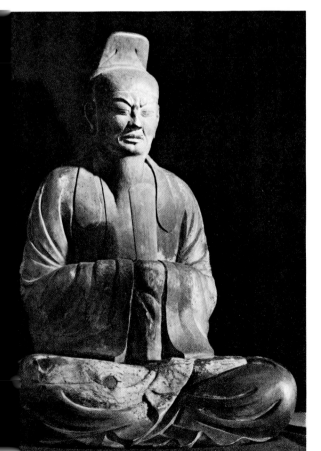

113. Male Shinto deity. Matsuo Shrine, Kyoto. Ninth century. H. 89 cm. (35 in.).

Steeped in the atmosphere of mysticism of the early Heian period, the Japanese began for the first time to depict their native gods in human guise. With few exceptions, these images were imbued with qualities different from those of Buddhist icons. They were dressed native style, were carved compactly, usually on a small scale, and given dignity and a stolid presence. The face of this statue is contorted by an expression of great psychic tension—the eyebrows gathered, the chin drawn rigidly.

114. General view, Kyoto Imperial Palace.
Without fortifications or deep moats, this imperial residence adds to the serenity and peaceful character of the city. There is little that is ostentatious about the palace, whose courtyards and surrounding parks have a quiet order and naturalness in keeping with Japanese concepts of sovereignty. Although built little more than a century and a half ago, the structures and their arrangement were made on the basis of careful research into the traditions of the ancient Heian Imperial Palace. In the distance looms Mount Hiei, a benevolent and protective form.

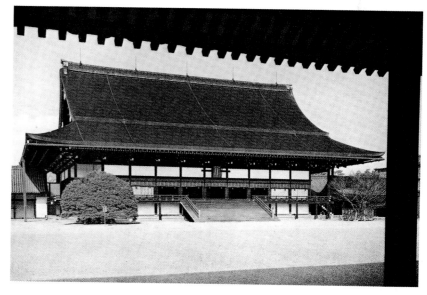

115. The Shishin-den, Kyoto Imperial Palace.
The heart of the palace is the Shishin-den, in which the coronation and other state ceremonies are performed. The enclosing corridors have tiled roofs and lacquered red woodwork, but the Shishin-den itself is built of unpainted timbers and roofed with cypress bark. Despite the grandeur of its scale, its dominant qualities are those of serenity and great simplicity, for the semidivine status of the Japanese emperor has long been assured among the people, and needs no bombastic affirmation. The only things standing in the broad forecourt of pure white sand are two trees: a mandarin orange and a cherry, traditionally grown at the entrance stairway. (See color plate 23.)

THE HEIAN CAPITAL 147

116. Interior of the Shishin-den.
Beneath the great wooden rafters stands the Imperial
Coronation Throne, the Takamikura. The interior
spaces of the hall, unbroken by partitions, look directly
out into the gleaming sand of the forecourt beyond.
Except for the thrones of the emperor and empress,
there are no other strictly imperial regalia inside this
vast chamber.

117. Seiryō-den, Kyoto Imperial Palace.
Directly behind the Shishin-den are the living quarters
of the emperor, the Seiryō-den. Its interior is parti-
tioned off into various chambers and possesses a throne
for informal audiences. A more compact and orderly
structure than the larger Shishin-den, its forecourt of
gravel is equally severe, ornamented with nothing more
than water channels and two clumps of bamboo named
after the ancient Chinese kingdoms of Wu and Han.

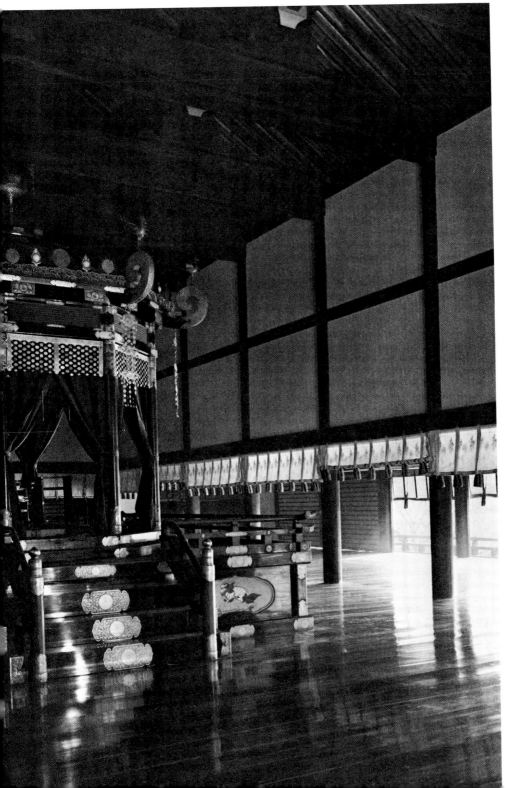

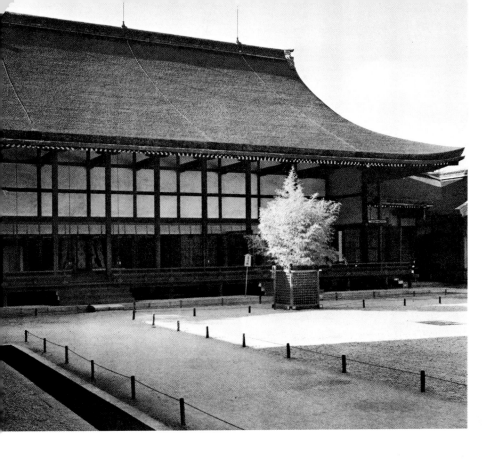

118. From *The Tale of Genji*, illustrated handscroll. Twelfth century. H. 22 cm. (8.6 in.).

This is one of the most poignant of the scenes from *The Tale of Genji*. Dressed as a monk holding a rosary, the retired Emperor Suzaku visits his daughter and is accompanied by her husband, Prince Genji (left foreground). The daughter is swept with remorse, for she is to have a child by another man, and vows to enter a nunnery. In this tragic confrontation, the principal figures and chambermaids are given over to melancholy and grief—each in his own manner. The muted harmonies of the color scheme reflect this mood. The high vantage point looking down into the chamber, the essentially abstract patterns of the women's garments and the curtains, the faces shown with a minimum of detail—these are all characteristic of the *yamato-e* style of painting and the exquisitely refined life of the court. (See color plate 24.)

119. From the *Shigisan Engi*, illustrated handscroll. Twelfth century. H. 31.5 cm. (12.4 in.); length of scroll, 35.6 m. (116.67 ft.).

Depicted here is an exciting incident from the legends of a saintly monk named Myōren, who dwelled in a small temple near Nara on the slopes of Mount Shigi. Through the power of his faith, he was able to send the rice granary of a wealthy man flying through the air on top of his begging bowl. The squire on horseback and the country people are shown in their humorous astonishment as they chase after the miraculous event. Everything in this scroll—people, warehouse, water—is imbued with a strong sense of movement rendered with restless strokes of the brush and with very thin, pale coloring. This is another facet of the *yamato-e* style, one which stressed dynamic action and a rustic, boisterous mood.

120. The *Ban Dainagon Ekotoba*, illustrated handscroll. Twelfth century. H. 30.4 cm. (11.9 in.); length of scroll, 26 m. (85.3 ft.).

The scene of the arson (for political reasons) of one of the main gates of the Imperial Palace is the opening episode in this set of scrolls. With consummate skill, the artist painted the crowds of citizens, some attracted by the spectacle, others crying out, others repelled by the heat of the flames—each person's reaction clearly shown through bodily gesture and facial expression.

121. Text of the *Lotus Sutra* written on fan-shaped paper. Twelfth century. H. 25.6 cm. (10 in.), w. 49.4 cm. (19.4 in.).

To make a copy of the *Lotus Sutra*, considered one of the holiest of the Buddhist gospels, was an act of great piety among the Heian aristocrats. By copying the text on paper made to decorate fans, the faith was linked more closely with everyday life. The illustrations, moreover, are scenes of court and city life not greatly different in spirit from those of the woodblock prints of the Edo period. Here, a man wearing a court hat is boldly shown chatting with a coquettish girl, and on the paper itself sumptuous bits of gold and silver leaf have been scattered in a random way.

122. Amulet covers. Shitennō-ji.

Protective amulets were wrapped in rare brocade and ornamented with fittings of gilded silver, delicately inlaid or filigreed. Like the painted fan sutras, they were donated by devout ladies among the Heian aristocracy to Shitenno-ji in Osaka, not far from the capital and one of the oldest and most sacred temples in Japan.

123. A page from *The Anthology of the Thirty-six Poets*, Nishi Hongan-ji. Twelfth century. H. 15.8 cm. (6.2 in.), w. 17.9 cm. (7 in.).

The flowing letters of the Japanese alphabetic script are in themselves an aesthetic achievement of a high order, but the design beneath enhances the whole. Ornamented with many kinds of colored paper that were torn and cut and pasted like a collage and then flecked with gold and silver, it is a vivid reminder of the days when men competed with each other in the search for sensuous beauty. (See color plate 25.)

124. Lacquered toiletries box with design of floating wheels. Twelfth century. L. 22.5 cm. (8.8 in.), w. 30.5 cm. (12 in.), h. 13 cm. (5.1 in.).

Passing along the banks of the Kamo River in Kyoto, one could see wheels of bullock carts set out into the water in order to keep them from drying and warping— a mundane motif here converted into a design of extraordinary beauty. Lacquer paint made of gold dust in two shades—reddish and bluish—sets the wheels and water patterns off against the black background. Mother-of-pearl is inlaid into the rims of every other wheel, and wheel-shaped studs for the tying cord are made of silver.

125. Satirical drawing. Kōzan-ji. Twelfth century. H. 30.5 cm. (12 in.).

Four scroll paintings at Kōzan-ji are attributed to the hand of a twelfth-century monk Kakuyū, popularly known as Toba Sōjō. When seen as humorous drawings, they are of great charm; if interpreted as essays in satire, their interest and importance becomes much deeper. Using only a soft brush to draw a simple black line, the artist caught an amazing variety of gestures and expressions of men and animals in motion. Kōzan-ji was an active center of Buddhist scroll painting and employed many skillful monk-painters, of whom Toba Sōjō was the most famous. This drawing technique, incredibly deft and sure, may well have been a by-product of their training in Buddhist iconography.

126. Satirical drawing. Kōzan-ji. Twelfth century. H. 31 cm. (12.2 in.).

The scene of monks and townspeople in the midst of a heated tug-of-war appears in the set of four scrolls. As the capital became increasingly an arena of intrigue and religious and political struggle, the painters of Kōzen-ji may well have been moved to comment in this fashion on the affairs of the city. It is regrettable that these scrolls are occasionally labeled cartoons, for the vision which produced them was a sharp and penetrating thing.

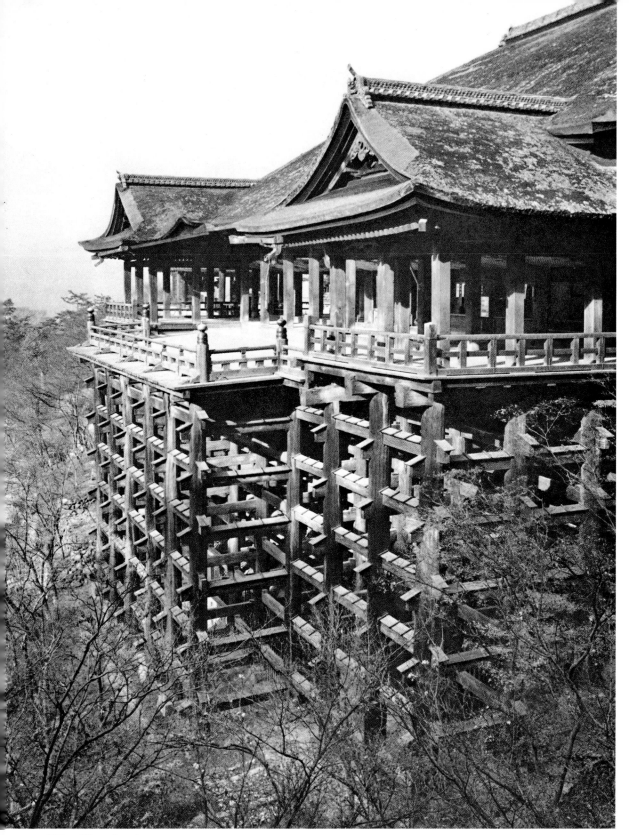

127. Kiyomizu-dera.
In keeping with its nickname, "the High Hall," the entire city of Kyoto can be seen from the viewing platform.

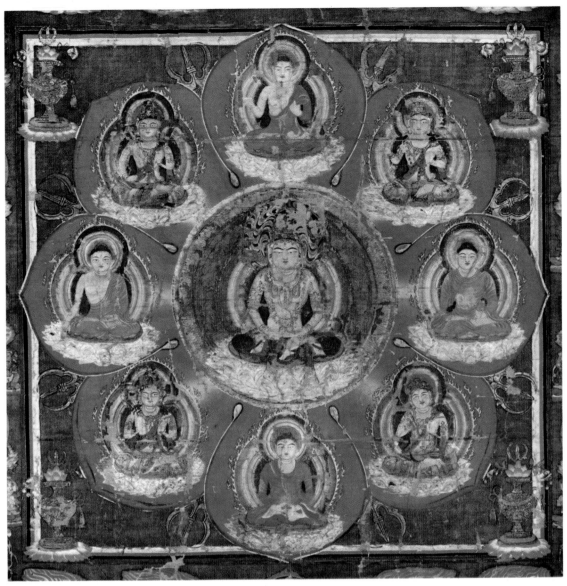

Plate 22. Mandala (detail of center section). Tōji. Late ninth or early tenth century. (See also figure 111.)

Plate 23. The Shishin-den, Kyoto Imperial Palace.
(See also figure 115.)

Plate 24. From *The Tale of Genji*, illustrated hand-
scroll. Twelfth century. (See also figure 118.)

Plate 25. A page from *The Anthology of the Thirty-six Poets*. Nishi Hongan-ji. Twelfth century. (See also figure 123.)

~⊘ *7* ⊘~

FROM DAIGO TO UJI

In the metropolitan area of Kyoto, prosperous and expanding today, many districts are still preserved in which episodes from its twelve centuries of history may be easily recalled. Outstanding among these is the stretch of land south of town from Daigo to Uji, linked by river and road with Nara and the rich Ōmi district around Lake Biwa. There one encounters a number of sites that speak eloquently of the past.

DAIGO-JI

Atop a steep mountain southeast of the capital, a Mikkyō-style monastery was built in the 870's by the monk Shōbō. The mountain and temple both were given the name Daigo, a word of Indian origin used to describe the essence of Buddhist teaching, and the prince who was to become the first imperial patron of the temple assumed the same name when he became the Emperor Daigo in 897. With his support and then that of his successors, the emperors Suzaku and Murakami, a more elaborate compound was built at the foot of the mountain on a site easily accessible from the city. At first, the religious movement of Esoteric Buddhism in Japan had burned with the spirit of reform, building its monasteries high in the mountains to escape the distractions of urban life. But as the period of such resoluteness passed and the pioneering spirit slackened, the Shingon sect aimed at establishing this new sanctuary close to the capital city. The five-story pagoda standing today at the foot of Mount Daigo may be seen as a milestone of this religious development. Inside the pagoda is an ancient mandala painted on the wooden walls, but in its color and composition the intense atmosphere of the earlier Mikkyō arts has been greatly moderated, a reflection of the taste for elegance in the nearby capital, if nothing else. Because of its links with the imperial court and the ranks of the aristocracy, Daigo-ji flourished and grew to be a major force in religious circles; large numbers of monk-scholars gathered there and developed their own variations of the Shingon creed. The temple compound as it appears today was greatly affected by the patronage of the supreme military ruler of Japan in the late sixteenth century, Toyotomi Hideyoshi, whose massive stronghold in the Momoyama Castle was close enough to be seen from the temple. In the spring of 1598, not long before his death, Hideyoshi

161

held a banquet for the viewing of cherry blossoms in the temple grounds, a party so lavish and expensive that it has lived in the annals of extravagance. The fact that the sacred grounds were thrown open in this way for a banquet shows the degree to which the Esoteric creeds had been drawn back into the common world; but in spite of this, their profound and mysterious doctrines were usually too difficult for the average layman to understand. Even the theological notion that enlightenment can be obtained here and now through austerities and prayer was too remote a goal for the men of the Heian period, accustomed to peace and the pursuit of comfort. A monk of the Tendai sect, Eshin Sōzu, was quick to notice this popular dissatisfaction and began to preach another doctrine of salvation.

THE PURE LAND CREED

Eshin restored to prominence the faith in the Pure Land (Jōdo) which had been rather ignored in Esoteric teaching, and he spread with great energy its major tenets: that the boundless love and compassion of Amitābha Buddha extends to all beings; that if a man simply recites the name of this Buddha with a sincere heart, he will be received after death into the Western Paradise, where he will find an atmosphere of such spiritual purity and eloquent teaching that *nirvāna* can be immediately attained. To those who had stood before the darkened universe of Esoterism, filled with frightful mysteries, this offered the vision of a brighter realm. For those who were living in fear because of the prediction that the world would enter its final stage of spiritual disintegration around the year 1052, this path to salvation brought great solace. Two texts written by Eshin became extremely influential, the *Ōjōyō-shū* ("A Collection of Principles Essential for Birth into the Pure Land," published in 985) and the *Jōdo Wasan* ("Poems in Praise of the Pure Land"). Moreover, a large painting was made according to a vision Eshin was said to have had while atop Mount Hiei. It depicted the Amida Raigō, the descent of Amitābha and a large following of Bodhisattvas and musicians in order to receive a man's soul. Such efforts convinced large numbers of people of the reality of the Raigō and the accessibility of the Western Paradise, and the Jōdo creed banished any trace of the grotesque from its main imagery. The painting based on Eshin's vision is kept today on Kōya-san, but was first displayed in Enryaku-ji on Mount Hiei. The golden image of Amitābha is in the center surrounded by a number of divine attendants riding on clouds; the Bodhisattva Kannon holds a lotus pedestal on which the soul of a dying man will be taken to Paradise. The proximity to earth is shown by a mountain top with trees and also some water; and the downward movement of the group is suggested by fluttering patterns along the trailing edges of the clouds and scarves. Some of the members of the heavenly host bear flowers, others join their hands in prayer, but most are playing musical instruments with a sense of fervor and joy. The visionary effect is enhanced by the elegance of the color scheme, with the golden figure of Amitābha in the center, and the delicately tinted bodies and garments of the host interrupted by the passage of transparent white clouds. Such an extraordinary religious icon can only have reflected the deep yearnings of men for the solace of divine grace. Among the ruling class, these feelings were especially strong, for having searched for gratification in this life, they hoped also to find it in the next, and they began building for themselves special private halls for the worship of Amitābha, the *amida-dō*. In these lavishly adorned chapels, they would sit absorbed in prayers and sermons and the rapture of their vision of blessed rebirth.

From early times, the Uji district has been a favorite resort of people of the capital; located along the river which threads the verdant mountain gorges from Lake Biwa, it is celebrated for its beauty and coolness in the summer. Here, a country villa of the powerful chancellor Fujiwara-no-Michinaga was converted into a temple by his son Yorimichi, and an *amida-dō* was built with the unstinting support of the wealthiest family in the land. Known popularly today as the Hōō-dō, or "Phoenix Hall," it stands at the edge of a small pond, its airy and colorful forms reflected in the still water. Its ground plan differs from that of the usual Amida halls in that it has two side wings extending to the right and left and also a taillike corridor in the rear; in outline it roughly resembles a bird with outstretched wings. The roofs are built in a variety of shapes, and the entire structure shows a great concern with the essential, creative aspects of the builders' craft. The second story of the wing corridors is too low for passage, and in fact the wings are present not for utility but for appearances; the building was conceived as a reproduction on earth of the jeweled palace of Amitābha in the Western Paradise, and it closely resembles those in Chinese and Japanese paintings of the theme.

In the center of the hall, seated on a lotus pedestal, is a statue of the deity, almost ten feet high, his face imbued with an expression of compassion and grace. The sculptor was the most accomplished and celebrated man of his generation, Jōchō Busshi. Although Amitābha had long exercised great religious appeal, images of him had not become sufficiently individualized or refined to satisfy the visions of his devotees. It was Jōchō, however, who finally answered this need, and this distinctive type of statue was soon adopted throughout the land. The expression of compassion on the face was not the only characteristic feature of Jōchō's style. A sense of tranquility arose from the equilibrium of the clearly defined masses of the body, and there was also a warmth in the sheer elegance and precision of the carving. For such large figures, Jōchō established rather simple proportions and shallow surface details in order that the statues could be constructed with many small blocks of wood and the labor divided among his assistants, a system rather like an assembly line which was soon widely imitated. Jōchō, who died in 1057, came to be regarded as the founder of this new method of workshop production as well as being the first of a new kind of master sculptor. His atelier, with the encouragement of the Chancellor Yorimichi, also provided the pedestal, halo, and canopies for the Phoenix Hall, carving them with the utmost refinement of craftsmanship; and their gilding and intricate openwork designs still invoke a visionary atmosphere of light and hope, even today.

High on the walls that enclose the seated Buddha are small carvings in shallow relief of some fifty-two Bodhisattvas and angels placed on clouds. Some of them are to accompany Amitābha when he descends to earth; others are to remain in the sky above. In addition, painted on the doors and wooden walls inside the hall are nine different versions of the Raigō motif, for, theologically, those reborn in Paradise are to be divided into nine classes according to the nature of their faith and good works. But regardless of these distinctions, each painting shows equally the welcoming of the souls of the dead and thus offers assurance that all who sincerely wish it may enter Paradise. The saving grace of Amitābha is shown as reaching different types of people, extending even into a mountain hut and across a field of grazing horses. In the painting technique, it is difficult at times to distinguish between passages done in the *yamato-e* style and those in the traditional Buddhist manner, for the two have been closely harmonized. Just as Jōchō

produced a new, classic type of Amitābha image in response to the needs of his time, so in the realm of painting, new requirements were also satisfied: the miracle of divine salvation was placed into the local landscape. (This is yet another manifestation of how the arts of this period took on a strong national flavor.) And with all the skills in the luxury arts concentrated in the capital, the image platform and upper tie beams were adorned with brightly painted designs, mother-of-pearl inlay, and gilded metal fittings. A person entering this chapel, his eyes enthralled by such a display, might well have believed that he had already risen to the Pure Land of Bliss. The channeling of such religious fervor in architecture was not limited to the Chancellor Yorimichi, however. It was the aspiration of almost all wealthy and highborn people of the day.

Hōkai-ji

Not far from Uji is the small temple of Hōkai-ji, once the site of a country villa of Hino Sukenari, head of an influential family related to the Fujiwaras. Records indicate that during the Heian period, no fewer than three Amida halls were built within these grounds, and one of them is still standing. Its patron lacked the resources and power of Yorimichi, and the architecture is more straightforward than that of the Phoenix Hall, having fewer radical inventions. If only because of the wide eaves and corridors which encircle the hall, it has the simplicity of a private dwelling and is probably more typical of the Amida halls ordinarily built during the time. The interior has a quiet, tasteful atmosphere, while the statue of Amitābha closely resembles that of Jōchō at Uji, if somewhat less eloquent. The angelic figures high on the walls are painted and not carved, and have a strangely sorrowful air about them. The members of the family may well have preferred the tranquility of their more humble building as they kneeled there at sundown, facing westward and reciting the *nembutsu*, muttering the name of Amitā-bha over and over. Yet the atmosphere around the capital, overripe with wealth and privilege, did not really encourage a quietly religious way of life. The courtiers tended to display their own wealth and power in the guise of pious building, and thus satisfied their desire for pomp and worldly glory.

The Building of Hōjō-ji

This new pattern of aristocratic patronage had been set by the father of Yorimichi, the Chancellor Michinaga (966–1027), whose thirty years of rule as the virtual dictator of the land marked the climax of the influence of the Fujiwaras. He constructed an immense temple called Hōjō-ji along the banks of the Kamo River on the eastern out-skirts of the capital, and entrusted the carving of the cult images to a workshop of which Jōchō became the leading figure. Records and descriptions of the temple are abundant, but unfortunately all traces of its buildings and statues have disappeared. The first major hall was completed in 1020, the Muryōju-in dedicated to Amitābha, who was represented by nine separate statues, each sixteen feet tall. The fact that this was the first hall completed indicates its importance to Michinaga, and indeed, at his own request, his dying moments were spent there, the *nembutsu* on his lips and the sounds of the chanting of the *Lotus Sutra* in his ears. The *kondō* was completed in 1022, and its imagery belonged to the older iconographic tradition: a statue of Dainichi (Mahāvairo-cana) over thirty feet tall, flanked by statues of the Bodhisattvas Mañjuśrī and Maitre-ya, eighteen feet high. Also on the altar platform were the figures of Indra, Brahma,

and the Four Guardian Kings. The other main hall was the Godai-dō, completed the same year, and dedicated to the Five Radiant Kings of the Esoteric Buddhist system. The central cult image was Fudō Myō-ō, eighteen feet tall, and it was surrounded by the other four Myō-ō, each sixteen feet high. There had been temple projects on a vast scale like this before, usually supported by the imperial court with the resources of the state, but this one was undertaken by a single courtier. He was, however, one who could accurately describe himself in a poem: "This world, I think, is indeed my world. Like the full moon am I, uncovered by any cloud." And it should be assumed that for all his genuine piety, Michinaga built the Hōjō-ji as the ultimate demonstration of his power and authority. According to the description of this project in the *Eiga Monogatari* ("Tales of Glory," a historical narrative of the day), over a hundred men with the rank of *busshi* were employed on the statuary, and many hundreds of craftsmen labored on the construction of the halls. With such prodigious expenditures of labor and materials, the aristocrats must indeed have expected the richest of spiritual rewards—for such was their way of thinking.

THE RETIRED EMPEROR SHIRAKAWA

As the Heian period drew to a close, an old Buddhist custom of a ruler abdicating the throne in order to enter a monastery became increasingly common. Along with the opportunity to concentrate on spiritual discipline, these abdications were also politically inspired, for a Japanese emperor in the guise of a monk had far greater freedom of action than he did when hedged by the ancient rituals and protocol of semidivine sovereignty. Thus the peculiar institution of the *insei* ("cloister government") came into prominence, especially when the Emperor Shirakawa abdicated in 1086 and, while giving himself over to meditation and religious activity, nonetheless remained active in the government for over forty years and schemed to suppress the power of the Fujiwaras. Such was his piety, though, that he is recorded in his lifetime as having commissioned Buddhist statues in the following quantities: standing images sixteen feet high, 5; seated images eight feet high, 127; life-sized statues, 3,150; those smaller than three feet high, over 2,930. The donation of images in excess of even these numbers became a major tendency at this time, for they would be installed in temples in groups of a hundred or a thousand. Spurred on by the example of the "cloistered emperors," the courtiers competed with each other in the size of their donations, not for the sake of spiritual blessings, but rather to gain divine assistance for worldly goals. The custom reached the point where, today, the records read like fantasies. The same excesses took place with Buddhist painting and the copying of sutras, but sculpture was the most important idiom. Naturally, it was impossible to maintain high aesthetic standards in the pursuit of sheer numbers.

The technique of making statues in vast quantities had been perfected by Jōchō, who devised the processes of assembled woodblock sculpture and of mass production, and who also reorganized the sculpture workshops (the *bussho*) into very elaborate corporations. In time, however, these workshops were forced to expand and develop new branches in order to keep up with their commissions.

EXPANSION OF THE SCULPTURE WORKSHOPS

To be closer to the site of the greatest building activity, Jōchō moved his atelier from

Nara to Kyoto; when he was succeeded by his son Kakujo, the shop was called the Shichijō Bussho, named for its location on Seventh Avenue. The following two generations of sculptors in Jōchō's tradition formed and reformed themselves into a number of other workshops bearing the names of their locations. One group worked at Sanjō (Third Avenue) in Kyoto; another group returned to the old workshop in Nara; another set up operation near the corner of Shichijō and Ōmiya avenues in Kyoto; yet another was near Rokujō (Sixth Avenue). Large numbers of students and craftsmen were active in these shops, and despite the fact that there was an almost insatiable demand for statues, a strong spirit of competition broke out among the ateliers. In Jōchō's time, the status of the master craftsman was at last officially recognized, and the heads of workshops appointed to increasingly high ecclesiastic ranks; but these too became the object of disputes. The style of these workshops was a mere repetition of the classic types established by Jōchō. Satisfied with their role as inheritors of a famous tradition, they had little desire for innovation and followed the well-marked path; as a result, the statuary they produced became increasingly formalized. It was also linked with the general pursuit of outward splendor and elaborateness of the day, and this became a heavy burden artistically for Buddhist sculpture to bear. It is ironical indeed that in this era of feverish enthusiasm for the commissioning of images, as the carving techniques and construction of statues themselves greatly advanced, aesthetic values declined markedly. This closely resembles the collapse of the social and political system of the patrons of the workshops, the aristocracy of the Heian capital—self-centered, steeped in excessive luxury, and increasingly out of contact with the realities of national life.

The doctrines of the Pure Land comprised a much easier path to salvation than the austere and complex ones of the Esoteric sects. For the most part, they had a popular character, but in order to develop among the elite classes of the capital, the Jōdo sect took on certain aristocratic traits. As a result, new subsects sprang into being in order to take advantage of this chance to preach the creed of the Western Paradise among the masses.

The late Heian period was not one in which the religious spirit soared to great heights. But even though the fears concerning the End of the Law and the deep longings for Paradise in the next life may have been mass illusions, they were ones which inspired exquisitely and elaborately executed works whose remains today give great pleasure. The illusions have largely vanished, but around the temple sites in the southeast suburbs of the capital still grow the gentle, feathery mōsō bamboo, as though guarding the ancient atmosphere. Carefully tended tea gardens have been added to the area, and here and there are stone Buddhist images along the wayside, set up by villagers in recent centuries. A district like this offers rich insights into the entire, long history of the Heian capital.

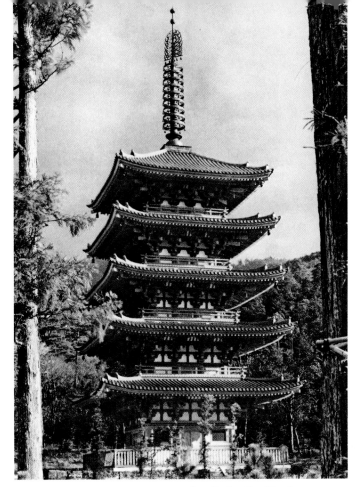

128. Five-story pagoda, Daigo-ji. Tenth century. H. 38.2 m. (118.75 ft.).

Enclosed by pine trees, this handsome structure is somewhat difficult to see or approach. It is similar in form to the pagoda at Hōryū-ji; but where the older monument has scenes from the life of Śākyamuni depicted in dry clay groups on the ground floor, in this one are paintings of mandalas and portraits of the founders of the Shingon sect. The oldest portion of the temple is on top of Mount Daigo in a dramatic setting typical of early Esoteric Buddhism in Japan. The construction of this pagoda and the rest of the compound at the foot of the mountain was an effort to make the sanctuary more accessible to the laymen of the capital city.

129. Detail of wall painting, interior of the pagoda. Tenth century. W. 70 cm. (27.5 in.).

The boards which encase the central mast of the pagoda are painted with many small figures of deities arranged in two mandalas. Although somewhat faded, the original coloring is otherwise well preserved in places. The hard outlines and modeling of the figures with reddish shadows are all traits of an archaic Buddhist style; the radiant halos and those painted with whirling patterns are peculiarities of Esoteric Buddhist symbolism. But one feels here that the fierce energies of early Mikkyō art have weakened. The color relationships are rather tranquil, and applications of cut gold show the tendency toward elegance in Buddhist painting of the mid-Heian period.

130. Garden and palatial buildings of the Sambō-in,
Daigo-ji. Late sixteenth century.

One of the important subtemples at Daigo-ji, this site
has long been used to house the abbot of the monastery
and royalty or other persons of high station coming to
the temple for their devotions. The current buildings
and gardens were constructed in the manner of an
aristocratic residence with the patronage of Toyotomi
Hideyoshi, military ruler of Japan from 1584 to 1598.
Together with the painted screens inside, the Sambō-
in is one of the most exquisite examples in later Japa-
nese architecture of the fusion of garden, building, and
paintings into a single aesthetic unit.

131. The *karamon* of the Sambō-in, Daigo-ji. Late sixteenth century.

This *karamon* ("Chinese gate"), ceremonial entrance to the garden of the Sambō-in, was erected as part of the preparations for the lavish banquet at cherry blossom time given by Toyotomi Hideyoshi in 1598. It is the classical example of the so-called *hira-karamon* gate, its roof of cypress-bark shingles having a gable at each end and a simple, unbroken frontal surface. The central doors are carved with bold designs of paulownia blossoms in low relief, Hideyoshi's emblem; the two side walls bear chrysanthemum flowers with twelve petals. In contrast with the delicacy of the gate itself, the floral motifs are assertively bold.

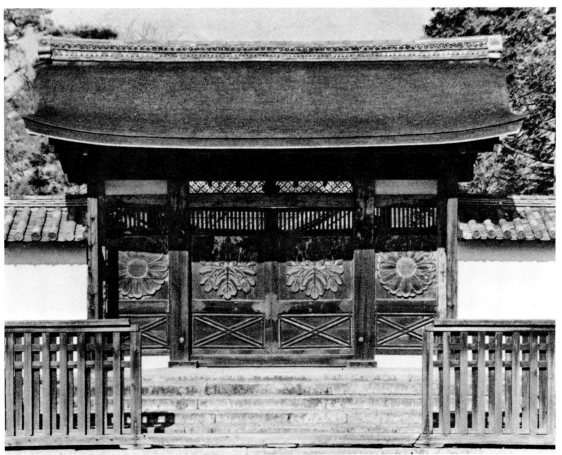

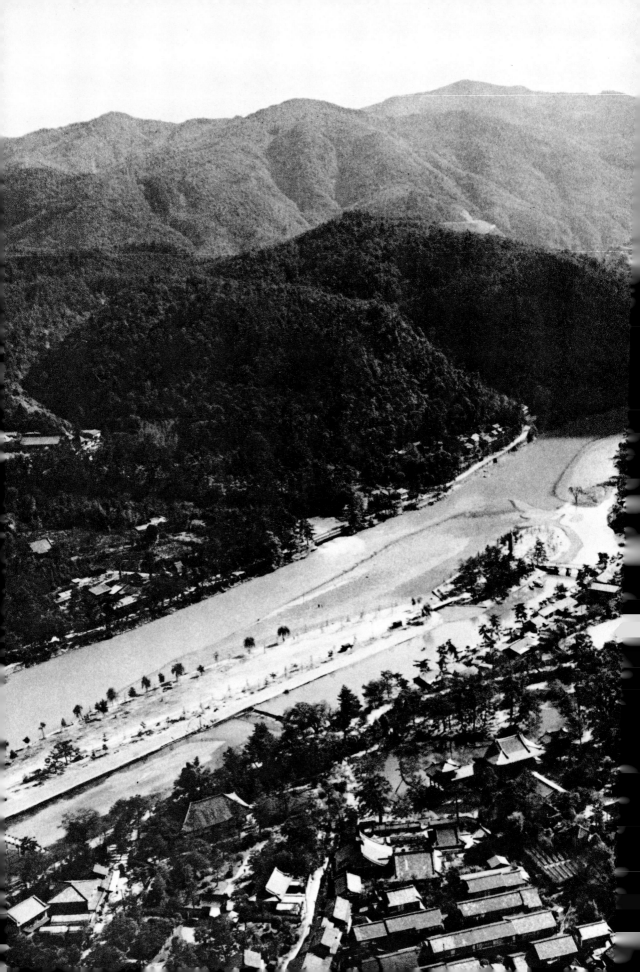

132. The Uji River gorge and the Byōdō-in.
The swift Uji River threads its way through the mountains, its waters fed by the overflow of Lake Biwa. Its cool and verdant banks have long attracted people of the old capital during the heat of summer. In the foreground is the Byōdō-in, where a country villa of the Fujiwara chancellors was converted into a temple in the eleventh century; its Phoenix Hall, seen from the rear, stands at the edge of a small pond once given the shape of the Sanskrit letter A. On the opposite bank is the chief Shinto shrine of the area, the Uji Kami Shrine, and the Hōshō-ji (Hashi-dera).

133 (overleaf). Phoenix Hall of the Byōdō-in, Uji. Eleventh century. Central hall, 33.8 × 16.3 m. (110.8 × 53.3 ft.).
The Phoenix Hall is a model of the heavenly palace of Amitābha as it had long been envisaged by Chinese and Japanese Buddhists, and inside is a large gilded statue of the Lord of the Western Paradise. The color of the exterior woodwork is a faded cinnabar, set off by the brilliant white of the plaster; the eaves of the gray tile roofs are turned gently upward, and the ranks of slender columns seem to bear their load with ease—the ensemble reflected in the shimmering waters of the pond before it. As if such visionary beauty were not yet enough to set this structure apart from the profane world, the water of the pond entirely surrounds it.

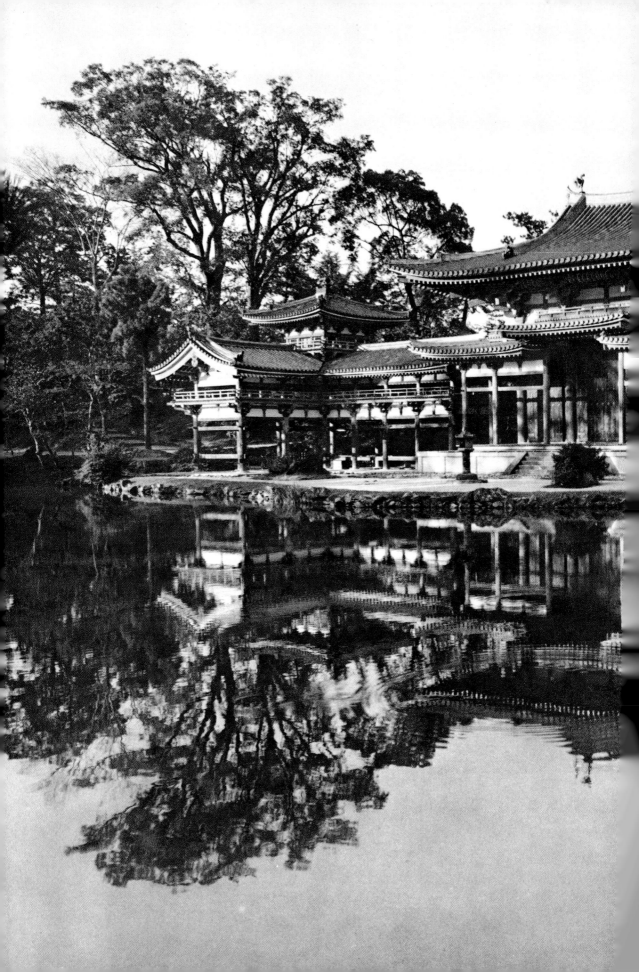

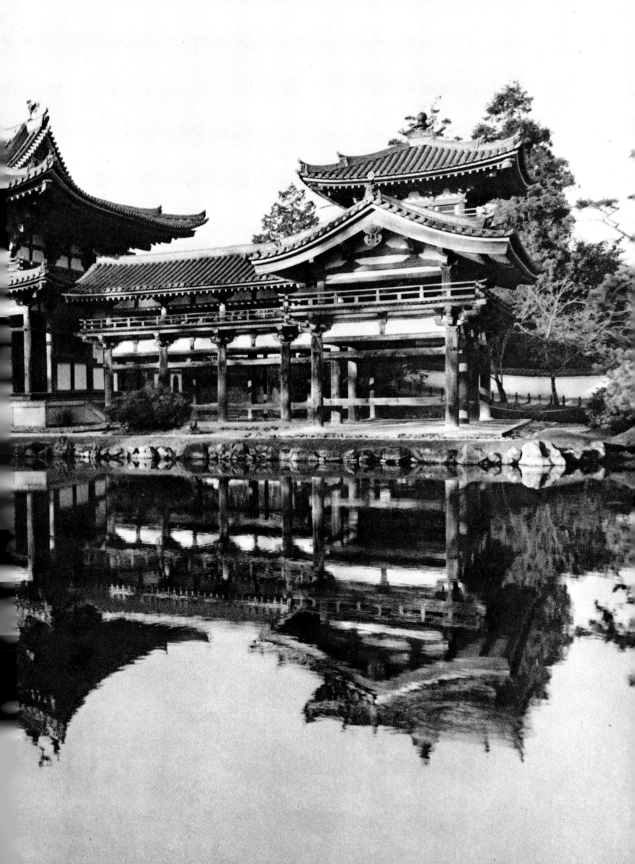

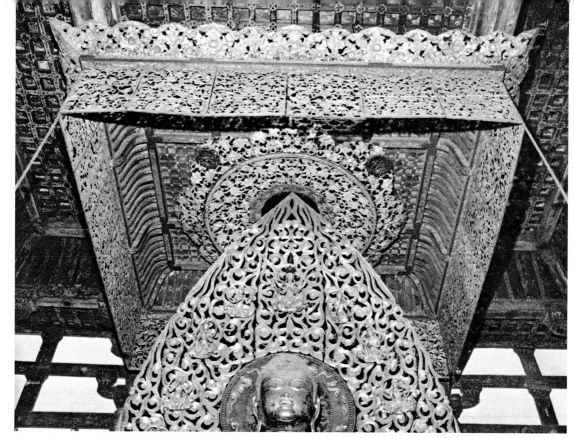

134. Canopy, Phoenix Hall. Eleventh century. Canopy, 4.36 × 4.87 m. (14.8 × 15.95 ft.); diameter of circular element, 2.94 m. (9.68 ft.).

Suspended over the head of the main cult image of Amitābha is a gilded canopy of openwork wooden panels carved with floral patterns. Part of the original furnishings of the hall, these forms are permeated with the artificial, intensely visionary atmosphere of the Pure Land creed.

135–36. Angelic musicians. Phoenix Hall. Eleventh century. Average height, 50 cm. (19.6 in.).

Fifty-two separate wooden figures are placed high on the walls which enclose the statue of Amitābha—musicians, dancers, Bodhisattvas, and even monks. Each stands on a soaring cloud and was originally painted and ornamented with cut-gold patterns. Averaging less than two feet in height, the figures are pervaded by a spirit of lyricism and unworldly beauty appropriate indeed to the "Paradise of Limitless Bliss."

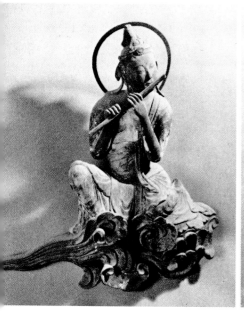
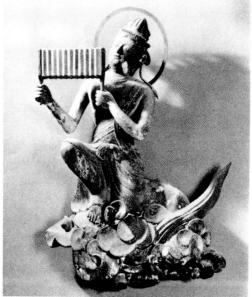

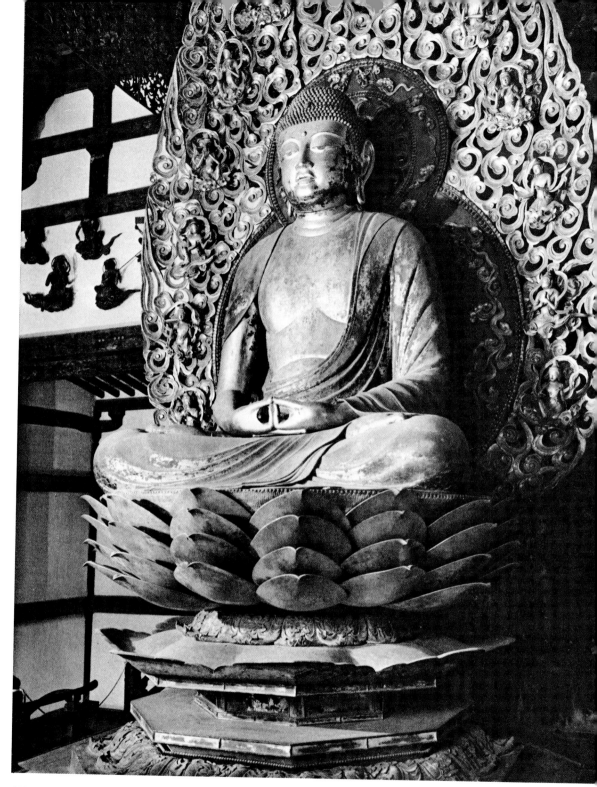

137. Amitābha Buddha. Phoenix Hall. Eleventh century. H. 2.84 m. (9.31 ft.).

Superlatives are concentrated in this statue: the patronage of the Fujiwaras at the apogee of their wealth and power, the skills of the most celebrated sculptor of the age, Jōchō Busshi. The result, within the limitations of a cult image, is one of the most subtle and exquisite achievements of the Heian period. The wide lap enhances the feeling of stability in the figure; the chest is relatively flat and its sense of volume restrained. The garment folds are shallow and carved with crispness and semigeometric simplicity. The eyes of the Buddha seem to look down upon the devotee, and the facial expression is suffused with serenity and compassion.

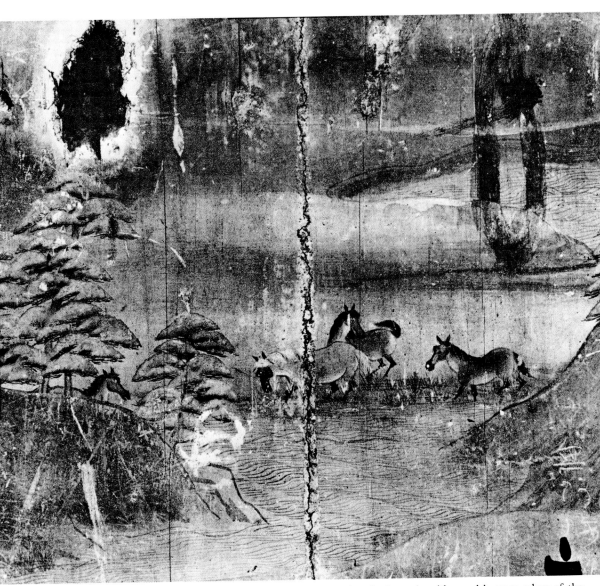

138. Detail from painted door, Phoenix Hall. Eleventh century.

Nine separate versions of the descent of Amitābha and his attendants to receive the souls of the dying were painted on the interior wooden walls of the Phoenix Hall and also on the inner faces of the doors. Scenes of local folk customs and landscape, such as this tiny detail of horses grazing along the banks of a stream, were placed along the sides and bottom edges of the complex compositions. The subordinate sections were painted in the *yamato-e* style, whereas the deities themselves were done in the more traditional Buddhist manner. The two styles nonetheless harmonize with each other, and it was very much in the spirit of the age to combine religious and secular imagery this way.

139. Detail from painted door, Phoenix Hall. Eleventh century.
Amitābha and his attendants were painted in the traditional Buddhist style formed in China during the T'ang period out of local and Indian elements and adopted throughout East Asia. The contour lines in red are rather hard and unvaried, the faces and bodies highly idealized; the color scheme is unrealistic and sumptuous in spirit. Nonetheless, these figures are imbued with a greater softness and lyricism than those, say, of the frescoes of the *kondō* of Hōryū-ji, reflecting the passage of the centuries and gradual change in religious attitudes. (See color plate 26.)

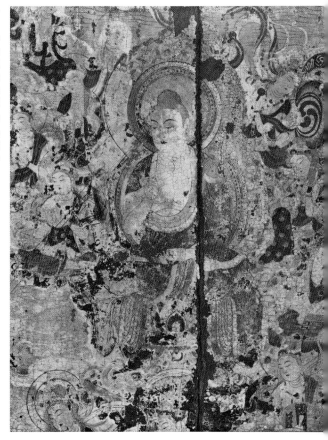

140 (overleaf). Interior of the *amida-dō*, Hōkai-ji. Twelfth century. H. 2.84 m. (9.13 ft.).
This statue of Amitābha has a tranquility and quiescence fitting the modesty of the hall. A classic example of the type of Amitābha perfected by Jōchō, it sits on an elaborate lotus pedestal symbolic of the nine divisions of the Western Paradise; the hand gesture is the one peculiar to Amitābha when in a state of deep meditation.

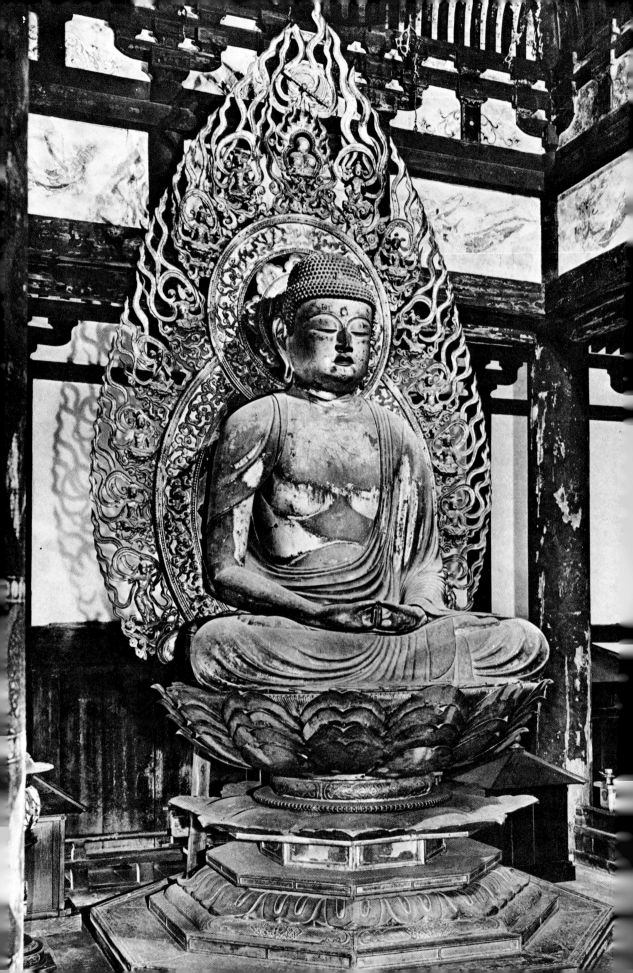

141. Flying angel. Wall painting, Hōkai-ji. Twelfth century.
High on the interior wall of the *amida-dō* of Hōkai-ji are painted flying angels. The rather broad, relaxed manner of working, with great variation in the lines, is the result of a new wave of artistic influence coming from Sung China.

142. *Amida-dō*, Hōkai-ji. Twelfth century.
This hall dedicated to Amitābha was part of a large, aristocratic country estate. Similar in function to the Phoenix Hall of the Byōdō-in less than two miles away, it is much more modest in structure. The corridor running around all four sides and the cypress-bark roof give it a relaxed air, yet the curving of the eaves adds a touch of refinement and delicacy.

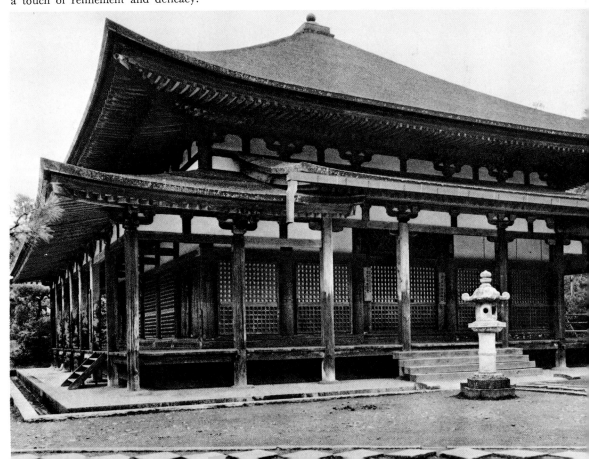

143. Bamboo groves and tea gardens near Uji.

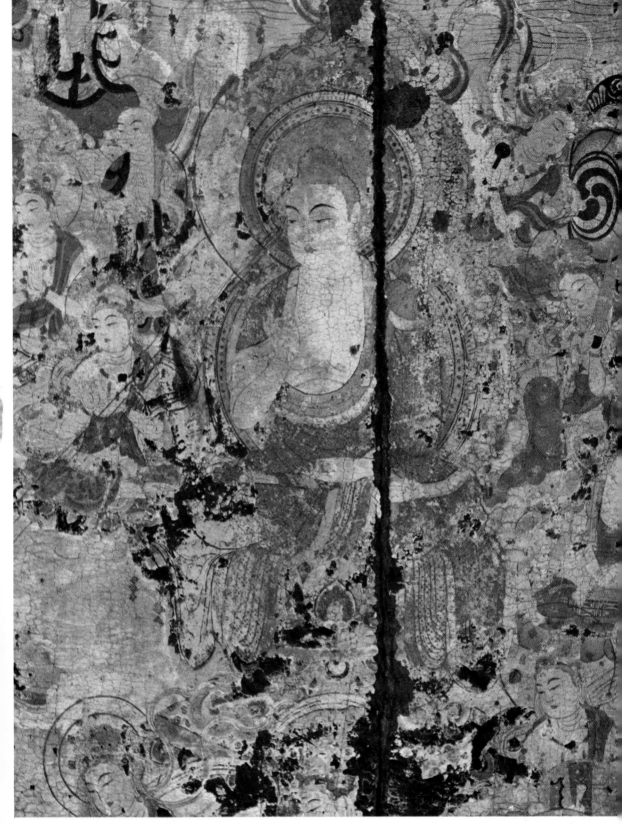

Plate 26. Detail from painted door, Phoenix Hall.
Eleventh century. (See also figure 139.)

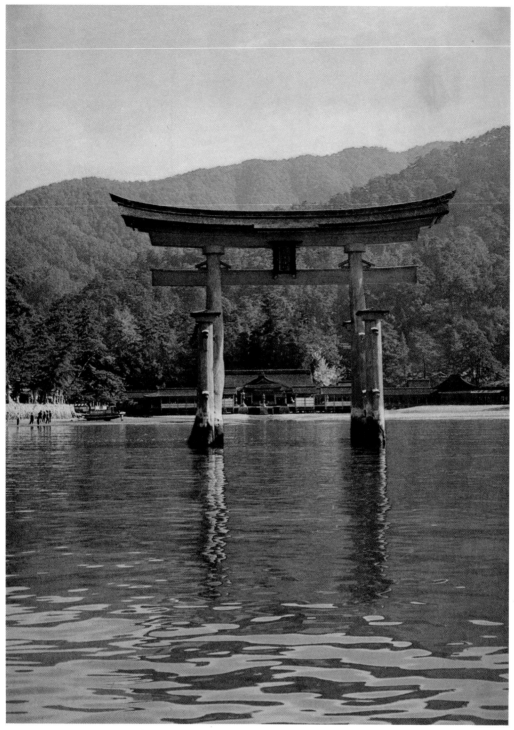

Plate 27. Distant view of the Itsukushima Shrine.
(See also figure 144.)

~⊛ 8 ⊛~

PROVINCIAL CENTERS:
ITSUKUSHIMA AND HIRAIZUMI

The hold of the Fujiwaras over the economic and political life of the country was gradually broken during the period of the cloister governments, and their position was contested by military families who had once been their subordinates. For a while the confederation of forces led by the Taira clan gained supremacy over their chief rivals, the Minamoto, and energetically took up the reins of real political authority. The Taira clan, who are often referred to as the Heike, were established with great pomp at the center of life in the capital and steeped themselves deeply in its atmosphere of religious and poetic sentiment. This luxurious way of life had great appeal also for influential families in the provinces, who prided themselves on emulating the culture of the great metropolis, just as governors sent out from the capital would console themselves by bringing along the latest fashions of dress, devotion, and architecture. This process of diffusion reached many places, but its most celebrated relics are at Itsukushima, near Hiroshima in western Japan, and at Hiraizumi in the northeast part of Honshū.

ITSUKUSHIMA

Unique in its beauty, as though floating on the waters of the Inland Sea, the current Shinto shrine of Itsukushima was conceived at the time the Taira clan began their rise to power. The patron was the warrior who led his family to supremacy, the bold and impetuous Taira-no-Kiyomori, who was sent from Kyoto in 1146 as governor of this region, then called the province of Aki. He offered devotions at what was then a small but ancient shrine erected over the off-shore waters of a tiny island in Hiroshima Bay. Struck with its air of sanctity and natural beauty, he chose it as the tutelary shrine of his family, and as his power increased, conceived the extraordinary plan of the buildings which stand there today. Kiyomori also schemed to reopen trade and commerce on a large scale with south China, ruled by the remnants of the Sung Dynasty, and to develop Hiroshima and other ports on the Inland Sea for this purpose. He naturally felt great hesitation about so hazardous and expensive an operation, but just as the Fujiwaras had made the Kasuga Shrine into their family shrine, he resolved to have a suitable deity to protect the enterprises of the Heike. Thus, when Kiyomori's daughter

183

became pregnant with the heir apparent to the throne, she came to the Itsukushima Shrine to pray; and all members of the family, and their vassals as well, must have come many times for their devotions.

Kiyomori built the shrine with the same audacity he used in his military and political affairs. It was not in his character to be content with the usual custom among the aristocracy of building a hall dedicated to Amitābha and praying fervently for rebirth in the Western Paradise, so he erected a great shrine comparable to an *amida-dō* and prayed to the sea for worldy success. Indeed, in the concept of architectural beauty, the closest parallel to the Itsukushima Shrine is the Phoenix Hall at Uji. Just as many of the Amida halls, faithful to the descriptions of Paradise in the sutras, were built beside small ponds which reflected the beauty of the structure, Kiyomori substituted the ocean for a pond and took advantage of the novel effects of the rise and fall of the tides. In this change to a more dynamic, moving kind of beauty, the sensibilities of a new era were coming into play. The shrine buildings were connected by long corridors of the sort found in the Imperial Palace and great mansions of the capital, and even garden pavilions and the like were adopted by Kiyomori's architects for the Itsukushima Shrine. The techniques of building in a dramatic and even perilous setting had, of course, been developed in the mountain temples and rustic villas of the period. Unique, however, was the large scale of the Itsukushima Shrine and its consummate beauty, created by a synthesis of many building and ornamental techniques. It was indeed a dreamlike conception, but the pragmatic realism of a military man translated the dream into concrete substance.

Kiyomori not only built a splendid shrine, he also attempted to transplant the courtly arts of the capital there. From his time to the present, the shrine has maintained traditional forms of dance and music along with a number of fine *bugaku* masks from Kyoto, as well as other costumes and instruments. *Bugaku,* which literally means dance and music, had been transmitted to Japan in the Nara period from T'ang China, and was made up of dance forms from courts and temples throughout East Asia, India, the oasis cities of Central Asia, and the Indies (Java, Sumatra, Malaya, and Champa). It had many elements in common with the *gigaku* dance, which was slightly older. In the Heian period, *bugaku* was greatly refined and some of its gaucheries weeded out; the children of the aristocracy were given training in one or another of its dances as part of their cultural education. Because it was frequently performed in secular settings, its instrumental music and dance forms could develop freely, and the wooden masks also increased in subtlety and refinement. The old sanctuaries of Nara have *bugaku* masks of this period—the Kasuga Shrine, the Tamukeyama Shrine (at Tōdai-ji), and Hōryū-ji—but those of Itsukushima are by far the finest, for only the best of things were brought here from the capital.

The shrine dances are still performed in a solemn, liturgical way on the stage which projects out over the water. Between the brilliant sky above and the broad, blue plane of the sea, this form of devotion invokes the gods of the Shinto pantheon in a distinctive way. In contrast to scenes of the Amida Raigō, in which exquisite music is shown descending from heaven to earth, here the music of earth rises into the realm of the gods. Salvation through faith and the divine grace of Amitābha is contrasted to this emphasis on the works of man himself, a resoluteness which reflects the spirit of the warrior class. In later centuries, the Itsukushima Shrine came to be worshiped as the tutelary shrine of music itself, and even today many other idioms in addition to *bugaku* are performed there, including the Nō dance-drama which became a major art form in the early

fifteenth century. The seeds of the *bugaku* which the Tairas transplanted from the capital continued thus to bear fruit. But beyond this, there are other relics at the shrine which call to mind the extravagant dreams of the Heike.

One of these is a set of Buddhist scrolls of unequaled richness which they gave to the shrine. Itsukushima was a Shinto sanctuary, to be sure, but the two creeds were closely intertwined during this time and their pantheons correlated—one of the deities of Itsukushima was considered a manifestation of the Eleven-headed Avalokiteśvara. Moreover, fears concerning the End of the Law had continued unabated, along with the great stimulus which this notion brought to the copying of texts. Throughout the twelfth century, great energy and funds were expended in copying the *Lotus Sutra* on paper or more permanent materials—on tiles, stones, or engraved bronze plates—and burying these in the earth for the use of later generations. In some districts, images and even ritual implements were buried with the texts in special depositories called sutra mounds. The set of scrolls donated by the Heike contain calligraphy which perhaps is not of the highest quality, but the design and ornament were carried out in a manner unparalleled by anything in the past. Each scroll is different, and even on the reverse of the paper (itself of the thinnest, finest quality), flakes of silver and gold were deftly applied. The color of the characters used in the text was richly varied, and at the opening of each scroll was attached a painting illustrating its religious content. The name of the text, engraved on a silver plate, was affixed on the outside, while the ends of the rollers were made of crystal covered with fine, openwork gilt-bronze patterns. The scrolls were placed in cases made of darkened bronze ornamented with dragons and clouds of gold and silver. In the records of this period are frequent references to the making of sutras whose extravagant beauty astonished those who saw them, but it is hard to imagine anything surpassing these donated by the Tairas; certainly there is nothing among the large number of scrolls preserved today. To be sure, this was a period in which aesthetic sensibilities were being lowered; ornament alone became weak and inelegant when applied with excess; but in the Heike scrolls the full resources of traditional design techniques were marshaled in the same way that building techniques had been exploited for the shrine itself. These scrolls were not buried in the earth for use in the distant future but were offered to the family deity, showing thus both the deep faith of the Heike in the Itsukushima Shrine and also their concern with the world of the here and now, even while pursuing a vision of unearthly beauty.

The shrine preserves quantities of fancy military equipment—armor, helmets, and swords—given during the ascendancy of the Heike by their commanders praying for victory in battle, or offered in gratitude after a successful campaign. As the warrior class (the samurai) gained in influence, its regalia naturally became more ornate. This being a period in which luxury and color permeated the lives of the elite, the warriors took great interest in the appearance as well as the utility of their arms. The equipment of the Heike is more consummately elegant than that even of the Kamakura period, when the military class came completely into its own, politically and culturally, for the aestheticism of the Heian age was retained despite the needs for strength and dependability. The shrine has kept for centuries the armor of majestic dark blue said to have been given by Taira-no-Shigemori, Kiyomori's favorite son, in which the color is not especially gaudy but is striking in the tasteful variations of a single hue; there is beauty moreover in the sheer precision by which the complex form was assembled. This custom of donating military equipment began at the Itsukushima Shrine but later was practiced by samurai at Ōsanjima in the Seto Inland Sea, at the Kasuga Shrine in Nara, and at

other shrines. It is extremely interesting to see these new forms of devotion of the warrior class replacing those of the aristocracy. Thus it was that Itsukushima became an important center of activity in art and building in the Heian period. In much the same way, at the temple of Fuki-ji in Ōita Prefecture, Kyūshū, the remains of an exquisite wall painting of the Paradise of Amitābha also show strongly the influence of the capital. If one looks for them, there are many other traces of the arts of the Heian-kyō in the remote provinces.

Hiraizumi

The customs of the capital city were transplanted to the far northeast as well. From very early in the Heian period, military expeditions had been dispatched to drive ever northward on Honshū Island the people referred to as Emishi, ancestors of the present-day Ainu, who differed ethnically and culturally from the Yamato race. After the pacification of these ferocious tribesmen, troops were stationed to guard the northern quarter of the island, and these became the nucleus of the dominant forces of that area. A branch of the Fujiwaras was established there, and as they grew in power a small version of Kyoto was developed at Hiraizumi, for even in these remote regions, people yearned greatly for the life of the capital. It had long been said that culture stopped at the Nakoso Barrier, the road checkpoint along the Pacific Ocean some 115 miles north of modern Tokyo. But not far from there, at Shiramizu, was such an elegant *amida-dō* that one might have thought himself in the suburbs of Kyoto itself when he came upon it. Inside, the trinity of Amitābha and two Bodhisattvas were also done in the full style of the metropolis. The hall had been pledged by the wife of a Taira baron for the benefit of his soul after his death, she having been the daughter of Fujiwara-no-Hidehira, descendant of the members of his clan who had set up a virtually independent state farther to the north. Despite its remote location, this small hall at Shiramizu does not have the slightest provincial flavor, for the northern Fujiwara had abundant wealth and could well afford the finest flowers of the arts of the Heian-kyō.

The Fujiwaras in the northern provinces began to vaunt their expanding power after the so-called Three Years' War (1086–87), when they ensured their full control of the provinces of Mutsu and Dewa and the large quantities of placer gold found in rivers there. With such wealth and large numbers of disciplined warriors, they became a major factor in the two-way struggle for national supremacy between the Taira and Minamoto and were deeply involved in affairs at the capital. Hiraizumi was their stronghold, and it was patterned after Kyoto—its streets laid out in the same grid system, and even the site itself selected because it resembled that of the Heian-kyō. Its greatest temple was Mōtsu-ji, in ruins today; originally it had over forty halls and pagodas in its compound. One of these was the Muryōkō-in ("Hall of Limitless Light"), whose foundation stones still stand by a pond, and from these it has been deduced that the hall closely resembled the layout of the Phoenix Hall at Uji, although its scale was much smaller. Another sanctuary, Chūson-ji, was built as a memorial and consolation to the souls of men lost in the struggles to pacify these provinces, and it too once had over forty halls and pagodas. But in 1189, because the northern Fujiwara had given help to the Taira, a huge army led by Minamoto-no-Yoritomo besieged Hiraizumi and put it to the torch. The only major building to survive the holocaust was the *amida-dō* of Chūson-ji, called the Konjiki-dō ("Hall of Golden Hue"). Although a very small building, it served in part as the actual tomb of the three most powerful members of

the local Fujiwara family, for their embalmed bodies were buried beneath the image platform.

The Konjiki-dō was erected by Fujiwara-no-Kiyohira in 1124, and though it does not differ much in size from the Shiramizu *amida-dō*, in ornamentation it is as lavish as a jewel box. The interior of the Konjiki-dō is decorated with inlaid gilded metal fittings, mother-of-pearl, and painted lacquer; elsewhere in the interior, and on parts of the outside, gold leaf has been applied over lacquer. Probably the interior of the Phoenix Hall at Uji had the same kind of showy brilliance, but because it was near the metropolis, most of its fittings and inlay have been defaced by excursionists and almost all lost. The Konjiki-dō has had far fewer visitors, so its original internal decor is almost completely preserved; it is ironical, however, that the forms once prevalent in the capital can best be recalled in a building hundreds of miles to the northeast. Kiyohira's motives for constructing this kind of hall were based, of course, on the doctrines of the Pure Land which had spread throughout Japan at this time, stimulating the desire to immerse oneself in the rapture of Paradise as it could be imagined or recreated on earth. Kiyohira also planned from the very beginning to make the Konjiki-dō his own final resting place after death, which indicates his unusually strong devotion to the Jōdo creed. The Buddhist statues on the image platform, with the Amitābha trinity in the center, are all rather small (none is over two feet high), for they too were part of the same original plan. In fact, three complete sets of images, almost identical in form, are installed on three daises, for as the body of Kiyohira was placed under the central dais, those of his son Motohira and his grandson Hidehira were buried under the left and right platforms, respectively. In their similarities, the statues show how strongly the arts had been formalized at this time, but when they are examined closely, slight differences in feeling and expression can be detected.

Most noteworthy among the elegant fittings of the interior of the hall are those made of gilt bronze. Discs called *keman* (flower pendants) were hung from the edges of the overhead framework of the image platform. Their designs feature fabulous bird-women of Indian mythology, which were shown amid filigree floral patterns, their charmingly feminine forms built up in a delicate relief. Similar in style are thin bronze panels showing peonies and peacocks in low relief attached to the walls enclosing the burial chambers beneath the image platforms. Metal was used extensively in this way for decoration, but the craftsmen of the period averted any feeling of a cold, hard, or heavy substance. Also, mirrors were cast in forms far different from the grave and dignified ones in the T'ang Chinese manner hitherto in vogue. Thin and light, their ornament in delicate low relief, they are designated *wagyō* (Japanese mirrors), and like the *keman* and panel plaques, have the qualities of softness and warmth even though wrought of cold bronze. Also preserved at Chūson-ji are tables, frames for holding chimes, and other wooden ritual furniture covered with painted lacquer and inlaid with mother-of-pearl. Few objects of this sort have survived from the twelfth century, and in these rare examples, one can experience the extreme refinement of craft techniques and aesthetic sensibilities perfected over many generations. These are extremely delicate, perhaps excessively so, but they show to perfection this one aspect of the taste of the Japanese.

A wooden image of Dainichi survived from one of the lost halls of Chūson-ji; precisely which one, however, is unknown. The painted surface of the statue has an almost uncanny quality of warmth and femininity. It suggests the skin of a human being to such an extent that it has been given the popular nickname of "the Dainichi with human skin." Sculpture at the very end of the Heian period became highly formalized, its carving

techniques increasingly refined; but the power to evoke deep spiritual awareness was very much weakened. As they worked to achieve elegance and fine surface finish, the sculptors came close to the effects of realism. In the strict sense of the word, realism did not come to the fore again until the restoration of the Nara temples during the thirteenth century, but in sculpture this tendency had already begun, perhaps unconsciously, a century earlier. The effects of this development are readily apparent at Hiraizumi, for the trends in the arts of the capital were quickly adopted in the provinces.

Even as warriors, the men of the Taira clan or the northern Fujiwaras were entirely sympathetic to the culture of the old aristocracy and tried to perpetuate it at the very time they were breaking the political power of the Heian courtiers. Unexpectedly, however, both of these confederations were themselves removed from the political scene by their chief rivals, the Minamoto clan. Their fall may well have been speeded by their pursuit of visionary ideals which diverted their eyes from the harsh realities of the time. But objects of unforgettable beauty are still to be seen in the out-of-the-way places where these ideals were realized—like transplanted flowers which bloomed all the more luxuriantly in alien soil.

144. Distant view of the Itsukushima Shrine.
The great red *torii* rises from the sea at high tide, the traditional entry point for devotees coming by boat from the mainland. (See color plate 27.)

145. The corridors of Itsukushima Shrine.
The shrine structures are built on piers set out into the tidal flats and connected by long, low corridors with roofs of cedar shingles. When the high tide rises almost to the floors, the buildings seem to float as their cinnabar red is mirrored on the shimmering surface of the waters. This building shows to the utmost the ideal of Heian period architecture of establishing aesthetic harmony between a building and its environment. Its daring plan was carried out under the patronage of Taira-no-Kiyomori (1118–81). And though the prosperity of the Taira clan was short-lived and their downfall a melancholy anticlimax, the extraordinary concept of their family shrine has come down to us remarkably intact.

146. Sutra scroll donated by the Taira family, Itsukushima Shrine. Twelfth century. Height of scrolls, approx. 26 cm. (10.2 in.).
On the banks of a garden pond, two court women in prayer experience divine grace, symbolized by the rays of golden light. The motif of light rays appears in most of the thirty-three illuminated scrolls dedicated by Taira-no-Kiyomori and his family to the Itsukushima Shrine. In keeping with the aestheticism and elegance which permeated the religious practices of the Heian aristocracy, the scrolls were ornamented regardless of cost in the most refined taste. The illustrations, done in the *yamato-e* style, give religious texts the luxuriant beauty of the narrative picture scrolls of the period. (See color plate 28.)

147. Sutra scrolls donated by the Taira family. Itsukushima Shrine. Twelfth century.
As could be expected of scrolls into which the deep aspirations of a wealthy family were committed, every detail of ornamentation was highly developed, outside as well as in. Crystal knobs were used for the ends of the rollers, some of them covered with filigree bronze. The titles of the scrolls and the plates covering the binding sticks were made of gilded metals. Moreover, each of the thirty-three scrolls was given a different decor. Their storage boxes were made of darkened bronze, on the surfaces of which were affixed designs of clouds and dragons in gold and silver.

148. *Butterfly Dance* at the Itsukushima Shrine.
On the stage which projects out over the sea, four boys perform this dance with strictest fidelity to the medieval tradition. In this unique setting—backed by the waters of the bay, the sky, and the distant mountains of the mainland—the vital spirit of the days of the Heike is restored to life.

149. Dance mask of Batō. Itsukushima Shrine. Twelfth century. H. 29.7 cm. (11.6 in.), w. 18.5 cm. (7.2 in.).
This is one of the wooden *bugaku* masks brought by the Heike from the capital and donated to the shrine. Batō is a character from Indian mythology, a ferocious figure with disheveled hair and frightening mien. Although painted a brilliant, deep red, the mask is imbued with the stylish elegance of the sculpture of the Heian capital.

150. Dance mask of Genjōraku. Itsukushima Shrine. Twelfth century. H. 24.5 cm. (9.6 in.), w. 17.2 cm. (6.7 in.).
In wild and animated gestures, the man who wears this mask attacks a mock serpent lying on the floor, both mask and *bugaku* dance having been derived from ancient Indian prototypes. Veins on the forehead and wrinkled cheeks reflect the high degree of realism of masks in the Nara period which survived as part of their traditional form.

151. Armor with deep-blue yarn. Itsukushima Shrine. Twelfth century. Height of main body armor, 39.5 cm. (15.5 in.).
Military commanders of the Taira family presented fighting equipment to the shrine, either to ask for success in battle or in gratitude for having received it. Splendid in color and finesse of craftsmanship, and yet highly efficient in use on the battlefield, such sets of armor attest to the growth of medieval ideals of chivalry. (See color plate 29.)

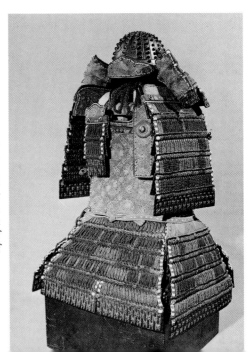

152. Amida hall at Shiramizu. Twelfth century.
Religious beliefs and sentiments of patricians in the
capital city were introduced even into the remote prov-
inces of northeastern Honshū. This tiny hall, still
standing in its lonely setting, has an elegance of pro-
portion and line reminiscent of buildings in metropol-
itan Kyoto. A square structure with each side divided
into three bays, it is typical of the private chapels
dedicated to Amitābha by the aristocracy throughout
the land.

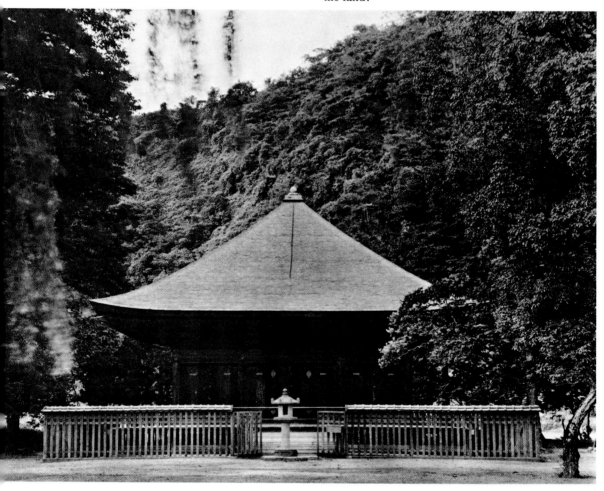

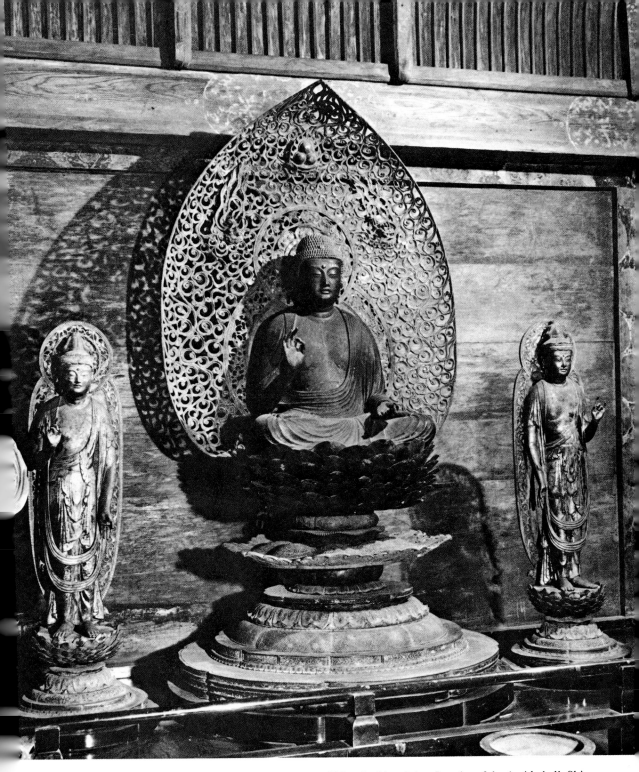

153. Amida trinity. Interior of the Amida hall, Shira-
mizu. Twelfth century.
Because they were neglected and virtually forgotten
for many years, the hall and its statues have become
dilapidated but remain more or less intact. The statues
were probably brought from Kyoto, and the delicacy
and subtlety of carving have a tranquil, almost som-
nolent quality typical of sculpture at the close of the
Heian period there.

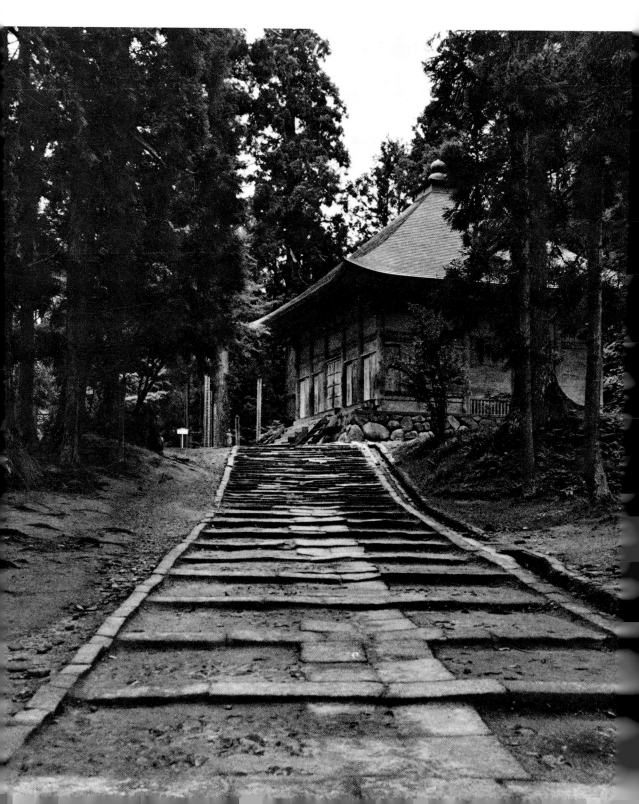

154. The Konjiki-dō, Hiraizumi. Twelfth century. 5.5 m. (18 ft.) square.

Hiraizumi was the stronghold of a provincial branch of the Fujiwara clan which wielded almost absolute power in the northeastern provinces. The town itself was patterned after Kyoto and, indeed, must have resembled it on a small scale. However, except for this tiny hall dedicated to Amitābha which has miraculously survived the centuries, all of the temple buildings and pagodas, palaces, and government quarters were destroyed less than a hundred years after they were erected.

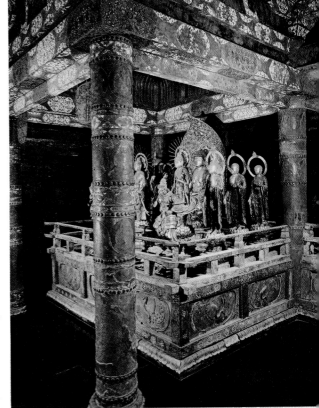

155. Interior of the Konjiki-dō. Twelfth century. Average height of seated Amida statues, 55 cm. (21.6 in.).

This hall served both for the worship of Amida (Amitābha) and for the burial of three leaders of the local Fujiwara clan. A body was placed beneath each of the three separate image platforms, which were furnished with virtually identical statues. The pillars and upper beams in the interior were covered with cloth, then lacquered and coated with gold leaf. Mother-of-pearl inlay and delicately wrought bronze fittings add to the splendor of the interior, which is, by far the best preserved of its kind and period in the entire country. (See color plate 30.)

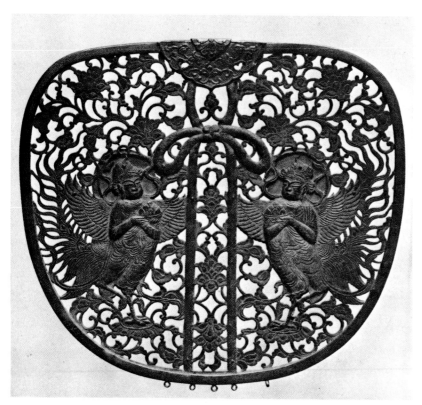

156. Pendant discs *(keman)*. Konjiki-dō. Twelfth century. H. 28.5 cm. (11.2 in.), w. 32.8 cm. (12.9 in.). *Keman* are thought to have originated as floral wreaths hung as offerings to Buddhist temples. In this one, amid openwork designs of leaves and flowers are two bird-women bearing gifts for the Buddha: the *karyōbingas*, or cuckoolike creatures with exquisite voices. Modeled in low relief, the birds have a warmth and vivacity which counteract the hardness of the metal. Five small rings at the bottom were for attaching ribbons and other decorative pendants.

157. Metal wall plaques. Konjiki-dō. Twelfth century.
Covering the interspaces of the moldings below the image platform, these bronze plaques are an impressive part of the hall's decor. The peacocks and flowers were made of separate pieces of gilded bronze and attached by nails to a background coated with silver leaf. Gems were embedded in the tails of the peacocks.

158. Dainichi. Chūson-ji. Twelfth century. H. 76.1 cm. (29.9 in.).
While faithful to the tradition of perfected, idealized Buddhist cult imagery, this statue bears distinct traces of realism—more in its overall effect than in individual, descriptive details. The establishment of the bodily masses and the refinement of craftmanship project a feminine, warm-blooded quality, and anticipate the developments of illusionism in the decades that were to follow. (See color plate 31.)

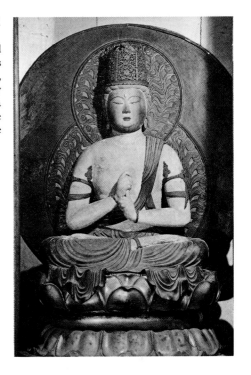

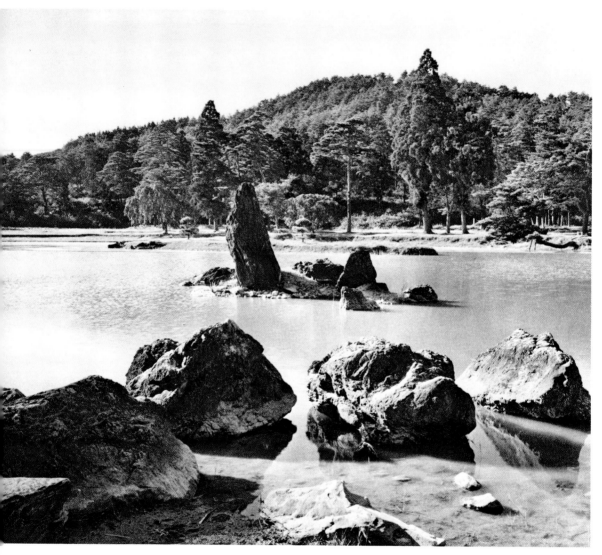

159. Garden of the Mōtsu-ji compound, Hiraizumi. During the last half of the twelfth century, Mōtsu-ji grew to be a vast temple compound, but all that remains today reminiscent of the past are the foundation stones from the Muryōkō-in on the shores of its pond.

妙法蓮華經妙莊嚴王本事品第二十七

爾時佛告諸大衆乃往古世過無量無邊不

可思議阿僧祇劫有佛名雲雷音宿王華智

Plate 28. Sutra scroll donated by the Taira family. Itsukushima Shrine. Twelfth century. (See also figure 146.)

Plate 30. Interior of the Konjiki-dō, Hiraizumi. Twelfth century. (See also figure 155.)

Plate 29. Armor with deep-blue yarn. Itsukushima Shrine. Twelfth century. (See also figure 151.)

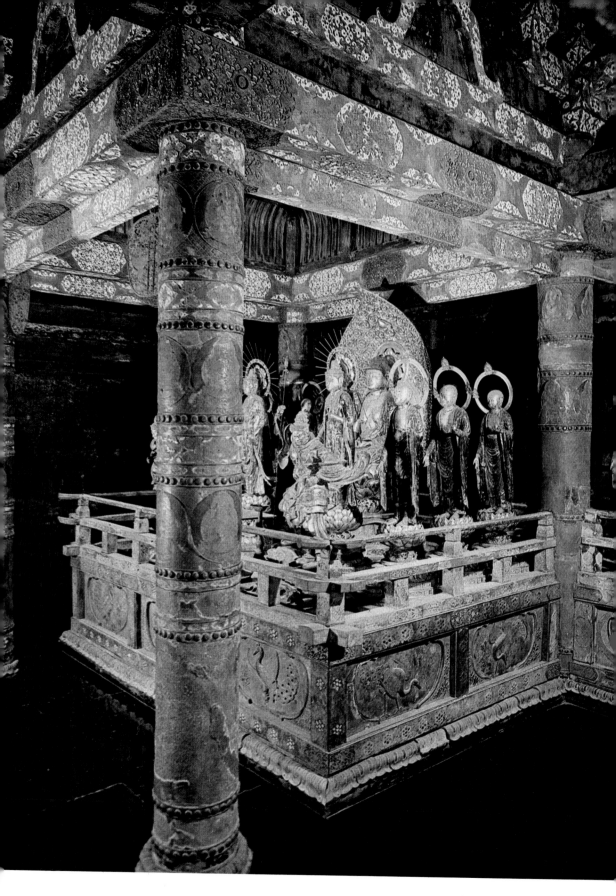

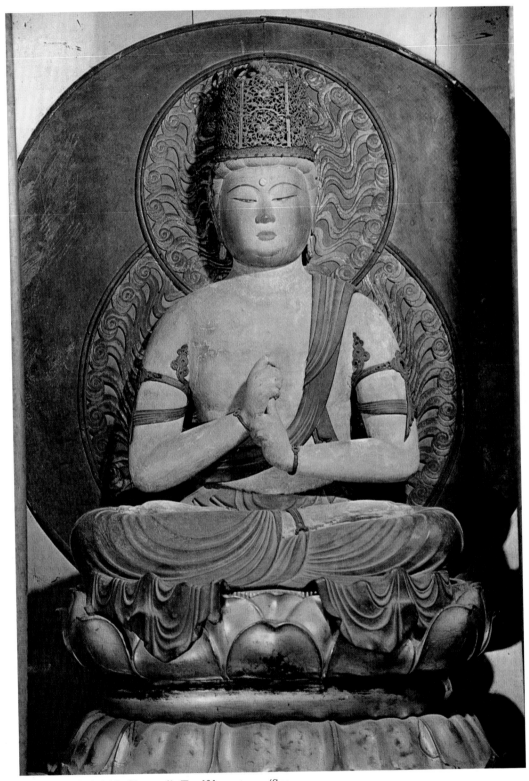

Plate 31. Dainichi. Chūson-ji. Twelfth century. (See
also figure 158.)

$$\sim 9 \sim$$

THE KAMAKURA DISTRICT

The Opening of the New City

In the stratified society of medieval Japan, the aristocrats who formed the government and clustered about the imperial court disdained the arts of warfare in favor of more refined pursuits. The military arm of the regime was staffed by families of professional warriors, or samurai, who had grown so powerful by the last half of the twelfth century that they fought among themselves for the authority to name the successors to the throne, the dominant position in the political life of the land.

Through their skill at arms and their rough-hewn courage, the men of the Taira clan at first reigned supreme; but in Kyoto they fell into the long-established culture patterns of the courtiers, and this subtly changed their mettle. In the bloody struggles of the 1180's their power was destroyed by the Minamoto clan based in eastern Japan; and the victorious general, Yoritomo, chose not to follow the footsteps of the Heike. Avoiding direct connections with the ancient capital, he established the *bakufu* (military government) at Kamakura, then little more than a fishing village at the head of a small peninsula thirty miles south of modern Tokyo. It was, however, protected by the ocean and hills and easily defended. Military families set up their villas in its many small valleys and ravines, and Kamakura suddenly became a major government and religious center, the rival of Kyoto.

The Age of the Samurai

In political affairs, the stern and pragmatic realism of the eastern warriors had triumphed over the idealism of the Heike; similarly in the arts, realism grew stronger and more pervasive. In general, however, the arts of the Kamakura period were characterized by great stylistic ferment and experimentation. Even within the limited circle of the dominant military families there were inconsistencies in taste. Where the wishes of the samurai directly influenced sculptors and painters, a certain intensity of expression appeared at times, yet in some of the popular religious art made for them, a rather literal approach developed which tended to negate emotional content. Ambivalence of this kind may be detected also in the character of Minamoto-no-Yoritomo, which

was marked by boldness and ferocity at times, and by great discipline at others. As the triumphant political figure of his age, he may well have set the pattern of aesthetic sensibilities among the new ruling families, and the impact of his personality may yet be felt in a painted portrait and one in wood. The painting is said to have been done by Fujiwara-no-Takanobu, the celebrated specialist in court portraiture, or *nise-e* ("likeness picture"), and it shows his face imbued with stern, cold intellect; the wooden statue captured a greater sense of combativeness along with the self-control. Working in different media, however, both artists seem to have been impressed by the intellect of the man himself, and both depicted him with rigidly straight lines, stressing the wide shoulders and sleeves of his new-style costume, in contrast to the softness and harmoniously curving lines which characterized older portraits. The deep undercutting in the wooden figure strengthened the blackness of the shadows and the vigor of the composition, making this an archetypal statue of a military commander. This new image type in both painting and sculpture was thus added to the repertory of themes in Japanese art, to take its place alongside images of Buddhist and Shinto deities and portraits of distinguished monks. The portraits of warriors naturally served as memorials after their death, but they were enshrined during their lifetime as well. One of the key traits of the Kamakura period was its respect for pragmatic realities, and this is clearly shown in the way by which the lords of the present world were celebrated, their power extolled, with an intensity at times greater than that of the lords of the world to come.

The New Buddhist Sects

In an age following the collapse of the cultural life of the old aristocracy and of their peculiar forms of worship, religious leaders turned their attention to the needs of the masses. In the Heian period, the major Buddhist sects were enveloped in the aura of aristocratic life and taste, for they had flourished under the patronage of wealthy families who gave lavish support with the hope of guaranteeing spiritual salvation. Bound in this way to the wishes of the upper classes, the Church became less and less identified with the spiritual needs of the common folk, but the last decades of the twelfth century were darkened by constant warfare and disorder in the breakup of the old social order, and the streets of Kyoto along with a score of battlefields were transformed into arenas of agony and death. This, along with the fall of so splendid a family as the Heike, seemed proof indeed of the uncertainties of fate; people were all the more convinced of the reality of the old predictions of the End of the Law, the descent of man into the last stages of barbarism and immorality. It was natural, thus, that new religious movements would develop in order to promote the salvation of the rootless masses; and a series of zealous, dedicated monks came to the fore to satisfy this deep need—men still revered as the patriarchs of the most active Buddhist sects in modern Japan. Hōnen Shōnin preached a simplified form of the Pure Land creed in which the main form of devotion was the *nembutsu,* the repetition of the name of Amida; Shinran Shōnin preached a doctrine of salvation broad enough to ensure rebirth in Paradise even for the wickedest of men. The itinerant preacher Ippen Shōnin wandered throughout the country with missionary fervor, organizing among the poor and outcast the mass performances of the *odori nembutsu,* in which monks and laymen danced in a circle, reciting the mystic formula *Namu Amida Butsu,* accompanied by frenzied clapping and ringing of gongs. The fiery monk Nichiren Shōnin carried out his evangelistic mission, preaching salvation through the *Lotus Sutra* alone.

In the midst of this sectarian activity, the creed of Zen Buddhism newly brought from Sung China began to receive the energetic support of the *bakufu* in Kamakura. It is true that Minamoto-no-Yoritomo extended vast amounts of aid in the rebuilding of Tōdai-ji, but this was because it had been burned by the armies of the Heike, and he wanted to demonstrate the benevolence of his rule in contrast to the evils of the previous regime. His support had no deeper motivation, for Yoritomo was very cautious concerning the old established Buddhist sects and did not wish to identify the new government with the old religious order. The doctrines of Zen were not only novel in Japan, they were brief and boldly phrased, and their emphasis upon personal discipline and austerities suited the temperament of the samurai. The unusual interest which the *bakufu* had in this sect is indicated by the fact that the monk Eisai was invited to Kamakura soon after his return from Sung China, for Eisai was one of the first Japanese to receive specialized training in Zen and is considered the patriarch of the Rinzai branch of the sect in Japan. The military government in Kamakura had the ambitious plan of also using the Zen sect as a medium for importing the culture of Sung China.

Trade and governmental contact with the Chinese mainland had been largely interrupted since the middle of the Heian period; in 894 the Japanese decided to send no more official diplomatic missions. Only a few rare trading vessels reached Japan bearing whatever traces they might have of cultural developments on the mainland, and yet the Sung period was one in which Chinese civilization—its painting, poetry, ceramics, statecraft, philosophy, and religion—flowered as rarely before. Taira-no-Kiyomori had planned to reopen positive trade contacts, but he passed away before the project could mature. It was not Kiyomori's wish alone, however, for among learned Japanese, contact with China was one of the deeply cherished desires of the age. Minamoto-no-Yoritomo also felt this strongly and wished to establish the identity of his regime in terms of the new capital, new styles of building, new forms of religious devotion, new standards in literature, painting, and ceramics. In the city of Kamakura itself, the building of temples became a major focus of activity, for the shoguns and regents there competed with the patrons of Kyoto in building a standard set of five major Zen monastic compounds called "The Five Mountains" (Gozan), and thus imbued their seat of power with the rich overtones of Sung art and architecture. Set into deep ravines just north of the city proper were two of the grandest Zen establishments. Kenchō-ji was founded in 1253 by the Chinese monk Lan-ch'i Tao-lung (Rankei Dōryū in Japanese pronunciation), and it was built in emulation of an important Zen temple in the Southern Sung capital of Hangchou. Engaku-ji was opened in 1283; its first resident patriarch was the Chinese monk Wu-hsüeh Tsu-yüan (Mugaku Sogen), and its buildings were based on the meticulous research of the Japanese monk Gikai, who went to south China purposely to study Zen architecture there.

THE ZEN SECT AND THE ARTS

As centered upon the Zen temples, the art forms newly imported from the mainland included a distinctive method of building called the *kara-yō*, or Chinese style, and this became identified with the sect itself. However, a parallel development in Sung China was a system of building given the name "Indian style," even though it seems to have arisen in the middle coastal provinces of China and owed very little to India. This style was also brought to Japan, where it was called the *tenjiku-yō* and employed extensively in the reconstruction of Tōdai-ji. The workmen of Nara were trained in this system by

the Chinese craftsmen Ch'en Ho-ch'ing and his brother, who had been invited by the monk in charge of refurbishing the temple, the celebrated Shunjōbō Chōgen. Probably the finest specimen of the *tenjiku-yō* today is the towering "South Gate" (Nandai-mon) of Tōdai-ji; but the technique was suited primarily for large and expensive projects such as this, and did not become very popular in Japan.

On the other hand, the *kara-yō* spread as widely as the Zen sect itself and had a great influence on Japanese architecture. Major Zen temples built in this manner restored the symmetry and the use of a central straight line to the layout of the main buildings, but the names and functions of many of the temple halls were changed in reflection of the doctrinal innovations of the sect. In the typical arrangement, entry into the compound was through a modest gate called the *sōmon*. Behind it towered a large, two-story structure, the *sammon* ("mountain gate"), on the upper floor of which were placed statues, usually of Arhats and Avalokiteśvara. The main elements of the compound were the *butsuden* ("Buddha hall") and the *hattō* ("Dharma hall"), whose functions were more or less similar to those of the traditional *kondō* and *kōdō* which they replaced. Although the halls were often built on a generous scale, sheer immensity and ornateness were not basic goals of Zen architecture, and the wood was usually left unpainted. The orderliness and sense of understatement in these ceremonial buildings reflected the ideals of the sect as it esteemed simplicity and brevity of thought, and there was much about this style which coincided with deeply rooted aesthetic instincts of the Japanese. Today, the oldest extant specimen of this "Chinese style" is the relic hall of Engaku-ji. There, the interior flooring is of stone and tile in a manner as common on the continent as it is rare in Japan. Other elements of the *kara-yō* include curvilinear ornament around the windows and on the columns and beams. The main image platform *(shumidan)* is decorated with an especially rich concentration of carved floral motifs done in a technique called *kamakura-bori* in Japan, which was also applied to furniture and lacquer boxes and trays, and was basically Chinese in origin. Many examples of Sung period pottery with rich blue-green celadon glaze have been found around Kamakura, and one realizes how deeply the arts of the Sung period penetrated into the life of this district.

PORTRAITURE OF THE ZEN SECT

An important and flourishing aspect of the arts of this sect was the *chinzō*, portraits of distinguished Zen monks done either in painting or sculpture. The emphasis given to portraiture was due in part to the fact that the Zen sect tended to minimize worship with cult images and the ceremonial reading of sutras. Instead, one of the essential requisites for a person's spiritual discipline was access to a wise monk, to gain insights, often subtle and indirect, into the nature of true wisdom from the man and his character. The student monks would also sit for long hours in meditation and carry through the mundane routines of the cloister—sweeping, gardening, cutting wood, and carrying water—in the belief that these too could lead to the state of enlightenment. Among the brotherhood of Zen monks were garden designers, skillful painters, and poets who looked upon these forms of expression not as hobbies or avocations but rather as opportunities for spiritual discipline akin to meditation. In this life in the monasteries, portraiture was singularly important. A scroll bearing the likeness of a revered teacher might be presented to a promising disciple when he left the tutelage of his master; a portrait statue was usually installed in a small shrine in the middle of a monastic dwell-

ing hall as a memorial to the most celebrated monk who lived and taught there. Calligraphic scrolls bearing a religious exhortation boldly written by a teacher served some of the same functions—to spur and guide the novice monks and keep alive the memory of one who had attained great insight. The attitudes of the Zen sect made a substantial contribution to the developing realism in the arts of the period, for the *chinzō* were often imbued with a frankness which was almost remorseless. The portraits of the shoguns were also done realistically, but a considerable amount of flattery and ornamentation was added in order to give their images a sense of official dignity. The sitters and artists of the *chinzō*, on the other hand, disclaimed all forms of flattery, and the portraits showed the monks with all their blemishes and signs of age or illness, with no attempt to improve or idealize their appearance.

THE POPULARIZATION OF RELIGIOUS CREEDS

In this fashion, the Zen monasteries in Kamakura, together with those of Kyoto, formed the two main centers of the sect in Japan; but other religious movements, both new and old, were attracted to the headquarters of the *bakufu*. It was here that Nichiren Shōnin preached his doctrines with such vehemence and opposed the older sects so intemperately that he was severely persecuted. The giant bronze image of Amitābha, made as the *honzon* of the Kōtoku-in at nearby Hase, is evidence that the Pure Land creed prospered greatly in the Kamakura area as well. Although made in emulation or even rivalry with the Daibutsu at Nara, the project seems to have been given no direct government support; it must have been financed by the donations of citizens of all classes. In fact, the samurai who controlled the government were almost exclusively devoted to the Zen sect and converted it into virtually a state creed; but the mass of the common people were still attracted by the less austere Pure Land faith, whose doctrines and arts were increasingly popularized and simplified. In this process, the earlier, more romantic and visionary scenes of the Raigō fell out of favor and were replaced by new images which were little more than attempts to make the idea of divine grace and power more easily understood, not so much emotionally or aesthetically as intellectually. Among them was one in which Amitābha was shown alone, painted largely in gold against a silk background dyed a deep, dark blue. He was painted in gold, and his garments had sections of gold leaf which had been cut into minute decorative patterns and attached to the silk with incredible skill and patience. The techniques of cut gold leaf *(kirikane)* had developed in the Heian period to enrich the sumptuous color schemes of Buddhist painting and sculpture. In the Kamakura period, the technique advanced only in terms of finesse; the aesthetic richness of the imagery was not enhanced, and the development was essentially a mechanical one which served chiefly to popularize the arts.

During this period the monks preaching doctrines of the Pure Land also began to emphasize not the visions of endless bliss for those reborn in Paradise but rather the terror of hell if one failed to gain heaven. This change in emphasis rather resembled the political atmosphere of Japan under the dictatorship of the samurai, who enforced their policies with far more application of stern penalties than rewards. Many scenes of hell—with demons prodding the damned into excruciating tortures—were depicted with graphic realism, in strong contrast to the exquisite grace and harmony of scenes of Amitābha's Western Paradise of earlier times. Confronted with the prospects of descent into hell, the common people turned fervently to the worship of the Bodhisattva Jizō (Kshitigarbha), who was thought to help those who had fallen there; and they also propitiat-

ed the Ten Kings led by Yama, the Lord of the Dead, who decided the fate of the deceased. The latter cult had developed in China as virtually a folk religion and accompanied the far more sophisticated Zen sect to Japan when contacts between the two countries were resumed. Impressive relics of this cult are in the Emma-dō ("Hall of Yama") of Ennō-ji in Kamakura, carvings in wood of the Ten Kings and their attendants done with an animated realism not unlike that of the Italian baroque.

Another unusual custom of this period was the making of statues of deities in the nude or seminude and dressing them in real garments. A typical example is the figure of the goddess Benzai-ten enshrined in the Tsurugaoka Hachiman Shrine in Kamakura. A figure very similar to it is kept in the Shrine of Enoshima nearby. Both of these were given their own silken robes, and the sculptors attempted to create the utmost sense of actuality. This concept was possibly due to foreign influences; it may also have been the result of the rather banal and unimaginative viewpoint of the popular realism of the day. Benzai-ten was shown as a woman of great beauty, for she was the deity who would bestow material wealth and good fortune; as her cult became increasingly popular it was inevitable, perhaps, that her imagery be coarsened.

In the Kamakura and Hakone regions are many small stone pagodas erected to promote the salvation of the dead. In an age of ceaseless wars and civil disorders, corpses were abandoned on battlefields and roads, but traveling monks would come care for those who had died without relatives to mourn them and ease their way to Paradise. These stone pagodas are only incidental details among the historical relics of this period, but they evoke most poignantly the tragic mood of medieval Japan.

The Military Families and Shinto Shrines

The Buddhist faith was not the only one to undergo great variations in creed, for in this era of the samurai and time of grave danger of foreign invasion, there was a rapid upsurge of feeling toward the national gods. We have already discussed the strong feelings of the Taira family for the Itsukushima Shrine and those of the Minamoto for the Tsurugaoka Hachiman Shrine. It became almost obligatory for a proud commander to identify himself and his family with a Shinto sanctuary where he might pray for victory and where his family and vassals might offer their devotions; and thus the shrines accumulated increasing numbers of votive gifts. For the most part, these were military gear—swords and armor—but they also included luxury items such as the celebrated inkstone box kept at the Tsurugaoka Shrine or the toiletry box at the Mishima Shrine. The writing case was donated by Minamoto-no-Yoritomo, and the latter was given by his wife Masako, but both objects were probably gifts from the capital to the shogun and his family. It is said that the writing case came from the retired Emperor Goshirakawa, but as it was too elegant for the use of a samurai, the spartan Yoritomo gave it to the shrine. The ornamentation of these boxes was imbued with all the elegance of taste of the imperial court in the use of painted lacquer and inlaid mother-of-pearl and demonstrates the fact that the ancient capital maintained its cultural vitality. Even Minamoto-no-Sanetomo, Yoritomo's son, born as he was into a famous samurai family, longed to lead the life of a poet and yearned with all his heart for the far-distant capital.

The warrior clans did everything possible to develop their stronghold at Kamakura, to provide it with the cultural facilities of a seat of government; but the results were often unsatisfactory. There was not enough time for artistic traditions to mature naturally and gradually there, and the region lacked the resident craftsmen with generations of experi-

ence or the old families who prided themselves in their artistic judgment. The transplanted flowers lived only briefly, and even though there are handsome temples and images remaining in Kamakura, their condition is somewhat forlorn. They do not rank with those of Kyoto, which has sustained centuries of artistic life. Moreover, the samurai of Kamakura distinguished themselves in the frantic efforts from 1264 through most of the 1280's to mobilize the nation and repel the invasions of the dreaded Mongols, when Japan for the first time was threatened with foreign domination. They were also deeply involved in the struggles between the so-called Northern and Southern courts, when two branches of the imperial family struggled for supremacy in the fourteenth century, and a rival court was established at Yoshino, in the mountains southeast of Nara. These affairs so absorbed the energies of the feudal barons that there was little left for the further development of Kamakura city. Moreover, in the midst of these great commotions some of the samurai families seized the opportunity to move from eastern Japan back to the capital, where, predictably, they developed a great fondness for the culture and life of the ancient city. And finally, when Shogun Ashikaga Yoshimitsu gained control of the administration, the military government abandoned Kamakura and established itself in Kyoto.

160. The Tsurugaoka Hachiman Shrine. Kamakura.
Set in a narrow plain between hills and deep ravines,
the city of Kamakura was bisected by Wakamiya Ōji,
the boulevard which ran from the great shrine of the
war-god Hachiman on the north to the shore of Sagami
Bay nearly a mile away. The family shrine of the
Minamoto family, victorious in the struggle between
the warrior clans at the close of the twelfth century,
became the keystone to the planning of Kamakura as
the seat of the military government and the de facto
capital of Japan.

161. Minamoto-no-Yoritomo, detail. Jingo-ji. Late
twelfth century. H. 139.4 cm. (54.9 in.), w. 118 cm.
(46.4 in.).
With the aid of a taut, wirelike line, the face was depict-
ed with incisive realism, the personality of Yoritomo
imbued with discipline, haughtiness, and shrewdness.
On the other hand, the formal court costume was
shown in an extremely abstract manner reflecting the
aesthetic sophistication of the *yamato-e*. The cloak was
reduced to a flat angular area of dark gray in which an
embroidery pattern was painted in black; the touch of
red in the collar was intended to emphasize the head.
Abstraction and realism, contradictory as they might
seem, were harmonized to record the individuality and
high dignity of this triumphant warrior. (See color
plate 32.)

162. Minamoto-no-Yoritomo. Late twelfth or thirteenth century. H. 70.6 cm. (27.8 in.).
Portrait statues of military commanders, carved in the realistic style of the Kamakura period, shared with the painted portraits a sense of bold abstraction in the treatment of the garments. With their wide shoulders and knees set boldly apart, they offer an impression of the energy and authority of the powerful samurai. The face of this portrait, said to be that of Minamoto-no-Yoritomo, has a striking sense of wariness and combativeness, in contrast to the discipline and keenness in the painted portrait at Jingo-ji.

163. Uesugi Shigefusa. Meigetsu-in. Thirteenth century. H. 68 cm. (26.7 in.).
Moving to Kamakura in 1252, Shigefusa was a prominent adviser to the military government and a patron of the Zen sect. Of all the secular portrait statues of this era, his is perhaps the most suave and successfully integrated. Departing from the old conventions of ecclesiastical portraiture, this new type of image is a reflection of the decisiveness by which the samurai created a powerful military government and left their imprint on the culture of the time.

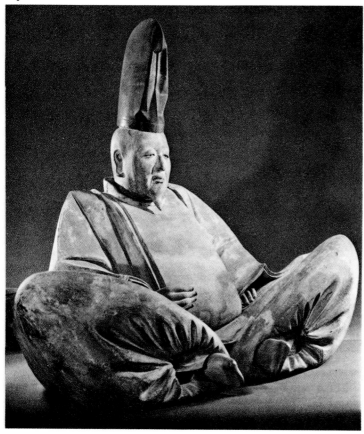

164. The *shariden* (hall of relics), Engaku-ji. Late thirteenth century. H. 10.5 m. (34.5 ft.); 8.1 m. (26.67 ft.) square.

This hall is the oldest extant example of the *kara-yō* or Chinese style of building brought by the Zen sect from Sung China. Its special features may be seen in many details of construction—in the strong upward curve to the eaves, in the use of a heavy masonry floor in the interior, in the cusped frame of the windows, the open transom windows, the delicately assembled wooden doors, in the complex system of bracketing, and others. The immense thatched roof was a later addition, having been adapted from the construction of farm buildings in the region. The original roof was made of shingles or tile and had a much lower profile and lighter feeling, like that of the roof of the enclosed corridor in the lower story.

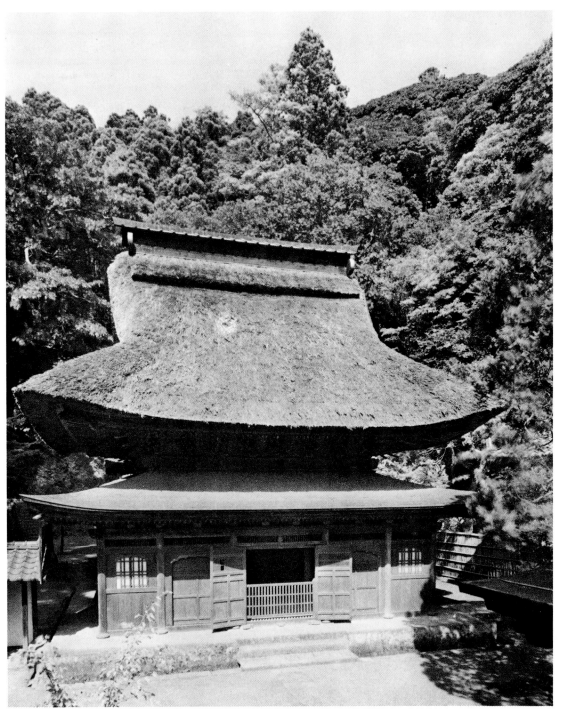

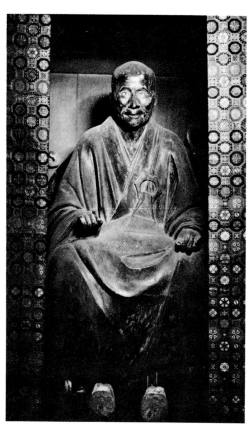

165. Bukkō Kokushi. Engaku-ji. Thirteenth century. H. 111 cm. (43.7 in.).

In the Zen sect, wise and accomplished monks were deeply revered; their role as teachers and as embodiments of the wisdom of the faith, handed down from generation to generation, was considered even more important than that of written texts. The first patriarch at the Zen monastery of Engaku-ji was the Chinese monk Wu-hsüeh Tsu-yüan, and his portrait in wood is enshrined in a small founder's hall behind the *shariden*. It is venerated each day, and given food offerings in such a way as to suggest that the monk is still a living presence. Slumped forward slightly, the face wrinkled and marked by age, he was depicted much as he must have appeared, with no attempts at flattery or idealization—an early example of the strong realism of Zen Buddhist portrait sculpture.

166. Sitting in meditation. Engaku-ji.

The very name of the Zen sect (Dhyana, or "Contemplation," in Sanskrit) indicates that it has always stressed the stern discipline of long hours of seated meditation, a practice which lies at the heart of traditional Buddhism. Persons who have not undergone this training cannot imagine the intensity of the spiritual struggle launched against the wandering of the mind and the claims of the flesh. Conceiving of supreme reality as a force so vast and powerful that the mind cannot grasp it rationally, Zen monks hold that the spirit must return to this first principle by means of intuitive identification, impassively, without agitated thought or intentional planning.

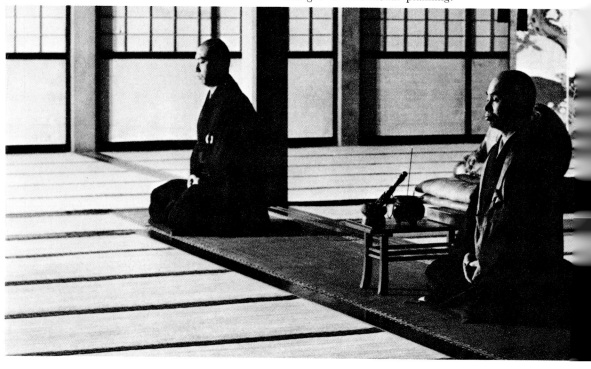

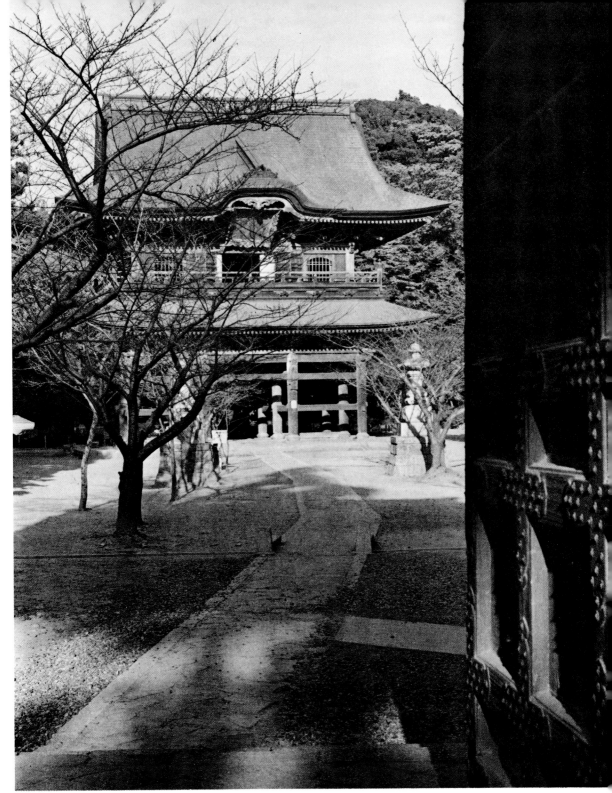

167. *Sammon* ("mountain gate"), Kenchō-ji.

Of the great Zen temples of Kamakura built with the patronage of the military families, Kenchō-ji was the oldest and was given the highest rank. Because of recurring fire and earthquake, its halls have been frequently rebuilt, but the *sammon*, in its large and imposing scale, recalls the earlier grandeur of the monastery. Itinerant monks still come here for training and endure a daily routine of severe discipline. Dressed in coarse clothing, they leave this gate to beg food in adjacent streets.

168. Musō Soseki. Zuisen-ji. Fourteenth century. H.
79 cm. (29.1 in.).

Musō was one of the most influential and active monks
in Zen circles during the fourteenth century. A man of
many gifts, he was an eloquent preacher, philosopher,
garden designer, poet, calligrapher, and political ad-
viser to the Ashikaga shoguns. While living in Kama-
kura, he founded the hermitage of Zuisen-ji in the
hills overlooking the city and Sagami Bay, and this
portrait has been carefully preserved there. With
narrow shoulders and delicate bone structure in the
head, the statue has a tranquil and even feminine
quality. The robes were carved in a deftly realistic,
graceful manner.

169. Garden of Zuisen-ji.
This celebrated garden was designed by Musō Soseki, and his original plans have been maintained with little change. Disarming in its simplicity and informality, it was arranged for casual strolling. To the rear is the shallow cavern and rock where Musō himself meditated outdoors and where a winding pathway joins the garden to the wilder foliage of the mountainside.

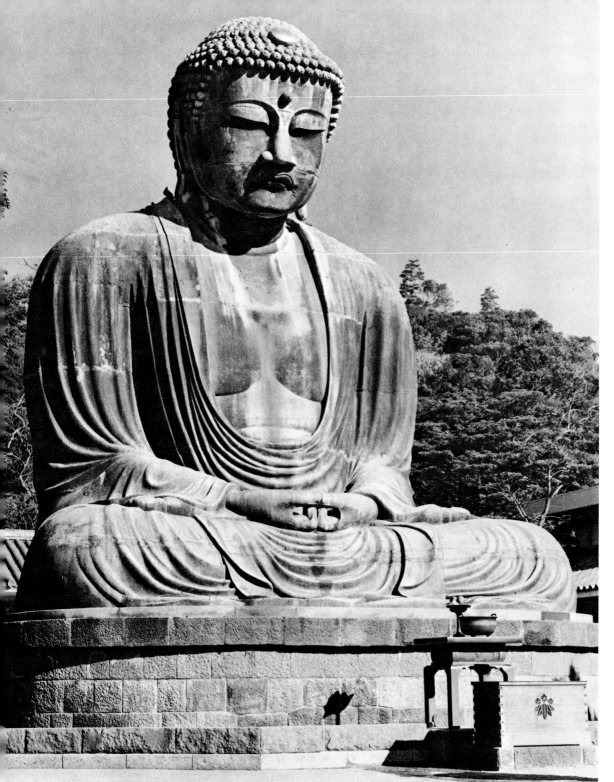

170. The Daibutsu at Hase, Kamakura. Thirteenth century. H. 11.4 m. (34.6 ft.).

The Amida hall which once enclosed this giant, hollow bronze image was lost to a tidal wave, and for nearly five hundred years the statue has sat beneath the open sky. Second in size only to the Daibutsu in Nara, it was apparently built not with official government support but through the contributions of citizens of all classes devoted to the Pure Land creed. The large head and broad hip section strengthen its sense of solidity; the face gazes downward with an aura of divine compassion. Despite its scale, the statue has strong cohesiveness and aesthetic fluency. It is imposing as a work of art as well as a relic of the decades in which Kamakura was a vital center of Japanese culture.

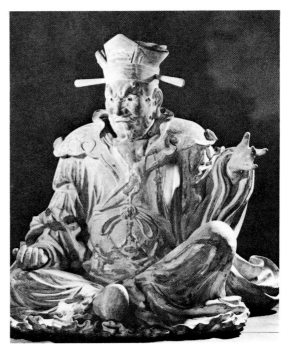

171. King Shokō. Ennō-ji. Thirteenth century. H. 102 cm. (40.1 in.).

During the Kamakura period, the fear of dreadful tortures in Hell became a prominent feature of popular Buddhism. The Ten Kings of Hell, led by Yama (or Emma-ō, the Lord of Death), were widely worshiped, for they were believed to sit in judgment of the souls of the dead and assign them to heaven or hell. This court was depicted by a group of large wooden statues in the Emma-dō (Hall of Yama) of Ennō-ji. Painted in bright colors, imbued with a sense of violent energy, and displayed in an atmosphere of gloom and mystery, the statues might well have struck terror in the heart of a devotee.

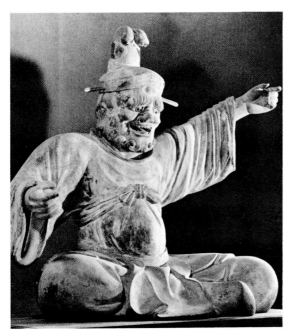

172. Kushō-jin. Ennō-ji. Thirteenth century. H. 100 cm. (39.4 in.).

Part of the court of Yama, Kushō-jin is said to be born at the same time as a given individual and to record the man's good and evil deeds and report them to Yama for the final judgment. The demigod's face is contorted with an expression of vehement energy as he confronts a man with the scroll bearing his spiritual accounts. The energetic gestures and open contours of these figures are strikingly reminiscent of Italian baroque sculpture, especially in the attempt to interpret spiritual matters in terms of almost melodramatic emotion.

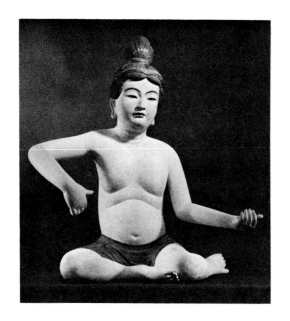

173. Benzai-ten (Sarasvatī). Tsurugaoka Hachiman Shrine. Thirteenth century. H. 96 cm. (37.7 in.).
It was intended that this image be dressed in silken robes and given a miniature *biwa*, or lute. Despite the fact that nude female figures were totally missing from traditional Sino-Japanese religious art, the sculptor was moved by the strong desire for concrete, popular realism of the time. Other deities, such as Jizō and Amida, and even monks' portraits were similarly carved and clothed in real garments.

174. The beach at Katase.
On this beach four miles from Kamakura, soldiers of the military government beheaded the envoys sent by Kublai Khan, Mongol emperor of China, to demand the submission of Japan. Here also, ten years earlier, the fiery monk Nichiren Shōnin was said to have been miraculously saved from the same fate. Offshore in the distance is the island of Enoshima with a large shrine dedicated to Benzai-ten. Two celebrated images of the goddess are enshrined there, one of them a nude figure which may have served as a model for the statue in the Tsurugaoka Hachiman Shrine.

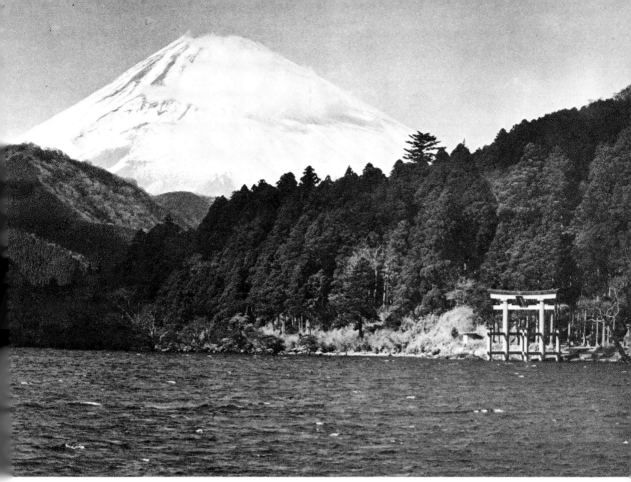

175. The Lake of Reeds (Ashi-no-ko) at Hakone.
The Hakone district lies in the belt of rugged mountains across Sagami Bay from Kamakura, its scenic vistas dominated by the perfect cone of Mount Fuji. This zone of volcanic mountains, hot springs, and small lakes was a natural stronghold of great strategic importance in the military history of Japan. The Hakone Barrier commanded the high road from the vast Kantō Plain and was the traditional point of entry to eastern Japan. Among the many historic relics of the district is the Hakone Shrine, whose *torii* stands in the waters of Lake Ashi.

176. Stone pagoda. Hakone. Thirteenth century. H. 254 cm. (8.33 ft.).
To the side of an ancient road now choked with grass stands this stone pagoda in the shape called the *hōkyōin-tō*. It bears a date of 1296 and is said to be a memorial to a warrior of the Minamoto clan, Tada-no-Mitsunaka, who lived three centuries earlier and campaigned in this district. His name, however, does not appear in the inscriptions, and the pagoda may be one of many erected in the region as memorials to soldiers lost on battlefields nearby.

177. Inkstone box. Tsurugaoka Hachiman Shrine. Thirteenth century. L. 28.5 cm. (11.2 in.), w. 24.2 cm. (9.5 in.), h. 5.5 cm. (2.1 in.).

The charming design of birds, chrysanthemums, and a rustic bamboo fence shows the persistence of the elegant, courtly taste of the capital into the age of the samurai. According to the shrine tradition, this box was originally presented by the retired Emperor Goshirakawa to Minamoto-no-Yoritomo, which indeed would have been evidence of the high prestige of the eastern warrior. The design is composed chiefly of mother-of-pearl inlay and gold lacquer, the shell having been cut into intricate, tiny shapes. The contrast between the figures and background is quite subtle, and the image seems to flicker with life as it changes in color when the lid of the box is moved.

178. Toiletries case from the Mishima Shrine. Thirteenth century. L. 25.8 cm. (10.1 in.), w. 34.5 cm. (13.5 in.), h. 19.7 cm. (7.7 in.).

Minamoto-no-Yoritomo prayed for success in battle at the Mishima Shrine, located at the head of the Izu Peninsula, and thereafter the sanctuary was revered and protected by succeeding generations of his family. His wife, Masako, an extraordinary personality in her own right, is said to have donated this handsome toiletries case. Covered with a design of plum trees in full blossom and flying geese, a motif essentially Chinese in origin, the surface also contains the characters of a Chinese poem in silver inlay.

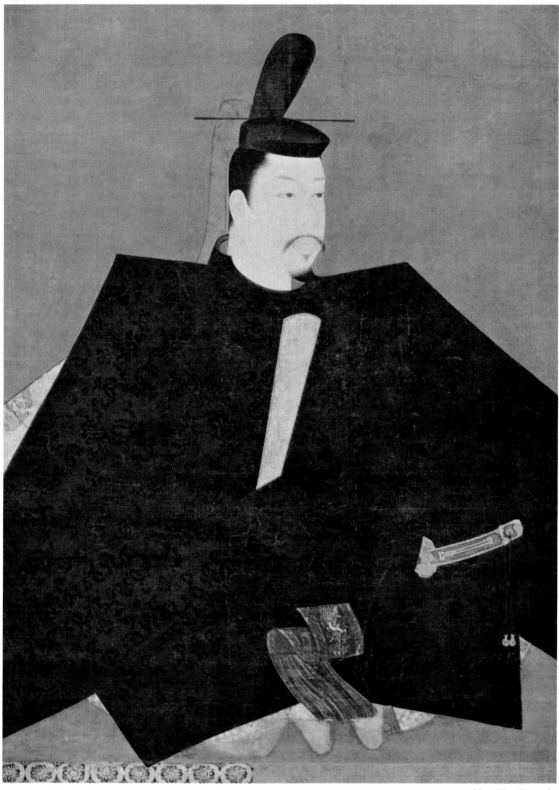

Plate 32. Minamoto-no-Yoritomo (detail). Jingo-ji.
Late twelfth century. (See also figure 161.)

Plate 33. The Golden Pavilion of Rokuon-ji. (See also figure 184.)

~⊚ 10 ⊚~

THE ZEN TEMPLES OF KYOTO

The ancient Heian capital suffered severe damage during the Gempei war, but with the end of hostilities in 1185, its deeply rooted aesthetic traditions were quickly restored to life. The Zen sect was established there even earlier than in Kamakura, and in both cities its temples became centers of artistic and philosophic developments destined to revolutionize the cultural life of the nation. The pioneer master of Japanese Zen, the monk Eisai, taught in Kyoto as early as 1202 in Kennin-ji; but the city's first major Zen monastery was Tōfuku-ji, pledged in 1236 by the Chancellor Kujō Michiie. After a long period of construction, it was turned over to its first patriarch, Ben'en (Shōitsu Kokushi), a distinguished theologian who had studied in China. From that time on, for over 150 years, monasteries and hermitages grew up steadily along the edges of the city. In the foothills to the east, Nanzen-ji was begun in 1293. Daitoku-ji was opened in 1324 a mile or so north of the Imperial Palace. To the west of town, Myōshin-ji was founded in 1337 on the site of a villa of the Emperor Hanazono.

An additional spur to this activity was the return to the capital of powerful samurai families from eastern Japan. Foremost of these were former allies of the Minamoto, the Ashikaga, whose leader Takauji pre-empted the supreme military rank of *taishōgun* and withstood all efforts to unseat him. He built his own elaborate palace on Muromachi Avenue in the northeast part of town, and the two and a half centuries in which the Ashikaga were the real or nominal governors of Japan are often named the Muromachi period after this headquarters of the *bakufu*.

The Shogun Takauji, in what was partially a mood of remorse, built the Zen temple of Tenryū-ji in 1339 in honor of the deceased Emperor Godaigo, whom he had banished from the throne and persecuted at the beginning of the long struggle between the Northern and Southern courts. To Tenryū-ji as its founding abbot came the celebrated Musō Soseki, who designed a remarkable garden there. Yet another vast Zen monastery, Shōkoku-ji, was built on the northern edge of the city by the third shogun, Yoshimitsu, a serious devotee of the sect. Thus the Zen establishments of Kyoto prospered and grew—especially the official Gozan, the five leading temples—and those of Kamakura declined. Moreover, within each monastery were numbers of the so-called *tatchū*, small but semiindependent clusters of dwelling and meditation halls. These lay behind their

225

own walls, had their own gardens and kitchens, their own patrons and revered teachers, their own collections of painting and pottery. It was within such subtemples that some of the most lively developments in the arts of the Zen sect took place.

ELEGANT SIMPLICITY

In order to impress a rather broad and unsophisticated audience, Buddhist arts of the Kamakura period had often stressed mechanical finesse and complexity in technique. Today, many of these works seem weak, lacking in profound emotional or aesthetic content, even though they continued to depict the traditional deities and didactic themes (Paradises, Raigō scenes, or mandalas). The close of the thirteenth century, in China as well as Japan, is often considered the end of the long period in which the ancient, hieratic styles of Buddhist art, based on Indian prototypes, set the highest standards of spiritual and formal quality. A breath of fresh air, however, was admitted by the Zen sect in the form of radically new concepts of religious imagery. Zen monks sought to counter the debasement of the arts by eliminating ostentatious technique and the confusion of excellence with complexity; they sought to develop highly personal, direct forms of expression rooted in the most profound levels of Buddhist thought (and Chinese natural philosophy), rather than the most easily understandable.

One product of this was the rapid development of *sumi-e,* painting done exclusively in dark monochrome inks *(sumi),* usually on paper. This differed from earlier ink painting in which color was simply disregarded—the satirical sketches in Kōzan-ji, for example, or iconographic drawings made by student monks—for it was an intentional rejection of color effects by men who well understood its potentialities. By restricting themselves to the simplest and most elemental of materials, the painters reflected the manner by which the philosophic tradition in Zen Buddhism saw a fundamental, unifying core of reality—eternal and incorruptible—within the complexity of the phenomenal, everyday world. Yet ink painting, simple as it may appear, had undergone a long history of development in China and was able to suggest the richness of the visible world without actually copying it. Ink painting was first practiced there by professional artists and learned dilettantes; but Zen monks in south China were strongly attracted by it and eventually began painting in this manner themselves. Of course, they as well as their Japanese colleagues could paint only in their spare time, when they were free from long sessions of seated meditation or duties around the cloister; their technique was not as advanced as that of the professional painters, but the simplicity and obvious sincerity of early Zen painting are emotionally quite moving. The first Japanese masters of *sumi-e* were rather conservative and restricted themselves to a strong, definitive line; but soon, under the influence of Chinese monk-painters of the thirteenth century like Mu-ch'i and Ying Yü-ch'ien, they worked with large, free areas of ink washes on semi-absorbent paper. Washes which happened to spread as random blots were seen not as blunders but rather as lively, natural additions to the composition. In their rough power, paintings of this kind were similar to the Zen calligraphic scrolls called *bokuseki* ("ink traces"), instructional phrases or exhortations written by monks in a bold hand with far more intensity and appeal than the work of professional calligraphers. Zen monks in Japan, inspired by new aesthetic standards rooted in the fusion of the spiritual values of Indian Buddhism and Chinese natural philosophy, brought about profound changes in many fields of expression.

Japanese gardens, for example, had heretofore been large and expansive, with lakes

and islands and bridges to the extent that some could be called lake-gardens. In Zen circles, though, particularly in the smaller *tatchū* or subtemples, the gardens became quite compressed in scale, and natural features such as mountains or rivers and bays were represented in a symbolic fashion. However, some of the old lake-gardens in and around Kyoto were remodeled according to Zen principles, and the result was a distinctly Japanese type of garden, carefully clipped and controlled, yet large enough to wander through. The earliest example of this was the one which Musō Soseki redesigned at Saihō-ji; it is known today as the Moss Garden.

OPULENT SPLENDOR

Simplicity and naturalness formed one side of the aesthetic tastes of the Zen sect; this did not prevent it, however, from introducing art works of luxuriant splendor from China of the Sung and Ming periods. These included pictures done in the style of the official Sung Painting Academy—delicately detailed, brightly colored, and rather realistic. Along with these came celadon pottery, simple in form yet aristocratic in air; finely wrought carved-lacquer trays, boxes, and furniture; and brocade cloth of gold and silver. Such works, having reached an extraordinary degree of technical perfection in China, were as eagerly sought in Ashikaga Japan as similar treasures had been in the Nara period. Also, the *bakufu* in Kyoto, realizing that this commerce was immensely profitable for the Japanese, sought to replenish its treasury by entering directly into trade relations with Ming China. The Zen temples were one of its main modes of contact, particularly Tenryū-ji, for, after all, they had received the patronage of the Ashikaga shoguns. Zen monks were often versed in the Chinese language, many had studied on the mainland and had personal knowledge of political and commercial conditions there. In addition, they had good judgment regarding the cultural objects which the Chinese usually sent in return for such Japanese exports as swords and armor, lacquer ware, horses, and raw materials like sulphur.

Seclusion from everyday secular affairs was essential to the severe spiritual discipline of a Zen monastery, yet Tenryū-ji and some of the others came to be storehouses for import and export goods, where collectors would come in quest of paintings and luxury items from abroad. While this would appear to violate the spirit of a hermitage, the capacity to reconcile such contradictions was one of the characteristics of the Muromachi period. In the twilight of the culture of the medieval world, dualistic situations like this were not uncommon, and it was possible for the spiritual values of monastic Buddhism to coexist with commercial values of the years to come. During much of this period, the Ashikaga family was the main buttress of government authority, the keystone of the feudal order among the military clans; and, as had happened so often in the past, the shoguns were increasingly attracted by the pattern of aristocratic life in Kyoto—building villas and family temples or shrines, writing poetry, commissioning pictures and even painting them, collecting pottery and lacquer, giving lavish parties, attending quasi-religious dance and theatrical performances. The very soil of the capital was enriched by historical traditions which were absent in Kamakura and which the Ashikaga, feeling themselves to be the successors of the Heike or the Fujiwara, warmly embraced.

The third shogun, Yoshimitsu, took over an old country estate northwest of town, the Kitayama Palace, and developed it into an elaborate establishment, but the only building to have survived into modern times was the Golden Pavilion (Kinkaku), his

private chapel. In this delicate wooden structure, disparate architectural elements had been boldly combined: the first and second stories were designed in the *shinden* style which had prevailed throughout the Heian period and was considered essentially Japanese in spirit; the third story was influenced by the *kara-yō* favored by the Zen sect. In emulation of this estate, another vast one was built two generations later by the Shogun Yoshimasa and called the Higashiyama Palace. The same combination of native and foreign elements may be seen in its chief remaining structure, the Kannon-dō, better known as the Silver Pavilion (Ginkaku). The development of this palace marked the high point in the artistic interests of the Ashikaga, yet it was begun in 1467 at the close of the Ōnin Rebellion, eleven years of bitter internal struggle in which much of Kyoto was reduced to ashes and the control exerted by the shoguns over the provincial warriors virtually ended. Despite these troubles, or perhaps because of them, Yoshimasa sought a life of extreme refinement, gathering around him the most gifted poets and painters and tea masters, and the half century of his shogunate, from 1443-90, was so rich in aesthetic achievement that it is often called the Higashiyama period. Along with the Silver Pavilion, another handsome relic of the palace is the Tōgu-dō, a seemingly rustic and humble thatched cottage which served Yoshimasa as a private chapel, teahouse, and study. Here, the informality of the newly evolved *shoin* ("writing hall") style of architecture far outweighed any feeling of the building's role as a Buddhist chapel, a considerable reversal of religious and aesthetic values. The quiet enjoyment of the garden outside and verdant mountainside beyond had taken on religious overtones, a clear reflection of the ideals of Zen Buddhism and of the growing influence of the Japanese tea ceremony.

DEVELOPMENTS IN PAINTING

The Higashiyama period saw the emergence of Sesshū, one of the most prominent figures in the history of Japanese art, but he did not belong to the rarefied aesthetic circle of the Higashiyama Palace. Instead, he lived for a while in Shōkoku-ji, where he studied the paintings of both Josetsu and Shūbun; but he was a restless and venturesome man, unable to restrict himself to the limited painting styles practiced thus far in Japanese Zen temples. He carefully studied Chinese pictures of the Sung and Yüan periods wherever he could find them, and even though his artistic horizons greatly widened, still he was not satisfied; so in 1467, just as civil war was breaking out in Kyoto, he joined a trade mission to Ming China and reached the mainland. After his return to Japan, he steadfastly refused to live in Kyoto but stayed in monasteries in the Yamaguchi district of western Honshū or in Ōita in Kyūshū, where he devoted himself chiefly to painting. Even though he remained a monk, his artistic skills developed to a degree far beyond those of the usual painter-monks, almost as though he had been destined to follow both of these vocations—and to separate them. He felt little obligation to follow many of the painting practices which had been standard in the Zen cloisters of his day. Where poems had been written by various monks within the compositions themselves, Sesshū's pictures stood independent of any text. Where most monks had restricted themselves to monochrome ink, Sesshū introduced color whenever he wished. It is even possible that, in his devotion to painting, he refused to return to Kyoto because he was unwilling or unable to endure the severe hardships of Zen discipline as enforced in the monasteries there. In any event, the subject matter of his paintings became quite varied and rich, developing into what is called *kanga* (Chinese painting), a style based on a

wide range of Chinese prototypes and not merely those identified with the Zen sect; for Sesshū had studied the works of professional and dilettante painters of China as well as those of Zen monks.

There is no doubt, however, that highly specialized painting techniques were also developed at the same time by artists patronized by the shoguns, who had collected large numbers of Chinese scrolls. One of the first to recognize these possibilities was Kanō Masanobu, a samurai who became an attendant of the shogun and later was appointed official painter, which gave him the chance to practice freely a number of pictorial techniques. His successor was his son Kanō Motonobu, and between them they developed a highly flexible style which was rooted in ink painting in the Chinese manner but suited to the use of bright color whenever necessary for decorative purposes. The Kanō style was transmitted in a hereditary manner for nearly four hundred years, becoming a dominant force in Japanese painting circles and the nearest thing to an official style when sponsored by high state officials. Another line of painters among the attendants of the shogun was formed by three generations of men with the name of Ami: Nōami, Geiami, and Sōami. Their function had been to authenticate the paintings in the shogun's collections, judge their quality and arrange them. It was natural that they would themselves also paint, and from their time has come the *Kundaikan Sōchōki*, the oldest extant work of art criticism in Japan, which records the principles of connoisseurship of the Ami family. The men of this school were not the shogun's official painters, like the Kanō artists, and were free to develop their own highly individual styles. The Ashikaga family thus provided the core of stimulus for a number of new developments in painting, the excitement of which reached even into the remote provinces, where gifted painters appeared one after the other. The classic example of this is the sixteenth-century master Sesson, who worked in northern and eastern Japan in the manner of Sesshū, but nonetheless produced a novel style of his own.

The Craftwork of the Higashiyama Period

Led by Yoshimasa's ceaseless search for both novelty and perfection, innovations took place in the crafts as well as in painting; for Kyoto was, if nothing else, a place where craftsmen in large numbers had worked for centuries. These men were naturally stimulated by the designs and techniques of the imported luxury goods which were entering the city, and in the quantities of exquisite objects they produced for the shogun and his followers, virtually a new movement in the crafts arose. Swordsmiths, masters of lacquerware, weavers of brocades and other fancy cloth would devote countless hours of meticulous handwork and precious materials to attain levels of craftsmanship possible only with the unstinting patronage of the de facto rulers of the land.

Impressive developments in craftwork took place during this period in the provinces where the stimulus of imported Chinese goods was also felt. Mainland dyeing and weaving techniques were imitated in port cities active in the China trade such as Hakata and Yamaguchi in western Japan, for example, or Sakai near the modern Osaka. Excellent pottery like Chinese Temmoku ware was produced at Seto, a village not far from the modern Nagoya—bowls and dishes given a dark, brownish black glaze with small, iridescent circles like oil-spots. This ware was greatly prized by tea masters, and its popularity coincided with the increasing emphasis placed upon the tea ceremony in aristocratic circles. A rather ascetic, more typically Japanese spirit of serving tea and ornamenting the tearoom came into fashion, in contrast to the informal and colorfully

exotic Chinese style of the past. The tea itself became more bitter and astringent, and for boiling the water the tea masters preferred iron kettles with a particularly rough, rustic quality produced in only two remote villages: at Ashiya in northern Kyūshū and Temmyō in northeast Honshū.

The craftsmen of Japan, true to the dualism of this age, were stimulated by the taste for exotic imported things and rediscovered the beauty of sumptuous ornament; indeed, they laid the foundations for the ornamentalism and overwhelming pomp in the arts of the Momoyama period. Yet at the same time, they discovered anew the simplicity and economy of means in the primordial, native tradition.

The Perfection of Nō

The dance-drama called Nō (literally "skill" or "talent") was added to the rich artistic harvest of this era. A blend of many cultural traditions, native and foreign, the Nō drama became one of the most challenging and impressive artistic achievements of the Japanese people, yet its origins could not have been more humble. It developed in part from a kind of popular sideshow called *sarugaku* attached to shrines and temples throughout the country beginning in the Heian period. Performed by acrobats, jugglers, puppeteers, mummers, and the like, it was uncouth and even bawdy—one of several such forms of entertainment current among farmers or the common city folk. It even had its own regional traditions, as in the Yamato district or in the Ōmi country around Lake Biwa. In 1374, a *sarugaku* dancer by the name of Kan'ami Kiyotsugu performed a refined version of a Yamato dance as part of a ritual at the Ima Kumano Shrine in Kyoto. It was witnessed by the Shogun Yoshimitsu, who had offered his support and encouragement to Kan'ami and his young son Seami in their efforts to convert such popular entertainment into something far more refined.

Kan'ami and Seami were both men of genius, steeped in the religious, philosophic, and aesthetic ferment of the new age, and they bequeathed to later generations a new art form of profound content. Seami wrote several treatises outlining his and his father's ideas on the theory and rules of performance of Nō; and in a way characteristic of his age, he attempted to reconcile two antithetical elements: theatrical brilliance and metaphysical content. To discuss the latter, Seami frequently used the term *yūgen*, which is usually translated as "mystery," but which has overtones of indistinct, distant, subtle, and of profound or hidden meaning. To Seami, a performance which evoked the quality of *yūgen* had the mark of the supreme artistic achievement, and the mood of *yūgen* seems to have been largely an outgrowth of that called *aware* which had set the tone for so much of the court poetry and painting of the Heian period, a sense of almost indefinable sadness in the fragility of life and beauty, a heightened awareness that even the subtlest of things suggest the unalterable rule of fate: a falling maple leaf, the distant cry of a crow, a wisp of cloud passing over the moon. The concept of *yūgen*, however, was also rooted in the ideology of Zen Buddhism, which injected into the Nō drama a philosophic dimension far deeper than that of the Heian court arts and also encouraged great economy of means in the dance gestures or costumes and musical background. But even though Seami's treatises employ numerous quotations from Zen literature, they also warn against excessive restraint. He and his father must have consciously admixed a certain amount of the elegance of classical theatrical traditions, and they also skillfully employed humorous elements as relief from the serious, often tragic con-

tent of their plays. The humorous interludes or entr'actes were adopted from another of the vernacular traditions, a comic burlesque called Kyōgen.

The Nō drama, in a way which delighted the men of the era, evoked the invisible world of metaphysics and the spirit of Buddhist morality by means of the charm and beauty of the theater; and for this, the masks worn by the chief characters were of basic importance. Along with the rather polished realism of the sculpture of the age, the mask makers consciously imbued them with a quality called "intermediate expression," whereby a single mask could serve to express joy or anger, pleasure or grief according to the gestures of the actor and the mood of a given episode. This ambivalence in a mask's expression reflected the aesthetic principle often seen in Zen Buddhist arts, by which a certain flexibility and incompleteness of form challenged the spectator to complete in his own mind the interpretation of a landscape painting or a semisymbolic dry garden. The Nō masks, together with the more grotesque and farcical ones used in Kyōgen, are unique as theatrical implements; they are also impressive as sculpture in the full sense of the word.

The Nō drama was but one part of the cultural achievements of the age, but it was a most original and important one. It and all the others—even the tea ceremony, flower arrangement, or incense blending—were rooted to one degree or other in the spirit of Zen Buddhism. They also shared in the tendency of this age to organize the performance of an art to the point that it resembled a ritual. Even so, the breadth of the original vision still lingers about the Zen monasteries of Kyoto where it was first nurtured in Japan, where the gardens and teahouses, the painting and pottery reflect a vision of nature as the benign matrix of spiritual and artistic life.

Seen in this way, the Muromachi period was by no means one of darkness, despite the political background of almost incessant quarrels and rebellions. Springing to life during these two and a half centuries were the art forms which were to mature in the so-called Recent Age—the Momoyama and Edo periods—and to become the last great expressions of traditional Japan before the introduction of the industrial civilization of the West.

179. Stone garden of Ryōan-ji. Late fifteenth century.

Having neither trees nor water, only white gravel, a few stones, and moss, this garden lies directly beside the abbot's quarters of the small hermitage. It is a classic example of the Japanese *kare-sansui* (dry landscape) garden, for it carries to the utmost the aesthetic principle by which simplicity and economy of means are used to produce an artistic effect of great richness. A weathered, stucco-covered wall encloses the expanse of sand, which is broad and unobstructed like an ocean beach; carefully raked in simple patterns, the sand combines with the rocks to suggest natural or symbolic forms. Whether these be mountain peaks soaring above the clouds, islands set in the sea, or nothing of the sort, the mind is challenged by the stark, puzzling simplicity.

180. Shōitsu Kokushi of Tōfuku-ji. By Minchō. Fourteenth century. H. 267.3 cm. (105.21 in.), w. 139.8 cm. (55 in.).

This is a convincing likeness of the founding abbot of Tōfukuji even though it was done a century or so after his death (in 1280) and was based on older paintings or sketches. Nearly nine feet high, the work must have been hung during memorial services in his honor. The painter, Minchō, was one of the pioneer masters of Chinese-style ink painting in Japan, but in this work he was faithful to the tradition of brightly colored, tightly executed Buddhist hanging scrolls which had prevailed for centuries. The outlines are strong and stiff, and only in the drapery patterns are there the boldness and inventiveness of which this monk-painter was capable.

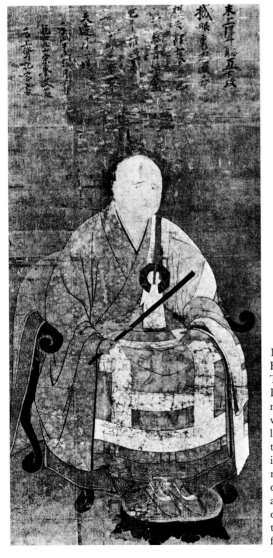

181. Daitō Kokushi. Daitoku-ji. Fourteenth century. H. 115.5 cm. (45.4 in.), w. 56.6 cm. (22.2 in.).

This portrait of the founder of the vast monastery of Daitoku-ji shows him dressed in a splendid robe ornamented with strips of gold and red brocade. Painted when he was fifty-three years old, he sits in a cathedra-like chair and holds a long bamboo baton used in teaching. The unknown painter sought to capture the individuality and dignity of this man, typical of the Zen monks who made such a deep impression upon the culture of their age—overflowing with both intellectual and physical vitality. Although this work was patterned closely after Sung Chinese portraits of Zen teachers, the treatment of the face and the rather broad areas of flat color are reflections of the *yamato-e*.

182. The "Moss Garden" of Saihō-ji. Fourteenth century.

Under a different name, Saihō-ji was one of the very oldest temples in the Kyoto area and was dedicated to Amitābha. When converted into a Zen hermitage by Musō Soseki, the pond and garden were given a more natural, forested feeling as a place for quiet walking and meditation, with several small pavilions and teahouses on the grounds. The result was a uniquely Japanese sense of natural beauty within a Zen garden; and even though most of the old buildings are lost and the garden has often been reconditioned, the atmosphere here is still powerfully compelling. The ground is carpeted by many varieties of moss, which offer an array of varied, intense greens during the spring and summer.

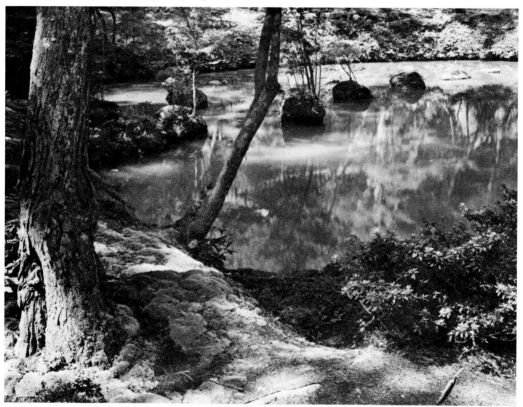

183. Garden of Daisen-in, Daitoku-ji. Sixteenth century.

A less severe version of the *kare-sansui* garden than the one at Ryōan-ji, the carefully pruned trees and the stones shaped like bridges or islands create the impression of a miniature landscape in a space barely nine feet wide. The tall rocks in the background suggest mountain cliffs and a waterfall, while the flat area of sand appears to flow like a stream. The Daisen-in is one of the many subtemples, or *tatchū*, of Daitoku-ji, and has preserved this garden since the beginning of the sixteenth century, when it was designed by the monk **Kogaku Zenshi.**

184. The Golden Pavilion of Rokuon-ji.

The *shariden*, known as the Golden Pavilion (Kinkaku), is the only one of the many structures of the Kitayama Palace which survived into modern times. It was part of the luxurious semihermitage built by Ashikaga Yoshimitsu at the time he resigned as shogun to become a tonsured Zen monk. Like a picturesque kiosk in a Southern Sung landscape painting, the Golden Pavilion sits beside the pond and boldly combines the native Japanese *shinden* style of building in the first two floors with the more formal and symmetrical *kara-yō* on the third. After being burned by an arsonist in 1950, it was carefully reconstructed, and its light and airy forms continue to lend their elegance to the ancient garden. (See color plate 33.)

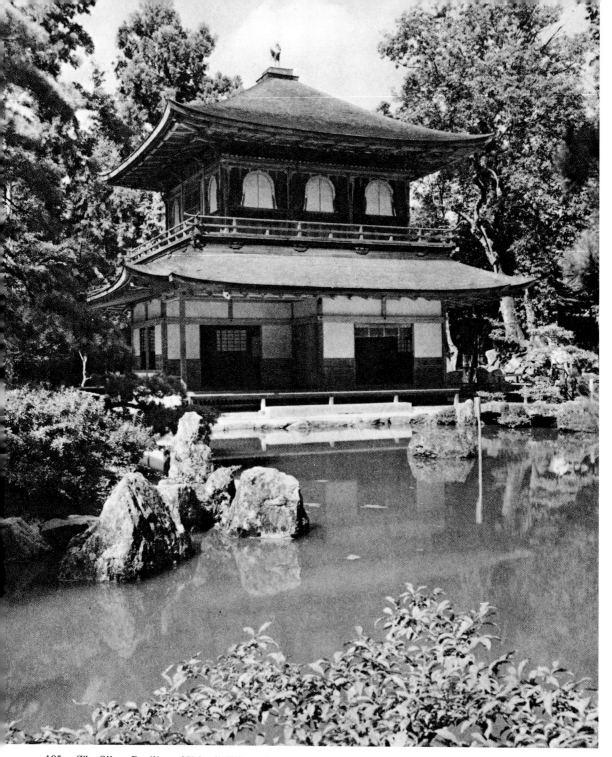

185. The Silver Pavilion of Jishō-ji. Fifteenth century.
The Silver Pavilion (Ginkaku) still stands in the
grounds of the former Higashiyama Palace, the ex-
quisite estate built by the Shogun Yoshimasa in emula-
tion of both the Kitayama Palace of his predecessor
and the garden-hermitage of Musō at Saihō-ji. Later
generations have been sparing in changes and renova-
tions, and the atmosphere of quiet, natural refinement
which lay at the heart of Yoshimasa's search for artistic
perfection can still be experienced.

186. The Tōgu-dō of Jishō-ji. Fifteenth century.
Even though a part of the Higashiyama Palace, from
the outside this hall looks no more impressive than a
farm cottage, yet on the inside it encompasses a number
of important architectural innovations and refinements.
It was primarily the shogun's private chapel, but its
religious nature is by no means obvious, for it served
also as a study and a teahouse. Its floors are covered
with tatami, and it has one of the oldest examples of an
attached writing ledge with its own *shōji* window; next
to it is an alcove with the so-called staggered shelves—
architectural details which had a great influence on
later building.

187. "New Moon over the Brushwood Gate." Artist unknown. Fifteenth century. W. 43 cm. (16.9 in.).
That this warmly poetic scene was painted by a cloistered monk is apparent neither in the technique of monochrome ink on paper—a great departure from the traditional brightly colored Buddhist paintings on silk—nor the subject matter. The moonlit setting, with a visitor and his servant at the rustic gate of a man who lives in the bamboo grove beyond, reflects Chinese nature poetry in which the highest wisdom lies in a man's identifying himself humbly and intuitively with the indwelling spirit of nature. Such ideals were absorbed into Zen Buddhist ideology, and directly above this scene are inscriptions by monks who speculated on the theme and added their own thoughts. This is one of the very oldest examples of Japanese ink landscape painting.

188. "Catching a Catfish with a Gourd," by Josetsu. Fifteenth century. W. 75.8 cm. (29.8 in.).

A barefoot man, foolish or demented, tries the impossible task of capturing a large catfish in a gourd with a tiny opening—a rare specimen of a Zen painting whose subject poses a riddle or sets up a paradoxical situation like those commonly found in Zen literature. Enriched by thin washes of pale color, the painting is a meticulously skillful essay in Chinese-style ink landscape paint-ing; great sensitivity was shown, for example, in the handling of the water patterns in relation to the swaying bamboo, and in the mist and distant hills. The artist, Josetsu, was a monk attached to Shōkoku-ji in Kyoto. Little is known about him personally, but he exerted great influence on succeeding generations of painters, particularly Shūbun and Sesshū, both of whom lived in the same monastery.

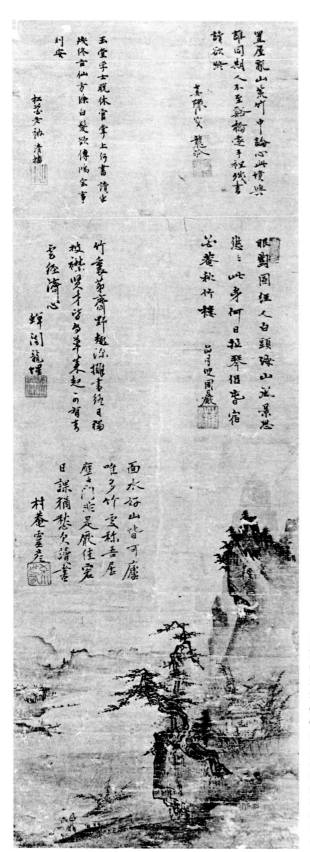

置屋乱山荒竹中 論心咄咄愫興
話同期人不至 溪橋遠手裡殘書
讀欲終

眼野圖經人白頭 海山戒景忠
淮淮此身何日 桂琴偓香宿

眞際笑
龍派

谷養秋竹樓

竹裏茅齋野趣深 攤書終日獨
枝稱喚手多年來起 一嘀肯

玉堂学士睨休官 寧上行書讀出
幾終言仙方陳白髪欲傳鴻宝事
刘安

雲經濟心

蝉閣龍暉

松花矢飲清播

面水好山皆可廬 唯多竹更多秋吾居
塵言不怕是嚴佳宅

日課猶愁欠讀書

村巷靈庄

189. "Reading in a Bamboo Grove Retreat," by Shū-bun. Fifteenth century. W. 33.3 cm. (13.1 in.).
Overlooking a lake or river, a man sits quietly reading in a rustic cottage far from the noise of the city. In the foreground, a visitor crosses a bridge; and the ideals of natural harmony which affected so many of the arts of Japan at this time—architecture and garden design as well—were given a classical expression. The style of such Southern Sung masters as Ma Yüan and Hsia Kuei served as the prototypes here, as may be seen in the severely angular brush strokes, the concentration of dark accents at different points, the contrast between near and far space. Despite this, the feeling for abstract composition is somewhat stronger than the illusion of deep space, a common occurrence in Japanese landscape painting.

190. Landscape in the ''broken ink'' manner, by Sesshū. Dated 1494. W. 32.7 cm. (12.8 in.).

In his rapid, apparently spontaneous technique, Sesshū took great liberties with illusionism. Not completely controlled were the ways in which the pools of ink might spread over the paper; the attack of the soft, wet brush was bold and undetailed, and yet all the elements of the composition form themselves into a clear image of mist and mountains and trees, as though polarized by a hidden compass. The brilliant contrast of light and shade has an almost electric vitality, and the technique itself is given the name *haboku*, which may be translated imperfectly as ''broken'' or ''flung'' or ''splattered ink.'' One of several styles practiced by Sesshū, it comes the closest to reflecting the tendency in Zen Buddhism to stress rapid flashes of intuitive insight into spiritual phenomena.

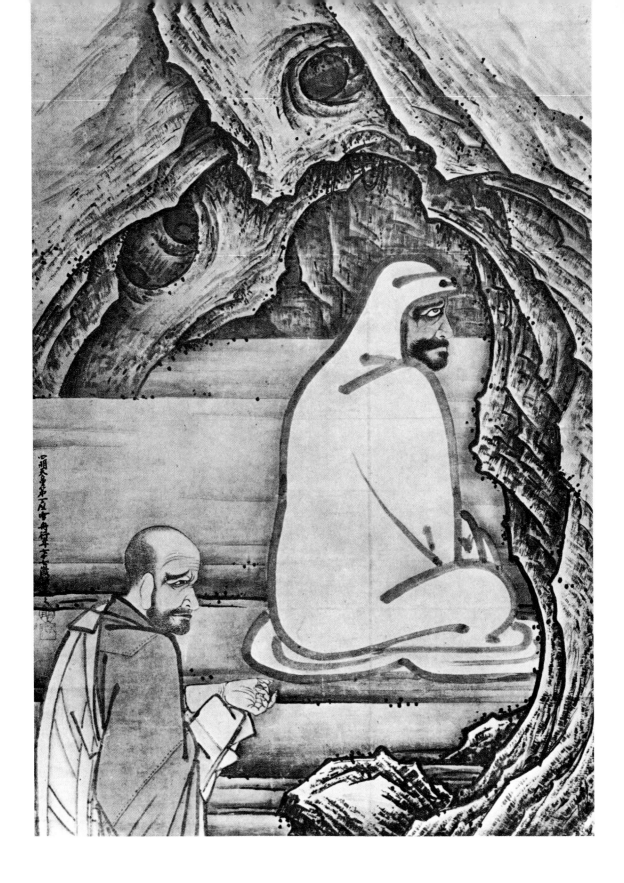

191. "Hui-k'o Presenting His Arm to Bodhidharma,"
by Sesshū. Detail. Fifteenth century. H. 200 cm. (78.7
in.), w. 114 cm. (44.8 in.).

Japanese painters of the Muromachi period did many
quasi portraits of the South Indian monk Bodhidharma
(Daruma), who came to China in the sixth century and
was revered as the first patriarch of the Zen sect. This
work of Sesshū shows him sitting in the snow in medita-
tion before the wall of a cavern while the Chinese monk
Hui-k'o, who was to become the second patriarch of
the sect, implores to be accepted as his disciple. To
prove his sincerity, the Chinese has cut off his left fore-
arm and hand. This large hanging scroll was painted in
Sesshū's more severe manner, with a thick ink line used
for the costumes of the monks and heavy hatching
strokes to depict the rock formations of the cave. In this
powerful painting, which is neither a hieratic icon nor
an illusionistic image, Sesshū sought to capture the
qualities of grim dedication and sternness which play
a major role in the atmosphere of the Zen monasteries.

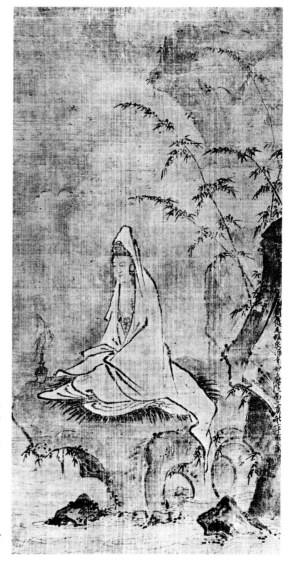

192. "Kannon in White," by Nōami. Dated 1469.
H. 109 cm. (43.9 in.), w. 38.2 cm. (15 in.).

Depicted for centuries as a regally ornate Bodhisattva,
Kannon (Avalokiteśvara) is shown here dressed in a
white robe seated in meditation on a crag overlooking
the sea. This motif was a favorite one of Zen monk-
painters, for it accommodated the imagery of the
Bodhisattva to the ideals of natural beauty and medita-
tion of the sect. This painting was done, however, not
by a monk but by a courtier, Nōami, founder of a school
of painters and connoisseurs who served the shoguns,
and this is the classic example of his style. The mono-
chrome ink on silk sets up a highly rhythmic interplay
of curved lines and broken contours, with softness of
contrast and movement.

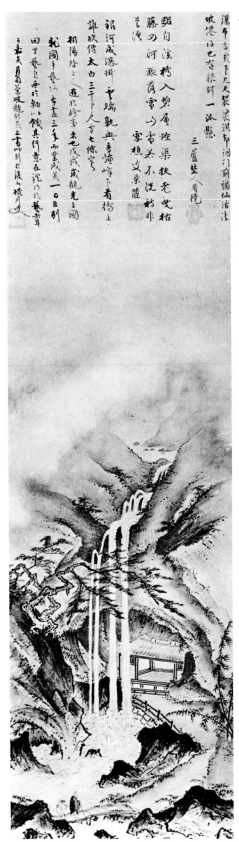

193. "Monk Watching a Waterfall," by Geiami. *Circa* 1478. H. 105.7 cm. (41.6 in.), w. 30.5 cm. (12 in.).

Geiami, the son of Nōami, seems to have painted in a style crisper and more assertive than his father's, although the number of works of either man verified as authentic is quite small. Strongly influenced by the aesthetic principles of the Zen sect, which had indeed begun to permeate all facets of Japanese cultural life, this charming landscape invokes a sense of the ceaseless movement of natural forces; the rustic cottage beneath the hanging cliff and tumbling streams of water is a retreat where the power and beauty of these forces may be felt. At the same time, the parallelism of the compositional lines in the crags, trees, and streams is far from spontaneous in effect and reminds one of the tendency of Japanese painters, even in this landscape style, to think more in terms of abstract schema than illusionistic effects.

194. "Birds and Waterfall," by Kanō Motonobu. Fifteenth century. H. 178 cm. (70 in.), w. 118 cm. (46.4 in.).

Painted in dark ink with touches of coloring, this remarkably fresh and lively scene shows how deeply the Kanō style was rooted in Chinese ink painting as first developed in Zen circles. Motonobu, the son of the founder of the school, had a strong influence on the development of Kanō traditions which were to receive the support of various shoguns for nearly four centuries. The crisp clarity of his brushwork and his tendency, as shown here, to control if not restrict pictorial depth made it possible for later generations of Kanō masters (Eitoku or Sanraku, for example) to admix areas of bright color and even gold leaf for decorative purposes and still retain the natural qualities of the subject matter.

196. The teahouse of Kohō-an, subtemple of Daitoku-ji. Seventeenth century.

The serving of tea in Zen temples was considered an exercise in spiritual cultivation, and among its many semiritualized aspects were the appreciation of pottery and painting and the art of intelligent conversation. Called the *cha-no-yu*, the ceremony was held in a special chamber or detached teahouse, immaculately clean, furnished with only the simplest of necessities, and imbued with a rarefied harmony of natural colors and textures. The Kohō-an is one of the most celebrated of the many fine teahouses within Daitoku-ji. Although frequently rebuilt, it has retained its unusually large size—its floor comprises twelve tatami mats—and the mood of the oldest Japanese tearooms built in the *shoin* style. The pillars and corner posts are heavy and thick; missing here are niceties of the tiny, rustic cottage-type tearooms which came into fashion in later centuries.

195. "Wind and Waves," by Sesson. Sixteenth century. H. 22 cm. (8.6 in.), w. 31.4 cm. (12.3 in.).

Among the many artists who fell under the spell of Sesshū's powerful styles of painting was Sesson, a Zen monk who lived in the extreme northeast part of Honshū and came no closer to the metropolitan centers than Kamakura. Nonetheless, he had opportunities to study Sesshū's work as well as Sung and Yüan Chinese painting, and developed a highly personal, expressive style of his own, one marked with turbulence at times and a love of energy well expressed in this small scene of a storm-tossed rivercraft.

197. Iron teakettle. Sixteenth century. H. 19 cm. (7.5 in.).

All the furnishings of a tearoom were selected with the utmost care—the kettle, the spoons, the water jars, and tea bowls. This celebrated iron kettle was made in a style greatly favored by the tea masters, for its surface has a rustic, unfinished air, and the water boiling inside makes a melodious rumbling sound. Its decoration appears only after careful scrutiny: five galloping horses shown in low relief; "distant hills" behind them; the dragon-shaped handle on the lid; monster-masks on the ring holders—an interplay between image and abstract texture like that of a dry garden or a "broken ink" landscape painting.

198. Nō stage.
At once colorfully splendid as well as composed and restrained, this is a performance of the Nō drama "Dōjō-ji." The Nō drama and the tea ceremony—arts of disciplined and elegant refinement—were formed under trying circumstances in an age of violent political struggle, but they expressed ideals which had long been gathering forces in the land. They burst upon the world as distinctly Japanese creations, yet each was a synthesis of aesthetic traditions, foreign as well as native, which had enriched the spirit of the nation for centuries.

THE ARTS OF JAPAN

GLOSSARY

Sanskrit equivalents of Japanese terms are given in parentheses; literal translations are placed in quotation marks.

Acala: *See* Fudō.

Ākāśagarbha Bodhisattva: *See* Kokūzō Bosatsu.

Amida (Amitābha): One of the most devoutly worshiped deities in Sino-Japanese Buddhism, Amitābha is the Buddha who reigns in the Western Paradise. As the personification of eternal life and boundless light and vast compassion, he will welcome to Paradise those who, with a sincere heart, call out his name. Figures 137, 140; *see also* Jōdo.

amida-dō: A temple hall dedicated to the worship of Amitābha and furnished chiefly with statues of that deity and his attendant Bodhisattvas, Avalokiteśvara and Mahāsthāmaprāpta (Kannon and Seishi, *q.v.*). See figures 133, 142, 152, 153.

Amida Raigō: The approach close to earth of Amitābha and his attendants to receive the soul of a dying believer and welcome him to Paradise. See figures 101, 138.

Amoghapāśa: *See* Fukūkensaku Kannon.

Apsaras: See *hiten*.

Arhat: See *rakan*.

Ārya Avalokiteśvara: *See* Shō-Kannon.

Asanga: *See* Muchaku.

Ashura (Asura): Malevolent demons of Indian epic mythology who challenge the authority of the Hindu gods; the Asuras were incorporated into Buddhist imagery as one of the eight classes of ferocious creatures (Hachi Bushū, *q.v.*) who protect the Buddhist realm. See figure 83.

Avalokiteśvara: *See* Kannon.

Avatamsaka Sūtra: See *Kegon-kyō*.

aware: A term denoting an aesthetic mood greatly cherished in Japanese court poetry and painting, especially in the eleventh and twelfth centuries. Difficult to translate directly into English, *aware* suggests the heightening of sensibility in the experience of nostalgia and melancholy, of awareness that all living things are transitory, of the disciplined acceptance of fate.

azekura: A native Japanese system of construction in rough-hewn logs wedge-shape in cross section; used primarily for utilitarian structures such as storehouses. See figures 74 and 75.

bakufu: "Tent government"; a term originally denoting the headquarters of an army in the field; it was adapted in the Kamakura period and used thereafter to refer to the government of a military dictator, usually with the rank of shogun *(q.v.)*.

Basara: Transliteration of the Sanskrit *vajra*, or thunderbolt; the name of one of the Twelve Divine Generals (Jūni Shinshō, *q.v.*) serving Yakushi Nyorai. See figures 90 and 92.

Benzai-ten (Sarasvatī): An ancient Indian deity believed to be the source of the gifts of language and letters, music and eloquence. She is widely worshiped today by Hindus in India but her cult came to Japan, together with that of the goddess Śrī Lakshmī (Kichijō-ten, *q.v.*) as an integral part of popular Buddhism of the eighth century. Interestingly, both goddesses were gradually admitted into the pantheon of the Shinto, or native Japanese, deities.

Bhaishajyagru: *See* Yakushi Nyorai.

Birushana or Rushana (Vairocana): The supreme deity of Esoteric Buddhism and its forerunners; symbol of the great generative force which lies at the heart of all creation. The worship of Vairocana was especially popular among ruling circles of China and Japan in the seventh and eighth centuries and was depicted by colossal statues of which the bronze Daibutsu in Nara (figure 64) and the rock-cut image of Lung-men, built between 672 and 675, are the best known surviving examples. Much of this worship was based on the *Kegon-kyō (q.v.)*.

Bishamon-ten (Vaiśravana): Chief of the Four Guardian Kings (Shitennō, *q.v.*). Vaiśravana, also known as Kubera, originated as an ancient

Indian folk god, Lord of Wealth, ruler of animistic deities such as Yakshas, and Regent of the Northern Quadrant. He became important in the popular religion of Central Asia, especially in Khotan, where he was offered an independent cult as the tutelary god of the kingdom. The painted scroll depicting the *Shigisan Engi* (figure 119) is a by-product of his cult in Japan.

biwa: A lutelike musical instrument brought to Japan from the Asian mainland. The four-stringed form with a bent neck seems to have originated in Iran; the five-stringed, straight-necked type was developed in India. Actual examples of both types are found in the Shōsō-in Treasure (figure 76, the five-stringed type).

Bodhisattva: *See* Bosatsu.

bokuseki: "Ink traces"; a term used in reference to the calligraphic writings of distinguished Buddhist monks, especially those of the Zen sect. Usually boldly and freely written, they would be given by a learned monk to a student or distinguished visitor and might contain a short scriptural quotation or even a single character aimed at stimulating the awareness of the viewer.

bon (Avalamba): The "All Souls' Festival" in Japan; a great popular celebration, held usually from the 13th to the 16th of August in honor of the spirits of deceased ancestors for seven generations past.

Bonten (Brahma): A Hindu deity incorporated as early as the first century A.D. into Buddhist imagery and legends as a devotee of the Buddha, thereby symbolizing the religious superiority of the new religion over Brahmanical orthodoxy. In the Indian Middle Ages, Brahma became one of the supreme figures of the Hindu pantheon, the lord of creation and sacred knowledge; but in Japanese Buddhist temples, statues of Bonten were paired with those of Indra (Taishaku-ten, *q.v.*) as subordinate attendants of a Buddhist deity. See note and figure 68.

bosatsu (Bodhisattva): A class of Buddhist deities extolled in Mahāyāna literature because they are believed to labor unceasingly for the benefit of mankind; among the major Bodhisattvas, only Maitreya (Miroku, *q.v.*) was related to a historical person; the rest were embodiments of theological and spiritual principles such as compassion, grace, divine wisdom, or steadfastness. In principle, the Bodhisattvas possess the wisdom and power necessary to enter *nirvāna* but refrain from doing so in order to help others reach salvation. In this they differ from the Arhats, who work only for their own enlightenment, and from the Buddhas, who (in theory) have already attained the highest level of spiritual insight and are usually no longer immediately connected with worldly affairs.

Buddha: *See* Nyorai.

bugaku: One of Japan's most ancient forms of dance with musical accompaniment, imported from China and Korea from the sixth to the eighth centuries. Employing elaborately carved masks, it was once performed chiefly by the aristocracy of Nara and Kyoto. With the decline of the court in the late Heian period, *bugaku* was preserved only at religious centers such as the Kasuga Shrine, Nara, Shitennō-ji in Osaka, and the Itsukushima Shrine near Hiroshima. It was similar to the *gigaku* dance *(q.v.)*, which, however, is now extinct. See figures 148, 149, and 150.

busshi: "Buddhist Master"; the title of a rank to which highly accomplished craftsmen were appointed as early as the Asuka period. Later, it was reserved for sculptors, and in the eleventh and twelfth centuries was somewhat superseded by more exalted ecclesiastical ranks.

bussho: Workshop for the production of Buddhist sculpture.

butsu (Buddha): *See* Nyorai.

butsuden: Hall for the enshrinement of Buddhist images.

Candraprabha: *See* Gakkō.

cha-no-yu: Ritualized tea ceremony as developed in the Muromachi period.

chigi: Boards which project above the ridgepole of the roof in Japanese-style buildings. The *chigi* originated as extensions of the rafters (technically called barge-couples) in very early forms of domestic architecture and have been preserved in Shinto shrine buildings, either functionally (as in the Ise Shrine, figure 18), or as decorative devices (as in buildings at Izumo, figure 17).

chinzō: A term used to denote the portraiture in painting and sculpture of distinguished monks of the Zen sect.

chokkomon: "Straight-arc design"; a decorative geometric pattern found in the mirrors and wall paintings of the protohistoric period. Thought to have been developed in the Kansai district and to be strictly Japanese in origin. See figure 15.

chōshū-den: An "assembly hall," at least two of which were set in the outer courtyards of the Hall of State compound of the early imperial palaces in Nara and Kyoto. One such hall, taken from the Nara Imperial Palace, was converted into the lecture hall *(kōdō)* of Tōshōdai-ji and is still standing. See figure 57.

Chūbu: The area in the central part of Honshū Island ranging from Sado Island in the north to the Izu Peninsula in the south, and to the border of Ōmi province (modern Shiga Prefecture) in the west; includes the modern cities of Nagoya, Gifu, and Nagano.

chūmon: "Central gate"; one of the standard parts of the early Japanese temple; the entry into the colonnade enclosing the central core of the compound. The *chūmon* often houses statues of the Ni-ō *(q.v.)* on either side of the entry door.

Daibutsu: "Great Buddha"; an ancient designation for the giant bronze statue of Vairocana at Tōdai-ji (figure 64). The bronze statue of Amitābha at Kamakura is also called a Daibutsu (figure 170).

daibutsu-den: The hall which encloses a Daibutsu.

Daijō (Mahāyāna): "Great Vehicle"; the second of the three main historic and doctrinal divisions of the Buddhist faith, the first being the "Small Vehicle," or Hīnayāna (Shōjō, *q.v.*), and the third being Esoteric Buddhism (Mikkyō, *q.v.*). Mahāyāna doctrines seem to have been formulated in India as early as the first century B.C. and, in part, stressed that the paths of salvation were open to laymen as well as monks, that salvation could be achieved through the assistance of a vast pantheon of powerful, compassionate deities.

Dainichi: *See* Birushana.

dogū: Clay figurines produced during the Jōmon (neolithic) period.

dōtaku: Bronze implements cast during the Kofun (protohistoric) period in the shape of bells but considered to be largely nonutilitarian in function, perhaps regalia or sacred objects used in fertility or hunting rituals.

Emma (Yama): An Indian deity of great antiquity, the lord of death in the *Vedas*; Yama was widely worshiped in China during the T'ang and Sung periods and in the Kamakura period in Japan as the chief magistrate at a court of judgment which determined whether the dead would be reborn in Paradise or Hell.

endō: "Circular hall"; a name given to octagonal temple structures built in part as memorials to distinguished men. See figures 42, 81, and 82.

Five Great Kokūzō Bodhisattvas: *See* Kokūzō Bosatsu.

Four Deva Kings: *See* Shitennō.

Four Guardian Kings: *See* Shitennō.

Fudō (Acala): "The Immovable"; perhaps the most prominent of the Five Myō-ō. Fudō symbolizes, among other things, fearlessness, steadfastness in the face of passion and temptation. *See also* Myō-ō.

Fugen Bosatsu (Samantabhadra): The Bodhisattva of all-pervading goodness, the special patron of believers in the *Lotus Sutra (Hokke-kyō, q.v.)*. In Buddhist imagery he is often shown mounted on an elephant placed to one side of Śākyamuni and paired with Mañjuśrī (Monju, *q.v.*) seated on a lion placed on the other side.

Fukūkensaku Kannon (Amoghapāśa): One of the many forms of the Bodhisattva Avalokiteśvara; the name suggests a deity whose lasso (a rope thrown to those in peril) is never empty in the work of salvation. Often depicted with eight arms which stress its power, this deity is largely Tantric in nature. The statue in the Sangatsu-dō of Tōdai-ji (figure 66) is perhaps the oldest representation of him extant in the Buddhist world.

gagaku: The musical forms which accompanied the *bugaku* dances *(q.v.)* performed in the Nara area from the seventh century onward. Considered correct and courtly in spirit, *gagaku* was strongly rooted in Confucian Chinese traditions.

gai-heiden: The "outer offering hall" of a Shinto shrine. See also *heiden*.

Gakkō (Candraprabha): "Luster of the Moon"; a Bodhisattva who, together with Nikkō *(q.v.)*, flanks the Buddha Yakushi. See figures 50, 68.

gekū: The outer sanctuary at the Ise Shrine; dedicated to the goddess Toyouke Ōmikami.

Gempei war: The struggle for military supremacy between the Genji (Minamoto) and Heike (Taira) clans at the close of the Heian period. Beginning in August, 1180, bitter warfare raged until 1184 and the triumph of Minamoto-no-Yoritomo. In the process, both Tōdai-ji and Kōfuku-ji were set afire by the Taira forces.

Genjōraku: A character from Indian mythology featured in a *bugaku* dance.

genkan: An ancient musical instrument resembling a *biwa* but having a flat body. The specimen in the Shōsō-in is the only example extant today. See figure 77.

gigaku: A dance-drama tradition similar to *bugaku* *(q.v.)*, if slightly more archaic in form. Imported in the seventh century and made up of Korean, Chinese, and Central Asian elements, it was performed mostly at the great Nara temples, where numerous *gigaku* masks have been preserved. The tradition seems to have died out in the beginning of the Edo period.

Godai Kokūzō Bosatsu: *See* Kokūzō Bosatsu.

Godai Myō-ō: *See* Myō-ō.

goko-rei: Bell used in Esoteric Buddhist rituals having five prongs on the handle which form the shape of a vajra, or thunderbolt *(kongō-sho, q.v.)*. See figure 100.

Goma (Homa): The ancient Vedic Indian ritual of burnt offerings; adapted by Esoteric Buddhists as a symbolic means of burning away passion and illusion and other obstacles to enlightenment. An important and dramatic part of the ceremonials of the Esoteric cults.

gorin-no-tō: "Five-wheel pagoda"; a pagoda-type peculiar to Esoteric Buddhist traditions. The five parts of the structure (square, round, triangular, crescent, and spherical) symbolize the elaborate system of fives by which the Esoteric sects, especially Shingon, interpret reality: the five basic elements of creation (earth, water, fire, air, space, and intelligence or mind), the Five Buddhas and their individual emanations, the five forms of wisdom, etc.

Gosho: Honorific name for a palace.

Gundari Myō-ō: One of the Five Myō-ō. *See* Myō-ō.

Guze Kannon: Kannon *(q.v.)* as the Universal Savior; one of the many forms under which this deity was worshiped. Shōtoku Taishi was believed to be an incarnation of the Guze Kannon,

whose statue serves as the *honzon* of the Yume-dono at Hōryū-ji. See figure 43.

haboku: "Flung- or broken-ink"; a term used to describe the rapidly executed ink paintings done frequently by Zen Buddhist painters, in which the image is so amorphous that a special effort is required of the spectator to recognize its referent. See figure 190.

Hachi Bushū: Eight classes of fierce demigods from Indian mythology who protect the Buddhist realm. See figure 83.

haiden: The "worship hall" of a Shinto shrine, where devotees face the deity's sanctuary and offer prayers.

haniwa: Hollow clay figurines of the Kofun (proto-historic) period which were placed around the grave mounds of persons of high status. See figures 9, 11, and 12.

Hannya (Prajñāpāramitā): "The perfection of wisdom"; the key terms in the title of a series of religious-philosophical texts produced in India during the first four centuries of the Christian Era and which are among the most important sources of Mahāyāna theology.

hattō: "Dharma hall"; the hall for major formal ceremonies (e.g., the anniversary of the death of Śākyamuni) in Zen Buddhist temple compounds. The *hattō* occupies more or less the same position as does the lecture hall in the conventional temple layout.

heiden: The "offering hall" in a Shinto shrine, where the clergy present food and other gifts to the deities enshrined in the *honden* (main shrine).

Hīnayāna: *See* Shōjō.

hira-karamon: "Flat Chinese gate"; a variant of the so-called Chinese gate *(karamon, q.v.)* in which the roof is unbroken by the usual gable directly over the entry proper; here the gables are only at the ends of the roof. See figure 131.

hiten: Flying angelic figures derived from ancient Indian mythology and arts; they include dancers (Apsaras) and musicians (Gandharvas).

Hokke-kyō: The so-called *Lotus Sutra (Saddharma-pundarika)*; one of the most influential works of Mahāyāna literature and one of the bases of the cult of Amitābha. Originating in India in probably the first century A.D., this rich and complex text extols, *inter alia,* the idea that anyone who has heard the preaching of a Buddha may attain supreme enlightenment himself. Those who are reborn in a Paradise are thus given access to a teaching Buddha and the opportunity to attain final release from the bondage of existence.

hokuen-dō: "North circular hall." See *endō*.

hōkyoin-tō: A type of memorial stupa similar to the *gorin-no-tō (q.v.),* usually small in scale and made of stone. On the face of the main shaft are either images of four Buddhas or else Sanskrit letters standing for their names. See figure 176.

honden: In a Shinto shrine, the main sanctuary building where the deity is supposed to dwell.

hondō: In a Buddhist temple, the hall where images of the principal deities are enshrined; similar in function to the *kondō (q.v.)*.

honzon: The deity (and his image) upon whom the devotions of a given Buddhist hall or entire temple are centered.

Hōō-dō: "Phoenix Hall"; a popular name given to the celebrated *amida-dō* of the Byōdō-in at Uji, southeast of Kyoto. See figure 133.

hōshu (Cintāmani): A gem which figures prominently in Buddhist art and architecture, being carried by such deities as Jizō (figure 155) and Kannon (figures 43, 102) as well as serving as a roof ornament on buildings such as the Yumedono (figure 42) and on the very top of the pagoda finial of Yakushi-ji (figure 47). It signifies the presence of the vast and precious treasure of the Buddhist Law, but it also signifies the capacity to achieve any goal—spiritual or material—as a result of the wisdom and insights of the faith.

hōsōge: Imaginary flowers rather resembling peonies which are prominent in Buddhist decorative arts.

Indra: *See* Taishaku-ten.

insei: The rule of cloistered emperors. An ancient Buddhist custom of a ruler renouncing his throne to concentrate upon spiritual concerns became, with the abdication of the Emperor Shirakawa in 1086, a political stratagem. The retired emperors who were nominally members of a monastic order had greater freedom of movement in the power struggles of the twelfth century than the actual regnant emperor, who would often be a child, or a puppet of one of the contending forces, or hedged in by the ceremonial nature of his office.

Jikoku-ten (Dhritarāshtra): "Bearer of Sovereignty"; one of the Shitennō *(q.v.);* Regent of the Eastern Quadrant.

Jingū: Designation of a Shinto sanctuary whose rank is higher than that of an ordinary shrine.

Jinja: Designation of the standard Shinto shrines, of which about eighty thousand exist in the entire country.

Jizō (Kshitigarbha): One of the most prominent Bodhisattvas in popular Mahāyāna Buddhism. The embodiment of compassion and service to mankind, Jizō is the guardian of children and protector of travelers and warriors; he intervenes in Hell for the sake of those suffering there. See figure 155.

Jōdo: "Pure Land"; a term used in reference to the numerous Paradises in Mahāyāna theology. The one most commonly prayed for, however, is that of Amitābha in the west, the Sukhāvatī, and the Jōdo sect which rose in Japan in the early Kamakura period made the ideal of rebirth there the center of its creed.

Jōmon: "Rope Pattern"; a name given to pottery of the neolithic period decorated by pressing straw ropes into the soft clay; the word also is used as the name of the period of Japan's neolithic civilization.

Jūni Shinshō: The Twelve Divine Generals who attend the Buddha Yakushi, helping him to enforce his twelve-fold vow of compassion to aid mankind and cure it of physical and spiritual ills. See figures 92 and 107.

kaizan-dō: The "founder's hall" in a temple compound, usually containing a portrait statue of the first abbot of the monastery and occasionally statues of other monks who worked for its benefit.

kampaku: Title of the highest dignitary in the imperial court, usually translated as "chancellor." During the Heian period the rank was usually held by members of the Fujiwara family, who were the de facto rulers of the land.

kana: The Japanese syllabaries; two systems of alphabetic writing made up of simplified forms of Chinese characters to represent the sounds of spoken Japanese. Inspired and guided perhaps by the model of the Sanskrit alphabet, *katakana* (the angular or straight-line form) is said to have been devised in the eighth century, and the *hiragana* (the cursive form) in the ninth; Kōbō Daishi is credited by legend with the invention of the latter.

kanga: Chinese paintings, or Japanese painting in the Chinese manner. See also *kara-e*.

kanji: Designation for state-supported temples of the early eighth century.

Kannon (Avalokiteśvara): A major Bodhisattva in Mahāyāna Buddhism. Theologically Kannon serves as one of two major attendants of Amida and is no more puissant than Monju or Miroku or Fugen. In fact, however, he is the most widely worshiped of all Bodhisattvas in Japan and is virtually the archetype of this class of deity. The embodiment of divine compassion with limitless power and skill, Kannon can assume any form necessary for his mission of salvation; but the most familiar formulations list thirty-three major guises. In this glossary, for example, see Fukūkensaku Kannon, Guze Kannon, Nyoirin Kannon, and Shō-Kannon.

Kanō style: A semihereditary tradition of Japanese painting begun in the mid-fifteenth century by Kanō Masanobu and Kanō Motonobu. While specializing in ink painting in the Chinese manner, later Kanō painters would also admix bright color and gold leaf when necessary for decorative purposes.

Kansai: The section of Honshū island extending from Shiga Prefecture around Lake Biwa on the northeast to Hyōgo Prefecture on the southwest and Wakayama and Mie prefectures to the southeast. Includes the major modern centers of Kobe, Osaka, Kyoto, Nara, and Ōtsu.

Kantō: The section of Honshū island extending from Kanagawa and Chiba prefectures on the south and including Tochigi Prefecture on the north and Saitama on the west. The district is dominated by the vast alluvial plain of which Tokyo is the main metropolis.

Kanzeon Bosatsu: "Regarder of the World's Sounds"; a name of Kannon *(q.v.)* which approximates the meaning of the Sanskrit Avalokiteśvara, a word difficult to define but which implies a deity who looks down on, or responds to, his devotees and their needs.

kara-e: Similar in meaning and use to *kanga (q.v.)*; in use from the mid-Heian period onward, when awareness of native Japanese standards prompted the need for a descriptive term for Chinese painting.

karamon: Gates thought to be in a Chinese style which were built frequently during the Momoyama period in castles and temples. Typical examples had gables over the entryway and at the sides, the ones in front having curved eaves resembling in shape the visor of a helmet. See *hira-karamon*.

kara-yō: "Chinese style"; an architectural style employed in Japanese Zen temples from the Kamakura period onward and based on the careful study of Zen temples on the mainland, especially those in the Hangchou area. See figure 164.

kare-sansui: "Dry, or withered, landscape"; a type of garden often found in Zen monasteries, in which the usual ponds, rivulets, and lush foliage have been replaced by sand, rocks, and a minimum of verdure. Befitting the austere taste and the tendency in Zen circles to restrict the materials of the arts, such gardens are not intended as rustic, pleasurable retreats so much as they are challenges to metaphysical insight.

karyōbinga (kalavinka): A bird in Indian mythology, like a cuckoo or sparrow, having an exquisitely melodious call; found frequently in Buddhist decorative arts. See figure 156.

Kegon-kyō (Avatamsaka Sūtra): Another of the fundamental Mahāyāna sutras, or rather an extensive group of texts and commentaries. Composed in India perhaps in the second or third century A.D., the *Avatamsaka* literature promotes the concept of the Buddha Vairocana (Birushana, *q.v.*) as the cosmic origin of all things, the essence of the Tathāgatas. The influence of these texts was extremely strong in Nara period Japan. *See* Daibutsu; figure 64.

keman: Pendant discs made of leather or copper used as temple ornaments. Thought to have originated as floral wreaths brought as Buddhist votive offerings. See figure 156.

Kichijō-ten (Śrī Lakshmī): Popular Indian goddess of beauty, good fortune, and wealth; similar in nature to Benzai-ten *(q.v.)*. See figure 53.

Kinki: The Kyoto-Osaka-Nara district.

kirikane: "Cut gold"; a technique of cutting thin gold leaf into decorative patterns and applying it to a painting or statue; the result is a linear

pattern far more delicate and richer in surface effect than that produced by painted gold. See figure 53.

Kochō-mai: "Butterfly Dance"; one of the traditional *bugaku* dances performed at the Itsukushima Shrine. See figure 148.

kōdō: "Lecture hall"; one of the basic parts of early Japanese temples; a hall for ceremonial reading of sutras, sermons, and other gatherings of monks. See figures 57 and 110.

kofun: "Old tomb"; a generic term for the large burial tumuli of the protohistoric period. *See* figure 10.

Kokūzō Bosatsu (Ākāśagarbha): An Esoteric Buddhist deity sometimes depicted in five different forms (see figures 97 and 98). Theologically the Ākāśagarbha (Womb of the Void) is part of the Taizōkai *(q.v.)*; the five Bodhisattvas of this realm symbolize the five types of wisdom and power of achievement rooted in the merits of Vairocana and the Buddhas of the four directions; their wisdom and mercy expand boundlessly, like space itself.

Kōmoku-ten: One of the Shitennō *(q.v.)*; the guardian of the West; Virūpāksha in Sanskrit, meaning one whose eyes are deformed or enlarged.

kondō: "Golden hall"; a standard part of early Japanese temple compounds housing images of the deities most sacred to the place.

Kongōkai (Vajradhātu): "The Ingredient of the Vajra *(q.v.)*"; in Esoteric Buddhist speculation, one of the ingredients out of which the entire creation was formed, the other being the Taizōkai *(q.v.)*. The Kongōkai is roughly equivalent to the Platonic *phenomenon*, or to material existence, to human knowledge, to contingency, to the first step by which the human consciousness returns to its divine matrix through Buddhist enlightenment. See also *mandara*.

kongō-sho (vajra): A thunderbolt originating in Indian mythology as the weapon of Indra, Vedic lord of rainfall. The vajra became a common feature in Buddhist arts as brandished by guardians (see figures 67, 70) but in Esoteric Buddhism (which is sometimes called Vajrayāna) it became a symbol of fundamental importance. The vajra is the emblem of Esoteric doctrine that cleaves the darkness of ignorance as lightning pierces the clouds. The wisdom of the vajra is also likened to a diamond as a material that is indestructible, irresistible, and of precious value. Vajras made of bronze in a great variety of shapes are commonly used in Esoteric Rituals. See figures 97, 98, 100, 111; see also *goko-rei*.

koto: Long, zitherlike, stringed musical instrument.

Kshitigarbha: *See* Jizō.

Kudara: Japanese pronunciation for the name of the Korean kingdom of Paekche (18 B.C.–A.D. 663), occupying the southwest quarter of the Korean Peninsula.

kyō (sūtra): A class of Buddhist texts said to be the record of the original words of Śākyamuni or else the product of a supernatural revelation.

Kyōgen: A theatrical form, farcical and burlesque in nature, incorporated into the performances of the Nō drama as entr'actes for comic relief. Like Nō itself, Kyōgen originated in the vulgar, popular theater but was refined and adapted to the taste of the aristocracy in the Muromachi period.

Lotus Sutra: See *Hokke-kyō*.

Mahāsthāmaprāpta: *See* Seishi.

Mahāvairocana: *See* Birushana.

Mahāyāna: *See* Daijō.

Maitreya: *See* Miroku.

maki-e: Lacquering technique developed in the Heian period; gold, silver, and copper powder and flakes are set into the lacquer ground or else modeled in designs in varying degrees of relief on boxes, furniture, etc. See figures 124, 177, 178.

mandara (mandala): Theological diagram or schema prominent in Esoteric Buddhism. The mandala originated in India, where highly abstract diagrams called Yantras, made up of interlocking triangles and circles, have been used by ascetics as aids to private meditation. Mandalas are used in the same way, but they bear pictures or other symbols of the deities and also have been employed in baptism and ordination rituals. In the *kondō* of Japanese Shingon temples, two large mandalas are frequently mounted on permanent wooden screens at right angles to the axis of the image platform. See figures 111, 129; *see also* Kongōkai and Taizōkai.

Mañjuśrī: *See* Monju.

Michōdai: Honorific name for the throne of the empress in the Shishin-den, the Throne Hall of the Kyoto Imperial Palace.

Mikkyō: Esoteric Buddhism; the third of three major types of Buddhism (see also Daijō and Shōjō), it is also called Tantric or Vajrayāna Buddhism. It developed in the sixth century A.D. as part of an extremely complex, religio-philosophic movement which embraced Indians of all creeds, and it injected into Buddhism a number of magical cult practices, as though to induce the state of spiritual enlightenment through the manipulation of occult forces. A large number of folk gods as well as lightly disguised Hindu deities entered the pantheon; and in general, a great change of mood and emphasis was produced in Buddhist arts. This is nowhere more clearly apparent than in Japan, where Esoterism was introduced largely through the efforts of Kūkai and Saichō, founders there of the Shingon and Tendai sects.

Miroku (Maitreya): The Buddha of the future. Early in the history of the faith, Indian Buddhists believed that another Buddha, to be called Maitreya, would appear on earth to lead

myriads of the faithful to salvation, and laymen prayed that they would be reborn at the time of his coming. The future Buddha would be the reincarnation of one of the lesser disciples of Śākyamuni, a former Brahman named Maitreya. After his death, Maitreya was to rise to the Tushita Paradise and dwell there as a Bodhisattva until the time (in the remote future) for him to return to earth and begin his messianic role.

mokoshi: An outer corridor added to the lower story of Buddhist halls and pagodas as additional protection for their contents. For the Hōryū-ji pagoda and *kondō*, see figure 23; for the pagoda of Yakushi-ji, where the *mokoshi* appear on three stories, see figure 47.

Monju (Mañjuśrī): One of the great Mahāyāna Bodhisattvas who are embodiments of compassion for mankind; but the emphasis in Mañjuśrī's character is also upon wisdom, and he is considered the guardian of the sacred doctrines of the Greater Vehicle.

mono-no-aware: See *aware*.

Muchaku (Asanga): An Indian theologian of probably the early fifth century A.D., he was one of the founders of a school of Yogācāra, or specialized meditation practices. The Japanese Hossō sect, of which Kōfuku-ji is the headquarters, was descended from that school. In legend, Asanga was said to have obtained the sutras of this school by magically rising to Maitreya's Paradise. Hence, at Kōfuku-ji, he and his colleague Vasubandhu (Seshin, *q.v.*) were depicted by over-life-sized statues placed at the feet of an image of Maitreya. See figures 85 and 87.

Myō-ō (Vidyārāja): Fierce Bodhisattvas, prominent in Esoteric Buddhist symbolism; the manifestations of Vairocana's wrath against evil. Although often seen in sets of five, their number and identities sometimes differ. The most commonly seen Myō-ō in Japan, however, is Fudō *(q.v.)*. See figure 110.

naikū: The name of the inner sanctuary at Ise, where the goddess Amaterasu Ōmikami is enshrined.

nan'en-dō: "South circular hall." See *endō*.

nehan (nirvāna): One of the many terms used to denote the psychospiritual state which is the ultimate human attainment in the Buddhist scale of values. The Sanskrit *nirvāna* implies extinction or blowing out (as of a flame), the annihilation of passion and sentiency, the escape of man from the chain of birth and rebirth, the dissolution of the elements of his individuality or ego. While used to refer to the attainment of full enlightenment by Śākyamuni, the term *nehan* in Japan often denotes his death. See also *satori*.

nembutsu: "Meditation on the Buddha"; the repetition of the prayer formula *Namu Amida Butsu* ("Homage to Amitābha Buddha"); the prime act of faith demanded of the followers of the

Jōdo sects in Japan.

Nikkō (Sūryaprabha): "Brilliance of the Sun"; *see* Gakkō.

Ninnō-kyō: *Sutra of the Benevolent Kings (Kārunikarāja Prajñāpāramitā Sūtra)*; a text of Indian origin which explains how the well-being of a state could be enhanced by the worship of the great guardian kings. A translation into Chinese attributed to the Indian monk Amoghavajra and permeated with Tantric concepts, it was used in ceremonies performed in the lecture hall of Tōji intended to promote the safety of the empire. See figure 110.

Ni-ō: "Two Kings"; two guardian kings frequently found on either side of the central entrance to the *chūmon* of a temple. Sometimes referred to as Dvārapālas, or door guardians, in Sanskrit.

nirvāna: See *nehan; satori.*

nise-e: "Likeness picture"; term used to denote a style of secular or court portraiture which developed in the Kamakura period. The special feature of this style was the attempt to depict the subtle qualities of individuality in the face. See figure 161.

nishi-no-Kyō: Originally the designation of the western half of the capital city of Nara; now, with the shrinkage of the size of the town, it refers to the semirural area around the temples of Tōshōdai-ji and Yakushi-ji.

Nō: The distinctly Japanese form of drama which developed in the Muromachi period; its origins were in the popular theater, such as *sarugaku (q.v.),* but it was converted into a highly refined form of expression permeated with Zen Buddhist ideals and aesthetic principles. See figure 198.

Nyoirin Kannon: One of the variant forms of Kannon *(q.v.)*. His images, usually four-armed, hold the wheel of the Buddhist Law and the jewel *(hōshu, q.v.)* symbolizing his ability to respond to the prayers of the faithful. See figure 102.

Nyorai (Tathāgata): The designation of the class of fully enlightened Buddhas who are totally identified with the metaphysical basis of all truth and existence. Those most commonly seen in Japanese art are Shaka (Śākyamuni), Amida (Amitābha), Yakushi (Bhaishajyaguru), and Birushana or Dainichi (Vairocana). Iconographically, the Nyorai are shown dressed in monastic robes without jewels or ornaments (for example, figures 25, 26, 64, and 137); but there are exceptions to this in Esoteric imagery (figures 111 and 158). See also *bosatsu*.

okashi: A term similar to *aware (q.v.)* expressing an aesthetic mood sought in literature and painting, particularly in the mid-Heian period. Whereas the quality of *aware* was melancholy and subdued, *okashi* was more comical, boisterous, and dynamic in spirit. The classic expression of the latter is the scroll painting of the *Shigisan Engi* (figure 119).

oku-no-in: The inner precinct of a temple, often set aside as the burial ground or else as a quiet monastic sector removed from the halls where laymen most frequently come in worship.

raden: Mother-of-pearl inlay into a wood or lacquer ground.

Raigō: *See* Amida Raigō.

rakan (Arhat): A class of men in Buddhist theology and art; the Sanskrit *arhat* was originally a term of respect addressed usually to an ascetic or sage. Among the Buddhists, it came to designate those men who exerted themselves strenuously to attain their own salvation but not to assist others. The ideal of the Arhat is said to characterize Hīnayāna Buddhism, whereas Mahāyāna is characterized by that of the Bodhisattva, whose divine powers are used to aid mankind. However, in later Buddhist theology (especially in the Zen sect) the Arhats, ugly and warped physically in their intense struggle, were revered as virtual demigods who had attained both wisdom and occult powers but refrained from entering *nirvāna* in order to sustain the Buddhist Law until the coming of Maitreya.

Renge Kokūzō Bosatsu: One of the five Kokūzō Bosatsu *(q.v.)*.

ron (Śāstra): A class of Buddhist texts which were written by specific authors and were more technical or systematic than the sutras *(kyō, q.v.)*, which purport to be the words of the Buddha or to be of supernatural origin.

Ryūtōki: "Dragon Lantern Goblin"; a semi-humorous demon, one of a pair depicted at Kōfuku-ji, Nara, holding a temple lantern. *See also* Tentōki.

sai-in: The west precinct of a temple; as at Hōryū-ji, where the *sai-in* includes the original nucleus of the monastery (pagoda, *kondō*, lecture hall, dormitories, etc.).

Śākyamuni: *See* Shaka.

sammon: The main ceremonial gate of a Zen temple compound. It is usually found behind a smaller and more modest *sōmon*, or general gate. The *sammon* often has a stairway to a second story in which statues of the Arhats (as many as five hundred) are installed.

sarugaku: "Monkey music"; a type of popular theatrical show performed as early as the Heian period around shrines and temples throughout the country; consisting of jugglers and puppeteers, acrobats and mummers. The *sarugaku* served as the basis of the Nō drama during the Muromachi period, when it was altered and refurbished as an aristocratic art form.

Śāstra: See *ron*.

satori: Another of the terms used to denote Buddhist enlightenment. Given special emphasis in Zen circles, *satori* may be translated simply as "understanding" or "comprehension"; but the full range of its meaning lies in the complex doctrines of Indian and Chinese metaphy-

sics. See also *nehan*.

Seishi (Mahāsthāmaprāpta): One of the major Mahāyāna Bodhisattvas. Seishi serves together with Kannon as attendants of Amida (See figures 101 and 153). His name suggests the deity whose power and wisdom reach everywhere.

Seshin (Vasubandhu): An Indian monk of perhaps the early fifth century A.D. who, together with Asanga (Muchaku, *q.v.*), founded the Mahāyāna Yogācāra school of Buddhist philosophy and discipline. See figure 87.

setsubun: A popular Japanese festival celebrating the advent of spring according to the lunar calendar.

Shaka (Śākyamuni): "Sage of the Śākya clan"; the historical founder of the Buddhist faith. Born into a princely family ruling in the Nepalese foothills around 560 B.C., his career as a religious leader was centered in eastern and central India until his death about 480. Other names by which he is called include: Siddhārtha, his given name which applies to his career prior to the attainment of enlightenment, after which he is called Buddha ("Enlightened," "Awakened"); Gautama; the Tathāgata (Nyorai, *q.v.*).

shari (*śarīra*): A relic; often used in reference to the corporeal remains (ashes or teeth) or the personal possessions of Śākyamuni after his death.

shariden: Hall for the enshrinement of relics.

shikken: A rank in the Kamakura *bakufu* (military government) equivalent to regent. This position was occupied in a hereditary manner by the Hōjō family. Upon the decline in vigor and authority of the Minamoto shoguns, the Hōjō regents became the de facto rulers of Japan and lavish patrons of the Zen temples of Kamakura for nearly two hundred years.

shinden-zukuri: One of the regularly established systems of Japanese residential and palatial architecture, perfected during the Heian period. The main hall *(shinden)* was set into a Chinese-style garden with artificial knolls, a pond with islands and bridges, rivulets and large rocks. At right angles to the *shinden* and connected to it by corridors were secondary residential quarters. The buildings were raised off the ground on posts; the woodwork was largely unpainted; the roofs generally made of shingles. In time, the ground plans became increasingly asymmetrical and the aesthetic interrelationship between buildings and gardens stressed.

Shingon: "True Word"; one of two major sects of Esoteric Buddhism in Japan, the other being Tendai *(q.v.)*. The Shingon sect was established in Japan by the monk Kūkai (Kōbō Daishi, A.D. 774–835), who studied Esoterism in China. Headquarters of the sect is the vast sanctuary atop Mount Kōya, still a remote and isolated spot (figure 99); other major temples include Jingo-ji near Kyoto (figures 94–98), Tōji within

the city proper (figure 110), Kanshin-ji in Osaka Prefecture (figure 102), and Murō-ji in Nara Prefecture (figures 103–7).

Shitennō: The Four Guardian (Deva) Kings; ancient Indian gods of the four cardinal points of the compass and rulers of the vast host of animistic deities which still hold the loyalties of Indian villagers. Depicted in early Buddhist arts as devotees and protectors of Śākyamuni, their imagery became increasingly prominent in China and Japan. *See* Bishamon-ten; Jikoku-ten; Kōmoku-ten; Zōchō-ten.

shōgun: Military rank equivalent to general; *taishōgun* is equivalent to generalissimo. The term is an abbreviation of *sei-i-taishōgun* ("military commander sent against the barbarians") used first in the eighth century as a temporary rank granted by the emperor. It was given on a lifetime and hereditary basis to Minamoto-no-Yoritomo, founder of the Kamakura *bakufu*. During the Kamakura and Muromachi periods, it designated what was theoretically the supreme secular authority in the land, subordinate only to the semidivine emperor. See, however, *shikken*.

shoin-zukuri: A type of domestic and religious building perfected in the Muromachi period (see also *shinden-zukuri*). The *shoin* style features a small, low, built-in writing desk with a window above it offering a view into a garden. Near the writing desk is an alcove with shelves. Another feature of the *shoin* style is the use of tatami mats over most of the interior floor. See figure 186.

Shōjō Bukkyō (Hīnayāna Buddhism): "Small Vehicle"; the first of three distinct divisions of Buddhist doctrine (see also Daijō or Mahāyāna, and Mikkyō or Esoteric Buddhism). Hīnayāna is the form currently prevailing in Ceylon, Burma, and Thailand. Its canonical literature is written in Pāli, an ancient vernacular language of the mid-Gangetic region of India. Its doctrines stress monasticism and, while recognizing the future coming of Maitreya, do not recognize the other great Bodhisattvas or the ideal of salvation in Paradises. Hīnayāna, more correctly called Sthaviravāda ("The Doctrine of the Elders"), claims to be the orthodox form of the faith, closest to·the original doctrines of Śākyamuni.

Shō-Kannon (Ārya Avalokiteśvara): One of the variant forms of Kannon; similar to the Kanzeon Bosatsu *(q.v.)*. Images of this Ārya ("Saintly") type stress the physical charm and beauty of the deity. See figures 48 and 49.

Shūhō-ō Bosatsu: "Many-jeweled King"; the name of one of the twenty-five Bodhisattvas who accompany the Buddha Amitābha in the Raigō *(q.v.)*. See figure 56.

Shūkongō-jin (Vajrapāni): "Thunderbolt Bearer"; in Indian Buddhist legends, originally a Yaksha, an animistic deity who accompanied Śākyamuni as a guardian armed with the thunderbolt. He is occasionally depicted as a single, isolated guardian figure in Japanese temples. See figure 67.

shumidan: A name for the platform upon which the main statues are placed in a Buddhist image hall such as a *kondō*. The name *shumi* is derived from the Sanskrit *sumeru*, which, in Indian and Buddhist cosmology, is the great mountain that serves as the navel of the world.

Śrī Lakshmī: *See* Kichijō-ten.

stūpa: The Sanskrit name for the Buddhist pagoda; originating in India as a solid hemispherical mound with a sacred relic placed at the summit. The *stūpa* form gradually became increasingly more vertical until the towerlike form which prevails in East Asia developed.

Subodai (Subhūti): One of the historical Ten Disciples of the Buddha. See figure 84.

Sukhāvatī vyūha: "Appearance of the Land of Bliss"; title of several sutras describing the Paradise of Amitābha and the means of attaining it. *See* Amida; Jōdo.

Sumeru: See *shumidan*.

sumi: Ink used in Sino-Japanese painting; ordinarily made in the form of pressed, dried black pigment (burnt ivory, lamp-black, etc.) which is ground by the artist on a small palette (see figure 177) and mixed with water to the desired degree of blackness.

sumi-e: Painting done predominantly in monochrome ink.

Sūryaprabha: *See* Nikkō.

sūtra: See *kyō*.

tahō-to: "Many-jeweled pagoda"; a type of pagoda having a cylindrical or domical first story in emulation of Indian *stūpas*, and then capped by a conventional peaked roof. Seen commonly in Esoteric temples in Japan, the type originated in Chinese Buddhist art in illustration of an episode of the *Lotus Sutra* in which the Buddha Prabhūtaratna (Tahō Nyorai), who once lived in the remote past, appeared in such a *stūpa* to hear Śākyamuni preach, revealing thus that *nirvāna* did not necessarily mean physical annihilation. Esoteric Buddhist traditions also hold that the Indian patriarch Nāgārjuna received the basic Tantric sutras from a legendary Iron Pagoda in South India, where they had been sealed off for centuries.

Taishaku-ten (Indra or Śakra): The Vedic Indian deity with many functions: lord of rainfall, archetype of earthly rulers, king of the heavenly hosts. He, together with Brahma (Bonten, *q.v.*) were shown in early Buddhist art as devotees of the Buddha, as though to demonstrate the superiority of Buddhism over orthodox Indian creeds. See note and figure 68.

Taizōkai ([Mahākarunā] garbhadhātu): "The Ingredient of the Womb, or Matrix"; in Esoteric Buddhist speculation, one of the ingredients out of which the entire creation was formed,

the other being the Kongōkai *(q.v.)*. The Taizōkai is roughly equivalent to the Platonic *noumenon*, or to innate existence, the first cause, the original step by which the divine ground of existence becomes matter. See also *mandara*.

Takamikura: The throne of the emperor in the Shishin-den of the Kyoto Imperial Palace (figure 116). *See also* Michōdai.

Tantrism: *See* Mikkyō.

tatchū: Small, semiindependent group of dwelling and meditation halls within the walls of a large Zen monastery.

Tathāgata: *See* Nyorai.

Tendai: One of the two major sects of Esoteric Buddhism in Japan, the other being Shingon *(q.v.)*. Tendai, however, originated in China long before the rise of Esoterism, and was an effort to systematize and harmonize all Mahāyāna teachings. When strong waves of Tantric Buddhism from India reached China in the T'ang period, they too were absorbed into the Tendai creed. Saichō (Dengyō Daishi, A.D. 766–822) established the sect in Japan, with headquarters atop Mount Hiei near Kyoto (figures 108, 114), and Esoteric elements predominate in the atmosphere of Japanese Tendai temples, which have nonetheless been havens for Jōdo and Zen Buddhist practices as well.

tenjiku or *tenchiku*: The Japanese name for India; the name of the style of large-scale temple architecture of the Kamakura period, the most celebrated extant example of which is the Nandai-mon of Tōdai-ji, Nara.

Tenjukoku: "Land of Celestial Immortality"; the subject of a pair of embroidered curtains made in memorial to the deceased Shōtoku Taishi by his consort and attendants (figure 44). Although preserved only in fragments, this Paradise differs from traditional Buddhist ones in that it apparently included elements from Sino-Japanese folklore and cosmology.

Tentōki: A demon lamp bearer. *See also* Ryūtōki.

tō-in: The east precinct of a temple compound; as at Hōryū-ji, where the *tō-in* is primarily a group of buildings centered on the Yumedono, but includes the Chūgū-ji as well.

torii: A gate erected exclusively before a Shinto sanctuary. See figures 144 and 160.

Tsune-goten: "Ordinary palace"; the residential quarters of the Kyoto Imperial Palace, set apart from the more ceremonial chambers of the Seiryō-den and Shishin-den.

Twelve Divine Generals: *See* Jūni Shinshō.

Two Guardian Kings: *See* Ni-ō.

Vairocana: *See* Birushana.

Vaiśravana: *See* Bishamon-ten.

vajra: See *kongō-sho*.

Vajradhara: *See* Ni-ō.

Vajrapāni: *See* Shūkongō-jin.

Vasubandhu: *See* Seshin.

Vimalakīrti: *See* Yuima.

Virūdhaka: *See* Zōchō-ten.

Virūpāksha: *See* Kōmoku-ten.

wagyō: A mirror decorated in the Japanese style; a term used from the mid-Heian period onward in reflection of the growing self-consciousness of the Japanese in their decoration of luxury objects in a style different from that of the Chinese.

waka: Also called *tanka*; a poetic form of thirty-one syllables in five lines, fashionable in court circles.

Yakushi Nyorai (Bhaishajyaguru): The Buddha who heals all ailments, including those of ignorance. Yakushi became one of the most popular deities in early Japanese Buddhism at a time when immediate and practical benefits were often expected from the faith. See figures 24, 50, 92, and 95. *See also* Gakkō; Jūni Shinshō; Nikkō.

Yama: *See* Emma.

Yamato: A name which the Japanese, since ancient times, have often given to their nation. It is also the name of the fertile region in the southeastern part of the great Kinki Plain. This encompasses the Asuka district, where the tombs of the earliest emperors, the first Buddhist temples, and the first imperial palaces were located; it also includes the Nara area.

yamato-e: Painting in the native Japanese style. A term which arose in the mid-Heian period when the development of a uniquely Japanese type of composition, coloring, and subject matter prompted the need of a term to distinguish this from the Chinese styles of painting which had hitherto prevailed. See also *kanga* and *kara-e*.

yamato-mai: An ancient ritual folk dance preserved at the Kasuga Shrine, Nara. See figure 89.

yūgen: A term long used in Japanese aesthetics but given particular emphasis in the rise of the cultural influence of Zen Buddhism. It denoted the highest, most desirable quality in literature, music, drama, as well as architecture and the visual arts. Difficult to define succinctly, *yūgen* is a quality like that of mystery, remoteness, evocation, or somberness. To possess this quality, a work of art should suggest more than it states, should heighten one's awareness of the profound mystery and grandeur which lies beyond the senses, should be expressed in terms of utmost simplicity and economy.

Yuima (Vimalakīrti): A semilegendary Indian layman who is the central figure of a Mahāyāna sutra written perhaps in the first century A.D., the *Vimalakīrti-nirdeśa*. This text states that sanctity is present in the life of a layman as well as in that of a monk—perhaps even more so. It thus became extremely influential in the development of lay Buddhism in China and Japan and was said to have played a marked role in the thinking of Shōtoku Taishi, to whom an ancient commentary on this sutra is attributed. See figure 38.

Yumedono: "Hall of Visions"; an octagonal building constructed at Hōryū-ji at the site of a former palace of Shōtoku Taishi, who was said to have had a religious vision there. See figure 42.

Zōchō-ten (Virūdhaka): One of the Shitennō (q.v.); the Regent of the Southern Quadrant. See figures 28 and 72.

SUPPLEMENTARY NOTES

Notes are numbered to correspond with the captions that they supplement. Notes for the following figures have been omitted: 1, 52, 143, 157, 166.

2. *Middle Jōmon ware* (縄文土器).
This is called a lamp partly because of the traces of smoke on the surface, and also, with its open-work sides, it could hardly have been used for serving or storing food. If it was a lamp, its form is so eccentric that it might have been used for magical, incantative purposes rather than as a simple utilitarian object. One can imagine that fire would have been worshiped as something sacred in the Jōmon period.
 From Fujimi-machi, Suwa County, Nagano Prefecture.

3. *Middle Jōmon ware* (縄文土器).
While the ornament may suggest basketwork or a cage made of braided vines, the decoration is really the result of the free play of the imagination and fancy of the craftsman. The wall of the vessel is thick and heavy, the clay reddish and coarse. Withal, it is an object typical of the exuberance and fantasy of middle Jōmon pottery.
 From Fujimi-machi, Suwa County, Nagano Prefecture. Miyasaka collection.

4. *Earthenware* (弥生土器). *Late Yayoi period.*
This is an example of a late Yayoi vessel from the Kantō district. The degree of refinement seen here is the result of an evolution of over three hundred years, beginning in northern Kyūshū and spreading gradually to the northeast parts of Honshū. The thin clay body was skillfully manipulated and fired; the utilitarian aspects of the vessel were honored by its stability and by the well-designed mouth and neck—in contrast to the almost anti-functional, expressionistic style of the neolithic period.

5. *Clay figurine* (dogū; 土偶). *Jōmon period.*
Most *dogū* do not stand by themselves, but this is a rare one whose base is wide enough to give it

stability. The holes in each arm and ear were probably made for hanging ornaments. How this type of object was actually used in worship is a secret still locked in the past.
 From Maruko-machi, Chiisagata County, Nagano Prefecture. Tokyo National Museum.

6. *Clay figurine* (dogū; 土偶). *Jōmon period.*
This figurine, together with one found nearby which closely resembles it, is a classic example of the freedom and charm of Jōmon period sculpture. Both were richly carved on front and back, and were not made to stand upright. Holes in the shoulders suggest that they may have been suspended from strings, and it is possible that these figures were translations into clay of idols which had previously been made of straw.
 From Kashiwazaki, Iwatsuki City, Saitama Prefecture. Nakazawa collection.

7. *Clay figurine* (dogū; 土偶). *Jōmon period.*
Hollow figurines of this type, with wide shoulders and small, widespread legs, have been found in considerable number in the Tōhoku region, the northeast part of Honshū island—from Yamagata Prefecture on the east to Aomori at the extreme northern tip of the island. Through the repetition of a standard type, the figures became quite finely wrought and ornate. Strange crownlike head-dresses were usually added and the decor on the heavy clothing shown with care, some areas being incised and others scraped away. This statue is clearly of a woman—the breasts are shown—and it can stand upright.
 From Monō County, Miyagi Prefecture. Tokyo National Museum.

8. Dōtaku (銅鐸). *Middle Yayoi period.*
These bronze implements must be considered nonutilitarian even though they were given the form of a hanging bell and despite the clappers that were occasionally found with them. *Dōtaku* of this type have been discovered in all parts of the Chūbu district of central Honshū (the region

around Nagoya and Gifu), and it is assumed that they were sacred objects, used possibly in fertility or hunting rituals. Their shapes are both refined and monumental, and their surface ornamentation is highly varied. Among those shown here can be seen designs in the shapes of deer and birds.

Large bell in center from Uzumori, Hyōgo Prefecture; large bell to right from Akugatani, Shizuoka Prefecture. Tokyo National Museum.

9. *Male and female* haniwa *figures* (埴輪の男女). *Sixth century.*
A rare example of paired statues, these *haniwa* were discovered in the Kantō district, far from the contemporary centers of Japanese civilization in the Kansai area. The smaller figure has indications of hair on both sides of the head, and is thus probably the male; the female would then be the larger of the two. They seem to be singing and dancing and to belong thus to the class of *haniwa* figures which depict musicians and other persons involved in mourning ceremonies. Of all *haniwa*, few are more abstract or show greater economy of means than these.

Found in Kohara-mura, Ōsato County, Saitama Prefecture.

10. *The tomb of the Emperor Nintoku* (仁徳天皇陵). *Fifth century.*
The tombs of the emperors Nintoku and Ōjin, which were built near each other, mark the climax of the custom of constructing giant tumuli. They consumed immense amounts of labor and were major concerns of the throne at the time. Stone chambers in the interior held ceremonial objects interred with the dead, and it is said that nearly twenty thousand *haniwa* had been placed around the tomb of Nintoku. Traditional Japanese chronology placed the rule of these two emperors in the last years of the third and most of the fourth century A.D., whereas on the basis of modern research, their reigns fell approximately in the last half of the fourth century and the first quarter of the fifth.
Sakai City, Osaka Prefecture.

11. *Seated female figure,* haniwa (埴輪の巫女). *Sixth century.*
In full regalia, seated stiffly on a chair, this is not an ordinary woman but a person of high station, possibly a sorceress or spirit medium. There is great discipline in her pose, which speaks of authority and purpose.

From Ōizumi, Gumma Prefecture. Tokyo National Museum.

12. *Head of girl,* haniwa (埴輪女子頭部). *Fifth century.*
Haniwa seem to have been developed in the great plain encompassing the modern Osaka, Nara, and Kyoto (the Kinki district) but they are found in largest numbers in eastern Japan, in the plain surrounding Tokyo. This fine specimen is said to

have come from the vicinity of Nintoku's tomb near Osaka and is typical of the finesse of style in the region.

Found in Dōmyōji-chō, Minami Kawachi County, Osaka Prefecture.

13. *Wall painting in the Takehara tomb* (竹原古墳の壁画). *Sixth century.*
Northern Kyūshū, in close proximity with both Korea and China, has over forty ancient tombs decorated like those on the mainland, with paintings on the walls of the inner stone chambers. However, it is natural that these paintings would also share in the simplicity and symbolic spirit of the *haniwa* with which they are contemporary.

Wakamiya-chō, Kurate County, Fukuoka Prefecture.

14. *Bronze mirror ornamented with a design of four houses* (家屋文鏡). *Fourth century.*
Each of the buildings shown on the back of this mirror is different. Two have raised floors on high foundations; on one of these is a balustrade and ladder; on the other, the ridgepole projects forward at each end so that the roof in profile appears to be upside down. A third house has an exaggerated pent gable, which gives the roof roughly an hourglass shape; and the fourth seems to be either a pit-dwelling or a winter house built close to the ground. These probably belonged to persons of high rank. The artist took pains to insert trees between them, perhaps to suggest a forest in the vicinity.

From the Takarazuka tomb, Samita, Kawai-mura, Nara Prefecture. Imperial Household Agency.

15. *Bronze mirror with* chokkomon *design* (直弧文鏡). *Fourth century.*
This peculiar design originated in the Kansai area and spread throughout Japan. It probably bore a magical or exorcistic meaning, for it was used to ornament sacred utensils and tombs.

Found at the Niiyama tomb. Kōryō-chō, Nara Prefecture. Imperial Household Agency.

16. *Gilded bronze helmet* (金銅の兜). *Fifth century.*
Discovered in a remote site along the east side of Tokyo Bay, this piece of splendid craftsmanship may have been part of the equipment of a military commander dispatched from the capital for the pacification of the eastern provinces. On the bands of the crown of the helmet are shown birds, fish, cows, and the like, engraved with stippled dots— extremely amusing in their symbolic transformations. A cow, for example, is shown pregnant, with the calf visible in her belly.

From the Gion tomb, Kisarazu City, Chiba Prefecture. Tokyo National Museum.

17. *The main hall* (honden) *of the Izumo Shrine* (出雲大社本殿).
This sanctuary is dedicated to the deity Ōkuni-

nushi-no-Mikoto, a Prometheus-like figure who gave medicine and fishing to men, developed the land, punished evil spirits, and the like. It is also the gathering place of all deities of the nation during October and a site, thus, of great sanctity. The main hall has preserved many features of ancient dwellings as known through mirrors and other representations—the shape of the room, the asymmetrical entrance, and high floor. The various elements of the roof have lost their functional significance, and the curve of the roof admits some continental influence. The present building dates from 1744 and is over twenty-four meters (78.7 feet) high, but according to the shrine tradition, it was originally twice that height, if not more.

Both front and sides are two bays wide; cypress-bark roof. Taisha-machi, Shimane Prefecture.

18. *The inner shrine* (naikū) *at Ise* (伊勢の内宮).
This is dedicated to the founder of the imperial line, Amaterasu Ōmikami, the goddess endowed with the virtue of the sun's rays. Originally she was enshrined within the imperial residence, but during the reign of the Emperor Suinin (in A.D. 5 according to tradition), her sanctuary was moved to this deep forest near the Isuzu River on the Ise Peninsula. The sixty rebuildings on record have not greatly distorted its original shape, which is that of an ancient storehouse. Imbued with a sense of purity of form and material, it is placed within the protection of four encircling fences and is not open to the public. The cypress wood used in the *honden* is taken from a special forest preserve in the Kiso mountains.

Facade, three bays wide; side, two bays wide. Thatch roof. Last rebuilding, 1973.

19. *Bearers of food offerings, Ise* (神宮の神饌使).
The daily offerings of food are prepared in kitchens by persons who have been ritually purified. Placed in a special wooden carrying box, they are brought to the offering hall *(heiden)* in front of the inner sanctuary. The priest in the rear of the photograph holds aloft the key with which to open the *heiden* door.

20. *Food offerings* (神饌).
The meals prepared for the deity consist of white rice (raised in specially supervised fields without use of horses or cattle), the bonito fish, seaweed or kelp, abalone, fresh vegetables, fruits, and the like. Served on unglazed pottery plates, these natural products were gathered in a ritual manner from fields, gardens, and zones of the sea reserved exclusively for the shrine.

21. *The outer offering halls* (gai-heiden), *Ise outer shrine* (gekū) (外宮の外幣殿).
The complex of shrines at Ise includes an outer sanctuary *(gekū)* devoted to the Goddess Toyouke Ōmikami. Like the inaccessible inner sanctuary, its buildings preserve the ancient architectural

tradition, but to distinguish it from the *naikū*, there are changes in the number of cross beams at the top and the way of cutting the *chigi* (the crossed raised rafters). The simplicity and refinement of technique exceeds that of the *honden*, and the small shrines surrounding it can be approached and closely studied.

22. *Distant view of Hōryū-ji from the northeast* (法隆寺の遠望).
The main part of the temple, as seen from the rear, is dominated by the towering pagoda. Visible here are other basic parts of the Asuka-style temple compound: the *kondō* ("golden hall," which houses the main cult images) with its very large roof, the *kōdō* ("lecture hall") to the right of the pagoda, and the bell tower directly in line with it. To the far left is the roof of the *chūmon* ("central gate"), the entry into the colonnade which encloses the compound. Parts of the monks' dormitories and dining hall can be seen in the left middleground. Not visible are the sutra storage opposite the bell tower, and the great south gate.

23. *Five-story pagoda, Hōryū-ji* (法隆寺五重塔).
Pagodas were originally allotted the central position in temple compounds in East Asia because of the central importance of Śākyamuni Buddha within the faith. In later centuries, however, as Buddhism developed a more elaborate pantheon, the *kondō* was given the dominant position, for it housed the images by which these deities were worshiped. Hōryū-ji in its present form is transitional between these two stages, for the pagoda and *kondō* share the middle of the enclosure with equal emphasis. The pagoda is probably a reconstruction of an older one, and is roughly datable by an entry in the temple records that the statues in dry clay on the ground floor were made in A.D. 711. The wooden enclosure around the ground floor is for the protection of the interior and was probably added soon after the building was built.

24. *Bronze statue of Yakushi Nyorai* (薬師如来像). *Hōryū-ji* kondō. *Seventh century.*
Although the halo inscription, which is dated in A.D. 607, does not name the sculptor, the statue of Yakushi was probably made in the workshop founded by Tori Busshi. Modern scholars have been puzzled by the fact that the halo seems to be more advanced in style than that of the Shaka Trinity, dated sixteen years later, and that the inscription employs terms which were not in use in 607. Moreover, the interior of the Yakushi figure shows evidence of a more orderly and advanced casting technique than that of the trinity. It is also difficult to account for the subtle differences in the drapery and proportions between the two works. Some scholars feel that the Yakushi image itself was the original *honzon* of the temple and that the halo was made at the time of the temple's reconstruction after the fire of 670. Others feel that both the image and the halo were

from the 670's. There are few doubts, however, that this work is an eloquent example of the Tori style.

25. *Shaka Trinity (Śākyamuni and two attendant Bodhisattvas), Hōryū-ji* kondō （法隆寺の釈迦三尊）. *Seventh century.*
The inscription on the back of the halo is dated in the thirty-first year of the reign of the Empress Suiko (A.D. 623). It states that the statue was made for the sake of the soul of Shōtoku Taishi, who had died the preceding year. The donors were his consort, son, and other courtiers, and the sculptor was the celebrated Tori Busshi, who had earlier enjoyed the trust and patronage of the prince. The enlarged plane of the robe, with its rhythmic fold patterns suspended in front of the pedestal, is a feature found in Chinese sculpture of a century earlier. The same is also true of the facial features and bodily proportions, and yet the style of Tori Busshi possesses its own unique sense of formal organization.
Gilded bronze.

26. *Attendant Bodhisattva from the Shaka Trinity.*
The identity of the two flanking Bodhisattvas holding jewels in their hands is uncertain. However, the seven figures in the central halo—the Buddhas of past ages—are reflections of a rather archaic stage in Buddhist theology and differ from the developed Mahāyāna (Daijō) concept of the simultaneous existence of many Buddhas. The bronze casting here shows a high level of technical mastery.
Gilded bronze.

27. *Kōmoku-ten, Hōryū-ji* kondō （法隆寺の広目天）.
The four militant deva kings (Shitennō), symbolic protectors of the Buddhist realm, were originally ancient Indian folk gods who were incorporated into the Buddhist faith. Kōmoku-ten is the guardian of the west; his name is derived from the Sanskrit Virūpākṣa, "the deformed- or wide-eyed." Unlike the guardian of the north, Vaiśravana or Bishamon-ten, he was rarely worshiped as an independent deity. According to the inscription on the halo, this statue (and probably the entire set of four) was made by a man active in the mid-seventh century, Yamaguchi-no-Ōguchi-no-Atai. The figures were polychromed; guardians and demons were made from separate blocks of wood.
Camphor wood.

28. *Zōchō-ten, Hōryū-ji* kondō （法隆寺の増長天）.
This is Virūdhaka, Regent of the Southern Quadrant. The style of these four guardian figures differs from that of Tori Busshi's works in that the surface details are carved in very low relief and the mood is lighter, less solemn. There are similarities between these guardians and the Kudara Kannon (figure 34), reflecting a new stage of development in Japanese sculpture, under the

influence perhaps of Chinese art of the Northern Ch'i Dynasty.
Camphor wood.

29. *Canopies, Hōryū-ji* kondō （法隆寺金堂の天蓋）. *Late seventh century.*
Canopies are one of the devices by which the sanctity of the place of installation of the Buddha images is shown. In their elaborate and highly colored form, they correspond to descriptions in Buddhist texts of gem-encrusted canopies over the heads of the great deities. The same type of object could also be seen in the wall paintings which adorned the *kondō*; and it is assumed thus that the canopies also date from the time of the temple's reconstruction at the end of the seventh century or the beginning of the eighth. The canopy on the east side, however, is a reconstruction of the Kamakura period.

30. *Musician from a canopy* （天蓋の楽天）. *Late seventh century.*
Angelic maidens *(hiten)* who play musical instruments while flying through the air are called "Apsaras" in Sanskrit. They are often seen ornamenting halos, canopies, and temple walls, expressing joy in the presence of the Buddha. The simplicity with which this figure was carved cannot disguise the consummate skill in craftsmanship. Rising scarves form an arabesque honeysuckle pattern, a motif especially popular during the period. Faint traces of coloring still retain their charm.
Polychromed camphor wood.

31. *Phoenix bird from a canopy* （天蓋の鳳凰）. *Late seventh century.*
The phoenix was an imaginary, sacred bird in ancient Chinese mythology, but was adapted and widely used as an ornament of Buddhist temples. The techniques of wood carving here closely resemble those of the Shitennō figures in the *kondō*, and they may all date from approximately the same time.

32. *The Tamamushi Shrine, Hōryū-ji* （法隆寺の玉虫厨子）. *Seventh century.*
This tabernacle, built to enshrine a small bronze statue, was originally kept in a palace or noble mansion. Even though, as a rule, objects for private devotion were not part of a temple's equipment, it was donated to Hōryū-ji at a very early date. In the upper portion, which seems to resemble a palace building, architectural details of brackets, rafters, and roof tiles are probably an accurate guide to the appearances of the original roofs of such early buildings as the Hōryū-ji *kondō*.
Made of wood with colored lacquer ornamentation.

33. *The Bodhisattva's self-sacrifice, Tamamushi Shrine* （玉虫厨子の施身聞偈図）. *Seventh century.*

The front and sides of the miniature building open up as doors. Decorating the front doors are two deva guardians; on the right and left sides are painted Bodhisattvas. The worship of Buddhist relics can be seen on the front of the pedestal. On either side are sacrifice scenes: to the right, the Bodhisattva offering his body to starving tigers; to the left, the scene reproduced here. On the rear of the pedestal is Mount Sumeru, the center of the world in Buddhist cosmology.

These scenes are painted over a ground of black lacquer, the shapes being established in flat areas of either tinted lacquer or, as is sometimes claimed, a form of oil paint. The contours are drawn with a heavy iron-wire line in the style of traditional Buddhist painting. Together with the method of continuous narrative (more than one episode of a story shown in a single frame), this technique and the legends themselves are all found in Chinese painting of the Six Dynasties period.

34. Head of the Kudara Kannon, Hōryū-ji (法隆寺の 百済観音). Seventh century.

The engraved image of the Buddha in the crown enables us to identify this figure as the deity called Kannon in Japan or Avalokiteśvara in India—the embodiment of compassion for mankind and boundless skill in aiding those in distress. It is not known in which temple this statue originally stood. It seems to have come to Hōryū-ji only in the Edo period, when legends were recorded—prompted perhaps by its unique beauty and height—that it had been brought in ancient times from the Korean kingdom of Paekche (which the Japanese call Kudara); hence its popular name, the Kudara Kannon. There is little question, however, that it was made in Japan or that it is one of the most compelling images in the whole of Buddhist art.

35. Kudara Kannon, Hōryū-ji (法隆寺の百済観音). Seventh century.

While this is a typical image of the Bodhisattva Kannon (Avalokiteśvara) iconographically speaking, the length of the body is quite extraordinary. Despite its great height, however, it does not have a sense of instability. It was carved of camphor wood, which was widely used for holy images in Japan at the time because the tree itself was revered for its impressive size and beauty and the medicinal qualities of its bark. The carving technique and metal ornaments may also be seen in other Japanese works, such as the Yumedono Kannon and the Shitennō statues at Hōryū-ji.

Polychromed camphor wood.

36. Bodhisattva in wood (菩薩像). Hōryū-ji. Late seventh century.

The six Bodhisattva statues carved of single blocks of camphor wood at Hōryū-ji are from an original set of eight which seem to have been placed in pairs as attendants to four Buddha images in the base of a pagoda. The formal organization of these pieces reflects the strong influence of Chinese sculpture of the Northern Ch'i period, over a half century earlier; yet a certain austerity and sense of abstraction which characterize that distinctive Chinese style are replaced in these Japanese works by an almost childlike innocence.

37. Bronze meditating Bodhisattva (弥勒菩薩像). Seventh century.

On the front rim of the pedestal is an inscription bearing a date in the Chinese cyclical system which is probably equivalent to A.D. 666. The statue is one of fifty-seven small bronze figurines which originated presumably in the Asuka district and were kept in Hōryū-ji until 1878, when they were presented to the Imperial Household collection of the Emperor Meiji. They are now kept in the Tokyo National Museum.

38–39. Dry clay statues in the five-story pagoda, Hōryū-ji (法隆寺の塑像). Eighth century.

Four groups of dry clay figures are placed about the central mast on the ground floor of the five-story pagoda. Each scene is in a mountain setting representing Mount Sumeru, the center of the earth in Buddhist cosmology. The group on the east represents the interview of Vimalakīrti and Mañjuśrī; to the north is the death of Śākyamuni; on the west, the division of his relics; and to the south, the appearance of Maitreya Buddha. According to temple records, these groups were made in A.D. 711. Extremely naturalistic in style, they reflect the strong wave of influence from T'ang China which reached Japan about that time. In fact, sculpture in stucco or dry clay was a distinctive feature of the Buddhist artistic tradition throughout Asia, examples having been found in northern and western India, Afghanistan, Thailand, Central Asia, and western China, as well as Japan.

40. Wall painting, Hōryū-ji kondō (法隆寺金堂の 壁画). Late seventh century.

The interior of the kondō was decorated with wall paintings on the plaster sections between the columns and above the horizontal tie beams. They were done, probably, about the time of the rebuilding following the fire of A.D. 670 or else in the early years of the eighth century. Paradise scenes were shown on four large panels, individual Bodhisattvas were placed on eight smaller ones; flying angelic figures were placed in the small sections just below the ceiling. This is a detail from wall number six, the Western Paradise of Amitābha (the Sukhāvatī). In 1949, these paintings were severely damaged by fire and have been removed from the hall—an irreparable loss of some of the noblest examples of religious art in Asia.

Polychrome on white clay priming.

41. *Amida trinity. The Shrine of the Lady Tachibana, Hōryū-ji* (橘夫人念持仏). *Late seventh century.*

This small bronze group is placed in a painted shrine said to have been donated by the Lady Tachibana, mother of the devout Empress Kōmyō (A.D. 701–60). The shape and decoration of the wooden shrine are quite similar to that of the canopies of the *kondō*, which must date from about the same time—the late seventh or early eighth century. The style of the bronze group shows a marked advance in design and technique over that of the preceding Asuka period. Despite the metallic surface, there is a softness of effect to which a touch of realism has been added, and also a remarkable rhythmic quality to the ornament in low relief—features which reflect the influence of T'ang China.

Cast bronze.

42. *Yumedono, Hōryū-ji* (法隆寺夢殿). *Eighth century.*

This type of octagonal building is called an *endō* ("circular hall"), and is a shape which, even though a novelty in its day, was frequently used in the Nara period for memorial chapels. The Yumedono was built in A.D. 739 by the monk Gyōshin Sōzu in the east precinct of Hōryū-ji as the main hall of a small, independent temple compound. The site was that of the palace of Shōtoku Taishi which had fallen into ruin, much to the dismay of the monk, who erected the Yumedono (or "Hall of Visions") as a memorial to the soul of the prince. The name of the hall arises from a legend that Shōtoku, while deep in meditation at this spot, had a vision of a deity who resolved his religious doubts. The hall has been frequently repaired and its original appearance somewhat altered; still it is a handsome and fitting memorial.

43. *The Guze Kannon, Yumedono* (夢殿の救世観音). *Seventh century.*

The Guze Kannon is a form of the Bodhisattva Avalokiteśvara as the universal saviour; after his death, Shōtoku Taishi himself came to be worshiped as a manifestation of this deity. This statue, said to have been worshiped by the prince, is actually older than the Yumedono itself. It was made the *honzon* of the building by Gyōshin Sōzu, and for many centuries remained a secret image in a shrine in the central axis of the building. Even today it is shown infrequently to the public, and its condition is extraordinarily good: the gold leaf on the surface, although dulled with age, is so well preserved that the work appears to be made of metal. In its accentuated smile, large eyes and nose, it is closely related to the style of Tori Busshi.

Made of joined blocks of camphor wood.

44. *Tenjukoku Mandala* (天寿図曼荼羅). *Chūgū-ji. Seventh century.*

These fragments of ancient embroidery are now preserved in the Chūgū-ji nunnery; originally, however, they belonged to the monastery of Hōryū-ji nearby. From an inscription which could be read when the work was intact, the circumstances of their origin were recorded. Upon the death of Shōtoku Taishi in A.D. 622, his wife, the Princess Tachibana-no-Ōiratsume, had some artists (whose names are listed) make a drawing of the Paradise (Tenjukoku) in which the prince was thought to dwell. Using these, the princess, together with her husband's ladies in waiting, embroidered two large curtains. The existing fragments are too few in number to permit a reconstruction of the original work, but as relics of ancient dyeing techniques, as well as of pictorial composition, they throw precious light on the age and its sentiments.

45. *The Bodhisattva in contemplation, Chūgū-ji* (中宮寺の弥勒菩薩). *Seventh century.*

According to the temple tradition, this is an image of the Nyoirin Kannon (see note to figure 102); however, that deity was introduced into Nara in the late eighth or ninth centuries by Esoteric Buddhism. In the seventh century, this pose ("half cross-legged in contemplation") was reserved usually for the Bodhisattva Maitreya, although occasionally Śākyamuni was also shown this way. The feeling of an overflowing gentleness, in contrast to the austerity of the Tori style, is possibly the result of changes which took place in the religious atmosphere of the time. The statue was originally coated with gold leaf and given ornamental gilt bronze fittings (now lost), whose shapes are still faintly visible. In its current state, however, the bare surface is a glistening black.

Made of joined blocks of camphor wood.

46. *Kokūzō Bodhisattva, Hōrin-ji* (法輪寺の虚空蔵菩薩). *Seventh century.*

Hōrin-ji is an ancient temple a short distance from Hōryū-ji and similar to it in layout, although much smaller in scale. This image also bears the name of a deity of Esoteric Buddhism, Kokūzō Bosatsu (see notes and figures 97–98), but it should be considered a conventional image of Kannon (Avalokiteśvara). Diametrically different from the long bodily form of the Kudara Kannon, the torso is short, the hands and head are large; the folds of the garments are shown with a feeling of stiffness. This style of representation is found in numerous small bronze Buddhist figures of the late Asuka period, giving thus an approximate date for this statue.

Wood.

47. *Eastern pagoda, Yakushi-ji* (薬師寺の東塔). *Eighth century.*

Of the two pagodas which originally stood at Yakushi-ji, only the eastern one remains today. Protective corridors with a roof were built around each of the three stories of the tower. Such corridors had been added at Hōryū-ji to the

ground floors of both the *kondō* and pagoda at a very early date in order to shelter the interiors and to provide an additional ambulatory. Aesthetically somewhat awkward, these corridors were built around the upper stories of the Yakushi-ji pagoda, perhaps in an experimental spirit which was never again repeated. The bracketing which supports the eaves shows a greater delicacy and complexity than that of Hōryū-ji.

48–49. *Shō-Kannon, Tōin-dō, Yakushi-ji* (薬師寺の聖観音). *Eighth century.*
As at Hōryū-ji, a subordinate sanctuary called the *tō-in*, or "east precinct," was erected at Yakushi-ji at an early date. During the Middle Ages, this remarkable statue of the Shō-Kannon (Ārya Avalokiteśvara) was moved into the Tōin-dō to serve as its *honzon*. The manner by which the thin robe is depicted adhering to the legs and the exceptionally rich, jeweled ornamentation are reflections of a new wave of aesthetic influence from T'ang China. Behind this, however, lie the bodily canons and sensuous stylistic spirit of Indian metal sculpture. The high quality of the bronze casting may be seen in the delicate details, a great advance in the use of the lost-wax *(cire perdue)* technique. Some of the ornaments of the head are missing, and the halo is of recent date.
Gilded, cast bronze.

50–51. *Yakushi trinity, Yakushi-ji* (薬師寺の薬師三尊). *Eighth century.*
These three giant images are the *honzon* of the temple, enshrined in the *kondō*. Scholars are uncertain whether they were made in the late seventh century for the original Yakushi-ji and then moved with the temple to Nara, or whether they were made in the 720's after the temple had been reestablished. The latter seems the more plausible, but in either case the statues show advances in many ways over previous imagery: in the technique of casting on a large scale, in the skillful admixture of subtle realism, in the rhythmic interrelationship of the three figures, and in the sumptuous ornament. The two flanking Bodhisattvas are those who regularly accompany Yakushi, the Lord of Healing: Nikkō (Sūryaprabha) and Gakkō (Candraprabha), personifications of the luster of the sun and moon. The halos are of recent date.
Gilded, cast bronze.

53. *Kichijō-ten, Yakushi-ji* (薬師寺の吉祥天). *Eighth century.*
Kichijō-ten originated as the ancient Indian goddess of beauty and wealth, Śrī Lakshmī, and was imported to China and Japan as part of the vast Buddhist pantheon. This painting, strongly influenced by T'ang Chinese prototypes, shows the goddess holding a gem and dressed in the manner of a lady of the T'ang court. It was used as the *honzon* of a ceremony which was very popular in Nara at the time, "The Rite of Repentance in Worship of the Goddess Śrī." Before the painting, devotees expressed their repentence for sins and transgressions, in return for which they expected to receive forgiveness, happiness, and prosperity.
Opapue coloring over hemp.

54. *Kondō, Tōshōdai-ji* (唐招提寺金堂). *Eighth century.*
The temple was founded in A.D. 759 by the Chinese monk Ganjin (Chien-chen) and combined many traits of continental architecture and sculpture with those of the Nara period in its final, most mature phase. The *kondō*, built between 759 and 764, differs considerably in proportion and layout from the *kondō* at Hōryū-ji; where the older structure is almost square in plan and its cult images face both the north and south, here the hall is long and narrow and its images are all arrayed to the south. The roof of this hall has been refurbished, its ridgepole raised, and its slope made steeper; thus its exterior proportions differ somewhat from the original.
Hipped tile roof.

55. *Interior of the* kondō (金堂の内部).
The main cult images of the *kondō* are a trinity of Birushana flanked by Yakushi and the Thousand-armed Kannon. The first two are made of hollow dry lacquer, a method which permitted sculpture on the same giant scale as at Yakushi-ji but with more modest technical equipment than is needed in bronze casting. Moreover, the modeling of these Tōshōdai-ji figures is considerably more static and austere than that of the Yakushi-ji trinity, less ornate and sensual. Wood figures of Indra and Brahma and the Four Guardian Kings on a much smaller scale complete the ensemble, which fills the rather narrow hall and looms before the devotee more impressively perhaps than any other of the ancient altar groups.

56. *Bodhisattva figure in wood, Tōshōdai-ji* (唐招提寺の衆宝王菩薩). *Eighth century.*
Tōshōdai-ji was one of the temples where a revival of wood carving took place at the very end of the Nara period. A large number of wooden statues are preserved there, having once been installed in subsidiary halls which are now lost; and it is possible that Chinese wood carvers were included in the entourage of Ganjin when he arrived in Japan. This method of using a massive log of cedar for the head, torso, and legs of a statue became a predominant one in Japan throughout the ninth and tenth centuries, until it was supplanted by the assembled-wood technique. This Bodhisattva figure has realistic overtones, particularly in the feeling of volume in its corpulent body, a style which was popular in the Buddhist towns of the oasis trade routes in Central Asia, from which it came to T'ang China before its transmission to Japan.
According to temple tradition, the statue shown here or one similar to it represents the Bodhisattva

called Shūhō-ō (the Many-jeweled King), one of the twenty-five Bodhisattvas who accompany the Buddha Amitābha; but the identification is rather tenuous.

Single block of cedar wood.

57. *Lecture hall, Tōshōdai-ji* (唐招提寺講堂). *Eighth century.*
This structure is the only existing specimen of court architecture of the Nara period, although somewhat altered by repairs. It was originally built as one of two assembly halls *(chōshū-den)* in the imperial court compound in Nara, then was given to the temple, moved timber by timber, and reconstructed as the lecture hall. Visible on the right is the bell tower dating from the Kamakura period.

The tile roof is both hipped and gabled.

58. *Portrait of the monk Ganjin (Chien-chen)* (鑑真和上像). *Eighth century.*
This portrait of the founder of Tōshōdai-ji was made in hollow dry lacquer in the same technique used for the cult images of the *kondō*. A rather malleable medium, lacquer was well adapted to a realistic style of depiction. Portraits of Ganjin were also made in China, a custom of memorializing a temple founder or great teacher which was of great antiquity there and was adopted by Japanese Buddhists as well.

Dry lacquer.

59. *Founder's hall* (kaizan-dō), *Tōshōdai-ji* (唐招提寺開山堂).
Halls which enshrined memorial portraits became a common feature of Japanese Buddhist compounds during the Heian period. At Tōshōdai-ji, ceremonies in honor of the soul of Ganjin have long been held in the *kaizan-dō* and in the lecture hall on June 6, the anniversary date of his death. The long building in the foreground was originally the monks' dormitory.

60. *Overall view of Tōshōda-ji* (唐招提寺の全景).
Photographed from the air over the northeast corner of the compound, the picture shows the lecture hall, the *kondō*, the south gate, the bell tower, and the relic hall. Obscured by the pine trees at the far right are the remains of the ordination platform. Farm buildings and paddy fields lie between Tōshōdai-ji and Yakushi-ji, faintly visible in the forests of the left middleground—an area once part of the thriving life of the capital.

61. *A view of Nara* (奈良の遠望).
Looking down from Mount Mikasa over Tōdai-ji, once the foremost official temple of the empire, one sees the massive bulk of the Daibutsu-den and its great roof, capped with gilded ornaments shaped like the tail of an owl. Off in the distance to the right floats the pagoda of Kōfuku-ji. These two monasteries once were immensely wealthy and crowded with fine halls and statuary. Now they are reduced to shadows of their former grandeur and overrun with throngs of tourists, yet enough remains to give important works of ancient art their proper setting.

62–63. *Bronze lantern before the Daibutsu-den, Tōdai-ji* (東大寺大仏殿前の燈籠). *Eighth century.*
This splendid object dates from a time when the donation of lamps to a temple, itself the source of the light of the spirit, was an act charged with great emotion and significance. Its scale is bold and the craftsmanship in casting exceedingly fine, befitting an object dedicated to the Daibutsu. The doors of the fire chamber are ornamented with angelic musicians, heavy and ornate, and with running lions seen from above—motifs strongly influenced by the decorative arts of T'ang China.

Cast bronze.

64. *Interior of the Daibutsu-den* (大仏殿の内部). *Tōdai-ji.*
Popularly called the Daibutsu (the Great Buddha), this colossal image is the symbol of one of the most abstruse of all theological concepts: that of a great generative force which lies at the heart of all creation, so immense in its power that the human mind cannot grasp it, so subtle in effect that it permeates everything, the very root principle of all things in existence—all men, all minds, all deities. This concept is far removed from the simpler doctrines of early Buddhism, and was developed by Indian speculative philosophers, both Buddhist and Hindu, who used many names to designate it. In the *Avatamsaka Sūtra (Kegon-kyō)*, the text which inspired the Emperor Shōmu and his religious advisers to build the Daibutsu, it was given the epithet Lord of Great Brilliance or The Great Illuminator (Vairocana in Sanskrit). In Japanese this was transliterated as Birushana, or else translated as Dainichi (the Great Sun).

65. *The Sangatsu-dō of Tōdai-ji* (東大寺三月堂).
This is the only one of Tōdai-ji's ancient devotional halls to have escaped destruction. Here, the ceremonial reading of the *Lotus Sutra (Hokke-kyō)* has been held each March, the third month of the year *(sangatsu)*; hence the building is called either the Hokke-dō or, more commonly, the Sangatsu-dō. The half of the building to the right is an addition of the Kamakura period, a space for public worship apart from the main sanctum. To the left, beneath the pyramidal roof, is the original structure of the Nara period which is almost square in floor plan, like the *kondō* at Hōryū-ji. Not visible in the photograph is the neighboring Nigatsu-dō, the hall where ceremonies are held marking the end of a period of monastic retreat and austerities during February *(nigatsu)*.

Facade is divided into eight bays, the sides into five. Tile roof.

66. *Interior of the Sangatsu-dō* (三月堂の内部).
While the interior is a veritable treasure house of statuary of the Nara period, the dais and the arrangement of the figures date only from the Kamakura period, and their original position and number is unknown. The central and main object of worship is a form of the Bodhisattva Kannon which reflects the influence of Esoteric or Tantric Buddhism, then gaining great strength in India and China. Shown on a great scale with six arms, it is the Fukūkensaku Kannon, or Amoghapāśa, the lord whose noose is unfailing, that is, the cord of salvation held out to aid those in distress.

Kannon statue made of hollow dry lacquer.

67. *Shūkongō-jin, Sangatsu-dō* (三月堂の執金剛神). *Eighth century.*
Brandishing a thunderbolt, this is Vajrapāni, one of the two Guardian Kings (Ni-ō) who are guardians of the Buddhist realm and are usually stationed in the entry gates of temple compounds. This statue has been kept in a closed shrine for centuries; it is shown only on the anniversary in December of the death of the monk Rōben, who was the spiritual adviser to the Emperor Shōmu and is said to have worshiped this image. Numerous legends of this sort adhere to the Sangatsu-dō, including the one that a flight of bees swarmed from the topknot of this statue and drove away the forces of Taira-no-Masakado which threatened the hall in the late tenth century—precisely the same type of legend which has been told about similar guardian figures in Central Asia and India.

Unbaked clay.

68. *Gakkō, Sangatsu-dō* (三月堂の月光菩薩). *Eighth century.*
This statue and its companion are now called Nikkō and Gakkō (Bodhisattvas named for the luster of the sun and moon), but most likely they were formerly enshrined in another hall under the names of Indra and Brahma (Taishaku-ten and Bonten). When moved to the Sangatsu-dō, which already owned large, dry-lacquer statues of Indra and Brahma, these smaller clay figures were renamed. They serve to remind us that even though the sculptors of the eighth century were fascinated by the problems of realism, they were also capable of idealization of form in the traditional sense. In these figures they sought for balance, perfection of form, and grace; even so, they did achieve a considerable amount of realism in the garment folds, deftly rendered in the pliable medium of soft clay.

Polychromed clay.

69. *The monk Chōgen Shōnin* (重源上人像). *Tōdai-ji. Early thirteenth century.*
Shunjōbō Chōgen (1120–1206) was one of the dedicated monks to whom the history of Japanese art is so deeply indebted. A man of vast influence during his lifetime, he went three times to Sung China, returning with texts, paintings, and even craftsmen. He was learned in Esoteric and Pure Land Buddhism, and once traveled with Eisai, the founder of the Rinzai school of Zen in Japan. His last great achievement was the rconstruction project at Tōdai-ji, for he raised most of the funds and supervised the recasting of the Daibutsu, the rebuilding of the Nandai-mon, and the like—even to the point of going into the forests to select timbers. He commissioned the sculptor Kaikei to do many of the sculptural projects at Tōdai-ji, and it is thought that this portrait may have been done by Kaikei or his assistants soon after Chōgen's death. It is enshrined in a special founder's hall *(kaizan-dō)* near the great bell tower of Tōdai-ji overlooking the Daibutsu-den.

70. *Kongō Rikishi, Sangatsu-dō* (三月堂の金剛力士). *Eighth century.*
This is one of the two large statues of the Ni-ō on the altar itself, and it closely resembles the statue of the same type in dry clay kept as a secret image at the rear of the hall (see figure 67). It is interesting to compare two versions of the same subject so close in time and intent, for there are subtle differences resulting from both the talent of the artists and also the media employed. The way in which this figure's hair bristles with rage shows clearly the special qualities of the lacquer technique.

Painted dry lacquer.

71–73. *Three of the Four Guardian Kings, Kaidan-in* (戒壇院の持国天・増長天・広目天). *Eighth century.*
At the four corners of the ordination platform are placed clay statues of the Four Guardian Kings in unbaked clay, classical examples of the realistic style of the Nara period. Closely resembling the Shūkongō-jin of the Sangatsu-dō, they may well have been produced by the same workshop that specialized in the modeling of clay images. Unfortunately the early history of these statues is unknown; they probably were originally installed in another hall nearby and later moved into the Kaidan-in. Their coloring has almost all flaked away, but traces of its former brilliance may be seen in the crevices.

Dry clay.

74–75. *Shōsō-in* (正倉院の校倉). *Eighth century.*
Warehouses for rice, cloth, or the like were commonly built near palatial mansions and in temple compounds. The giant storehouse of Tōdai-ji, called the Shōsō-in—its scale in keeping with the magnitude of the temple itself—is the largest of all extant examples and probably was completed about the same time as the bronze Daibutsu. The main portion of its treasure was donated by the Empress Kōmyō on June 21, 756, but objects were added throughout that year and occasionally thereafter as late as 768. The treasure remained attached to Tōdai-ji until the modern era, when it was taken under the custody of the Imperial Household Agency. In recent years, samples of its contents have been placed on public display

during the autumn in the Nara Museum.

Facade is divided into nine bays; sides divided into three bays; roof is hipped and tiled.

76. *Bottom surface of the five-string* biwa, *Shōsō-in* (正倉院の五絃琵琶). *Eighth century.*
The *biwa* is a lutelike instrument which originated in the West—some forms in India, others in Iran and West Asia. This specimen is unique for having a straight neck and five strings; the usual ones have four strings. All of its wooden surfaces are decorated with inlaid designs, even the neck and tuning keys. On the upper side, at the plectrum guard, is a charming scene of a man riding a running camel and playing a *biwa;* above him is a banana plant. This motif, Iranian in origin, is typical of the taste for exotic things which fascinated court circles in eighth-century China and Japan.

77. Genkan, *Shōsō-in* (正倉院の阮咸). *Eighth century.*
Resembling a *biwa* with a flat body, this is the only known specimen of the *genkan*, a musical instrument occasionally noted in ancient records. On its upper side, the plectrum guard is a circle of painted leather ornamented with a romantic scene of two ladies and a gentleman listening to a third lady play this instrument beneath a flowering plum tree. This and the *biwa* above were among the first objects donated by the Empress Kōmyō to the Daibutsu.

78. *Lacquered ewer, Shōsō-in* (正倉院の漆胡瓶). *Eighth century.*
This wine vessel was made in China in imitation of Iranian examples in silver. It was made, however, of delicate strips of bamboo woven together like a fine basket and then covered with layers of black lacquer. For the rich surface decoration, the floral and animal forms were cut out in layers and removed from the lacquer ground, which was then filled with gold and silver leaf cut to the correct shape. A silver chain joins the removable lid to the body.

79. *Mirror inlaid with mother-of-pearl and amber, Shōsō-in* (正倉院の螺鈿鏡). *Eighth century.*
Traditionally, Chinese mirrors had been made chiefly of bronze with decorations in low relief on their backs. But the imperial T'ang courts, in their quest for physical splendor, sponsored the decoration of mirrors in colorful new materials —a taste which the court in Nara shared with enthusiasm.

80. *Silver incense burner, Shōsō-in* (正倉院の銀薫炉). *Eighth century.*
Although incense was used primarily in Buddhist devotions, the Nara aristocracy delighted in rare scents for their own sake and eagerly imported them from abroad. This device was used to burn incense amid a person's clothing, and for safety's sake a series of rings and pivots like a gimbal were put inside to keep the iron fire-plate

horizontal. The design pattern of lions and *hōsōge* (imaginary flowers rather like peonies) was a favorite of the time.

81. *North Circular Hall (Hokuen-dō), Kōfuku-ji* (興福寺北円堂). *Thirteenth century.*
Octagonal halls such as this one or the Yumedono at Hōryū-ji were intended as memorial structures. Kōfuku-ji was the family temple of the powerful Fujiwara clan, and the Hokuen-dō was built in honor of the head of the family, Fubito, who died in A.D. 720. Its fourth and final reconstruction occurred in A.D. 1207, a time when the so-called *tenjiku* or "Indian style" of architecture was current in Japan. This added a certain delicacy in proportion and bracketing to the more solemn, majestic spirit of the traditional Japanese style.

82. *South Circular Hall (Nan'en-dō), Kōfuku-ji* (興福寺南円堂). *Eighteenth century.*
This hall was built in A.D. 813 in fulfillment of the final wishes of the mother of the powerful courtier Fujiwara-no-Fuyutsugu. It was repeatedly burned, however, and its present form is the reconstruction of the mid-eighteenth century, one which unfortunately lost the harmonious proportions of the ancient type. The Nan'en-dō is often crowded with devotees because it is counted as the ninth of the thirty-three temples in western Japan sacred to the Bodhisattva Kannon, and is thus an obligatory pilgrimage site.

83. *Ashura, Kōfuku-ji* (興福寺の阿修羅). *Eighth century.*
Ashura is derived from the Asuras of ancient Indian mythology, hordes of demons who were constantly fighting the benevolent Hindu gods. As adapted by Buddhist mythology, they became one of the eight classes of fierce gods (the Hachi Bushū) who protect the Buddhist realm. This figure was thus one of a set of eight placed around a statue of Śākyamuni in the west *kondō*. Together with statues of the Ten Disciples of the Buddha, they were ordered in A.D. 734 by the Empress Kōmyō for the sake of her mother, the Lady Tachibana, and were made in the workshop of the naturalized Japanese, Shōgun Mampuku. They were built up with hemp cloth saturated with lacquer and stretched over a light wooden armature, then coated with lacquer and painted.

84. *Subodai, Kōfuku-ji* (興福寺の須菩提). *Eighth century.*
This imaginary portrait of Subhūti is from the celebrated set of the Ten Disciples of the Buddha which were made in the same workshop as the Eight Classes of Guardians (Hachi Bushū) and installed with them in the west *kondō* of Kōfuku-ji. Today only six of the original ten remain, but each is clearly individualized in face and body, reflecting the strong concern with realism, an important tendency of Buddhist art in T'ang China.

Hollow dry lacquer.

85, 87. *Imaginary portraits of Muchaku (Asanga) and Seshin (Vasubandhu), Kōfuku-ji* (興福寺の無着・世親). *Thirteenth century.*

The Kōfuku-ji sculpture workshop, under the direction of the Buddhist master Unkei, produced this pair of imaginary portraits of Asanga and Vasubandhu, two Indian monks of the fifth century A.D. who were considered founding teachers of the Hossō sect to which Kōfuku-ji belonged. These large-sized portraits were made in A.D. 1208 and installed in the North Circular Hall flanking a statue of Maitreya Buddha. Awesome and grave in mood, they are among the noblest examples of the new realism of the Kamakura period.

Assembled wood construction; polychromed.

86. *Kongō Rikishi, Kōfuku-ji* (興福寺の金剛力士). *Thirteenth century.*

One of the two Ni-ō (Guardian Kings) who serve as guardians at the main gateway of a Buddhist temple, this work is thought to have been carved around 1190–99 by Jōkei, a follower and possibly a son of the master Unkei. The style, which combines meticulous realism with dynamic movement, was perfected by Unkei at the time of the restorations of Kōfuku-ji and Tōdai-ji at the beginning of the century, and was continued by several generations of followers. There are startling similarities between figures like this and Italian sculpture of the seventeenth century in the baroque style.

Assembled wood.

88. *Approach path to the Kasuga Shrine* (春日大社の参道).

When Kōfuku-ji was moved to Nara, the Kasuga Shrine was established on the hillside overlooking the temple. The four main deities enshrined there served as protectors of the temple and as tutelary deities of the Fujiwara family; the connections between the shrine and the Kōfuku-ji were once extremely close. Even after the fall of the Fujiwaras, the shrine was maintained through the devotions and gifts of the people at large—as testified by the presence of over a thousand hanging lamps and seventeen hundred stone lanterns. These are lighted in February, for the ceremony of Setsubun (a festival celebrating the advent of spring according to the lunar calendar), and in August, for the Bon Festival (the Buddhist All Souls' Day), presenting one of the grand spectacles of the ancient southern capital.

89. *Sacred dance at the Kasuga Shrine* (春日大社の大和舞).

Because of the long centuries of patronage by the Fujiwara family, the Kasuga Shrine has been steeped in traditional dance and music of the imperial court and aristocracy. Preserved here is the form of court entertainment called *bugaku,* as well as the *yamato-mai,* an ancient ritual folk dance. The Nō drama is also performed following major festivals. Costumes, musical instruments, and masks are carefully tended as the shrine faithfully maintains these ancient art forms.

90. *Basara, one of the Twelve Divine Generals of Shin-Yakushi-ji* (新薬師寺の伐折羅大将). *Eighth century.*

The Jūni Shinshō, the Twelve Divine Generals, are described in the scriptures as guardians of each of the twelve vows of compassion made by Yakushi in order to aid and cure mankind. It is said that this set of dry clay figures had been brought from the Iwabuchi-dera, at the foot of nearby Mount Kasuga, which had fallen into ruin. An inscription was discovered on the pedestal of one of the figures stating that it was made in the Tempyō period (A.D. 729–67)—most likely in the latter part. The figures were somewhat hastily executed and lack the quality of others in the same medium, such as those in the Kaidan-in; but the expression in their faces still has great strength and power.

Polychromed unbaked clay.

91. *Main hall* (hondō), *Shin-Yakushi-ji* (新薬師寺本堂). *Eighth century.*

Dedicated to Yakushi, the Buddha of Healing, this temple was ordered by the Empress Kōmyō in A.D. 747 at the time of an illness of the Emperor Shōmu. The main hall extant today is not the original *hondō;* and even though the temple was burned and rebuilt at the end of the eighth century and the main hall reconstructed in the tenth, it has preserved the original plan, dimensions, and spirit of the Nara period.

92. *Interior of Shin-Yakushi-ji* (新薬師寺の内部).

The statue of Yakushi Nyorai, made chiefly from a single, massive block of wood, dates probably from the very end of the Nara period. Aesthetically it shares much in common with the standing Yakushi statue in Jingo-ji, Kyoto; for in their stolid and brooding quality, they both anticipate the stylistic developments of the early Heian period.

93. *Detail of court ladies in a garden, from an illustrated sutra* (過去現在因果経部分). *Eighth century.*

Early Buddhism was very much centered upon the person and teachings of its historic founder, Śākyamuni. In keeping with the Indian idea of the transmigration of the soul after a person dies, his biographies told of both his most recent incarnation and also of the many previous ones in which he accumulated the spiritual merit *(karma)* which led to his final enlightenment. The *Kako Genzai Inga-kyō* ("Sutra of Past and Present Karma") is one such text, and illustrated versions brought from China were copied with great fidelity in the Nara period. Fragments of these are preserved today in the Tokyo Fine Arts University, the Jōbon Rendai-ji in Kyoto, the Hōon-ji in Kyoto Prefecture, and elsewhere. Even at the time they

were painted, the pictorial style was an archaic one and unusually simplified, but the mode of composition, in which the story unfolds in a continuous narrative, had considerable influence upon later Japanese scroll painting.

Color on paper.

94. *The path to Jingo-ji* (神護寺への道).
Jingo-ji is said to have been located originally in the Kawachi district, east of Osaka. Called Shingan-ji, it was the family temple of the loyal minister Wake-no-Kiyomaro; but with Kiyomaro's desire to reform the faith, the temple was moved by his sons to this remote site deep in the mountains west of modern Kyoto. Jingo-ji later housed some of the most celebrated figures in the history of Japanese Buddhism: Kūkai and Saichō, who were pioneers of Esoteric Buddhism in Japan; Kakuyū (or Toba Sōjō) and Mongaku Shōnin, two of the leading clerics of the later Fujiwara period; Myōe Shōnin, who led the revival of the Kegon school in the middle Kamakura period; and the Emperor Goshirakawa, who lived at Jingo-ji after abdicating the throne in A.D. 1158 and made it a major center of political power.

95–96. *Yakushi Nyorai, Jingo-ji* (神護寺の薬師寺如来). *About A.D. 799.*
This statue of the Buddha of Healing may have been brought from the Kawachi district to Jingo-ji when the temple was moved. It reflects dissatisfaction with the illusionism of the Nara styles and shows a search for a deeper spirituality. Its style is not immediately pleasing to modern taste, but it was one which struck a responsive chord in ninth-century Japan and was widely adopted. Statues in more or less this same manner can still be seen in Murō-ji, Gangō-ji, Tachibana-dera, Shin-Yakushi-ji, and elsewhere.

Cypress wood.

97–98. *The Five Great Kokūzō Bodhisattvas, Jingo-ji* (神護寺の五大虚空蔵). *Mid-ninth century.*
Symbolically, the Five Great Kokūzō Bodhisattvas are emanations of the Ākāśagarbha, the Womb of the Void, and are the embodiments of five forms of wisdom and achievement—purity, abundance of talent, abundance of fortune, and the like. These images served as the main cult objects of an Esoteric Buddhist ritual aimed at the acquisition of wealth and the avoidance of calamity. They were made about A.D. 848 in accordance with the vow of the Emperor Nimmyō, and were installed in Jingo-ji's *tahō-tō*, a single-story pagoda whose shape is also peculiar to Esoteric Buddhism. The sculptural techniques are typical of this particular style of the early Heian period. The wood was heavily coated with a plasterlike priming and then painted; the hair tresses were modeled in dry lacquer. However, the surface color and movable implements have been subject to restoration over the centuries.

Cypress wood.

99. *Kōya-san* (高野山).
The monk Kūkai explored Mount Kōya in A.D. 816 seeking an appropriate site for a seminary of the Shingon branch of Esoteric Buddhism and for his own meditation. Having received an imperial grant, he began building operations, and three years later the *kondō* was completed. Structures were gradually added, but because of innumerable fires, most of them have been lost, although some of their treasures have been preserved. Visible to the left is the roof of the Kompon Daitō, the main pagoda at Kōya, built in recent decades chiefly in ferroconcrete.

100. *Ritual implements of Esoteric Buddhism* (密教の法具).
In its elaborate liturgy, Tantric Buddhism employed many unusual implements. Four of the more important types are shown here, made of gilt and cast bronze, and usually are placed on the altar in a special bronze dish. The bell with a five-pronged handle *(goko-rei)* is used to mark stages of a prayer recital and, among other things, symbolizes through its fading ring the fleeting quality of the world as known through the senses. The daggerlike thunderbolt *(kongō-sho)* originated in India as the *vajra*, the weapon of Indra, Vedic lord of rainfall. In Tantric Buddhism, it became the symbol of the indestructible diamondlike wisdom which can dispel ignorance and evil. Shown here are the one-, three-, and five-pronged forms, each with its distinct symbolic value.

101. *"Descent of Amida and His Heavenly Host"* (阿弥陀聖衆来迎図). *Late eleventh or early twelfth century. Reihō-kan, Kōya-san.*
This is a rare instance where the scale of a Japanese painting approaches that of the large murals found in Chinese Buddhist temples or, indeed, those of the Italian Renaissance. Thirty-one figures are arranged in almost symphonic complexity, with the linear currents of the cloud forms weaving in and around them. Traditionally, this work is said to have been painted by the Tendai theologian Genshin (Eshin Sōzu, 942–1017) in accordance with his own mystic vision of the Raigō. Stylistically, however, it seems to be more advanced than the wall paintings of the Hōō-dō at Uji of about 1053 and to have been painted as much as a century after Genshin's death. Genshin's essays and poems devoted to the Pure Land of Amida, however, were largely responsible for the revival of the cult in the Heian period, and for centuries this painting was kept as a secret image on Mount Hiei, where Genshin had lived. In the conflagration set by Oda Nobunaga in 1571, it was saved and transferred to Kōya-san, where it was shared by several sanctuaries. In recent years, it has been on display in the Reihō-kan (the temple museum).

102. *Nyoirin Kannon, Kanshin-ji* (観心寺の如意輪観音). *Ninth century.*

Holding in one hand the Jewel of Enlightenment and the Wheel of the Law in another, this deity is believed to respond quickly to the prayers of the devout and thus is widely worshiped. The Kanshin-ji statue is mentioned in an entry in the temple's records as early as A.D. 882, and was probably made a generation earlier. Except for the arms and left leg, it was carved from a single block of cypress wood, which was primed with plaster and painted. Although the movable attributes and the flames on the aureole are of recent vintage, this is the best-preserved example of polychromed sculpture of the early Heian period.

Cypress wood.

103. *The rock-cut Buddha image at Ōno* (大野の石仏). *Thirteenth century.*
Maitreya Buddha is engraved on the cliff face overlooking the Uda River at the small temple of Ōno-ji, marking the entry of the valley leading to Murō-ji. This elegant stone image was dedicated in A.D. 1209 in a ceremony which attracted the retired Emperor Gotoba. One tradition holds that it was carved by Chinese artisans; the fluid line quality of the draperies and the full features of the face would tend to bear this out.

104. *Five-story pagoda, Murō-ji* (室生寺の五重塔). *Late eighth or early ninth century.*
Murō-ji was first built around A.D. 780–82, and this tiny pagoda, in its form and building technique, seems to belong to that period and to be the oldest structure in the compound. The slight curvature of the eaves gives it a subtle grace; the roof itself is made of cypress bark, a rarity in pagodas and one of the earliest uses of this strictly Japanese material in Buddhist architecture.

105. *Seated Buddha, Murō-ji* (室生寺の釈迦如来). *Ninth century.*
This method of carving folds of cloth is called the rolling-wave style *(hompa-shiki)*, by which a slightly peaked, sharp ridge is placed between each of the heavier, rounded folds. This adds an extra and somewhat arbitrary shadow, strengthening the play of light and dark in a rather pictorial way. Indeed, it has been speculated that this effect originated in the use of Chinese copybooks with pictures of celebrated Indian images. The Murō-ji statue is often labeled Śākyamuni, but the hand and arm positions suggest that it is probably Bhaishajyaguru (Yakushi Nyorai).

Hinoki cedar with traces of plaster.

106. *Kondō, Murō-ji* (室生寺の金堂). *Ninth century.*
This was built in the early Heian period, slightly later than the founding of the temple, but the extra bay along the front was added much later. Despite these changes, the building has a remarkable sense of harmony with its surroundings and is one of the rare specimens of early Heian period

architecture. In the interior, as well as the exterior, antique building techniques can still be seen.

107. *Interior of the* kondō, *Murō-ji* (室生寺金堂の内部).
Arrayed beneath the latticed ceiling of the inner sanctuary are standing wooden images of Śākyamuni, Mañjuśri, the Eleven-headed Avalokiteśvara, Bhaishajyaguru, and Kshitigarbha, each bearing its own painted wooden halo. Each figure varies slightly from the others, but a style distinctive of Murō-ji can be detected throughout in the light chisel marks, which impart a mobile, fluid beauty over the surface. Standing before them are the rather humorous images of the Twelve Divine Generals, special protectors of the healing Buddha—relieving the atmosphere of austerity and rigor.

Śākyamuni Buddha, ninth or tenth century.

108. *The Komponchū-dō of Enryaku-ji* (延暦寺の根本中堂).
Inaugurated during the period 782–805, this hall was originally three small buildings which were later joined together as one. Its interior is typical of a Tendai place of worship, with an outer hall where the lay devotees offer prayer and an inner sanctum, cavernously dark, which is separated by a grill from the outer hall and set on a considerably lower level. There the monks perform such rituals as the blazing Goma ceremony before the complex altar which extends almost the entire width of the hall and is comprised of three separate units: one dedicated to Bhaishajyaguru (Yakushi), the others dedicated to Saichō and to the deity Vaiśravana (Bishamon-ten). The present hall was reconstructed in A.D. 1640, but it has preserved the ancient building traditions of the Tendai sect.

109. *A sutra box in gilt bronze* (金銅の経箱). *Eleventh century.*
Recently excavated, this box held a copy of the *Lotus Sutra* believed to be the one copied by the Lady Jōtōmon-in, daughter of the powerful minister Fujiwara-no-Michinaga and consort of the Emperor Ichijō. It was buried in A.D. 1031 for the sake of posterity and with the prayer that the lady would rejoin her family in Paradise. The occasion of its burial was the two-hundredth anniversary of a copy of the sutra made by the celebrated monk Jikaku Daishi (Ennin), who had lived in a thatched hut at the site. The Nyohō-dō, now in ruins, was built to mark this place and was a center for the ritual copying of the *Lotus Sutra* by laymen.

Kept at Enryaku-ji, Shiga Prefecture.

110. *Interior of the lecture hall, Kyōōgokoku-ji (Tōji)* (教王護国寺講堂の内部). *Ninth century.*
This arrangement of twenty-one large statues was designed by Kūkai (Kōbō Daishi) himself in A.D.

829 as a three-dimensional version of the pictorial mandalas which outline the processes by which spirit had become matter and, conversely, by which the soul of man can find its way back to its essential origins. Seated in the center of the platform is the personification of the prime creative principle, Vairocana Buddha. He is surrounded by the other four supreme Buddhas. To the east is the group of the Five Great Bodhisattvas (Go-bosatsu), embodiments of different forms of perfect and indestructible wisdom. To the west are the Five Radiant Kings (Godai Myō-ō) shown here. The Four Guardian Kings (Shitennō) are placed in the usual manner at the four corners of the platform, joined by Indra (Taishaku-ten) and Brahma (Bonten) at either end. The statues of the Five Radiant Kings date from the period 834–48, whereas six of the statues in the other two main groups are later replacements.

Podocarpus wood.

111. *Mandala* (曼荼羅), *detail of center section. Tōji. Late ninth or early tenth century.*
This Taizōkai mandala is one of the best preserved and oldest of the colored mandalas in Japan, only a few decades later than the ones found on the interior walls of the pagoda at Daigo-ji dated A.D. 951. It is paired with a Kongōkai mandala of the same age in the usual set of two used in Esoteric rituals. Shingon monks were trained in the complex meaning of such diagrams, which were employed by them in meditation, in baptismal ceremonies, and in the regular rituals of the temple; and the two diagrams were often mounted on large panels set along the sides of the chancel of the *kondō* of Shingon temples.

112–13. *Male and female Shinto deities, Matsuo Shrine, Kyoto* (松尾神社の男女神). *Ninth century.*
The historic Matsuo Jinja originated as the family shrine of the powerful Hata family, and was long connected with Kōryū-ji, an ancient temple in the western part of Kyoto. The remarkable statues of Shinto deities at the shrine must have been made by a prominent Buddhist sculptor of the time, probably the last decades of the ninth century; for although clearly distinguished from Buddhist sculpture, they share elements in common, such as the carving of garment folds in the wavelike pattern called *hompa-shiki*. The names of the deities have been lost, but with a quality of portraiture about them, they may have represented deified ancestors.

Polychromed wood.

114. *General view of the Kyoto Imperial Palace* (京都御所).
The Kyoto Imperial Palace has had an unusually complex history, for it was subject to recurring perils—earthquakes, fires, dynastic disputes—and has been frequently destroyed. At the time of the original layout of the city in the late eighth century, the palace was located about a mile west of the current one, though at the same latitude, at the north end of town. It was the capstone of the plan of the city, which was 3 by 3½ miles square and divided into an orderly checkerboard pattern of streets like that of Nara—the entire system being based on a Chinese prototype, probably of the Sui and T'ang capital at Ch'ang-an. The north-south avenue which divided the city in two parts began at the south gate of the palace enclosure; the system of numbered avenues running east and west began with First Avenue about the latitude of the Throne Hall. The current palace, called the Gosho, was built chiefly between 1789 and 1800, and lacks two of the most important compounds of the ancient palace: the Chōdō-in, housing the offices of state and the Throne Hall, and the Buraku-in, the center for state rituals and entertainment.

115. *The Shishin-den* (紫宸殿), *Kyoto Imperial Palace.*
The Shishin-den is the chief ceremonial hall within the modern palace enclosure, but in the palaces of the Heian period, it was an audience hall within the residential area, and high state rituals were performed elsewhere. The entire complex of state buildings has not been reconstructed, and some of their functions have been transferred to the Shishin-den, especially the coronation ritual. The building is an affirmation of Japanese taste in the use of unpainted cypress wood and its cypress-bark roof, and the austere gravel forecourt. The latter is enclosed with three gates, of which the main ceremonial one is on the south, the Shōmei-mon.

116. *Interior of the Shishin-den* (紫宸殿の内部).
The structure of the Shishin-den is that of a nobleman's residence of the Heian period, a type of domestic architecture now called the *shinden-zukuri*. A veranda runs around all four sides of the building, roofed by deeply projecting eaves. Ranks of columns rise from the broad floors, and the underside of the vast roof, seen through the rafters, imparts a sense of great scale and solemnity. Behind the thrones of the emperor (Takamikura) and empress (Michōdai) are screens painted with figures of thirty-two Chinese sages.

117. *Seiryō-den* (清涼殿), *Kyoto Imperial Palace.*
The Seiryō-den ("Pure, Cool Hall") was intended to house the everyday life and minor ceremonials of the sovereign. However, the Tsune-goten ("Ordinary Palace") was added to the compound to provide more comfortable quarters, and as a result the former reverted primarily to ceremonial functions. The Seiryō-den is also built in the *shinden-zukuri* style, unpainted and largely open to its surrounding gardens. The garden on the east is severely plain, but those opening off other chambers are more colorful.

118. *From* The Tale of Genji, *illustrated hand-*

scroll (源氏物語絵巻). *Twelfth century,*
The oldest remaining illustrated version of the *Genji Monogatari* was painted early in the twelfth century, approximately a century after the classic novel was written by the Lady Murasaki. It originally consisted of illustrations of the important events of all fifty-four chapters, and may have comprised as many as ten scrolls. All that has survived are nineteen paintings, mounted as single framed panels and found chiefly in the Tokugawa Reimei-kai (the Tokugawa collection) and the Gotō Museum, both in Tokyo. The names of the artists are unknown, but there is no question that they worked in a strictly secular, courtly atmosphere, filled with the emotional values of the aristocracy and reflecting little of contemporary Buddhist arts.

Polychromed paper. Tokugawa Reimei-kai, Tokyo.

119. *From the* Shigisan Engi, *illustrated handscroll* (信貴山縁起絵巻). *Twelfth century.*
This section is taken from the first of three scrolls depicting the miraculous deeds of a monk attached to the Chōgosonshi-ji, a small temple on Mount Shigi, southwest of Nara. The first scroll relates the manner by which the monk, Myōren Shōnin, caused the rice granary of a thoughtless patron to fly in the air through his magic powers, gained by the worship of Bishamon-ten, the chief deity worshiped at the temple. The second deals with his miraculous curing of an illness of the Emperor Daigo; and the third deals with his sister, a nun who had been separated from him and searched to find him. The text portions of the scroll are lost, but the stories appear in an old collection of tales, the *Ujishūi Monogatari* (edited 1212–30) and other anthologies.

Polychromed paper. Chōgosonshi-ji.

120. The Ban Dainagon Ekotoba, *illustrated handscroll* (伴大納言絵詞). *Twelfth century.*
The plot of the scheming minister Ban Dainagon (or more correctly, Tomo-no-Dainagon) took place during the reign of the Emperor Seiwa (A.D. 858–76) and is included in the anthology of stories, the *Ujishūi Monogatari.* In order to embarrass a rival for power, the minister had a gate of the Imperial Palace, the Ōten-mon, burned and tried to cast the blame on his rival. Due to an argument among servants, however, the conspiracy was discovered. This painted version of the story dates from the late twelfth century and consists of three scrolls which successfully depict both the raucous excitement of the populace and the bitter grief of the minister's family when he is unmasked, bringing the full emotional range of the *yamato-e* together in a single work.

Polychromed paper. Sakai collection, Tokyo.

121. *Text of the* Lotus Sutra *written on fan-shaped paper* (扇面古写経). *Twelfth century.*
Using paper originally intended for a fan, the

Hokke-kyō and commentary in ten scrolls were copied and made into folding albums. Today, five albums remain in the ancient Shitennō-ji in Osaka, one book in the Tokyo National Museum, and a few leaves in private collections. As illuminated sutras, they show extraordinary ingenuity of design, and some of them were made by a simple form of block printing. Although the scenes of everyday life of both the aristocracy and the common people are not actually related to the text, the fusion of sacred and profane implied here has important theological overtones.

Shitennō-ji, Osaka.

122. *Amulet covers, Shitennō-ji* (四天王寺の懸守).
Amulets which were worn when women ventured out from their homes reflect the sumptuous taste of the aristocracy as the Heian period drew to a close, for the covers were made with utmost care and expense. Even the woven strings, made with an arrow-notch design, show the meticulous concern for tasteful decor.

123. *A page from* The Anthology of the Thirty-six Poets, *Nishi Hongan-ji* (西本願寺の三十六人家集). *Twelfth century.*
This collection of poems was originally the property of the imperial family, but in 1549 the Emperor Gonara presented it to the monk Shōnyo of the Hongan-ji temple. Because the temple was originally located at Ishiyama in Osaka, the remaining parts of the collection are known as the Ishiyama set. The collection consists of nearly three thousand pages ornamented in a great variety of styles and techniques.

124. *Lacquered toiletries box with design of floating wheels* (片輪車の手箱). *Twelfth century.*
Around the middle of the Heian period, lavishly ornamented toiletries boxes of this kind came into great vogue. The swelling contours of the lid and body give the box a subtle softness, while the surface design transforms an ordinary event into a scene of poetic beauty. The interior of the box is decorated with equal finesse by the scenes of flowering grasses of the four seasons.

Tokyo National Museum.

125–26. *Satirical drawings, Kōzan-ji* (高山寺の鳥獣人物戯画). *Twelfth century.*
The artist to whom these scrolls are conventionally attributed is Kakuyū (or Toba Sōjō), a theologian and painter of the Tendai sect who lived from 1053 to 1140. However, most scholars agree that the authorship and precise dating are unknown; moreover, there are enough differences in style between the two scrolls in which animals predominate and the two in which men predominate to see them as the work of more than one artist. Most likely, they were done by monks in the painting workshop at Kōzan-ji as relief from the rigors of the more traditional religious themes. Despite their spontaneous, informal spirit,

they were carefully preserved because of their obviously high quality. In the descriptive technique, there are analogies to the *yamato-e* style as seen in the scrolls of the *Shigisan Engi*.

Sumi (ink) on paper.

127. *Kiyomizu-dera* (清水寺).
This temple is said to have been founded in the early Heian period by the warrior Sakanoue-no-Tamuramaro; the current *honden* was reconstructed after a devastating fire in 1622, but was a careful copy of the older building. Resting atop many columns, which are tied and buttressed in a complex manner, the hall projects outward over the steep incline of the hillside. The interior of the *honden* is divided into an inner and outer sanctum in the classical manner of an Esoteric Buddhist ceremonial hall. In the center of its porch is a viewing platform, which is flanked by side pavilions and corridors.

128. *Five-story pagoda, Daigo-ji* (醍醐寺の五重塔). *Tenth century.*
The pagoda was completed in A.D. 952, twenty years after it had been originally planned. It was built on a generous scale, in an orderly and traditional manner, and has survived the centuries remarkably well. Its latest repair and thorough renovation was completed in 1959. Its position in the temple layout was balanced not by another pagoda, as at Yakushi-ji, but by a shrine dedicated to a Shinto god, the tutelary deity of the site—further evidence of the conscious fusion of Esoteric Buddhism and the native religion. The structural system of the pagoda, particularly the corner bracketing, shows the complexity of mid-Heian period architecture. The roof is tiled.

129. *Detail of wall painting, interior of the pagoda* (塔内の壁画). *Tenth century.*
In Shingon Buddhism, mandalas were used to outline essential religious and philosophical concepts: the origins of matter, the relationship of matter and spirit, the way in which the mind is to be concentrated in meditation, and so on. Two main mandalas were used in its rituals, each demonstrating an aspect of the great first principle of existence; the Taizōkai and Kongōkai mandalas, the former symbolizing the underlying principle of the Lord's existence, the latter the understanding of this existence. Both mandalas were painted around the central mast of the Daigo-ji pagoda, showing how this abstract theological system of Esoteric Buddhism had come to replace the simpler pietism of the cult of relics, which was the origin of the pagoda form.

Polychromed wood.

130. *Garden and palatial buildings of the Sambō-in, Daigo-ji* (三宝院の殿舎と庭). *Late sixteenth century.*
Buildings at this site date back to the twelfth century, but were frequently lost to fire. In 1598, on the occasion of his famous cherry-blossom-

viewing party, Toyotomi Hideyoshi ordered the reconstruction and enlargement of the Sambō-in, and the work continued well after his death, until 1606. The structural system combines the traditional *shinden* style of the Heian capital with the new *shoin* style being developed in the Momoyama period. The garden was designed with lavish care, with waterfalls and islands, and hundreds of rocks and shrubs brought specially for the purpose.

131. *The karamon of the Sambō-in, Daigo-ji* (三宝院の唐門). *Late sixteenth century.*
In his preparations for the cherry-blossom party, Hideyoshi restored many of the halls at Daigo-ji. This *karamon* was either moved down from his castle at nearby Fushimi, Momoyama, or else it was built on the spot. It is a rare specimen of early Momoyama period architecture in a subdued, modest spirit.

132. *The Uji River gorge and the Byōdō-in* (宇治川と平等院).
The Chancellor Fujiwara-no-Michinaga retired from office to practice Buddhist meditation and austerities at his country villa on this site. His son Yorimichi converted the estate into a temple in 1052, and over the next three decades it became a very elaborate compound. The chief relic of its past is the hall dedicated to Amitābha, popularly called the Phoenix Hall (Hōō-dō), whose plan indeed resembles a bird in flight with its side wings and a rear corridor like a tail.

133. *General view of the Phoenix Hall (Hōō-dō), Byōdō-in* (鳳凰堂全景). *Eleventh century.*
The Phoenix Hall is divided into a central hall housing the chief cult image, with wings off to each side and a corridor (whose original use is uncertain) in the rear. The roofs of heavy gray tile are extremely varied in appearance. The roof over the central hall is hipped and gabled and is crowned by two bronze statues of phoenixes on the ridge. Lower eaves protect the portico. The side wings have a simple gabled roof, but the end pavilions are capped with pyramidal shapes.

134. *Canopy, Phoenix Hall* (鳳凰堂の天蓋). *Eleventh century.*
Installed for the same symbolic reasons as the canopies of the *kondō* at Hōryū-ji, this complex of intricately carved wooden panels was probably produced by the workshop of Jōchō Busshi, which made the main cult image beneath. Great manual dexterity and refined craftsmanship were major features of this workshop's style.

Gilded wood.

135–36. *Angelic musicians, Phoenix Hall* (鳳凰堂の飛天). *Eleventh century.*
These fifty-two figurines carved in semirelief are among the treasures of the temple. Although subject to repairs and later restorations (one figure is of the Meiji period), the group as a whole

belongs to the style of Jōchō's workshop. The hands of at least four different sculptors can be detected in them.

Gilded and polychromed wood.

137. *Amitābha Buddha, Phoenix Hall* （鳳凰堂の本尊）. *Eleventh century.*
This is the most celebrated work known to have been made by Jōchō, whose fame as the leading master of his day far outstrips the number of existing examples from his hand. It was dedicated at an elaborate ceremony in 1053, four years before his death. Assembled from many small blocks of wood, the image is largely hollow inside and thus relatively light in weight. At the time of repairs in recent years, a beautifully painted lotus pedestal was found in the aperture, its top inscribed with an elaborate prayer formula dedicated to Amitābha and written in Sanskrit. This statue is often considered one of the most distinctive and originally Japanese interpretations of the Buddha figure, and this style became the model for subsequent representations of Amitābha.

Assembled wood construction.

138–39. *Door paintings, Phoenix Hall* （鳳凰堂の壁面）. *Eleventh century.*
The wall and door paintings of the Hōō-dō were based on the *Sukhāvatī vyūha*, "Descriptions [or Manifestations] of the Land of Bliss." The nine scenes of the descent of Amitābha *(Amida raigō)* relate to the notion that the Paradise is divided into nine regions, and those reborn there are divided into nine classes according to the nature and intensity of their beliefs. The paintings have been badly worn and defaced; only fragments are preserved, but the level of accomplishment is extremely high. They must have been done by a workshop whose skill and reputation was comparable to that of Jōchō.

140. *Interior of the* amida-dō, *Hōkai-ji* （法界寺阿弥陀堂の内部）. *Twelfth century.*
This statue is one of a number of large Amitābha figures in wood in the Kyoto area which were based on the prototype established by Jōchō. Its precise date and origin is unknown, but there is a possibility that it was produced in Jōchō's workshop after the master's death. The *honzon* of the Phoenix Hall is more lively and ornate, whereas this one is reserved and quiet. Perhaps a touch of the sadness and tribulations of the imperial court can be detected in this figure within the ample hall.

Assembled wood.

141. *Flying angel; wall painting, Hōkai-ji* （天人の壁画）. *Twelfth century.*
In each of twelve wall panels high above the tie beams surrounding the figure of Amitābha were painted flying angels. They belong to the very end of the Heian period and reflect a new wave of influence in art and religion from Sung China

which was just beginning and would increase in strength throughout the thirteenth century. This may be seen in the features of the faces, which are rather coarse, in the deep shading, and in the fluid, painterly line quality. The more meticulous and ornate pictorical style at the Phoenix Hall belongs to an older tradition.

142. *Amida-dō, Hōkai-ji* （法界寺の阿弥陀堂）. *Twelfth century.*
Hōkai-ji stands on the site where Hino Sukenari built a country estate. According to ancient records, two or three halls dedicated to Amitābha were built there during the Heian period; but it is unclear which of them has survived as the current one. The influence of the domestic building style of the Heian capital, the so-called *shinden-zukuri*, is evident in the porch which encloses the building and in the cypress-bark roof. Interestingly, the roof-line of the porch is broken and raised at the entrance way in much the same manner as that of the Phoenix Hall of the Byōdō-in.

144. *Distant view of the Itsukushima Shrine* （巌島神社の遠望）.
The shrine honors the goddess Ichikishimahime-no-mikoto and two other daughters of the storm god Susa-no-ō. It was founded in A.D. 592, but when taken under the patronage of Taira-no-Kiyomori in the mid-twelfth century, it was turned into a large and splendid establishment. The shrine traditions claim that prior to this time, the island itself was considered sacred and ordinary men forbidden even to set foot on it. Thus the sanctuary was built on pilings out in the water and could be approached by laymen from the mainland by ship only, passing through the *torii* (gate). The current structures are the result of restorations in the thirteenth and sixteenth centuries, but the old forms were faithfully preserved.

145. *The corridors of the Itsukushima Shrine* （巌島神社の廻廊）.
The long, handsome corridors are about 1,020 feet in length, joining the shrine buildings with each other and the mainland. The main shrine consists primarily of the *honden* ("main sanctuary") and the *heiden* ("offering hall") and the *haraiden* ("hall of purification"). To one side is a secondary shrine with the same set of buildings, built over the water on a slightly smaller scale. When the tide is full and the hundreds of hanging lamps lit, the natural beauty and sense of isolation from the ordinary world are unequaled.

146–47. *Sutra scrolls donated by the Taira family* （平家納経とその箱）, *Itsukushima Shrine. Twelfth century.*
Of the thirty-three scrolls given by the Heike to the shrine, twenty-eight present one chapter each of the *Lotus Sutra*. One other scroll contains the dedicatory text. The remaining four titles include

the *Sukhāvatī vyūha* and *Amitābha* sutras (both centered on the Pure Land creed), and a sutra explaining meditation upon the Bodhisattva Samantabhadra (Fugen); the last is a *Prajñāpāramitā (Hannya)* text. Written on the back of the dedicatory scroll is the date of presentation, 1164. Although there have been restorations and repairs, the ensemble offers an authentic impression of the taste and unlimited resources of the Taira family in its prime. The picture illustrated here is from the twenty-seventh chapter of the *Lotus Sutra*, in which the Indian King Śubhavyūha, his family, and the women of the court become worthy of receiving the teaching of the True Law. The picture depicts two court women holding rosaries; the cranes and rocks and flowers in the background probably stand for words in an elaborate picture puzzle related to the text, but the meaning is no longer clear.

148. Butterfly Dance *at the Itsukushima Shrine* (嚴島社頭の胡蝶舞).
Called the *Kochō-mai*, this dance features four young men wearing butterfly wings and one dressed as a *karyōbinga* (the Indian *kalavinka*, or cuckoo bird). An illustration of an ancient Chinese legend, the music is of Korean origin but the dance form itself was devised in Japan and practiced commonly by the youths of the Heian capital. Such rare and charming survivals can be deeply moving to the modern spectator.

149. *Dance mask of Batō* (舞楽面の抜頭), *Itsukushima Shrine. Twelfth century.*
According to the inscription inside this mask, it was made in Kyoto in 1173 by the sculptor Gyōmei Busshi (otherwise unknown) and was copied from a mask in the Sonshō-ji temple there, then given to the Itsukushima Shrine. The *bugaku* dance in which this is used has been handed down by a single family, father to son, attached to the Itsukushima Shrine for centuries.
Lacquered wood.

150. *Dance mask of Genjōraku* (舞楽面の還城楽), *Itsukushima Shrine. Twelfth century.*
Like the previous mask, this was also made in 1173 in Kyoto as a copy of a mask in the Sonshō-ji. A set of *bugaku* masks almost identical to these in Itsukushima is found at Hōryū-ji. They are older, having been carved in 1144, but in the subtleties of carving and expression are less exciting than these.
Lacquered wood.

151. *Armor with deep-blue yarn* (紺糸縅の大鎧), *Itsukushima Shrine. Twelfth century.*
Said to be the bequest of Taira-no-Shigemori, son of the shrine's founder, Kiyomori, this suit is distinguished by the use of blue yarns to join together the leather and small black-lacquered iron plates. Because it was actually worn, the sleeves and neck-hole are quite large. The gallant

officers of the capital were very much aware of the amorous appeal of their trappings, and vied with each other in commissioning equipment from the fine craftsmen of the city.

152. *Amida hall at Shiramizu* (白水の阿弥陀堂). *Twelfth century.*
This hall was built in 1160 at Shiramizu, near the official barrier at Nakoso. It was donated by the widow of Taira-no-Norimichi, the deceased governor of the locale, in hopes of thus securing the well-being of his soul. She was the daughter of Fujiwara-no-Hidehira, virtually the independent ruler in the northernmost provinces. It is a classical example of an Amida hall as generally built at the time, with its graceful pyramidal roof originally covered with reed thatch but now with sod. It has lost the ornament which crowned the peak of the roof, the *hōshu*, the flaming jewel probably made of bronze.

153. *Amida trinity, interior of the* amida-dō, *Shiramizu* (白水阿弥陀堂内の阿弥陀三尊). *Twelfth century.*
The trinity of Amitābha flanked by Avalokiteśvara (Kannon) and Mahāsthāmaprāpta (Seishi), his two active attendants, stand on the image platform along with two guardian deva kings. Undoubtedly carved in one of the Kyoto ateliers working in the tradition of Jōchō, this set of figures is imbued with a delicacy which verges on the effete, and the drapery is so deftly modeled that it is almost realistic in effect. The openwork halo and pedestals are original, and were carved with the extreme dexterity and finesse of the decorative arts of the day.

154. *The Konjiki-dō, Hiraizumi* (平泉の金色堂). *Twelfth century.*
This Amida hall was originally part of the large temple called Chūson-ji, and its name—the "Hall of Golden Hue" or sometimes Hikari-dō, the "Hall of Brilliance"—was taken from the use of bright gold leaf throughout the interior. According to an inscription on one of the interior columns, it was begun in 1124 by the most powerful of the Fujiwara barons of the north, Kiyohira. Built both as an *amida-dō* and a funerary hall, the bodies of his son and grandson were later placed there and separate altar platforms built for them. It was customary during the Heian period to bring corpses or ashes into an *amida-dō* to pray for the soul's rebirth in Paradise, and it was a natural step to install the remains near the altar. In the later part of the Kamakura period, the small building was simply enclosed in a larger structure for protection.
Inner building, pyramidal wooden roof with planks cut to the shape of tiles.

155. *Interior of the Konjiki-dō* (金色堂の内部). *Twelfth century.*
Beneath the central image platform, the body of Fujiwara-no-Kiyohira was placed. To the right

was that of his son Motohira, and to the left his grandson, Hidehira—the remains mummified and given lavish costumes in the caskets. The three sets of images on the platforms each consist of the following: Amitābha flanked by Avalokiteśvara and Mahāsthāmaprāpta; then six identical statues of Kshitigarbha (Jizō), the Bodhisattva who compassionately aids souls in each of the six stages of sentient existence (including those in Hell) to find their way to Paradise; two deva guardians complete the sets.

156. *Pendant discs* (keman), *Konjiki-dō* (金色堂の華鬘). *Twelfth century.*
Twelve metal *keman* have been preserved in the Konjiki-dō, but in them three different styles of execution can be seen, a reflection of the manner in which the hall was equipped for each of the three successive burials. The object reproduced here is from the oldest group, a set of six identical *keman* which hung over the central dias. The birds were covered with gold leaf, the surrounding circular part with silver.

158. *Dainichi,* *Chūson-ji* (中尊寺の一字金輪). *Twelfth century.*
This type of Dainichi (Mahāvairocana) image is called the Ichiji Kinrin and is a strictly Esoteric Buddhist figure. It symbolizes Dainichi as containing within himself all other deities of the pantheon, which is to say all forms of being and cognition. This concept is reinforced by the hand gesture whose basic significance is that of the union of spiritual and material realms. The original location of this statue at Chūson-ji is unknown, and it has been heavily restored. The back half of the image is missing; whether intentionally or otherwise is not known. The eyes and *urna* are of inlaid crystal.

159. *Garden of the Mōtsu-ji compound* (毛越寺の庭), *Hiraizumi.*
According to tradition, Mōtsu-ji was founded in A.D. 850 by Jikaku Daishi, better known as Ennin, the monk of the Tendai sect who traveled in T'ang China and, after his return, spread the doctrines of his sect throughout this region. During the middle of the twelfth century, the temple was refurbished and built up on a lavish scale by the three prosperous generations of Fujiwaras in Hiraizumi. In 1189, however, as the Shogun Minamoto-no-Yoritomo was consolidating his hold on the nation, his armies broke the power of these barons, and the temple compound was put to the torch by the leader of the doomed fourth generation, Yasuhira.

160. *The Tsurugaoka Hachiman Shrine, Kamakura* (鎌倉の鶴岡八幡宮).
The foremost sanctuary of the war-god Hachiman in all Japan has long been the Iwashimizu Shrine near Kyoto, and a branch of it was established in 1051 at the village of Yuigahama near Kamakura

by the warrior Minamoto-no-Yoriyoshi. His distant descendant Yoritomo moved the branch to its present site (the hill called Tsurugaoka) as the keystone of the city plan of Kamakura, the seat of Yoritomo's military government; one of the *torii* (gates) of the shrine, however, still remains at Yuigahama. The shrine has been frequently damaged by fire, and most of the structures currently standing were built in 1828.

161. *Minamoto-no-Yoritomo* *(detail),* *Jingo-ji, Kyoto* (神護寺の源頼朝). *Late twelfth century.*
The painter of this portrait is said to have been Fujiwara-no-Takanobu (1142–1205), a courtier known from historical records to have been a master of *nise-e* ("likeness drawing"), the subtle art of depicting the individuality of a face. This portrait of Yoritomo was one of a set of five which were commissioned of Takanobu by the Emperor Goshirakawa in A.D. 1188 to be hung in the Sentō-in, a dwelling hall at Jingo-ji where the emperor stayed after he had abdicated the throne. The set also included a portrait of the emperor himself, which has been lost, and those of his other prominent supporters: Taira-no-Shigemori (the son of Kiyomori), Fujiwara-no-Mitsuyoshi, and Taira-no-Narifusa (painting also lost).
Color on silk.

162. *Minamoto-no-Yoritomo* (源頼朝). *Late twelfth or thirteenth century.*
This statue was originally placed in the Shirahata-gū, a shrine within the precincts of the Tsurugaoka Hachiman Shrine at Kamakura. When compared with the painted portrait in Jingo-ji, it seems to have depicted Yoritomo (who died in 1199) at a later stage of life. It is one of three such statues of major political figures of the day which have survived as evidence of the growth of a tradition of secular portrait sculpture around Kamakura. The others are of Uesugi Shigefusa and the Regent Hōjō Tokiyori, and together they represent the equivalent in wood of the painted portraits done in the *yamato-e* style.
Assembled wood construction, polychromed; inserted crystal eyes. Now in the Tokyo National Museum.

163. *Uesugi Shigefusa, Meigetsu-in* (明月院の上杉重房). *Thirteenth century.*
The early history of this statue is unclear, but probably it was installed first in the temple called Saimyō-ji (later renamed Zenkō-ji), which was part of the giant compound of Kenchō-ji, foremost among the Zen temples of Kamakura. Toward the end of the fourteenth century, the villa of Shigefusa's descendant Norikata was converted into a branch of Zenkō-ji and this portrait of the patriarch of the family was installed there. It was made of assembled wood blocks, the eyes inlaid with crystal, and the surface covered with plaster and painted. It closely resembles the portrait of the Regent Hōjō Tokiyori kept at Kenchō-ji.

164. *The* shariden *("hall of relics"), Engaku-ji* (円覚寺の舎利殿). *Late thirteenth century.*
Members of the Hōjō family served as hereditary advisers to the *bakufu* (military government); however, they quickly took the reigns of power from the hands of the Minamoto and through much of the thirteenth century were the real rulers of the land under the title of *shikken,* or regent. Hōjō Tokimune was the prime patron of the Zen temple of Engaku-ji, second ranked of the Gozan of Kamakura, but the *shariden* is thought to have been built around 1285, just after his death. The style in which it was constructed, the *kara-yō,* must have been used for all the buildings of the temple, but the *shariden* is the only one of the original buildings to survive, essentially a subordinate hall set off to one side of the central axis of the compound.

Hipped and gabled thatch roof.

165. *Bukkō Kokushi* (仏光国師), *Engaku-ji. Thirteenth century.*
The Sung monk Wu-hsüen Tsu-yüan (Mugaku Sogen) came to Japan at the invitation of the Regent Hōjō Tokimune in 1279 and was made the first patriarch of Engaku-ji in 1286, the year he died. He was given posthumously the honorific title of Bukkō Kokushi. Like the portraits of military men, the image was made of assembled blocks of wood with eyes of inlaid crystal. The original paint surface has flaked away, leaving the the wood to darken and glisten with age. Originally the hands held a fly whisk. The work was probably completed about the time of the monk's death.

167. Sammon *("mountain gate"), Kenchō-ji* (建長寺の山門).
Kenchō-ji was founded in 1253 by the Regent Hōjō Tokiyori, and its first patriarch was the Chinese monk Lan-ch'i Tao-lung (Rankei Dōryū). It was modeled after a temple on Ching-shan near Hangchou, which dated back to the mid-eighth century and was ranked as one of the five main Zen monasteries of China. The current *sammon* of Kenchō-ji was built in 1755, and except for the helmet-shaped projection from the upper roof, it is faithful to the traditional form of the peculiar, two-story gates of Zen monastery compounds. On the second story are small statues of the Five Hundred Arhats together with a seated figure of Amitābha.

168. *Musō Soseki, Zuisen-ji* (瑞泉寺の夢窓国師). *Fourteenth century.*
Musō Soseki (1271–1351) was born in Ise and was related to the Minamoto clan. He began his Buddhist studies at the age of nine and was learned in Mikkyō and Jōdo doctrines before he mastered those of Zen. He lived in both Kyoto and Kamakura, and traveled widely throughout the country spreading Zen doctrines. He was highly sensitive to aesthetic values, and his influence on the Emperor Godaigo and the Ashikaga shoguns was partially responsible for their role as patrons of architecture and the arts. Having founded a number of temples (including Tenryū-ji in Kyoto as well as Zuisen-ji in Kamakura) and having lived at many others, he was frequently depicted in portrait scrolls or statues; and his sensitive, rather emaciated face is one of the most characteristic images of early Zen arts in Japan. This portrait at Zuisen-ji is one of the oldest of the statues of him, and may well have been done by a Kyoto artist rather than a local one.

Assembled woodblock construction; polychromed, with inlaid crystal eyes.

169. *Garden of Zuisen-ji* (瑞泉寺の庭).
Zuisen-ji was reestablished in 1327 by Musō Soseki. Even though it was a modest hermitage, it was a subtemple of Engaku-ji and had as many as ten dwelling halls; throughout the fourteenth century, it was visited by prominent political figures of the Ashikaga family and by celebrated monks. The garden of Zuisen-ji resembles the larger and more famous one designed by Musō at Saihō-ji in Kyoto. Strongly influenced by Chinese ideas concerning the role of nature in the meditative life, both are informal gardens, large enough to wander through, and although carefully tended and weeded, have been allowed to grow in a rather free and natural way.

170. *The Daibutsu at Hase* (長谷の大仏), *Kamakura. Thirteenth century.*
There is little historical data on the erection of this prominent image of Amitābha in the Kōtoku-in, but it was probably made sometime between 1249 and 1256. There is mention in one document that in the nearby village of Fukuzawa, the monk Jōkō Shōnin erected a large image of the Buddha in wood around 1238–47, and then in 1252 began making another one in bronze. The names of the craftsmen and date of completion are unknown, but the statue bears traces of the style of Kaikei, who was active at this time in Nara. It also was influenced by Sung Chinese sculpture, evident in the fleshy quality of the lips and jowls and the heaviness of the body itself.

Bronze, cast in sections and joined.

171–72. *King Shokō and Kushō-jin, Ennō-ji* (円応寺の初江王と倶生神). *Thirteenth century.*
Ennō-ji is a branch temple of Kenchō-ji and is located only a hundred yards or so from its entry gate. The assemblage of large wooden figures in the Emma-dō (Hall of Yama) is one of the most impressive of all relics of the medieval cult of propitiating the judges of the dead, Yama having been a very ancient Indian lord of death who was changed in Chinese folk religion into the head of a frightening tribunal at the gates of hell. This statue of Shokō, one of the Ten Kings, has an inscription inside it with the date 1251 and the name of the sculptor Kōyū, who is otherwise

unknown. During this period, however, the highly realistic style of Unkei which was in full flower in the Nara-Kyoto region was transferred to Kamakura as well. There it joined with the strong stylistic influences from the mainland brought by Chinese monks and craftsmen invited by the *bakufu*. These statues in the Emma-dō show the fusion of these tendencies, the Sung elements being most evident in the grotesque faces and swirling garments.

173. *Benzai-ten (Sarasvatī), Tsurugaoka Hachiman Shrine* (鶴岡八幡宮の弁才天). *Thirteenth century.*
Inscribed on the back of the statue's knee is the date 1266, the name of the chief donor, Nakahara-no-Ason Mitsuuji, and the fact that the statue was installed in the Bugaku-in. The building is no longer extant, but it must have been the center for the performance of the shrine's dances. The donor was probably a dancer at the shrine and a member of a family of Kyoto court musicians. It is not illogical that the Indian goddess Sarasvatī—patron of music, eloquence, learning, and material good fortune—was enshrined in a Shinto sanctuary. Her cult was similar to that of Kichijō-ten (Śrī Lakshmī), and reached Japan at the same time. Essentially a non-Buddhist folk deity still widely worshiped today in India, her absorption into the pantheon of native Japanese, non-Buddhist deities reflects her original pagan nature.

Assembled woodblock construction, polychromed.

174. *The beach at Katase* (片瀬の海岸).
Enoshima is one of three islands sacred to Benzai-ten in Japan, the other two being Itsukushima and Chikubushima (on Lake Biwa). The Benzai-ten Shrine on Enoshima is now purely Shinto, but before the Meiji period it was a joint Shinto-Buddhist sanctuary. The images of the goddess are said to date from 1182, when Minamoto-no-Yoritomo invited Mongaku Shōnin, celebrated monk from Jingo-ji in Kyoto, to promote her cult and refurbish the shrine. Later, Yoritomo's son Sanetomo and the Hōjō regents offered their devotions there.

175. *The Lake of Reeds (Ashi-no-ko) at Hakone* (箱根の芦ノ湖).
The Hakone Shrine was said to have been founded in A.D. 767 by Mangan Shōnin, one of the Nara monks who sought remote and secluded spots for meditation. Minamoto-no-Yoritomo came here after his defeat by the Taira at Odawara, and he prayed that he might restore his forces and subdue his enemies. After this time, the sanctuary was lavishly supported by the military families. Both Buddhist and Shinto services were held here, but at the beginning of the Meiji period, the site was turned over exclusively to the Shinto priests. Among its many historical relics, however, is a ninth-century wooden portrait of the founder, Mangan Shōnin.

176. *Stone pagoda, Hakone* (箱根の石塔). *Thirteenth century.*
In the mountains around Hakone are many stone pagodas erected to those who died in the countless skirmishes fought in this strategic region over the centuries. This *hōkyōin-tō* was erected near the banks of Lake Shōjin, and by local tradition it is a memorial in honor of one of the ancient patriarchs of the Genji, Tada-no-Mitsunaka, who was also called Minamoto-no-Mitsunaka. On one face of its main shaft is the image of a seated Buddha; the other three faces bear the initial in Sanskrit of the names of the other Buddhas. The pinnacle of the pagoda is a later restoration.

177. *Inkstone box, Tsurugaoka Hachiman Shrine* (鶴岡八幡宮の硯箱). *Thirteenth century.*
This fragile object, so rich in historical associations, is a registered National Treasure. In the interior is a complete set of writing implements—a stone palette for grinding ink, a holder for the ink block, a small metal water jar, brushes and their cases, a pair of scissors, a small knife, and an auger. The inside of the lid of the box, painted with a design similar to that of the top, is done in *maki-e* alone.

178. *Toiletries case, Mishima Shrine* (三島大社の手箱). *Thirteenth century.*
The interior of this case contains two trays and a complete set of cosmetic equipment: a bronze mirror, a box for white powder, incense, a comb, eyebrow makeup, scissors, hair tweezers, a silver hairpin, and the like.

179. *Stone garden of Ryōan-ji* (竜安寺の石庭). *Late fifteenth century.*
Ryōan-ji is a detached subtemple of Myōshin-ji nestled in the low hills on the west edge of Kyoto. The site was originally a villa of the warrior Hosokawa Katsumoto, a major figure in the Ōnin Rebellion. He had it restored in 1450; later it was converted into a Zen hermitage, and the garden was laid out near the very end of the century. By long tradition, the designer was supposed to have been Sōami (died 1525), the distinguished landscape painter and garden expert, but this has never been confirmed. It is the most celebrated of all the Zen-style dry gardens, and has probably preserved its original design with little change except the enriched patina of age.

180. *Shōitsu Kokushi of Tōfuku-ji* (東福寺の聖一国師), *by Minchō. Fourteenth century.*
Kichizan Minchō (1352–1431) spent most of his life as a monk in Tōfuku-ji, where he held the largely honorary position of *densu*, a warden in charge of maintaining the ceremonial halls, preparing for rituals, and the like. As a painter, he carefully studied works in the style of such Chinese masters as Li Lung-mien and Yen Hui. His own works range in technique from traditional cult icons painted on silk in bright colors to freely executed landscapes in monochrome ink on paper;

in fact, the transition from the old to the new aesthetic system in Buddhist art is nowhere more clearly demonstrated than in the art of Minchō. Shōitsu Kokushi (Ben'en) was first trained in both Tendai and Shingon forms of Esoteric Buddhism and later became an adept of Zen. He studied for six years in China, where he was recognized as a true patriarch of the Rinzai school; back in Japan, however, he continued to recognize the validity of Esoterism as well, which accounts for his reputation as a tolerant, learned theologian.

Color on paper.

181. *Daitō Kokushi, Daitoku-ji* (大徳寺の大燈国師). *Fourteenth century.*
The Zen monk Shūhō Myōchō (1282–1337) was the first resident abbot at Daitoku-ji and served the emperors Hanazono and Godaigo, from the former of whom he received the honorific title of Daitō Kokushi. Above this portrait is an inscription in his own hand telling that it was painted in 1334, when he was fifty-three years old. Despite the sumptuous, ceremonial quality of the robes, the realism of the face preserves the lack of pretense or vanity characteristic of the Zen *chinzō*. Other early portraits of this monk are preserved in various subtemples and branches of Daitoku-ji.

Silk with coloring.

182. *The "Moss Garden" of Saihō-ji* (西芳寺の庭). *Fourteenth century.*
Saihō-ji was said to have been founded in the Tempyō period; it was also the site in Kyoto of an ancient Buddhist ceremony of "The Liberation of Living Beings" (the *hōjō-e*), in which carp were set free in its pond as an expression of compassion for all sentient beings. In 1339 it was redesigned as a Zen hermitage by Musō Soseki at the invitation of a priest of the nearby Matsuo Shrine, Fujiwara-no-Chikahide. Many of its features, no longer preserved, were incorporated in the great palace-estates of the Ashikagas: notably the Kitayama-dono, which includes the Golden Pavilion, and the Higashiyama-dono, which includes the Silver Pavilion. It is now a branch of Tenryū-ji, and the chief architectural relic of Saihō-ji is the Shōnan-tei, a garden teahouse of the kind cherished by Musō but built well after his time.

183. *Garden of Daisen-in* (大仙院の庭), *Daitoku-ji. Sixteenth century.*
This garden, set in a narrow space on one side of the dwelling quarters of the abbot, suggests a mountain ravine and brook. It leads into a much larger garden area made almost entirely of smoothed sand. The suggestion is that of an ocean into which the brook is flowing—a setting susceptible of endless interpretations.

184. *The Golden Pavilion of Rokuon-ji* (鹿苑寺の金閣).
The Saionji family's country estate and gardens, the largest and most famous of their day, were taken over and expanded by Yoshimitsu about the time he gave up his government positions to become a monk in 1394. In fact, he was imitating the customs of the old "cloistered emperors," for he continued to exercise real political power from this palace, which was formally converted into the Rokuon-ji ("Deer Garden Temple") only after his death in 1408. Yoshimitsu built up the Kitayama Palace in a novel fusion of domestic and religious architectural styles. This is still apparent in the reconstructed Golden Pavilion (Kinkaku), which was said to have been modeled originally on the Lapis Lazuli Pavilion (Rurikaku) of Musō Soseki at Saihō-ji. The first floor of the Golden Pavilion was called the Hōsui-in and had both paintings and statues of the Amida Raigō in the interior. The second floor was devoted to the worship of Kannon, while the third floor (the Kyūkyō-chō) was given a symmetrical design and pyramidal roof, with windows offering a vista in all four directions. The name Kinkaku derived from the fact that gold leaf had been applied to almost all the exterior walls and even parts of the interior.

Cedar-bark shingle roofs.

185. *The Silver Pavilion of Jishō-ji* (慈照寺の銀閣). *Fifteenth century.*
After the death of Yoshimasa, the Higashiyama Palace was turned into a temple called Jishō-ji. The Silver Pavilion (Ginkaku) had served as a votive hall in the estate, the Kannon-dō. It was begun in 1489, about a century after the Golden Pavilion, and closely resembled it in the combination of domestic and ecclesiastic styles, particularly in the upper story in the *kara-yō* style, with the bell-shaped windows, balustrade, and pyramidal roof. There are subtle differences, however, in the ground floor, where the newer *shoin* ("writing hall") system of building was employed. Slightly more informal than the older *shinden* style, this was characterized by the use of a low, built-in writing ledge, usually made of fine wood, with a special window above it through which the person writing might gaze out into a garden.

Cedar-bark shingle roof.

186. *The Tōgu-dō of Jishō-ji* (慈照寺の東求堂). *Fifteenth century.*
Like many other important structures of the Muromachi period, the Tōgu-dō (built in 1486) was patterned after a building designed by Musō for Saihō-ji; in this case, it was the Sairai-dō for the worship of Amitābha. Yoshimasa built the Tōgu-dō as a private chapel; statues of the Amitābha trinity were installed in one of the four rooms (they have been replaced by a portrait of Yoshimasa himself); and the name of the building implies the wish of men of the East for rebirth in the Western Paradise. Among the other rooms is the Dōnin-sai shown here; in principle this was

for the ritual copying of sutras, but writing ledges and windows of this kind served as the basis for the development of the elaborate writing alcoves of the developed *shoin* style of a palatial building.

One story; hipped and gabled roof; slat shingles.

187. *"New Moon over the Brushwood Gate"* (柴門新月図). *Artist unknown. Fifteenth century.*
Picture scrolls in which monks would write eulogistic poems and comments came into great fashion in Zen circles around the end of the fourteenth and the first quarter of the fifteenth centuries. To this scene, which is based on a poem by the eighth-century Chinese writer Tu Fu, eighteen monks from the main Zen temples (Gozan) of Kyoto added their stanzas. An introductory colophon with the date of 1405 was written by the monk-painter Gyokuen Bompō, himself a master of ink painting in the Chinese manner and a specialist in depicting orchids. The emotional warmth and sincerity of this picture overshadow the fact that it was painted with a relatively simple, ingenuous technique, built up in thin washes with the dark accents added at the very end.

Ink on paper. Fujita Art Museum, Osaka.

188. *"Catching a Catfish with a Gourd," by Josetsu* (如拙筆瓢鮎図). *Fifteenth century.*
The symbolic significance of this painting, whatever it may have been, was purposely left as unclear as that of the dry garden at Ryōan-ji, as though to prod the mind to concentrate on fundamental matters concerning enlightenment and how to reach it. On the upper portion of this scroll are poetic comments by thirty monks, including Bompō, along with the notation that this work ''in the new style'' was painted on the orders of a shogun (either Yoshimitsu or Yoshimochi), mounted on a screen, and always kept near his seat. It has been remounted as a hanging scroll.

Ink and thin color on paper. Taizō-in, Myōshin-ji, Kyoto.

189. *"Reading in a Bamboo Grove Retreat," by Shūbun* (周文筆竹斎読書図). *Fifteenth century.*
Shūbun, a monk of Shōkoku-ji, excelled in sculpture as well as in painting, and is said to have studied with Josetsu. Despite his position as a monk, he was also appointed the official painter to the Ashikaga shogun. It is difficult to establish a corpus of certified works for Shūbun, but of all the paintings attributed to him, the one reproduced here is the most majestic and evocative. The poems inserted boldly into the composition make this a good example of the *shiga-jiku* (poetry-painting scroll); and from their content, the work can be dated about 1446–48.

Ink on paper with thin color. Tokyo National Museum.

190. *Landscape in the "broken ink" manner, by Sesshū* (雪舟筆破墨山水図). *Dated 1494.*
Above the composition but written on the same sheet of paper is a long dedicatory inscription by Sesshū which in part recounts his own career. It tells of his trip to China and of his feeling that no painter there could equal Josetsu or Shūbun in their fidelity to the standards of Southern Sung painting. Additional poetic comments were written by monks of the Gozan of Kyoto, including one who observed correctly that Sesshū had worked here in the manner of the eccentric Chinese Zen master Ying Yü-chien; but for all his fidelity to Chinese prototypes, the style of Sesshū is more schematic and abstractly composed, inherently less illusionistic.

Monochrome ink on paper. Tokyo National Museum.

191. *"Hui-k'o Presenting His Arm to Bodhidharma,"* by Sesshū (雪舟筆恵可断臂図). *Detail. Fifteenth century.*
The story of the manner by which Hui-k'o finally persuaded Bodhidharma to accept him as a disciple is one of the standard legends of the Zen sect but is found only rarely in paintings. Sesshū concentrated so much energy into this version that it has the power of a religious icon, even though it lacks most of the features of hieratic imagery: symmetry, idealized forms, and an otherwordly atmosphere. Painted three years after the *haboku* landscape in the Tokyo National Museum, it demonstrates the great range of styles of which Sesshū was capable. The inscription states that it was done at the age of seventy-seven by Sesshū, who had (once) been given the seat of honor at the Chinese monastery of T'ien-tung.

Ink and thin color on paper. Collection of Sai-nen-ji, Aichi Prefecture.

192. *"Kannon in White," by Nōami* (能阿弥筆白衣観音図). *Dated 1469.*
Nōami (1397–1471, also called Shinnō), his son, and his grandson all served the Ashikaga shoguns as *dōbōshu*, attendants who advised in matters of arts and crafts, and they also painted in the Chinese style. Their techniques were not those of a unified family style like that of the Kanōs, but were rather individual and personal, Nōami's being the softest and most lyrical. This is considered the best-authenticated work from his hand, and according to the inscription, it was painted when he was seventy-two years old in honor of his deceased son Shūkei.

Color and ink on silk.

193. *"Monk Watching a Waterfall," by Geiami* (芸阿弥筆観瀑僧図). *Circa 1478.*
Geiami (1431–85, also called Shingei) was an accomplished poet in the idiom of linked verse as well as a gifted painter and connoisseur, typical of the kind of men involved in the aesthetic ferment of the Higashiyama period. This scroll was painted when he was fifty years old; above are poetic

inscriptions by five monks, one from each of the Gozan, and there are indications that Geiami painted this as a parting gift to his student, Kei Shoki, who was to become a distinguished master in his own right. The inscriptions also state that Geiami had helped his pupil by obtaining permission for him to see the shogun's collection of paintings.

Ink and thin color on paper. Nezu Museum, Tokyo.

194. *"Birds and Waterfall," by Kanō Motonobu* (元信筆花鳥図). *Fifteenth century.*
This is one of a set of forty-nine paintings originally mounted on sliding screens in the Reiun-in, a subtemple of the Zen monastery of Myōshin-ji. Motonobu had received instruction in Zen doctrines at this temple and presumably left these paintings in gratitude and regard for his teacher, Sōkyū (Daikyū Kokushi). Motonobu (1476–1559) remained a layman and professional painter, but he painted large screens of this kind for other Zen hermitages, such as the Daisen-in of Daitoku-ji. In the screen paintings for the Reiun-in, which have been remounted as hanging scrolls, Motonobu worked in at least three separate styles based on the works of celebrated Sung period Chinese painters, Mu Ch'i, Ying Yü-chien, and (as shown here) Hsia Kuei.

Ink and slight color on paper. Reiun-in.

195. *"Wind and Waves," by Sesson* (雪村筆風濤 山水図). *Sixteenth century.*
Sesson Sōkei (1504–ca. 1589) was a native of Hitachi province, in the extreme northeast of Honshū, and spent most of his life as a Zen monk in the region. Relatively little is known about him personally, but the fact that he attained such a high degree of artistic achievement is evidence of the way the new aesthetic system of the Muro-machi period spread throughout the land.

Ink on paper. Collection of F. Nomura, Kyoto.

196. *The teahouse of Kohō-an, subtemple of Daitoku-ji* (孤篷庵の忘筌). *Seventeenth century.*
The Kohō-an was built in 1611 for Kobori Enshū (1579–1647), the outstanding expert of his day in the unified art of garden design, tea ceremony, and architecture. It was moved in 1643 to its present location at the west edge of the temple compound, and its subsequent history has been very complicated. Although rebuilt several times, it still retains the broad simplicity of what was an archaic building style even in the early seventeenth century.

197. *Iron teakettle* (五匹馬の茶釜). *Sixteenth century.*
Tea masters of the Higashiyama period preferred iron kettles produced in two remote spots. One was Ashiya, near Fukuoka in northern Kyūshū, a long-established center of metal working dating back to early historic times. The other was in Temmyō, near Sano in Tochigi Prefecture on Honshū. Reproduced here is a product of the Ashiya workshops of the last half of the sixteenth century and said to have belonged to Furuta Oribe (1561–1600), a warrior who founded the Oribe school of tea ceremony.

Tokyo National Museum.

198. *Nō stage* (能の舞台).
The Nō drama was based upon popular theatricals performed around temples and shrines as a means of raising money for the sanctuaries and drawing crowds. The conversion of these crude and sometimes vulgar theatricals into the high art form of today was done through the patronage of the Ashikaga shoguns and the creative genius of Kan'-ami and Seami.

CHRONOLOGY OF JAPANESE ART UNTIL 1568

The history of Japanese culture and art is usually divided into eras and periods in much the same manner as is European history. Japanese scholars use terms equivalent to ''Renaissance'' or ''Enlightenment'' or ''Rococo period'' with a variety of shades of meaning, in order to clarify cultural questions which are subtle and complex. The precise dates inevitably attached to these period names should not mislead the reader into thinking that the development of the arts actually fell into orderly compartments of time. Outlined below are the terms used in this book, together with a few of the major landmark dates in the evolution of Japanese art.

JŌMON PERIOD (until *ca.* 250 B.C.). The Japanese neolithic culture, begun *ca.* 4500 B.C. if not before, with livelihood based on hunting and food gathering and rudimentary village units. Most characteristic relics are Jōmon pottery with highly expressive, convoluted shapes, and small clay figurines *(dogū)*. Very little foreign influence apparent.

YAYOI PERIOD (*ca.* 250 B.C.–A.D. 250). Importation of metal crafts (both bronze and iron) from the Asian continent; development of agriculture, stable communities, and regional political units. Characteristic relics are ritual weapons and bell-shaped objects *(dōtaku)* made of bronze, jewelry of semiprecious stone, and rather fine pottery (some of it made on a wheel). Marked continental influences in the arts.

KOFUN PERIOD (*ca.* A.D. 250–552). The proto-historic period, marked by growth of national consciousness and the power of a supreme imperial ruler. Chief remains are the *kofun* (ancient tombs) concentrated in the Kinki area (Osaka, Nara, Kashiwara, Sakai), the *haniwa* clay figurines ceremonially placed around such grave mounds, bronze mirrors and tomb furnishings, and (in the Kyūshū tombs) wall paintings.

ASUKA PERIOD (552–646). The rise of Buddhist art and institutions in the Asuka district, patterned on Korean and Chinese examples and given the support of the imperial family.

558　Presentation of relics of the Buddha to the Japanese court by the king of Paekche, who also dispatched monks, temple architects, tile makers, bronze casters, and a painter. Erection by Soga-no-Umako of the Hokkō-ji at Asuka-magami-no-hara, the first full-fledged monastic compound in Japan.

592　Shōtoku Taishi's building of the Shiten-nō-ji at Arahaka in Naniwa (now part of Osaka City).

603　Hata Kawakatsu's construction of the Hachioka-dera (now Kōryū-ji in Kyoto).

606　Bronze statue of Śākyamuni, made by Tori Busshi, installed in the *kondō* of the Moto-Gangō-ji (originally part of Hokkō-ji; now called the Asuka-dera).

607　Date of the building of Hōryū-ji, according to the halo inscription of the statue of Yakushi in the *kondō* of the temple.

623　Completion by Tori Busshi of the Shaka Trinity (now in the *kondō* of Hōryū-ji) in memory of Shōtoku Taishi (died 622).

645　Downfall of the Soga family; beginning of the Taika Reformation.

EARLY NARA (OR HAKUHŌ) PERIOD (646–710). Increased centralization of political power; continued contacts with China and Korea; maturing of Japanese Buddhist arts.

650　Approximate date of the four guardian figures, *kondō* of Hōryū-ji.

657　Building of Yamashina-dera near Kyoto by Nakatomi-no-Kamatari, founder of the fortunes of the Fujiwara family.

670　Recorded date of the burning of Hōryū-ji.

680　Pledging of the construction of Yakushi-ji in the Asuka district by the Emperor Temmu.

698 Dedication of the Yakushi trinity as the *honzon* of Yakushi-ji.

NARA (OR TEMPYŌ) PERIOD (710–94). Establishment of Japan's first permanent seat of government at Nara; profound influence of the Buddhist Church over the imperial court; lavish state patronage of Buddhist architecture and sculpture.

710 Imperial court relocated at the Heijō-kyū ("Palace of the Fortress of Peace"), Nara. Family temple of the Fujiwaras moved to Nara and renamed Kōfuku-ji.

711 Date of clay statues at the base of the five-story pagoda, Hōryū-ji, as well as of the two clay guardian figures in the Central Gate.

717 Approximate date of the moving of Yakushi-ji to Nara.

739 Erection of *tō-in* ("east precinct"), including the Yumedono, at Hōryū-ji by the monk Gyōshin.

741 Establishment of system of official state monasteries (Kokubun-ji) and nunneries in provincial capitals.

743 Emperor Shōmu's pledge to erect a giant image of Birushana (Vairocana) Buddha, to be built in Ōmi district. Project later moved to Nara.

747 Casting of the Daibutsu at Tōdai-ji begun; Empress Kōmyō builds the Shin-Yakushi-ji in Nara for benefit of the health of Emperor Shōmu. Giant image of the Fukūkensaku Kannon (Amoghapāśa) at Tōdai-ji of approximately this date.

752 Great consecration ceremony of the Daibutsu, Tōdai-ji.

756 Death of the Emperor Shōmu and the presentation by the Empress Kōmyō of his prized possessions to the Daibutsu (origin of the Shōsō-in collection).

759 Building of Tōshōdai-ji near Nara for the Chinese monk Chien-chen (Ganjin).

782 Five-story pagoda at Murō-ji begun about this time.

784 Nagaoka Palace begun in Yamashiro province (near modern Kyoto).

EARLY HEIAN PERIOD (794–898). Establishment of the Heian capital; introduction of Esoteric Buddhism and its distinctive aesthetic system.

794 Moving of the capital to the Heian-kyō, the modern Kyoto.

796 Construction of Tōji and Saiji at the south entry to the capital.

798 Founding of the Kiyomizu-dera in Kyoto.

805 Return of Saichō (Dengyō Daishi) from China.

806 Return of Kūkai (Kōbō Daishi) from China.

816 Construction of the Kongōbu-ji on Mount Kōya by Kūkai.

823 Entrusting of Tōji to Kūkai, its conversion into a Shingon temple, its being given the new name of Kyōōgokoku-ji.

824 Moving of the Wake family temple to Jingo-ji on Mount Takao near Kyoto about this time.

839 Date of the cult statues in the lecture hall, Tōji.

848 Approximate date of the Five Great Kokūzō statues, Jingo-ji.

873 Approximate date of the portrait of Dō-zen Risshi, Yumedono, Hōryū-ji.

LATE HEIAN (OR FUJIWARA) PERIOD (898–1185). Closing of direct contacts with the Chinese mainland; increased awareness of native Japanese subject matter and aesthetic attitudes in the arts.

898 Approximate date of three statues of Shinto deities in the Hachiman Shrine, Yakushi-ji, Nara.

907 Approximate date of the Yakushi-dō at the Upper Daigo-ji, Kyoto, and of the statue of Yakushi.

952 Building of the five-story pagoda, Daigo-ji and the painting of the Ryōkai Mandala on the interior wall panels.

985 Writing of the *Ōjōyō-shū* by Eshin Sōzu.

1003 Approximate date of the literary activities of such talented women as Murasaki Shikibu (author of *The Tale of Genji*), Sei Shōnagon *(Pillow Book),* and Akazome Emon (traditionally the author of the *Eiga Monogatari*).

1022 Dedication by Fujiwara-no-Michinaga of the Hōjō-ji *kondō* and Godai-dō.

1031 Gilt bronze sutra box buried at the Nyohō-dō at Enryaku-ji, a center for the ritual copying of the *Lotus Sutra*.

1051 Building of Hokkai-ji by Hino Sukenari.

1053 Carving of the statue of Amitābha by Jōchō for the Phoenix Hall of the Byōdō-in under the patronage of Fujiwara-no-Yorimichi.

1086 Beginning of the rule of the *insei* ("cloistered emperors") with the retirement of the Emperor Shirakawa.

1108 Beginning of Chūson-ji at Hiraizumi by Fujiwara-no-Kiyohira.

1126 Building of the Konjiki-dō at Chūson-ji.

1164 Donation of ornamented sutras by the Taira family (Heike) to the Itsukushima Shrine.

1180 Burning of Tōdai-ji and Kōfuku-ji by Taira-no-Shigehira.

1183 Recasting of the Daibutsu of Tōdai-ji begun by the monk Chōgen and the Chinese craftsmen Ch'en Ho-ch'ing and his brother.

KAMAKURA PERIOD (1185–1333). Establishment of the headquarters of the military government at Kamakura under rule of Minamoto clan and then under the Hōjō family; reconstruction of damaged Nara temples; rise of Zen Buddhism to status of

semiofficial state religion; strong waves of artistic influence from Sung China.

1189 Fall of Fujiwaras of Hiraizumi to Mina-moto-no-Yoritomo; reconstruction work at Kōfuku-ji; sculpture by Kōkei.

1191 Return of the monk Eisai from Sung China (his second trip) and his founding of the Rinzai school of Zen Buddhism in Japan.

1195 Dedication ceremony for restoration work at Tōdai-ji with Minamoto-no-Yoritomo in attendance.

1203 Supervision by master sculptors Unkei and Kaikei of the carving of two giant guardian figures at the Nandai-mon, Tōdai-ji.

1236 Founding of Tōfuku-ji in Kyoto by the Chancellor Fujiwara-no-Michiie; appointment of Ben'en (Shōitsu Kokushi) as the first Zen abbot there.

1249 Building of Kenchō-ji in Kamakura.

1252 Approximate date of casting of bronze Daibutsu in Kamakura.

1266 Making of the thousand images of Kannon in the Sanjūsangen-dō, Kyoto; the date of the Benzai-ten image in the Tsurugaoka Hachiman Shrine, Kamakura.

1274 Invasion of Kyūshū by the Mongols.

1281 Second Mongol attack in Kyūshū.

1282 Building of Engaku-ji in Kamakura; death of Nichiren.

1302 Conversion of imperial villa of retired Emperor Kameyama into Nanzen-ji, Kyoto.

1327 Musō Soseki's buildings at Zuisen-ji, Kamakura.

1330 Portrait of Daitō Kokushi at Myōshin-ji, Kyoto.

1331 Forcing of the Emperor Godaigo to leave the capital.

1333 End of the authority of the Hōjō family; Ashikaga Takauji's support for the claims of the Northern Court.

MUROMACHI (OR ASHIKAGA) PERIOD (1337–1573). Moving of headquarters of military government to Kyoto under control of Ashikaga family; rise of arts cultivated by Zen sect to dominant position in Japanese taste, especially ink landscape painting and tea ceremony; growth of unified aesthetic system for painting, shoin-style architecture, ceramics, and other crafts; trade and cultural contacts with China and Korea.

1338 Assumption of rank of taishōgun by Ashikaga Takauji.

1339 Conversion of Saihō-ji, Kyoto, into Zen temple.

1340 Founding of Tenryū-ji in Kyoto; sending of Tenryū-ji ship for trade with China.

1342 Formal designation of the Gozan (five chief Zen temples of Kyoto) by military government; beginning of Myōshin-ji in Kyoto by the Emperor Hanazono.

1351 Death of Musō Soseki.

1374 Recognition of Seami's achievements in the Nō drama by the Shogun Ashikaga Toshimitsu.

1378 Establishment of new residence of the military government at the Hana-no-Gosho in Muromachi district, Kyoto.

1382 Zen temple of Shōkoku-ji established by Yoshimitsu.

1386 Painting of the Five Hundred Arhats by Minchō on fifty hanging scrolls, the majority of which remain in Tōfuku-ji.

1392 Return of the Emperor Gokameyama to Kyoto; presentation of imperial regalia to the Emperor Gokomatsu; end of the division of the throne into North and South dynasties.

1397 Building of the Kitayama Palace (including the Golden Pavilion) by Yoshimitsu.

1423 Entry of the fourth shogun, Yoshimochi, into Zen monastic orders at the Tōji-in; return of the monk-painter Shūbun from Korea.

1426 Building of the five-story pagoda at Kōfuku-ji.

1427 Painting of the Thirty Patriarchs of the Zen sect by Minchō at Tōfuku-ji.

1443 Orders to Nōami to assist in the judgment of the shogun's Chinese paintings.

1450 Building of Ryōan-ji by Hosokawa Katsumoto.

1467 Outbreak of the Ōnin Rebellion; Sesshū's voyage to Ming China; entry of Kanō Masanobu into service of the shogun.

1477 End of the Ōnin Rebellion.

1486 Ashikaga Yoshimasa's building of the Tōgu-dō at the Higashiyama Palace.

1490 Building of the Silver Pavilion at the Higashiyama Palace.

1495 Date of the haboku landscape of Sesshū, Tokyo National Museum.

1513 Building of the hondō of Daisen-in in Daitoku-ji, Kyoto.

1530 Death of Kanō Masanobu.

1543 Arrival of Portuguese at Tanegashima, bringing the science of firearms.

1559 Death of Kanō Motonobu.

1568 Entry of the warrior Oda Nobunaga into capital.

MOMOYAMA PERIOD (1586–1615)
EDO PERIOD (1615–1867)
MEIJI PERIOD (1868–1912)

SELECTED BIBLIOGRAPHY

Religious, Cultural, and Political Background

Anesaki, Masaharu. *Art, Life and Nature in Japan*. 1933. Reprint. Westport, Conn.: Greenwood Press, 1971.

_____. *Buddhist Art in Its Relation to Buddhist Ideals, with Special Reference to Buddhism in Japan*. Boston: Houghton Mifflin, 1923.

Brower, Robert H., and Miner, Earl. *Japanese Court Poetry*. Stanford: Stanford University Press, 1961.

de Bary, William Theodore, ed. *Sources of Japanese Tradition*. 2 vols. New York: Columbia University Press, 1958.

de Visser, M. W. *Ancient Buddhism in Japan*. 2 vols. Leiden: E. J. Brill, 1935.

Dumoulin, Heinrich. *A History of Zen Buddhism*. New York: Pantheon Books, 1963.

Eliot, Charles. *Japanese Buddhism*. 1935. Reprint. Boston: Routledge and Kegan Paul, 1967.

Hakeda, Yoshito. *Kukai: Major Works, Translated with an Account of His Life and a Study of His Thought*. New York: Columbia University Press, 1972.

Hall, John Whitney. *Japan from Prehistory to Modern Times*. New York: Dell, 1970.

_____, and Mass, Jeffrey, eds. *Medieval Japan: Essays in Institutional History*. New Haven: Yale University Press, 1974.

_____, and Toyoda, Takeshi, eds. *Japan in the Muromachi Age*. Berkeley and Los Angeles: University of California Press, 1975.

Hurst, G. Cameron. *Insei: Abdicated Sovereigns in the Politics of Late Heian Japan, 1068–1185*. New York: Columbia University Press, 1976.

Kitagawa, Joseph. *Religion in Japanese History*. New York: Columbia University Press, 1966.

Morris, Ivan. *The World of the Shining Prince: Court Life in Ancient Japan*. New York: Alfred A. Knopf, 1964.

Papinot, Edmond. *Historical and Geographical Dictionary of Japan*. 1910. Reprint. Tokyo and Rutland, Vt.: Charles E. Tuttle, 1972.

Sansom, George. *A History of Japan to 1334*. Stanford: Stanford University Press, 1958.

_____. *A History of Japan, 1334–1615*. Stanford: Stanford University Press, 1961.

_____. *Japan: A Short Cultural History*. Rev. ed. Englewood Cliffs, N. J.: Prentice-Hall, 1962.

Suzuki, Daisetsu T. *Zen and Japanese Culture*. Princeton: Princeton University Press, 1959.

Varley, H. Paul. *The Onin War: History of Its Origins and Background with a Selective Translation of the Chronicle of Onin*. New York: Columbia University Press, 1966.

_____. *The Imperial Restoration in Medieval Japan*. New York: Columbia University Press, 1971.

_____. *Japanese Culture: A Short History*. New York: Praeger Publications, 1973.

General Art Studies

Buhot, Jean. *Histoire des Arts du Japon, Dès Origine à 1350*. Paris: Van Oest, 1949.

Cultural Properties Protection Commission, ed. *Kokuhō Jiten* (National Treasure Dictionary). Kyoto: Benridō, 1961.

Fukuyama, Toshio. *Heian Temples: Byodo-in and Chuson-ji.* New York and Tokyo: John Weatherhill, 1976.

Henderson, Harold G., and Minamoto, Hoshu. *An Illustrated History of Japanese Art.* Kyoto: Hoshino, 1939.

Kidder, J. Edward. *Japanese Temples, Sculpture, Paintings, and Architecture.* London: Thames and Hudson, 1964.

Kobayashi, Takeshi. *Nara Buddhist Art: Todai-ji.* New York and Tokyo: John Weatherhill, 1975.

Lee, Sherman E. *Tea Taste in Japanese Art.* 1963. Reprint. New York: Arno Press, 1975.

Mizuno, Seiichi. *Asuka Buddhist Art: Horyu-ji.* New York and Tokyo: John Weatherhill, 1974.

Munsterburg, Hugo. *The Arts of Japan.* Tokyo and Rutland, Vt.: Charles E. Tuttle, 1957.

Noma, Seiroku et al. *Nihon Bijutsu Zenshi* (Art History of Japan). 2 vols. Tokyo: Bijutsu Shuppansha, 1959.

Office of the Important Cultural Properties Commission and Mainichi Newspaper, eds. *Jūyōbunkazai* (Important Cultural Properties of Japan). 32 vols. Tokyo: Mainichi Newspaper, 1972–78.

Ooka, Minoru. *Temples of Nara and Their Art.* New York and Tokyo: John Weatherhill, 1973.

Paine, Robert T., and Soper, Alexander. *The Art and Architecture of Japan.* Rev. ed. New York: Penguin Books, 1974.

Roberts, Laurence P. *A Dictionary of Japanese Artists: Painting, Sculpture, Ceramics, Prints, Lacquer.* Tokyo and New York: John Weatherhill, 1976.

Rosenfield, John M. *Japanese Arts of the Heian Period.* New York: Asia Society, 1967.

_____, and Shimada, Shujiro. *Traditions of Japanese Art: Selections from the Kimiko and John Powers Collection.* Cambridge: Fogg Art Museum, 1970.

_____; Cranston, Fumiko; and Cranston, Edwin. *The Courtly Tradition in Japanese Art and Literature: Selections from the Hofer and Hyde Collections.* Cambridge: Fogg Art Museum, 1973.

Sawa, Takaaki [Ryūken]. *Art in Japanese Esoteric Buddhism.* New York and Tokyo: John Weatherhill, 1972.

Shimada, Shūjiro. *Zaigai Hihō* (Japanese Paintings in Western Collections). 3 vols. Tokyo: Gakushūkenkyūsha, 1969.

Snellgrove, David, ed. *The Image of the Buddha.* Tokyo, New York, and Paris: Kodansha International and UNESCO, 1978.

Swann, Peter. *An Introduction to the Arts of Japan.* Rev. ed. New York and Tokyo: Kodansha International, forthcoming.

Tokyo National Museum, ed. *Pageant of Japanese Art.* 6 vols. Tokyo: Toto Shuppan, 1952.

Warner, Langdon. *The Enduring Art of Japan.* 1952. Reprint. New York: Grove Press, 1958.

Yamada, Chisaburoh, ed. *Decorative Arts of Japan.* New York and Tokyo: Kodansha International, 1964.

Yashiro, Yukio. *2,000 Years of Japanese Art.* New York: Harry N. Abrams, 1958.

_____, ed. *Art Treasures of Japan.* 2 vols. Tokyo: Kokusai Bunka Shinkokai, 1960.

Yoshikawa, Itsuji. *Major Themes in Japanese Art.* New York and Tokyo: John Weatherhill, 1976.

Pre-Buddhist and Shinto

Egami, Namio. *The Beginnings of Japanese Art.* New York and Tokyo: John Weatherhill, 1973.

Kageyama, Haruki. *The Arts of Shinto.* New York and Tokyo: John Weatherhill, 1973.

_____, and Kanda, Christine Guth. *Shinto Arts: Nature, Gods and Man in Japan.* New York, 1976.

Kidder, J. Edward. *Early Japanese Art: The Great Tombs and Treasures.* Princeton, N.J.: Van Nostrand, 1964.

_____. *The Birth of Japanese Art.* New York: Praeger Publications, 1965.

_____. *Japan Before Buddhism.* Rev. ed. New York: Praeger Publications, 1966.

Miki, Fumio. *Haniwa.* Tokyo and Rutland, Vt.: Charles E. Tuttle, 1960.

_____. *Haniwa.* New York and Tokyo: John Weatherhill, 1974.

Tsuboi, Kiyotaru, ed. *Nihon Genshi-bijutsu Taikei* (Archaeological Treasures of Japan). 6 vols. Tokyo: Kōdansha, 1977–.

Watanabe, Yasutada. *Shinto Art: Ise and Izumo Shrines.* New York and Tokyo: John Weatherhill, 1974.

Architecture and Town Planning

Alex, William. *Japanese Architecture.* New York: George Braziller, 1963.

Futagawa, Yukio. *The Roots of Japanese Architecture.* New York: Harper and Row, 1963.

Ponsoby-Fane, Richard A. *Kyoto: The Old Capital of Japan*. 1956. Reprint. Collected Works, vol. 2. New York: International Publications Service, 1973.

Sekino, Masaru. *Tera to Yashiro* (Temples and Shrines). Tokyo: Kōdansha, 1956.

Soper, Alexander C. *The Evolution of Buddhist Architecture in Japan*. Princeton: Princeton University Press, 1942.

Tange, Kenzo, and Kawazoe, Noboru. *Ise: Prototype of Japanese Architecture*. Cambridge: M. I. T. Press, 1964.

PAINTING

Akiyama, Terukazu. *Japanese Painting*. 1961. Reprint. London: Macmillan, 1977.

Armbruster, Gisela. *Das Shigisan Engi Emaki*. Mitteilungen der Gesselschaft für Natur- und Völkerkunde Ostasiens, vol. 40. Hamburg, 1959.

Brinker, Helmut. *Die Zen-Buddhistische Bildnismalerei in China und Japan*. Münchener Ostasiatische Studien, vol. 10. Wiesbaden, 1973.

Covell, John Carter. *Under the Seal of Sesshu*. 1941. Reprint. New York: Hacker Art Books, 1974.

Fontein, Jan, and Hickman, Money. *Zen Painting et Calligraphy*. Boston: New York Graphic Society, 1970.

Hōryū-ji Kondō Hekiga-shū Kankōkai, ed. *Hōryū-kondō Hekiga-shū* (Wall Paintings of the Hōryū-ji Monastery). Kyoto: Benrido, 1951.

Ienaga, Saburo. *Painting in the Yamato Style*. New York and Tokyo: John Weatherhill, 1973.

Matsushita, Takaaki. *Ink Painting*. New York and Tokyo: John Weatherhill, 1974.

_____, and Elisseeff, Serge. *Japan: Ancient Buddhist Paintings*. Boston: New York Graphic Society, 1959.

Morris, Ivan. *The Tale of Genji Scroll*. New York and Tokyo: Kodansha International, 1971.

Museem der Stadt Köln, ed. *Sho: Pinselschrift und Malerei in Japan vom 7–19 Jahrhundert*. Cologne, 1975.

Naito, Toichiro. *The Wall Paintings of Horyu-ji*. Washington, D. C.: American Council of Learned Societies, 1940.

Okazaki, Jōji. *Pure Land Buddhist Painting*. Tokyo and New York: Kodansha International, 1977.

Okudaira, Hideo. *Narrative Picture Scrolls*. New York and Tokyo: John Weatherhill, 1973.

Seckel, Dietrich. *Emakimono: The Art of the Japanese Painted Hand-scroll*. New York: Pantheon Books, 1959.

Shimizu, Yoshiaki, and Wheelwright, Carolyn, eds. *Japanese Ink Paintings from American Collections*. Princeton: Princeton University Press, 1976.

Society of Friends of Eastern Art. *Index of Japanese Painters*. Tokyo and Rutland, Vt.: Charles E. Tuttle, 1959.

Tanaka, Ichimatsu. *Japanese Ink Painting: Shubun to Sesshu*. New York and Tokyo: John Weatherhill, 1972.

_____, ed. *Nihon Emakimono Zenshū* (Japanese Scroll Paintings). 30 vols. Tokyo: Kadokawa Shoten, 1975–.

Toda, Kenji. *Japanese Scroll Painting*. 1935. Reprint. Westport, Conn.: Greenwood Press, 1969.

SCULPTURE

Kidder, J. Edward. *Masterpieces of Japanese Sculpture*. Tokyo and Rutland, Vt.: Charles E. Tuttle, 1961.

Kuno, Takeshi, ed. *A Guide to Japanese Sculpture*. Tokyo: Maruyama, 1963.

Moran, Sherwood, "The Yumedono Kannon of Hōryū-ji." *Archives of the Chinese Art Society of America* 11 (1957): 59–68.

_____. "The Statue of Miroku Bosatsu of Chūgū-ji." *Artibus Asiae* 21 (1958): 179–203.

_____. "The Statue of Muchaku, Hokuen-dō, Kōfuku-ji: A Detailed Study." *Arts Asiatiques* 5 (1958): 49–64.

_____. "The Portrait Statue of Uesugi Shigefusa." *Arts Asiatiques* 4 (1959): 283–96.

_____. "Structural Features of Clay Sculpture." *Artibus Asiae* 23 (1960): 41–66.

_____. "The Statue of Fugen Bosatsu, Okura Museum, Tokyo." *Arts Asiatiques* 7 (1960): 287–310.

_____. "The Statue of Amida, Hōō-dō, Byōdō-in." *Oriental Art*, n.s. 6 (1960): 49–55.

_____. "Ashura: A Dry-lacquer Statue of the Nara Period." *Artibus Asiae* 27 (1964): 99–133.

Mōri, Hisashi. *Japanese Portrait Sculpture*. Tokyo and New York: Kodansha International, 1977.

Nishikawa, Kyōtarō. *Bugaku Masks*. New York and Tokyo: Kodansha International, 1978.

Noma, Seiroku. *Gyobutsu kondō-butsu* (Ancient Japanese Gilt Bronze Buddhas). Kyoto: Benrido, 1952.

_____. *Tsuchi to Geijutsu* (The Art of Clay). Tokyo: Bijutsu Shuppansha, 1954.

Warner, Langdon. *Japanese Sculpture of the Suiko Period*. New Haven: Yale University Press, 1923.

_____. *The Craft of the Japanese Sculptor*. New York: Japan Society, 1936.

_____. *Japanese Sculpture of the Tempyo Period: Masterpieces of the Eighth Century*. Cambridge: Harvard University Press, *ca.* 1959.

OTHERS

Harada, Jiro. *English Catalogue of Treasures in the Shōsō-in*. Tokyo: Imperial Household Museum, 1932.

Hayashi, Ryoichi. *The Silk Road and the Shoso-in*. New York and Tokyo: John Weatherhill, 1975.

Miller, Roy Andrew. *Japanese Ceramics*. Tokyo: Toto Shuppan, 1960.

Munsterberg, Hugo. *The Ceramic Art of Japan*. Tokyo and Rutland, Vt.: Charles E. Tuttle, 1964.

Shoso-in Office, ed. *Treasures of the Shoso-in*. Tokyo: Asahi Newspaper, 1965.

MAP OF JAPAN

HOKKAIDŌ

o SAPPORO

AOMORI

AOMORI

IWATE

MORIOKA

HIRAIZUMI

MIYAGI

SENDAI

AKITA

YAMAGATA

YAMAGATA

FUKUSHIMA

FUKUSHIMA

TOCHIGI

IBARAKI

MITO

UTSUNOMIYA

SAITAMA

CHIBA

CHIBA

TOKYO

NIIGATA

NIIGATA

URAWA

TŌKYŌ

KANAGAWA

YOKOHAMA

KAMAKURA

GUMMA

MAEBASHIO

NAGANO

NAGANO

KŌFU

YAMANASHI

TOYAMA

TOYAMA

SHIZUOKA

SHIZUOKA

ISHIKAWA

KANAZAWA

GIFU

GIFU

AICHI

NAGOYA

KYOTO

FUKUI

FUKUI

SHIGA

ŌTSU

TSU

MIE

SHIMANE

TOTTORI

TOTTORI

HYŌGO

KYOTO

KYŌTO

NARA

NARA

IKARUGA

MATSUE

KOBE

OSAKA

OSAKA

WAKAYAMA

WAKAYAMA

YAMAGUCHI

HIROSHIMA

OKAYAMA

OKAYAMA

HIROSHIMA

TAKAMATSU

KAGAWA

TOKUSHIMA

TOKUSHIMA

ITSUKUSHIMA

KŌCHI

YAMAGUCHI

MATSUYAMA

EHIME

KŌCHI

FUKUOKA

SAGA

FUKUOKA

ŌITA

ŌITA

MIYAZAKI

NAGASAKI

SAGA

KUMAMOTO

KUMAMOTO

MIYAZAKI

NAGASAKI

KAGOSHIMA

KAGOSHIMA

KAGOSHIMA

400km

200

0

293

NARA AND VICINITY

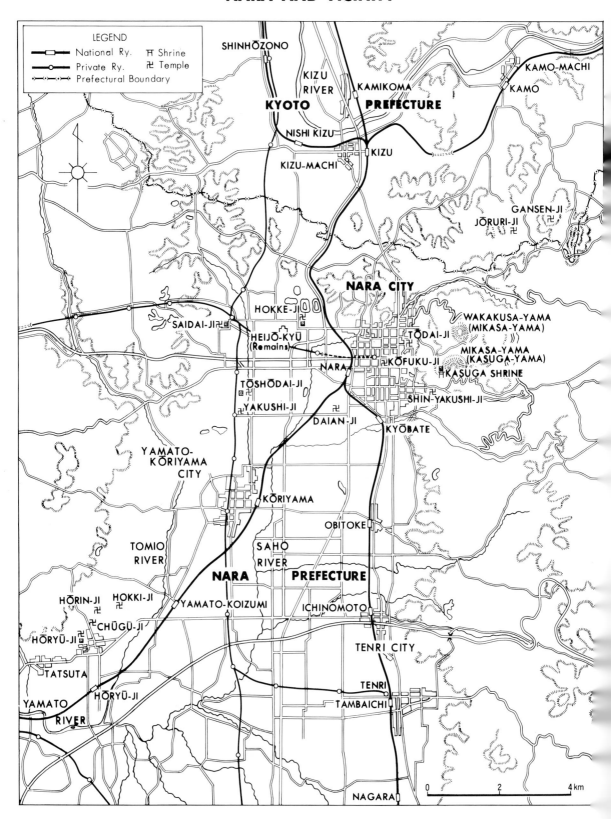

LEGEND
- ▭ National Ry.
- ○ Private Ry.
- Prefectural Boundary
- 卅 Shrine
- 卍 Temple

SHINHŌZONO

KIZU RIVER

KAMIKOMA

KAMO-MACHI

KAMO

KYOTO **PREFECTURE**

NISHI KIZU

KIZU

KIZU-MACHI

GANSEN-JI

JŌRURI-JI

NARA CITY

HOKKE-JI

SAIDAI-JI

HEIJŌ-KYŪ (Remains)

WAKAKUSA-YAMA (MIKASA-YAMA)

TŌDAI-JI

MIKASA-YAMA (KASUGA-YAMA)

KŌFUKU-JI

NARA

KASUGA SHRINE

TŌSHŌDAI-JI

YAKUSHI-JI

SHIN-YAKUSHI-JI

DAIAN-JI

KYŌBATE

YAMATO-KŌRIYAMA CITY

KŌRIYAMA

OBITOKE

TOMIO RIVER

SAHO RIVER

NARA **PREFECTURE**

HŌRIN-JI

HOKKI-JI

YAMATO-KOIZUMI

ICHINOMOTO

CHŪGŪ-JI

HŌRYŪ-JI

TENRI CITY

TATSUTA

HŌRYŪ-JI

TENRI

YAMATO RIVER

TAMBAICHI

NAGARA

0 2 4 km

KYOTO AND VICINITY

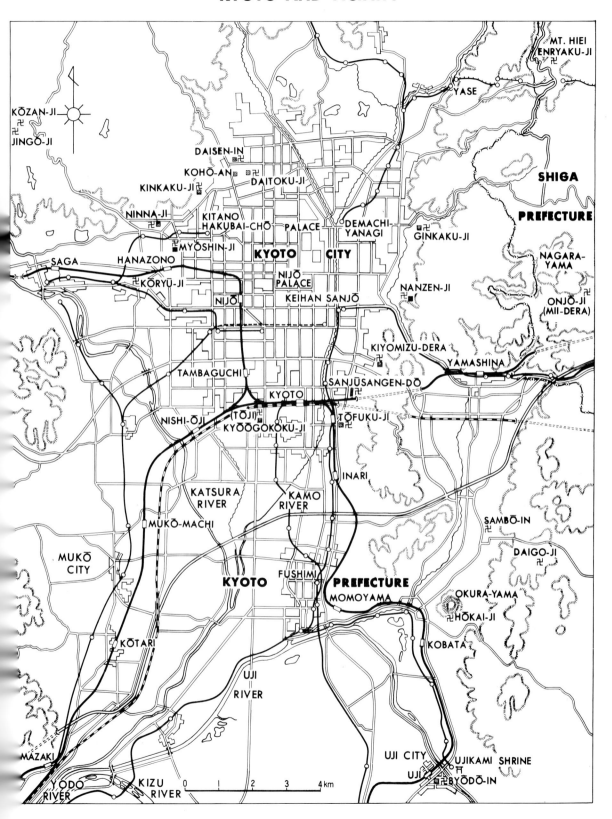

KŌZAN-JI
卍
JINGO-JI

DAISEN-IN
KOHŌ-AN
KINKAKU-JI 卍 DAITOKU-JI

NINNA-JI
卍

KITANO
HAKUBAI-CHŌ PALACE
MYŌSHIN-JI

MT. HIEI
ENRYAKU-JI
卍

YASE

SHIGA

PREFECTURE

SAGA
HANAZONO
KŌRYŪ-JI

NIJŌ

DEMACHI-
YANAGI
GINKAKU-JI
卍

KYOTO CITY

NIJŌ
PALACE

KEIHAN SANJŌ

NANZEN-JI
■

NAGARA-
YAMA

ONJŌ-JI
(MII-DERA)

TAMBAGUCHI

KYOTO

KIYOMIZU-DERA

YAMASHINA

SANJŪSANGEN-DŌ

NISHI-ŌJI
(TŌJI)
KYŌŌGOKOKU-JI

TŌFUKU-JI

KATSURA
RIVER

KAMO
RIVER

INARI

SAMBŌ-IN
卍

MUKŌ-MACHI

DAIGO-JI
卍

MUKŌ
CITY

KYOTO FUSHIMI **PREFECTURE**

MOMOYAMA

OKURA-YAMA

HŌKAI-JI
卍

KŌTARI

KOBATA

UJI
RIVER

MĀZAKI

UJI CITY
UJIKAMI SHRINE
UJI
BYŌDŌ-IN

YODO
RIVER

KIZU
RIVER

0 1 2 3 4 km

KAMAKURA AND VICINITY

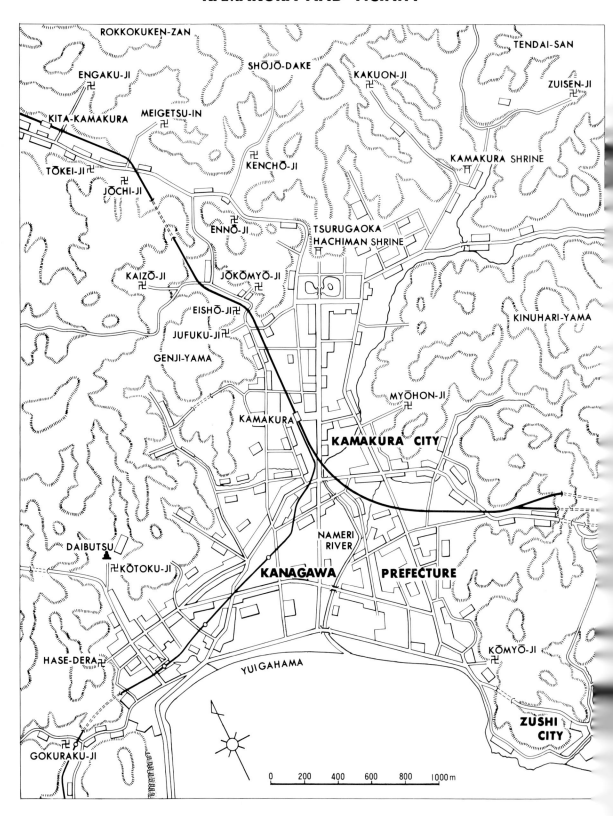

ROKKOKUKEN-ZAN

TENDAI-SAN

ENGAKU-JI 卍

SHŌJŌ-DAKE

KAKUON-JI 卍

ZUISEN-JI

KITA-KAMAKURA

MEIGETSU-IN 卍

TŌKEI-JI 卍

KAMAKURA SHRINE 卍

JŌCHI-JI 卍

KENCHŌ-JI 卍

ENNŌ-JI 卍

TSURUGAOKA
HACHIMAN SHRINE

KAIZŌ-JI

JŌKŌMYŌ-JI 卍

EISHŌ-JI 卍

KINUHARI-YAMA

JUFUKU-JI 卍

GENJI-YAMA

MYŌHON-JI 卍

KAMAKURA

KAMAKURA CITY

DAIBUTSU

NAMERI
RIVER

卍 KŌTOKU-JI

KANAGAWA

PREFECTURE

KŌMYŌ-JI 卍

HASE-DERA 卍

YUIGAHAMA

**ZUSHI
CITY**

GOKURAKU-JI

0 200 400 600 800 1000m

INDEX

of arts during, 138, 139, capt. 112, 275 n. 115, 164; painting during, 139; sculpture at end of, 187–88, capt. 153; stylistic developments of, anticipated, 272 n. 92. *See also* Chronological Chart

Heian Shrine, 139

Heijō-kyū, 62

Heike. *See* Taira

Heike Nōkyō (Itsukushima Shrine). *See* sutra scrolls donated by the Taira family

hell, 207, capt. 171

Higashiyama Palace, 228, 283 n. 182, capt. 185, 283 n. 185. *See also* Silver Pavilion; Tōgu-dō

Higashiyama period, 228, 229–30, 284 n. 193

Hinduism, 114, 115

Hiraizumi, 183, 186–88, capt. 154

hira-karamon, 277 n. 131, fig. 131. *See also* Glossary

hiten: in Hōō-dō, 277 n. 135–36, figs. 135–36, 278 n. 141; in Hōryū-ji's *kondō*, 265 n. 30, fig. 30, 63; at Tōdai-ji's Daibutsu-den, 82; at Yakushi-ji's eastern pagoda, capt. 47, 63. *See also* Glossary

hōjō-e, 283 n. 182

Hōjō family, 281 n. 164; Hōjō Tokimune, 281 n. 164; Hōjō Tokiyori, 281 n. 167

Hōjō-ji, 164–65

Hōkai-ji, 164; *amida-dō* of, 278 n. 142, figs. 140–42

Hokke-dō. *See* Sangatsu-dō

Hokke-kyō. *See Lotus Sutra*

Hokki-ji, 38

Hokkō-ji, 34

Hokuen-dō (North Circular Hall; Kōfuku-ji), 85, 86, 271 n. 81, fig. 81. *See also* Glossary (*endō*)

hōkyōin-tō, 282 n. 176, fig. 176. *See also* Glossary

hompa-shiki, 274 n. 105, fig. 105, 275 n. 112–13

Hōnen Shōnin, 204

Hōō-dō (Phoenix Hall), 163–64, 277 n. 133–39, figs. 133–39; compared with Hōkai-ji's *amida-dō*, 164, 278 n. 142; compared with Itsukushima Shrine, 184; compared with Konjiki-dō, 187; compared with Muryōkō-in, 186; wall paintings at, compared with "Descent of Amida and His Heavenly Host," 273 n. 101. *See also* Glossary

Hōrin-ji, 38, 267 n. 46

Hōryū-ji, 34–35, 37, 264 n. 22, fig. 22, 65, capt. 54. *See also* Hōryū-ji's *kondō*; Hōryū-ji's pagoda

Hōryū-ji's *kondō*: canopies over altar at, 265 n. 29–31, figs. 29–31, 63; compared with Shrine of Lady Tachibana, 267 n. 41; compared with Sangatsu-dō, 269 n. 65; contrasted to Tōshōdai-ji's *kondō*, 268 n. 54; function of, 264 n. 23, 63; protective corridors at, 268 n. 47; Tamamushi Shrine's resemblances to, capt. 32, 265 n. 32; and Tori Busshi, 36; wall paintings in, 266 n. 40, fig. 40, capt. 139

Hōryū-ji's pagoda, 264 n. 22–23, figs. 22–23; compared with Daigo-ji's pagoda, capt. 128; contrasted to Yakushi-ji's eastern pagoda, 63; dry clay statues at, 266 n. 38–39, figs. 38–39; function of, 264 n. 23, 62; protective corridors at, 268 n. 47

hōsōge, capt. 29, 271 n. 80, fig. 80. *See also* Glossary

household icons, 37–38, capt. 37

Hsia Kuei, capt. 189, 285 n. 194

Hui-k'o, capt. 191, 284 n. 191

"Hui-k'o Presenting His Arm to Bodhidharma" (Sesshū), 284 n. 191, fig. 191

ichiboku, 268 n. 56

Ichiji Kinrin (Chūson-ji). *See* Dainichi (Chūson-ji)

Ichikishimahime-no-mikoto, 278 n. 144

Ikaruga-dera. *See* Hōryū-ji

illustrated handscroll. *See e-makimono*

Imperial Palace, 62, 138–39, 274 n. 114–17, figs. 114–17, 184

incense, capt. 80, 271 n. 80, 231

incense burner (Shōsō-in), 271 n. 80, fig. 80

India: and canopies in Hōryū-ji's *kondō*, capt. 29; and Kichijō-ten, 268 n. 53; musical borrowings from, 63; and paintings at Hōō-dō, capt. 139; and ritual implements, capt. 100; and Shō-Kannon (Yakushi-ji), 268 n. 48–49; and Tōji's mandala, capt. 111; and wall paintings in Hōryū-ji's *kondō*, capt. 40; and Yakushi Nyorai (Jingo-ji), capt. 95. See also *tenjiku*

"Indian style" architecture. *See tenjiku*

Indra (Taishaku-ten), capt. 33, 66, 82. *See also* Glossary

inkstone box (Tsurugaoka Hachiman Shrine), 208, 282 n. 177, fig. 177

insei ("cloistered emperors"), 165, 183. *See also* Glossary

Ippen Shōnin, 204

Iran, capt. 29, 84, 271 n. 76, 271 n. 78

iron teakettles, 230, 285 n. 197, fig. 197

"iron wire" lines, capt. 40, 265 n. 33

Ise Shrine, 15, 264 n. 18–21, figs. 18–21

Itsukushima Shrine, 183–86, 278 n. 144–45, figs. 144–45

Iwashimizu Shrine, 280 n. 160

Izumo clan, capt. 17

Izumo Shrine, 15, 264 n. 17, fig. 17

Jikaku Daishi, 280 n. 159

Jikkei, 117

Jikoku-ten (Kaidan-in), 270 n. 71–73, fig. 71. *See also* Glossary

Jingo-ji, 113, 115–16, 273 n. 94, fig. 94

Jishō-ji, 283 n. 185. *See also* Silver Pavilion

Jizō, 207; statue of (Murō-ji), 118, 274 n. 107, fig. 107. *See also* Glossary

Jōchō: creator of Amitābha Buddha (Hōō-dō), 163, 278 n. 137, capt. 137, 278 n. 140; and Hōjō-ji, 164; and Hōō-dō, 277 n. 134–36; methods of, 165; style of, 163; trained at Kōfuku-ji, 85; and workshops, 163, 165, 166

Jōdo. *See* Pure Land Buddhism

Jōdo Wasan, 162

Jōkei, 85; Ni-ō by, 272 n. 86, fig. 86

Jōmon period, 11, 12, 14. *See also* Chronological Chart; Glossary (Jōmon)

Jōmon pottery, 11, 12, 262 n. 2–3, figs. 2–3, capt. 4. *See also* Glossary (Jōmon)

（新装版）日本美術 上巻
The Arts of Japan (vol. 1)

2003年6月6日　第1刷発行

著　者　野間清六

訳　者　ジョン・ローゼンフィールド

発行者　畑野文夫

発行所　講談社インターナショナル株式会社
　　　　〒112-8652　東京都文京区音羽 1-17-14
　　　　電話　03-3944-6493（編集部）
　　　　　　　03-3944-6492（営業部・業務部）
　　　　ホームページ　www.kodansha-intl.co.jp

印刷所　大日本印刷株式会社

製本所　大日本印刷株式会社

落丁本、乱丁本は購入書店名を明記のうえ、講談社インターナショナル
業務部宛にお送りください。送料小社負担にてお取替えいたします。な
お、この本についてのお問い合わせは、編集部宛にお願いいたします。本
書の無断複写（コピー）は著作権法上での例外を除き、禁じられています。

定価はカバーに表示してあります。

© 野間清六 1966
Printed in Japan
ISBN4-7700-2977-2